JAPANESE
SCULPTURE
OF THE
TEMPYO PERIOD

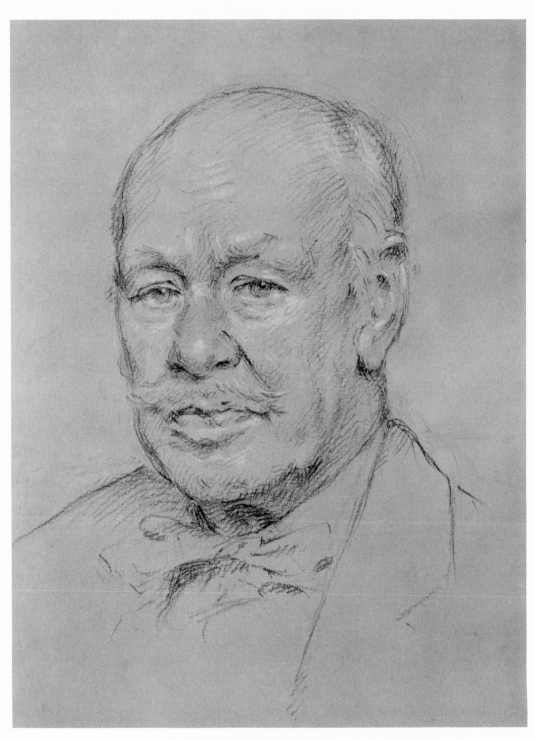

LANGDON WARNER
A Portrait Sketch Done in 1950 by Arthur Pope

JAPANESE SCULPTURE OF THE TEMPYO PERIOD

Masterpieces of the Eighth Century

By

LANGDON WARNER

Edited and Arranged by

JAMES MARSHALL PLUMER

HARVARD UNIVERSITY PRESS · CAMBRIDGE, MASSACHUSETTS

One-volume edition, 1964

152489

Dedicated to the Memory of

Kakuzo Okakura

Chunosuke Niiro

and

Abbot Jo-in Saeki of Hōryū-ji

NOTE ON THE NAME TEMPYO

The origin of the word Tempyo is recorded in the *Shoku Nihongi* (A.D. 697–791). During the seventh month of the sixth year of Jinki (A.D. 729) a tortoise appeared in a suburb of Nara. The natural pattern of its shell spelled seven Chinese characters, and Fujiwara Maro, magistrate of the city, brought the miraculous creature to the palace. From the seven, the Emperor Shōmu selected two auspicious characters: *Ten* 天 (Heaven) and *Pyō* 平 (Peace). The next month he proclaimed that the name of the era be changed from Jinki to Tempyo and that the calendar be made to conform. Although the era name was again changed in 749, and there were a round dozen others within a space of eighty-four years covered by this chapter of art history, I have followed Okakura and the familiar Japanese custom of using the word Tempyo to conjure up the social and political conditions, and indeed the very shapes of the Buddhist gods, during the eight decades while Nara city was the seat of Empire.

In some ways it might seem more logical to accept the label "Late Nara," devised in recent years, for it implies the existence of Nara as imperial residence before 710, and the removal of the capital in 794; but the name Tempyo is still cogent to evoke thoughts that the more logical title does not suggest. L. W.

CONTENTS

ix

CONTENTS

ILLUSTRATIONS IN TEXT

LIST OF PLATES

Location of sculptures where not shown is the same as the last given location

CONTENTS

CONTENTS

CONTENTS

CONTENTS

xiv

CONTENTS

XV

CONTENTS

CONTENTS

xvii

CONTENTS

CONTENTS

INTRODUCTION

A MAN AND AN ERA

By

James Marshall Plumer

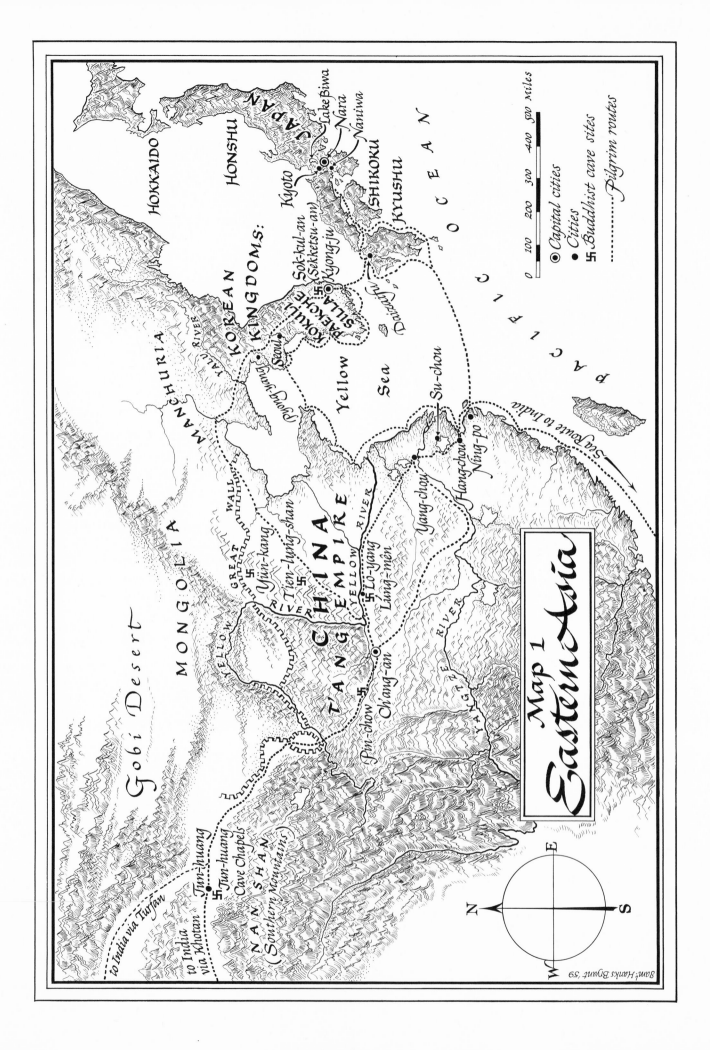

Map 1
Eastern Asia

HOKKAIDO

HONSHU

JAPAN

Lake Biwa
Nara
Naniwa
Kyoto

Sok-kul-an
(Sŏkketsu-an)
Kyŏng-ju

SHIKOKU

KYUSHU

Dazaifu

KORYŎ
PAEKCHE
SILLA
KOREAN KINGDOMS:

Seoul

P'yŏng-yang

YALU RIVER

MANCHURIA

MONGOLIA

Gobi Desert

Yellow Sea

Yün-kang

Tien-lung-shan

GREAT WALL

YELLOW RIVER

CHINA
T'ANG EMPIRE

Lo-yang
Lung-mên

Yellow River

Ch'ang-an

Pin-chou

Su-chou

Yang-chou

Hang-chou

Ning-po

YANGTZE RIVER

Tun-huang
Tun-huang Cave Chapels

NAN SHAN
(Southern mountains)

to India via Turfan

to India via Khotan

PACIFIC OCEAN

Sea Route to India

0 100 200 300 400 500 miles

◉ Capital cities
• Cities
卍 Buddhist cave sites
------- Pilgrim routes

N
E
S
W

Sam'Hanks Bryant '59

A MAN AND AN ERA

THE MAN

THIS book stands for a man and an era. And the era stands for that which is great in other eras — as the author stands amongst men. The two, man and era, Warner and Tempyo, were closely associated through the better part of half a century. Here was a Golden Age of Art that would amaze the West. Here was a young man with the conviction that that age and the country which produced it should be known. The conviction remained with him all his life — and this book is the result.

Langdon Warner was born on the first of August, 1881, in Cambridge, Massachusetts. He graduated from Harvard in 1903. The next year saw him in Russian Turkestan with the Pumpelly-Carnegie Expedition. He was to know the heart of Asia well. Investigations of the potentials for archaeological research and study, on behalf of Mr. Charles L. Freer in 1913–1914, took him to China, Manchuria, and Mongolia. On a special United States consular assignment at Harbin in 1917–1918, involving liaison with isolated Czecho-Slovakian forces, he crossed Siberia several times. He led two Harvard expeditions in 1923 and 1925 to the remote Chinese Buddhist caves at Tun-huang and Wan-fo-hsia. In 1931, on one of his many visits to Peking, he took tea and gloated over old paintings with the last of the Ch'ing Imperial line, Mr. Henry P'u-i, then living in seclusion in the Japanese concession at Tientsin. He visited Indo-China in 1913 and again in 1938 when he also went to Bangkok. More than once he traveled in Korea, interested as much in Buddhist sculpture as in excavated pottery and surviving traditional crafts.

As for Japan, Mr. Warner first came under its spell in the person of Kakuzo Okakura whom he met at the Museum of Fine Arts, Boston, in 1906. Before the year was up he was off to Japan to study the language, lore, and art with a group of Okakura's pupils. Amongst these were Chunosuke Niiro the sculptor, Shisui Rokkaku the metal-worker, Kakuya Okabe the lacquerer, and Yokoyama Taikan the painter. From 1907 to 1912 his time was divided between Japan and the museum in Boston where in 1909 he was appointed Assistant Curator of Chinese and Japanese Art. It was about this time

I

that he undertook his first important assignment in his chosen field, helping Okakura with the English version of the Japanese Government publication, "Japanese Temples and Their Treasures." Once during these early years he traveled alone to the "Loo-choos," and he has left a few casual notes recording his admiration of the dignified and graceful Okinawans and his chagrin in retrospect at the unceremonious assault upon their castle at Naha by Commodore Perry's party some decades before.

In 1910 he was in Tokyo with his bride, a typewriter, inadequate funds, and the zeal to make, as he wrote to the late Edward Jackson Holmes, "the first attempt at a logical approach to Japanese art." Deep in the study of the Suiko period when he wrote those words — a grander scheme, including the Tempyo period was already in his mind, and the first sentences had been written.

From 1912 with his first appointment as lecturer until his retirement in 1950, Mr. Warner held a nearly continuous series of teaching appointments at Harvard. He was undoubtedly one of the great art teachers of our time. His knowledge, conviction, persuasion, humor, and personal magnetism were such that before his retirement other institutions across America were adding Far Eastern Art courses to their curricula — many of them taught by his own students. The University of California conferred upon him the degree of Doctor of Laws in 1939.

At Harvard, in addition to his teaching, Mr. Warner was always active in the art museum world. He also held a succession of appointments at the Fogg Museum of Art as Fellow of the Museum for Research in Asia, as Keeper, and as Curator of the Oriental Department. He held, periodically, a number of outside appointments or commissions from the Cleveland Museum of Art, the William Rockhill Nelson Gallery of Art in Kansas City, the Honolulu Academy of Arts, and Radcliffe College. At one time, in 1914, he volunteered his assistance at the Hermitage Museum; in 1917 he was director of the Philadelphia Museum of Art. He was invited to lecture at the Exhibition of Chinese Art in London in 1936. In the face of rising world tensions he sailed for Asia and assembled the remarkable exhibition of "Pacific Cultures" for the International Exposition held in 1939–1940 at San Francisco.

Consulted on the preservation of arts and monuments in Asia in the early 1940's, he was instrumental in convincing the authorities in Washington that Kyoto was of greater cultural than military significance and should therefore be spared air attack. Less known is the fact that it was Mr. Warner who conceived and was perhaps initially responsible for the last-minute direct appeal from President Roosevelt to His Imperial Japanese Majesty to maintain the peace. It was a matter of great sorrow to him to discover that by that time even the heads of state were unable to stem the resistless tide of tragedy. As special consultant attached to General MacArthur's Arts and Monuments Division in Tokyo in 1946 he did everything in his power to assuage a nation stunned. An element

of humor was injected into the extraordinary occasion of his being invited into the presence of the Emperor. With no formal clothing fit for audience and none available in Tokyo, the situation was saved by dispatching a jeep on a hundred-mile round trip to fetch a stiff white paper Naval officer's collar from the coast. Whatever was discussed at that remarkable meeting, the Imperial Household Museum, utterly without funds, soon became nationalized with a plan for proper support from national funds, and the Imperial authority over the Shōsō-in at Nara, exerted for twelve hundred years, remained unchanged.

Mr. Warner's last trip to Japan, in 1952, was in connection with the forthcoming (1953) Loan Exhibition of Japanese Painting and Sculpture. Through five museums, hundreds of thousands of Americans saw Japanese art objects of quality for the first time and one of Mr. Warner's fondest dreams was realized. The Order of the Sacred Treasure was conferred on him posthumously by the Emperor in September 1955.

Mr. Warner himself was never far from Japan — whether sharing his love and knowledge of it with his students in Cambridge or seeking out the traces of its heritage in the wastes of Asia. It fell to my lot to be at Hōryū-ji when flames all but consumed its ancient murals — and on returning to Tokyo I found a cable from Mr. Warner stating that the Fogg Museum courtyard had been hung with full size photographic replicas of those paintings within forty-eight hours of their destruction. One of Mr. Warner's students, riding in a Kyoto streetcar in the summer of 1955, was startled to see his photograph, advertising, it seemed, a memorial meeting, amongst the placards. In the city he loved so well his passing was of public concern.

He was not less fond of Nara. It came to be a part of him, even as — long before the memorial to him at Hōryū-ji was projected — he became a part of Nara. Indeed, for months on end he had slept and eaten, conversed and jotted notes in the Tōdai-ji, living virtually as a lay brother from New England in Nara's mightiest temple. Some years ago his opinion was sought when the Nara Hotel was being planned. His ready approval was tempered with the expressed hope that it be unobtrusive. So we have today the pleasantly rambling structure with low roof in temple style. While shopping during his last visit to Nara in 1952, he was accosted by a simple Japanese workman who hopped off a bicycle doffed his hat and said "Warner-san — so glad you come!" then mounted his cycle and disappeared. One had spoken for many.

The trivial as well as the dramatic moves people in Japan. In a symposium of memories of Mr. Warner published by the Tokyo National Museum, Seiroku Noma recalls noticing during a tea ceremony that Mr. Warner was wearing ordinary cotton socks, and comments: "Those mended socks told Mr. Warner's personality more vividly than anything else." Noritake Tsuda, referring to hectic preparation for the Pacific Cultures exhibition, notes that "Mr. Warner developed the habit of sleeping on a table after work-

ing deep into the night." Jiro Harada tells again of how once Mr. Warner in top hat and frock coat insisted on walking to the Shōsō-in airing when other dignitaries rode — and he concludes with the tribute, "As long as I live, I shall never forget Mr. Warner's humble heart!"

THE MANUSCRIPT

Few were the times when the author could devote himself for long exclusively to his vision of a work on Tempyo. His aim never was to write a definitive work on a single aspect of the period, but rather to treat the sculpture as a gauge of its greatness. Most of the photographs were taken by Mr. Seiyo Ogawa of the Asuka-en, Nara, a few being made under Mr. Warner's direction by the Kyoto firm of Benridō that also made the collotype plates. The arrangement of over 65,000 unnumbered plates posed problems of time, space, and method, that were eventually solved at Harvard. The final order is based primarily on craftsmanship and materials — and to a lesser extent on chronology, iconography, and location. The special boxes were made in Japan, where they were covered with silk closely following the design of an eighth-century fragment in Hōryū-ji.

Much of the manuscript was written in 1915 and a good deal in the 1930's and 1940's — but by the 1950's when he had already written five other books and perhaps fifty articles, his strength began to fail and the work was unfinished at the time of his death on June 9, 1955. The manuscript came into my hands soon afterward and for two years I have endeavored to bring the work to its proper completion.

In a curious set of circumstances, a part of the manuscript was read before the Lowell Institute in Boston in 1950 and two years later appeared as Chapters I and II with his other lectures in that series, under the title, *The Enduring Art of Japan*. The second chapter, "Shinto, Nurse of the Arts," indeed had already seen print in the *Art Bulletin* for December, 1948. That entire book, including the two chapters in question, was translated into Japanese by Mr. Bunsho Jugaku and, with a biographical sketch by his friend Yukio Yashiro, published in Tokyo in 1954. Those two chapters have now been returned to the original manuscript and appear here almost verbatim as Chapters I and II under titles appropriate to the whole.

For the remainder of the manuscript there was need for a final rearrangement, a process which the author had begun. It had been written with exacting care, indeed, but at many different times — some portions being duplicated, some out of order, and some lost.

The sequence of the plates, which in some instances had been altered as many as seven times, is maintained as Mr. Warner left it, with a few exceptions in the interest of consistency. The first two are designated "A" and "B" on reverting to their logical position.

INTRODUCTION

The book is designed in two parts, the eight chapters of the first forming at once a broad background and an introduction to the second. Each of the chapters, however, is complete in itself. Part Two is formed of about a hundred separate commentaries devoted to the sculptures singly or in groups. While there is a continuity here of arrangement and viewpoint, all are separately conceived, and may be read in any order.

Spelling of Japanese words and names in general follows Hepburn. The long "ō" is so indicated except in personal names, the names of periods like "Hakuho" and "Tempyo," place names such as "Tokyo" and "Kyoto," and the familiar "Shinto." The "w" is generally omitted as in "Sangatsu-do," as opposed to "Sangwatsu-do," but "Kwannon" follows popular usage. Designatory suffixes for buildings and monasteries are hyphenated thus: "the Jiki-dō of Hōryū-ji," except for some shorter words such as "Kondō".

Sanskrit is preferred only for the most familiar Buddhist generic terms, for example, "a Buddha," "a Bodhisattva," Japanese being used for specific deities, as "Shaka Nyorai," for the Buddha Sakyamuni, "Miroku Bosatsu" for the Bodhisattva Maitreya.

The names of priests regardless of nationality are to be found in Japanese. Chinese place names follow Wade-Giles system except for the old treaty ports, and for provinces that follow Chinese postal service spellings.

The familiar botanical identification, *rhus toxicodendron*, has been permitted to stand on page 55 for our own poison ivy, even though the latest edition of Gray's Manual applies the term to poison oak and substitutes *rhus radicans.*

The author's renderings and usages in these matters have been respected, as has his expressed wish of a few years ago that there be no footnotes.

The author's sources of information are not always known. A few random notes from amongst his papers have helped to supplement information found in published works and in some instances his plain statement has been accepted as authoritative.

The system of dating follows Papinot, and though occasionally differing a year from A. K. Reischauer's tables, is believed to be essentially accurate.

The text as it stands can hardly be entirely free from error or at best without some inconsistencies and imperfections — and for such as there may be I hasten to accept entire responsibility and blame.

THE TEMPLES

The full impact of Tempyo cannot be found in any single spot — nor all at once. To become immersed as Langdon Warner was, one should follow the footprints of priests and pilgrims. In the mist of early morning one can ascend the pagoda of Kōfuku-ji, attaining the momentary isolation from the world, breathing the very air that rings the

pagoda bells. On the city side, as the mist clears, the entire plan of an eighth-century Buddhist temple is seen below — and away from the town, across the tops of giant trees, is seen the mountain in whose bosom nestles Kasuga Shrine. For a thousand years nothing has come between temple and shrine but a park for deer. These deer, sacred to the Shinto shrine, are not averse to eating Buddha cakes. Thus we learn in Nara that one religion can be palatable to another. The embossed deity of the wafer is none other than the Great Buddha.

The very rooftree of the present Daibutsu-den — which houses that Buddha at the north end of the park — was raised with Shinto rites during repairs in 1911. And I can testify to the presence of small Shinto shrines within Buddhist precincts at Shinyakushi-ji and the Shōsō-in, and to a boisterous Shinto seasonal procession with its seething mass of celebrants cutting straight through the calm precincts of Hōryū-ji. Tolerance is typical of the religious scene.

Most perfectly preserved of the ancient monasteries, Hōryū-ji was already old and rebuilt when Tempyo began. Its pine-lined approach reaches out into the rice fields to meet the traveler; an acolyte may guide him to the inner enclosure, hallowed for thirteen hundred years. The gate, the cloister, the Kondō and the five-roofed pagoda have been there all that time — as have the deities of bronze and wood within.

No surviving Tempyo establishment approaches such completeness, but the spaciousness and grandeur are still felt at Tōshōdai-ji with its mighty Kondō and at Taemadera with its twin pagodas. The Tōdai-ji, once rivaling the Imperial Palace in extent, must have been one of the great temples of all Asia. Its Daibutsu-den, rebuilt in recent times in greatly reduced scale, is nevertheless reckoned by some as the largest wooden building in the world.

We must picture these monasteries as aglow inside with candles, fragrant with incense, permanently peopled with a numerous priesthood, and visited by thousands, especially at festivals. Landowners beyond the precinct walls, they were indeed highly organized religious communities. All were possessed of libraries and the habit of meticulously recording their own histories. Though scattered far and wide, the majority in the eighth century, as now, were in and about Nara.

THE IMAGES

The hierarchy of Buddhist deities as it existed in the eighth century must have depended only in part on what was popular in China; myth and history and special vow undoubtedly accounted for some preferences that were peculiarly Japanese. Extant eighth-century images from the two countries differ too much for fair comparison. China is rich in remains of wall paintings and stone sculptures — in which Japan is poor

INTRODUCTION

— while Japan is rich in the free-standing images in bronze, clay, lacquer, and wood that are all but totally lost in China. Some fifteen of these are an amazing ten or more feet high. Not counting angels in relief and demons under foot — nor masks, nor miniature Buddhas on Roshana's nimbus — Japan's surviving eighth-century sculptures exceed two hundred. A few may be seen, remarkably, in the halls for which they were made, many are still in their original temples, and others have been moved; and for some all original associations are lost. The Nara National Museum houses a number which are listed under their original temple ownership — for example, the eighteen hollow-lacquers of Kōfuku-ji. For many years this unique depository has functioned as a sort of spiritual guest house, some of its incumbents remaining permanently and others visiting from time to time.

It is an impressive fact that many of the images of Tempyo, whatever their original housing may have been, have remained together in pairs, triads, and groups of four or more, as surely as their counterparts hewn in the mother rock of China.

All of the sculptures in this volume are national treasure in a general sense — and, individually or in groups, most are registered with the Cultural Properties Preservation Commission of the Ministry of Education and designated today as "National Treasures," a term used by the Empress Kōmyō for objects deposited in Shōsō-in in A.D. 756.

These eighth-century images have survived in remarkably good condition as I can vouch from firsthand acquaintance with nearly all. While many must have been lost by fire, many were saved when their halls were burned. Of those which survived very few have been damaged through neglect. Repairs and restorations have, in some cases, been made, and if of more than minor significance have been noted in the text. Examples classified as "bronze" are in almost every instance to be understood as having been originally gilt — and those described as "clay," "lacquer" of all kinds, and "wood," were embellished with colors, including occasional use of gold. Not infrequently traces of polychrome remain.

Sound condition as well as the loss of original surface pigments may usually be ascribed to a single cause — the rubbing and dusting of loving care over the centuries. Thus has the ancient golden splendor of the Yakushi-ji bronze trinity become today a lustrous black. Most of the images are sacred as they have always been, and still used for contemplation and for worship. A few like the Shukkongō-jin are especially revered and ordinarily kept in secret.

It is not surprising then that only a few of them have gone abroad. These include the bronze Kwannon from the Kakurin-ji (Plate 19) which was loaned to Berlin in 1939 and the United States in 1953; the hollow lacquer Yakushi from Kōzan-ji (Plate 174) to Berlin in 1939; the lacquered wood Yakushi from Jingō-ji (Plate 171) and the Tōshōdai-ji's wood Shūhō-ō (Plate 178), both to the United States in 1953. The 1953

Exhibition took them to leading museums in Washington, D.C., New York, Chicago, Seattle, and Boston.

Gigaku masks, never rivaling the full images in sacredness, are, if only as ancient relics, still held in awe. No longer used as ritual objects however, a number of them have been released for exhibition overseas — the facts being noted in the pertinent plate descriptions.

ICONOGRAPHY

The simple facts of iconography are generally apparent. Known names, known provenance, known groups appear throughout the text. Problems of identification that so often beset archaeologist and curator are largely absent. Yet a few words may not be out of place.

Each temple has its main image or *honzon*, usually a Buddha. If the original one, it was presumably vowed first, and the temple then designed to house it and to provide for its protection and worship together with associated deities. The extent of further buildings for other purposes including housing of clergy, storage of holy books, and so on, depended on matters of endowment, growth, catastrophe, and faith.

The essential forms and proportions of the sculptures, like the hierarchies themselves, stemming originally from India, have a tendency to be maintained for gods of higher order, and to be progressively relaxed on descending to the lower. Along with natural change in style, the Buddhas tend to adhere to Indian prototypes, the Bodhisattvas tend to reflect Chinese parallels, and the demons to spring from the earth of Japan. But the fact that all these are Buddhist is never less important than the fact that they are Japanese. The portraits of priests are in effect abstract ideals in the realm of humanity toward which the good monks of today or of Tempyo might equally aspire.

Some general if oversimplified comment may help to show how different the rigid requirements are for the Buddhist icon-maker than for the free-lance sculptor. A seated Buddha image, for example, perpetuates the posture of the Indian sage in *yoga*. The immovability of that posture symbolizes the unassailability of Truth. The Buddha image standing, so unlike a public statue, is conceived rather as a revelation than a portrait — a vision, in short, made tangible.

The suggested movement of a Bodhisattva implies the action inherent in the concept of a savior.

The necessity for constant vigilance and the potential for defense from every quarter is seen in the Four Heavenly Kings. They hold in abeyance the demons underfoot, evil in countenance, yet good in function — for they support the Kings. Unregenerate these devils — but not eternally damned, for in them as in every creature Buddhahood is inherent.

8

INTRODUCTION

Bon-ten and Taishaku-ten, gods from the Hindu pantheon, undoubtedly serve even if — as appears to be the case — they "only stand and wait." Less constant in attire and gesture than the rest, the two are frequently confused alike by priests and scholars.

Doubt occurs as to identity of only a few individual pieces. The lacquered wood figure of Yakushi Nyorai at Jingō-ji (Plate 171), for example, was known as "Shaka Nyorai" some years ago, and the true identity of Tōshōdai-ji's wood-cored clay Bodhisattva, called "Hōshō Nyorai" is in fact unknown.

ACKNOWLEDGMENTS

It was the good fortune of many persons to come under the spell of Langdon Warner in the course of his active life. Many of these were aware of this work on Tempyo — and not a few became associated with him in the project. That association was in every case clearly the most satisfactory reward. Yet he would have wished this gratitude to be individually expressed.

To my regret the best that I can do on his behalf is to record his thanks to all, mentioning a few names that needs must also stand for others whose names I do not know.

There would have been no book had it not been for the three great friends to whom, long ago, he dedicated this work: Okakura the philosopher, Niiro the craftsman, and Saeki the priest. Willingly guided by them, his relationship with each was one of mutual respect and lifelong affection.

The many other interested friends in Japan include Soetsu Yanagi of the Mingeikan who long shared his love of simple craftsmanship and who once arranged a secluded retreat that the work on Tempyo might go on undisturbed. There is Jiro Harada long associated with the Imperial Household, the Shōsō-in and the national collections, so full himself of Mr. Warner's humble qualities, so equally dedicated to the art of Japan. There are Yukio Yashiro, accustomed to Western ways, an able, unassuming, helpful friend, and Goji Kobayashi who was of great assistance in 1931 in the matter of photographs, and always modestly in the background that great gentleman and connoisseur, Moritatsu, the former Marquis Hosokawa. In Nara, interested and obliging from the beginning, was the late Kanae Kubota, director of the museum that has held so generous a gathering of Tempyo sculptures.

To these the author was grateful and to many who are nameless — but two more names I find amongst Mr. Warner's papers. One note, a mere jotting, gratefully acknowledges the photograph of the lacquer guardian's head on Plate 129, to the late Mr. Kudo of Nara. The other was a longer and touching reference to Manso Tanaka, also deceased, and from this I quote:

Descended from an almost incredibly long line of Kyoto wood carvers, his approach was not,

however, that of the academies. For him his own carefully compiled recordings were of interest mainly when they bore on techniques and on temple lore and on the actual practices of popular Buddhism with its local myths and often quite unorthodox variations. He died in 1948, half-starved, in a fever of haste to complete his book on the sculptor Unkei which was printed after his death. His last affectionate request was to let him rise from his death-bed and help still further with this manuscript on Tempyo sculpture to which he had devoted months of unselfish labor.

Not to be set apart from friends in Japan is Sir George Sansom whose kindly interest in this work dates almost from its inception.

At the Fogg Museum of Art at Harvard, faith and every manner of tangible encouragement were offered by the co-directors under whom he served, Paul J. Sachs and Edward W. Forbes. In that institution, which matured and flourished under their direction, Mr. Warner gave his famed courses on the Art of China and Japan. Here he lectured on Tempyo. Here essential works of reference were gathered through the enlightened generosity of C. Adrian Rübel. Here Mr. Warner trimmed down and tuned up his growing manuscript with the devoted help of Blanche Magurn Leeper and Marjory Krummel Sieger. Here at the very end Usher Coolidge helped to smooth out last lingering details.

There is no sharp line between those to whom the author or I, his admiring follower, would be thankful. To some priest high or low at every temple, no less than to the beloved old Abbot Saeki, gratitude is due, and to unnamed staff members of the museums in Tokyo and Nara over the decades, and to Gunichi Wada of the Shōsō-in. The debt to Osamu Takata of the Research Institute, Tokyo, cannot be put in words. Scholar, friend, and guide, well versed in the lore of Tempyo, it was he who led me to so many of the sculptures.

From amongst Mr. Warner's loyal friends old and young, I wish to single out for special thanks a scholar in the field who helped in practical matters of research, Kojiro Tomita, kind and resourceful successor to Okakura at the Museum of Fine Arts, Boston. For suggestions and encouragement, I would also thank two men of letters, Ellery Sedgwick and David McCord. No one has been closer to the book than Mrs. Warner — a part of her is in it; she has been helpful in a hundred ways.

In conclusion I would express my gratitude to my wife Carol, to George H. Forsyth, Jr., chairman of the Department of Fine Arts, University of Michigan, and to Thomas J. Wilson of the Harvard University Press, for their real interest and aid in the bringing of the manuscript to its final tangible form.

But with the author was the original vision.

<div style="text-align: right">James Marshall Plumer</div>

University of Michigan
Ann Arbor
October 1, 1957

PART ONE

THE PERIOD

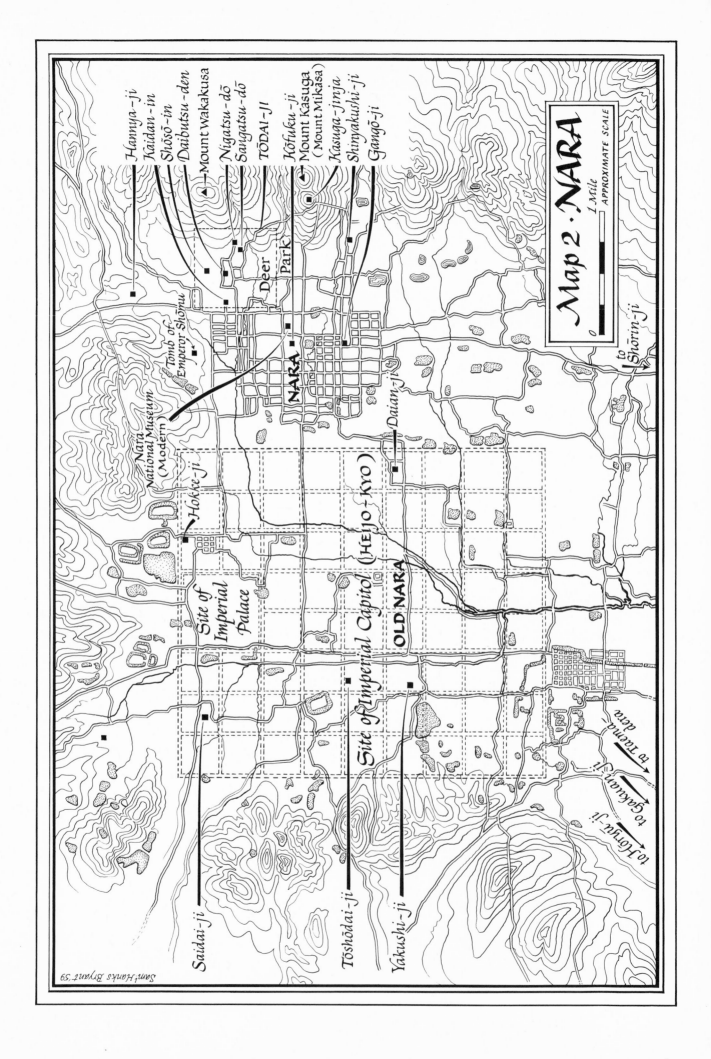

Map 2 · NARA

1 Mile
APPROXIMATE SCALE

Hannya-ji
Kaidan-in
Shōsō-in
Daibutsu-den
Mount Wakakusa
Nigatsu-dō
Sangatsu-dō
TŌDAI-JI
Kōfuku-ji
Mount Kasuga
(Mount Mikasa)
Kasuga-Jinja
Shinyakushi-ji
Gangō-ji

Tomb of Emperor Shōmu

Deer Park

NARA

Daian-ji

Nara National Museum (Modern)

Hokke-ji

Site of Imperial Palace

Site of Imperial Capitol (Heijō-Kyō)

OLD NARA

to Shōrin-ji

Saidai-ji

Tōshōdai-ji

Yakushi-ji

to Hōryū-ji
to Gakuan-ji
to Taema-dera

Sam Hanks Bryant '59

CHAPTER I

SOCIETY AND THE CRAFTSMAN

IT was my good luck to spend some years, at different times, working in Japan with the happy companionship of native scholars who were unbelievably generous to the stranger. They supplied me with a store of factual information and of sensitive, enlightened comment without which there could have been no comprehension.

And this was not quite all. There remains, after these years of pleasant delving, the feeling that I know something of what those paintings and statues were "about," and this in a very special and, to me, trustworthy sense.

I had the good fortune, during one full year and parts of several more, to walk in the seventh and eighth centuries in Japan; going from temple to temple along the streets of the ancient capital of Nara by day and by night, stopping work on the temple treasures to gossip with the abbot's gardener or to drink tea with his master. Gardener and abbot, like the temple precincts they trod, had been demonstrably there since the seventh century. And so, instead of exercising one's fallible imagination in trying to bridge thirteen centuries and recreate the Hōryū-ji or the Tōdai-ji or Yakushi-ji monastery where I sat, the more rewarding method was to abandon so doubtful a process and, quite simply, to exist in the ambient air for deep weeks at a time. Gradually it came to pass that there was no rupture of the eighth-century thread when it came time to board the little steam train, for its twenty-minute trip to my inn, nor need to dodge the troops of Japanese trippers who clustered there.

The space within which I moved was that of those ancient times, and why was not the time manifestly that of the space? Though I was ignorant of Einstein, time and space included one another. Twelve hundred years ago Shōtoku Taishi himself had taken no longer to walk from his Golden Hall to the great image in the Yumedono than I took to cover that distance along his very path, seeing the same things as I went. Was I able to occupy the same space he had filled and not to share something of his times?

1 3

Over and over again the validity of living within the Nara period, and a century back of it, was brought home to me without shock or surprise. Once I had the luck to unearth from a muniment chest a fragment of a gilt bronze crown and unhesitatingly to walk across and fit it on the brow of the sacred image where it had belonged. The jagged edges met with precision, and nail sank in nail hole, corresponding to a nicety. More than a dozen times, details of iconography, which had never been explained to me and I had never known to be in question, were triumphantly settled on fresh evidence by the scholars, and I wondered idly when the correct information had come to me.

This was very far from being the inspired knowledge of the mystic, and it seems to me, as I look back on the period of my immersion, to be only what one saw while swimming under water, all quite naturally to be reëxamined by the man above when he hauled it up to his boat. Of course profounder scholarship was a thing to envy, since the chances of error in vision during immersion are very great. And yet it seemed worth while to practice what little skill I had for groping in the twilight, and occasions were numerous when I was unalterably convinced of what may be called the "correctness" of it all. Factual information, dredged from the bottom and brought to the surface to dry, forms the basis for ideas which become the very stuff of scholarship.

Obviously, I can represent to the Western reader only partially and brokenly the truth as the Japanese native scholars must see it. But there is something to be said for the point of view of an outsider, if he is a sympathetic one. This I claim to be, and I shall make no attempt to persuade any reader of my own views or load him down with foreign names and dates and facts. The task I've set for myself is far more difficult. It is the task of laying before him conclusions that have been arrived at after years spent on the early labor of accumulating information from the Japanese. For this reason, during this chapter, I shall confine myself to the eighth-century craftsmen. There is no better way to emphasize the aesthetics of my subject which, though not my primary interest, is usually the first thing to attract attention. I am engrossed in discovering what values lie, for contemporary Americans, in a noble foreign tradition, comparable with yet very different from our own. For I am convinced that there can be no progress for us, no improvement, no originality, without deliberate study of the stream of the spirit through the entire human race. This particular Japanese stream is all the more obviously enduring and undeniably a stream for the fact that there are in it conflicting directions and shifts in the speed of the current.

I had looked forward to dwelling on the broad flood of Chinese culture, into which the Japanese had stepped hesitatingly at first in the sixth century, but in which they were swimming strongly by the eighth. Perhaps never in all history were people so conscious of what they lacked, materially and spiritually, so avid to receive it, or so capable to make use of it, as were the Japanese in the middle of the sixth century when

Buddhism came to them out of China by way of Korea. One sees them simple, even primitive, anchored off the Asia coast, tantalizingly almost out of reach of their Far Eastern heritage in China, which was unquestionably the most advanced culture of the contemporary world.

A short hundred years later Buddhism, with its arts and crafts, was in full flood in Japan. At last Chinese literature, the treasures of Confucianism, Buddhism, and Taoism, already developed during the wise centuries in the alembics of India and China, were eagerly seized. A bulk of poetry and metaphysics and literature of the imagination came with them. An incomparably rich material civilization, with its superior techniques and skills, was carried on the crest of the same wave.

To shift the metaphor, the T'ang dynasty of China was hanging like a brilliant brocaded background, against which we must look at Japan and its capital city of Nara to watch the eighth century, while the Japanese were at work weaving their own brocade on patterns similar but not the same.

Since it is our purpose to comprehend the Japanese people during that century, it is of prime significance to see Nara, with its palaces and religious establishments that were springing up, and to discover what the artists and craftsmen were, before we examine what they made and how they made it. Only thus can we arrive at the conclusion that the China heritage was so broad a foundation that it was inevitable for the Japanese to develop a noble national art of their own with its own masters, its own techniques, and its own traditions.

Half a dozen paintings, half a dozen temple buildings, a meager series of liturgical paraphernalia, some few aristocratic weapons and pieces of furniture (most of them imported), and less than three hundred Buddhist images of clay, lacquer, bronze, and wood, make up the total of material objects left from eighth-century Japan. Not a single ordinary dress of the period, not a peasant's hut with its scanty fittings is left. And yet folk art is indispensable if we would know the genius of a people. For it is certain that neither precious materials nor embellishment add much to our knowledge of the craftsman's accomplishment. Frequently these serve actually to obliterate evidence of his more direct instinctive impulse and of his traditional methods.

By the eighth century, when our period begins, the character and temper of the race was already formed: a close people and a simple one, regardful of their self-respect and that of their neighbors. Among the lower classes, they were often merry when not oppressed, and were given to dancing at harvest and when planting was done; workers with sensitive fingers and an innate sense of pattern; a people with single aims and a single language, that developed but did not change in its essential character. All about them were the little Shinto gods of field and fen and crossroad and of hearth and mattock. Presently, alongside these, there appeared the principal figures which are my sub-

ject, the gods of Indian Buddhism, brought all the way across Central Asia and China and down the Korean peninsula.

During the century of building, Nara was a hive of craftsmen. In the temple compounds mat sheds covered the workmen, busy with construction or with forge or loom or carver's bench, and the doors of huts stood open to catch the sultry breeze. In winter there were no tight frosts, but the world was dank and chill. Outside, workers clustered over braziers or by fires of chips raked from the timber yard.

Nature suggests the materials used by the artist and the limitations that cramp him. Thus, the volcanic islands yield little stone for building and next to none for sculpture, but hard and soft wood grow there abundantly. Artists' pigments are to be found in the minerals, and a full dyer's palette in flowers, barks, lichens, and roots. Clay for the modelers and the potters can be found under the shingle of any river beach. Copper, gold, and iron are mined, and lacquer trees grow there.

What, then, was the outward look of the capital city of Nara, and what were the craftsman's surroundings in that short eighth century that bulks so big in Japanese history? The town of Nara was laid out like a grid as was Ch'ang-an, the contemporary capital of the T'ang dynasty in China. In Nara streets were broader than they are today, for on one or two of the main avenues three bullcarts could go abreast. But they were often sloughs, and the man afoot chose to walk under dripping eaves or to scrape against a mud wall or a quickset hedge rather than plow down the middle.

For lack of draft animals, workers bore their own burdens on carrying poles on their shoulders. No wheeled vehicles were seen, except when the aristocracy passed on two-wheeled bullcarts, hooded and curtained like prairie schooners. These whined and groaned on wooden axles, a sound that has become part of the trite furniture of the classical poet and is reproduced with archaeological accuracy, even today, when an Emperor is borne with antique ceremony to his tomb. But the huge balks of building timber, on their way to the temples and palaces under construction, were pulled on log rollers by bulls or by long lines of men on the ropes.

On the slopes of the hills, four miles apart to east and west in Nara city, were great monasteries set in their parks, and one could see their pagodas and groves from the rice fields and from the city streets. Midway between these temples lay the palace buildings, recently tiled in place of the old thatch, and with corner posts painted red. They were walled about, however, with rammed clay walls topped by tiles, so that the humble never saw the courtyards or the gardens.

Except in winter, the city stank with sewage, for Nara plain is hot and flat, but the odor of it could probably not be compared with the stench of the close European town of that day. The Japanese were, even then, ceremonially clean in their persons, which was emphatically not true of Europeans.

SOCIETY AND THE CRAFTSMAN

Once clear of Nara, the tracks narrowed to footpaths, unless one chose a road recently widened and mended for the passage of nobility in bullcarts. On it were unending streams of burden carriers fetching produce to town. But the line must scatter when a cavalier came by with his mounted men and his men afoot. He took for himself the beaten track, and other wayfarers must plunge into the mud of the bordering paddy fields or take a beating.

The messenger from the court to the provinces, carrying letters to some distant governor, was a knight riding a high wooden saddle with immense scoops for stirrups. He went in silk and fine hemp cloth, tan colored in summer, for the road, but in his painted boxes, carried on shoulder poles by the escort, was plate armor of lacquered leather with iron fitments and a store of food for the journey and lacquered trays and bowls to serve it. He would find no inns and must put up at the houses of such rural nobles as lived along his route and, best of all, at temples when he found them. Failing either of these, the headman of a village was warned in advance by runner, and, when the knight reached the end of his day's stage, the farmhouse would be garnished and the peasant host and family moved out to sleep with the neighbors.

No fine foods or luxuries could be got at such places, but there was hot water, and fodder could be requisitioned for the beasts. Tea was a rarity occasionally imported and not yet grown in Japan. Rice and barley or millet could usually be supplied, but the knight brought his own wine and flat dumpling cakes or salt bean paste. He and his followers often had fresh fish, but could be sure of nothing more than bowls of steamed millet, flavored perhaps with morsels of salt fish.

At this time, when Buddhism was spreading among the upper classes with increasing speed, meat eating was frowned upon and hunting a sin. However, on the road, necessity knows no law. The fare was often varied by venison, wild pig, a pheasant from the villagers' snares, or an occasional duck. The further one left behind the dominant great temples of Nara and their ever-present clergy the more generally one saw meat being eaten when it could be got. The well-found traveler took with him a leash of hunting dogs and a perch of falcons, to beguile the journey and fill the pot.

Except for hilltops, shrine precincts, and the boundaries between fields, the countryside for some two or three days out of Nara was, before the middle of the eighth century, already stripped of the best timber. But if the traveler headed north, he came on the third day to forests where he had dread of wild beasts and evil spirits of the woods. As a matter of fact, there was little to harm, though wolves did come down so far when snow was deep in the north. Monkeys and deer and boar and foxes and *tanuki*, the lumbering badger, could be seen and, rarely, the small brown bear. It would be a good eight days' march northeast of Nara before one reached the aborigines' country. Even there, unless a campaign was forward, there was seldom danger. If the escort were too small,

a flight of arrows might whistle out of a thicket or a lagging porter be cut off from the rear of a troop. But no forces the enemy could muster would stand against the mounted knight or dared attack his spearmen. These original Ainu tribes used poison on their arrows, but their bows had short range compared to the splendid eight-foot war bow of the Japanese, with its pull of seventy pounds and its shaft, well over a cloth-yard length, tipped with iron and fletched with falcon.

The Ainu aborigines were by no means all unfriendly, and, when they were, it was in the furtive way of a conquered people. Often they were glad enough to supply the party with the fish and game they captured so adeptly. A greater danger came from such spirits of evil as might be abroad. These infested the spots where man failed to observe the proper rites or where his deliberate sin allowed them to congregate.

Most feared of all were the bands of well-armed robbers who had taken to the road. These were not aborigines, but Japanese outcasts, often well-trained and desperate. Neither the villagers nor the local lord of the manor could always cope with them. They were mobile and would as soon attack the court messenger as a private traveler, provided they had a fair chance to beat down his resistance and despoil the party. The records of the time are crowded with rescripts, ordering suppression of the bandits by provincial levies and sending troops from the capital to guard the roads.

The lot of the plebeian in Nara at this time was indeed a hard one. His simple diet was, in good years, barely enough. He tasted little meat, especially in the city and communities dominated by nearby monasteries; but fish from river and sea have always been abundant in Japan. The capital, however, was far from the coast and has always been worse supplied with sea fish than any other considerable town. In the eighth century, during hot weather, ocean fish were never seen there except by the rich, who had it fetched across the hills from Naniwa (Osaka). But, then as now, innumerable varieties were salted down to serve rather as relishes for cereals than for nourishment or bulk.

Rice was never staple for the lower classes. They steamed and boiled barley and millet, or made noodles and dumplings from their flour. During the two centuries before Nara city had been established, immigrants from Korea had been settled in the villages along the coast and over the great plain. These foreigners amalgamated with the Japanese and introduced their peculiar modes of pickling and fermenting greens, which, though never adopted by the Japanese in their full odoriferous richness of putrescence, brought new savories to the islands. Beans were a common small crop in the householder's garden patch, but *tōfu*, bean curd, was as yet a staple only of the monastic diet. The admirable fermented bean sauce, now known in the West in its Chinese form of soy and made famous to us as the basis of Worcestershire sauce, was fermented by the farmer who could construct a keg to ripen it. Of cooking fat he had little or none from animals, except what could be saved from the lean wild things he occasionally trapped. But

vegetable oils, laboriously expressed from rape seed and bean and nut, were used to make his rare dishes of fry and to feed the pith wick of his dim saucer lamp. He had neither sugar nor honey. Garlic was used for medicine. Millet, *awa* and *kibi*, and the two sorts of barley, made flour and porridge. Food was less highly flavored than even today, and the Buddhist prohibition against the "five flavors" was not needed in Japan as it was in India. Even tea, brought by the clergy from China, was at first drunk exclusively by them, mixed with salt and herbs as a soup, like the *hyaku sō* in the Kinano mountains of Shinano today. On the whole, in spite of the total lack of butcher's meat, the peasant's diet, dull and unvaried as it was, seems to have been fairly nourishing. The sea fish, except on the Nara plain, and the various seaweeds of which he made good use, gave him iodine. What he conspicuously lacked was animal fats.

His cooking flame was started by a fire drill of *hinoki* wood or by a flint. Charcoal from the communal kiln was his fuel when it could be afforded. But for many it was not procurable, and faggot gathering had already become a vital problem for the city poor, since the sacred groves were jealously guarded and the forest had receded far beyond the city limits. Cooking gear was unglazed pottery and perhaps a rare soapstone griddle or pot, such as is used today in Korea. Food was eaten off wood trenchers or out of shallow wood troughs and bowls and platted leaves.

Each family owned some sort of small pestle and mortar, but meal in larger quantities was usually ground at the communal millstone, turned by hand or by a cow, whose milk was never drunk nor her flesh eaten. Sometimes the nearest temple, as in China today, provided both threshing floor and millstone, where each family could take its turn at the grinding and leave a small portion in kind for tithes and rent.

The thatched cottages were dark in winter, earth floored and bitterly drafty. The clay stove was chimneyless; frequently all cooking was done, as in Europe, over an open pit lined with stones in the floor. In fact the whole dwelling was often a shallow pit, set round with stakes to support the rafters and thatch. Such huts were inundated during the rains and often consumed suddenly by fire. Beds were loose straw covered with a straw mat.

While courtiers and dignitaries of the church rode splashing by in splendid robes of brocade cut after the latest Chinese fashion, peasants went in breechclouts for seven months of the year, barefoot or straw sandaled. They thatched themselves, like their huts, with straw against snow or rain, and made rough capes and gowns from hemp twine or the string rolled from mulberry bark paper waterproofed with persimmon juice. The winter crowds clad in such fustian were somber enough. Their commonest dye was derived from the *tsuruba-me* tree that produced a dark brown color, so unfading that poets adopted this word to stand for unchanging love, in contrast to the more showy red that soon faded. The many priests were clad in cloth of reddish brown or

dingy saffron, tinged by vegetable dyes. Only slaves seem to have worn undyed cloth, which, till white cotton became more usual, was a light tan color.

Animal hair and wool, banned by Buddhism, was totally lacking, except for furs and the few felts brought from North China for court use. Cotton was now being grown in Kyushu but was not generally available. A wistful poem from the *Manyo Shu* (557–764) reflects the damp chill of the Japanese winter:

> The wadded cloak looks warm.
> I've never worn one.

Local floods, crop failures, or plagues that reduced the manpower of whole villages at a time, often left the peasant desperate. In such times of stress a community living in so hand-to-mouth a way suffered immediately. They starved to death. Only an occasional man or boy could escape to the frontiers or manage to enroll in the levies. These at least were fed and clothed by the government, though it is on record that no pay was available for the families of those up with the colors. To be tied to the land in time of famine or drought or plague was sentence of death. It is true that, in the middle of the seventh century, the good Prince Shōtoku had built several small reservoirs in the Asuka plain for impounding water against drought, and had installed granaries where stores were held against famine years. Buddhism and the prince's tender heart were to be thanked for that. But the practice was by no means general, nor was all he could do very far-reaching. Government granaries existed at the capital and in the provinces, but these were nothing more than subtreasuries where taxes, paid in kind, were stored for the exclusive use of the government and carefully guarded against the poor.

So nurtured, and with such housing, the farmer or the city laborer went out to tend his field or ply his craft, while the wife and daughter tended cocoons to make the luxury silk they never flaunted. His crops and her silk were used for taxes. In such a hut they twisted the twine for nets and for their few garments; there they did their simple cooking.

The state of the laborer or peasant in the metropolitan district of Nara was much more advanced than that of his provincial cousin. Even when he devoted himself purely to farming, his son, by reason of the nearby monasteries and the court, had opportunities to learn a craft. Thus the lad helping with the balks of timber for the Daibutsu temple, if he proved himself handy at stripping bark and squaring trunks for the sawyers, could become a carpenter. His sister, helping at the nunnery, could graduate from unreeling cocoons and from spinning to become a weaver. But in the remoter countryside the chief crafts were those of the home, and the farmer's family practiced them all. The communal charcoal kilns were used by each household in turn, and the village pestle and mortar of stone or log in the same way. Also, as was once the case in parts of New Eng-

land, the loom itself seems sometimes to have been common property — though it is not clear whether in Japan this was not the silk loom exclusively. Looms for the hemp and bark-string cloth were but the simplest frames, barely a foot wide.

If the upper classes got small book learning, farmers and laborers, from whom the artists sprang, got none. Their trades were taught them as apprentices, and their spiritual training consisted in the homely virtues of hard work and thrift and in Shinto observances. Europe before the Renaissance presents much the same picture of noble arts, produced for the church and court, contemporary with a great folk art of no less intrinsic beauty and perhaps even greater vitality and significance, all made, by means of a traditional and instinctive technique, by people who could count but not calculate and draw but not write.

Lean life and oppression are, however, hardly enough to produce a race of noble artists. To explain the consistent high level of eighth-century Japanese art, we must not only examine the manner of living, but must realize the widespread patronage of the Buddhist church and the Sinified aristocracy. More important than all was the stimulus provided by troops of master craftsmen, who were coming to Nara in the train of Chinese abbots. It is proof of the imagination and the dexterity of the native farm boys and laborers' sons that, before two generations were over, they had become masters in their own right.

Now, with the Nara period, came a more intricate system of land tenure for cultivators held close to the land. Taxes paid in kind had the important effect of creating, if not guilds, at least hereditary classes, based on a single occupation that held tight grip on the family. For if cloth or arrowheads were demanded from a householder in such quantity that he must spend months in producing them, and if his sons were restricted to the same craft, that family perforce became specialists in those goods. If such a man did not give up working the land completely, it was only when his women folk and younger boys could help with the crop.

With the spread of Buddhism and its ban on taking life and eating meat, slaughter and its attendant crafts of tanning and leatherwork were added to the list of slave labor. Partly because of the unclean nature of these crafts, but mainly, no doubt, because certain of them were introduced and best understood by the lower classes of Korean refugees and captives, a group of outcastes grew up whose traces can be detected today in the social framework.

By no means all foreigners were despised. Indeed, by the end of the seventh century, according to *Shōjiroku*, a peerage of that time, over a third of the noble families of Japan claimed Chinese or Korean descent. In fact it becomes pretty clear that in those days there were few barriers of prejudice, and a stranger was accepted in the islands at his face value. If he were a low fellow, willing to sell his soul by catering to the irreligious

who ate butcher's meat, he became a butcher and an outcaste. If he were a holy man and a scholar, he became a revered teacher.

On at least four occasions during the eighth century, certain groups of artisans among whom foreigners were most frequently found (such as leatherworkers, grooms, iron-, copper-, and goldsmiths, bowyers, fletchers, spearmakers, and saddlers) were freed from their social disabilities, a proof that an increasing value was put on their products by the aristocracy and that familiar intercourse, implied by patronage, made it necessary to raise their status. It is worth noticing that it was often the women of these foreigners who introduced or improved the arts of dyeing, cookery, brewing, weaving, embroidery, and midwifery.

The importance of these foreign craftsmen in the history of art can hardly be emphasized enough. They were the best teachers, and their presence at the next bench to their Japanese apprentices was the greatest force in creating what was to become the truly national art of the eighth century in Japan. Obviously the young native worker, though a free man as freedom went in those days, could never look on such master craftsmen, even the few who remained slave, as socially inferior or even very different from himself. Not only did the foreigners demonstrate daily and hourly their superior methods and skill, but when all hands knocked off for the midday meal and gathered round the cook-fires of chips from the carpenter's shed, there was exchange of gossip and of experience. These foreigners knew something of Buddhism, the patron for which all were working; they were sound in its liturgy, knew the purposes of these images, could explain the virtues of some of the prayers and charms, and even trace a few Chinese characters.

It is to these groups, with their common absorption in the job, their long working hours and short holidays in each others' company, and their not infrequent intermarriage, that we must look for the explanation of such amazing sudden fertilizing of the Japanese native genius and the burgeoning of the arts. The modern historian of art would give more for a stroll through the bronze casters', sculptors', and lacquerers' sheds that clustered where the new temple buildings were rising, than for all the art history books in the world.

CHAPTER II

CRAFTSMAN, NATURE, AND SHINTO

KNOWLEDGE of natural processes is the very basis of all the arts which transform raw materials into artifacts. Possession of the mysteries of a craft means nothing less than a power over nature gods and it creates a priest out of the man who controls it.

Students of the history of religions divide Japanese Shinto today into three: state, sectarian, and cult. We are concerned with an aspect of primitive Shinto which, in spite of its deep social significance, seems to have been neglected by historians for its traces have already been largely obliterated by a mechanized culture.

Lying deep beneath the creation myth, which has been so much studied and emphasized by reason of its translation into ritual and finally to government, was a natural and all-pervasive animism that bound together the spiritual and material life of the common people. It was based on their concept of all natural forces and laws and the observed fact that these could frequently, to a degree, be controlled by adepts.

This animism differed from similar beliefs in other parts of the world as the Japanese themselves differed. The horrors we find in Africa and the Americas and the dark practices of voodoo seem largely to have spared Japan. Emphasis seems to have been laid to an unusual degree on gratitude to the beneficent forces of nature rather than on appeasing the dreadful ones. Sin, probably the main sin, was to omit gratitude and the respect that was due. This due respect brought about an emphasis on ritual purification and resulted in a long list of defilements and their corresponding ceremonial purges.

The land and the very air of Japan was crowded with a host of presences. These, and the reverence exacted by the other *kami*, which were spirits of the nearer generations of the family dead, and, later, by the clan and imperial ancestors, made up the foundation of primitive Shinto.

With the exception of the imperial divine ancestors, Shinto gods were largely local. Province differed from province and village from village and farm from farm in the

names and attributes of the *genii locarum*. There were in common of course the fertility deities and those which dwelt in storm and shine, birth and death, and in the animals of the wild.

Sansom records that before the middle of the Tempyo period, in A.D. 737, there were already more than three thousand officially recognized Shinto shrines in Japan. Add to those the shrines of every family, the recognized but unofficial spirits in cooking fire and cooking pot, the mysterious genius that presides over the process of aging going on in the household pickle jar and the yeast in beer, the matutinal salute to the sun, the festivals of harvest home and of planting, to name but a few out of thousands. Such things, in addition to the reverence exacted by one's own clan forbears and by the imperial ancestors, made up the power of the Shinto religion.

It may be significant of how satisfactory to the Japanese racial character this relatively simple animism proved to be that even nineteenth-century attempts to develop a metaphysic within the framework of Shinto have failed. Nothing comparable to Sufism, Zen, or Thomism seems ever to have been suggested. Japanese minds demanding these higher flights of intellectual or religious mysticism have found their satisfaction in the imported creed of Buddhism.

A fact lost sight of by most historians of art is that Shinto has always been the artist's way of life. Natural forces are the very subject matter for those who produce artifacts from raw material or who hunt and fish and farm. Thus Shinto taught succeeding generations of Japanese how such forces are controlled and these formulas have become embedded in Shinto liturgies. Dealing, as this body of beliefs does, with the essence of life and with the spirits inhabiting all natural and artificial objects, it came about that no tree could be marked for felling, no bush tapped for lacquer juice, no oven built for smelting or for pottery, and no forge fire lit without appeal to the *kami* resident in each.

Buddhism, arriving hesitant in the sixth century and growing into an irresistible force in the eighth, provided the greatest impetus Japanese art had ever known. It was the artist's munificent patron; it destroyed no native beliefs, but served merely to provide more work and higher standards for these same Shinto gods and the artists who invoked them. Buddhist temples were erected, Buddhist bronzes cast, priest robes woven, and holy pictures painted all in foreign style, but it was all done by artists who invoked native Shinto spirits of timber, fire, metal, loom, and pigment. Even the newly introduced and very welcome practice of Indian medicine brought over by Buddhism was tempered and improved by Shinto ritual cleanliness and the enforced isolation of the sick which was quite un-Indian in character. Only a Western mind will see in such double beliefs and practices an apparent contradiction or presume to imagine any inconsistencies with even the official Buddhism. In truth there were none.

Even in the dim days before the trades were separated there must have existed a

basis on which specialization would become inevitable. Growing knowledge of the controls and formulas needed in dealing with a variety of natural forces implied the formation of guilds with their separate mysteries and trade secrets at an early period.

The correct (religious) way to build a house, forge a sword, or brew liquor had been, from earliest times, in Japan as elsewhere, imbued with a peculiar guarantee of success through its dependence on a divine patron who established rules and divided labor and in whose honor the chanties were sung. To be right has always, until lately, been to be religious.

Each of the trades came to have its peculiar divinity, comparable to the patron saints of the vintners, tanners, brewers, masons, and goldsmiths in medieval Europe. And, by the eighth century, the formulas and techniques in each had long ago taken on formal patterns which gave them the character of Shinto liturgies, a principle easily understood by any Freemason in the West today.

The elaborate and ancient craft of house and temple building in Japan serves as a perfect illustration of the way in which Shinto, in one of its important aspects, acted as did the European guilds to conserve and perpetuate the secrets of the art. It provided for the training of apprentices and established standards in a rough examination system by which they were gradually advanced to the grade of master craftsman and priest initiate. When an apprentice had reached a certain grade of manual skill he was initiated into the theory of what he did and was taught the charms and procedures necessary to insure success. It is beside the point to argue that his rhyme giving the correct pitch for a tiled roof and the different one for thatch or the mnemonic chant embodying the proper spans between pillars had better be printed in tabular form or point out that there is no god who would wish to bring down an ill-constructed roof. These people were happily illiterate. They needed aids to memory and a system for transmitting their formulas intact to their sons. Also, if no neglected god can bring down a faulty roof, *something* does. Further, it seems highly probable that skillful, conscientious house building logically can be, and perhaps should be, in some way connected with a man's religion.

It was by rules of Shinto that the jobs of fellers and haulers of timber were distinguished from those of carpenters competent to build with it. Shinto chanties hoisted the roof beam into place, timed the movements of gang labor, and preserved the necessary orderly progress that marks the stages of any construction job. Failure to observe the logical stages halts the work and therefore becomes impious, an evidence of divine disapproval. The time clock, rules of the labor union, holidays, penalties, and promotions were all part of it. The carpenter's try square and plumb bob, as well as his simple yet sufficient rule-of-thumb * formulas of angles and proportions, have all been embedded

* What is that very expression "rule-of-thumb," that has been embalmed in English, but a relic of times when tape measures were not always on hand and a man's digits were?

in Shinto rhymes and patters and aids to memory that were liturgy, litany, and sound sense.

Thirty years ago a fresh log for the repair of the huge Daibutsu-den in Nara was laid on blocks to keep it from the damp earth and a mat shed was built above it. I was told it had been felled already three years, three more moons must pass before it was hewn square, more moons still before it could be sawn and then, the planks wedged apart for air in the pile, still another specified number of moons before they could be pegged in place on the great building. By that time the dryad, *ki no kami*, who writhes in agony and splits the log would have made her escape.

It is precisely this sort of old wives' tale that competent sociologists and folklorists should collect in order to work out the preservative power that Shinto has had on the arts of Japan. For here was the mother of science.

Superstitious practices connected with the maturing of yeast in wine, beer, and bread are divine (and therefore unforgettable) ordinances to insure success through cleanliness and the regulation of temperature. Forging, planting, manufacturing and harvest, animal husbandry, cookery, medicine, navigation, and hunting have in every country been among the arts perpetuated by liturgy, song, and drama of religious character.

The more hidden and complicated the natural process involved, the more necessary are the mnemonic and religious devices to preserve correct procedure. One has but to watch pink-coated gentlemen of England gravely performing blood sacrifice on the brow of a neophyte after a successful day with the foxhounds in order to understand why Shinto has withstood even science so long.

A talk about fisherman's luck with a Portuguese out of Gloucester for the Banks, or with a European baker or vintner on the subject of yeast, will demonstrate the persistence in the West of animistic religion in the modern crafts.

In early times the craftsman of the greatest skill (the master) was naturally the one on whom the duty fell to make sacrifice and perform the purifications to insure the success of the job in hand, whether it was a building or a boat or a sword or the cure of the sick or the difficult pouring of bronze for an image or the communal rice planting in spring.

To invoke the nature gods correctly meant that the farmer must be weatherwise and the smith experienced in the precise shade of cherry red when the blade must be drawn from the forge and quenched in its bath. Further, the correct prayers and songs and ceremonial gestures must be employed. This of course was a kind of priestcraft, an ability to control the nature gods.

But the invocations and liturgies that grew up as part of the arts can by no means be dismissed as senseless mumbo-jumbo. Embedded in them was much of the necessary pro-

cedure rediscovered by the unsentimental scientists today. They were actual rules in rhyme or rhythm or tune or cadence to insure their correct transmission from master to apprentice in a shape that made them impossible to alter or forget. The fact that these formulas were not only utilitarian but associated with the god of the forge in one case, the weather in another, and the mysterious spirit of growing yeast in a third, gave them a sacred ritual character that made it "sin" to alter or forget them.

At the time when Buddhism was at its imperial height during the eighth century, superior techniques of image-making, architecture, weaving, and scores of other crafts came crowding across from China in its train. The fresh skills were eagerly absorbed by native craftsmen who made them their own and planted them in the friendly soil of Shinto. Tools never before seen were tried and found good. New formulas for bronze mirror casting, new tricks in the lacquerer's and temple builder's trades, were learned by heart and passed over to young men by means of rhymes and chants. Thus a richer litany and more elaborate liturgy grew up in the service of the craft gods and their virtue was proved by the production of more perfect and elaborate works of art than the old days had ever seen. The patron gods remained the same. Man was better informed on how to control them.

A man skilled in such formulas was not only the head of his shop or guild. He was a priest in the very act. The Shinto priesthood, recognized as such today, no longer includes these master craftsmen. But even the recognized ones are still called on to invoke the spirits of weather and crops as well as the gods who hold the welfare of the nation and of the imperial family in their power. Until a few decades ago, however, the head of the guild performed priestly offices in special robes and was, on such occasions, sacred. Even today some villages can be found where preëminence in boatbuilding or fishing implies a temporary priesthood with its accompanying social and religious distinction. Where this is preserved, sociologists and ethnologists and folklorists must search for material on which to reconstruct the primitive Shinto of eighth-century Japan.

It will be seen then that Shinto, seldom the patron of the arts, was from the very beginning both nurse and preserver.

It is neither sentimental nostalgia nor ignorant worship of the good old days which makes us see a large measure of human good in this society where the material culture was fostered by so natural a system of craftsmen-priests. Compared with the output of an industrialized society it is certain that fewer conveniences were produced but equally demonstrable that one necessity we lack today was then available. The necessity we lack is, of course, the prime requirement that a man's trade should permit and train him to grow into a complete man.

Tending our factory and assembly lines quite blocks the complete human development of potential skills of hand and mind and soul, without which one can never be

called whole and wholesome. With us, however knowing and ingenious the designer of a machine may be, however adequate the foreman of the production line, few complete individuals emerge at the end of a fruitful life. Trained first to his craft and growing week by week in knowledge of a hundred natural laws, the European or Japanese medieval maker could rise to govern his small crew, lay out their work, teach youngsters the way he himself had come, and, by reason of his responsibility and wisdom, and by virtue of his master craftsmanship, take honorable place in the community.

With us, servile mechanical science dares not admit the need to show any respect to such outworn gods as those that govern all processes, all results of making, from the strains and stresses sealed within a building or a boat to the mysterious working of yeast in liquor, or the three years' ripening of clay before it is fit for the potter's wheel and kiln. And yet there is little harm and much good in a condition that breeds reverence toward natural forces, emphasizing and preserving a manner of doing things which long experience has proved "correct."

The nonscientific and religious attitude of the Shinto craftsman is necessary for a bookless culture, so that recipes and techniques and procedures (scientific formulas) may be kept without loss down the generations in the shape of chanties and rhymes learned by rote of heart. They become all the more indelible through their double character for they are at the same time aids to memory and magic charms like our own churning chant, to "make the butter come" and the unforgettable three-four-five rule for a right angle. Their virtue is none the less when simple minds tend to see in them a magic power over nature gods. If the essence of priestcraft can be said to be human control over natural forces this is indeed the religion of the craftsman-priest and his community.

CHAPTER III

BUDDHISM AND THE ARTS

THE Suiko and Hakuho and Tempyo records quote scores of orders that show constantly increasing efforts of the court to spread Buddhism. Of these I shall mention only a few. The Empress Saimei (655–661) set up a hundred centers throughout the provinces. The Emperor Shōmu, who ascended the throne in 724, distributed copies of various holy books in 726 throughout the land, and three years later sent out lectures and sermons based on the Konkōmyō and Ninno scriptures. From this time, too, if not indeed earlier, the two scriptures were read in the Imperial Audience Chamber. In 737 every province was directed to set up within its own boundaries an image of the Buddha. It fell naturally to Tōdai-ji (not consolidated under that name until 745) as chief temple of the Empire to make the arrangements for such Buddha images, and sometimes even to supply priests from its own staff to carry on the observances *in partibus* and dispatch builders and image-makers to the new establishments. Indian Buddhism thus had become acknowledged in Japan as a state cult inextricably combined with court life and with the conduct of Empire.

In 740 each provincial capital was directed to build a seven-storeyed pagoda in which were to be placed ten sets of the Hokke-kyō or Lotus Sutra. Near each pagoda was to be a monastery to house twenty priests and a nunnery for ten women and, for the support of these, fifty households and sixty rice fields were to be set apart. This meant likewise an extended distribution of skilled artisans, carpenters, builders and tile-makers, image-makers, and calligraphers throughout the provinces. It meant the setting up of centers where master craftsmen recruited and trained the local youths.

In 741, in the first moon, five thousand houses were confiscated from the estates of Fujiwara no Fushito. Of these the rents from three thousand were allocated to pay for the installation of a "sixteen-foot image" of the Buddha for each province.

Two months later the Emperor Shōmu issued a decree pointing out that crops had

noticeably improved and that rain and fair weather had kept their appointed round since the images had been distributed with their accompanying copies of the Daihannya-kyō. It is important, in connection with the merging of native Shinto with Buddhism, to notice that, by the same ordinance, the Emperor had increased the number of Shinto shrines. "Let officials tell this thing to the people: the income from fifty houses and ten *cho* of rice land shall be given over to the Prior of each Provincial temple and it shall be called Konkōmyō-shitennō-gokoku-no-tera (Temple of the Glorious Four Heavenly Kings, Protectors of the Empire). For each nunnery ten *cho* of rice lands shall be set aside and ten nuns shall be in residence. In nunneries and monasteries alike the *taishō* sutras shall be read on the eighth day of every month." Several years before, there had been introduced the earlier Chinese practice by which the book was "taken as read" when all but the first and last paragraphs were skipped.

A study of the texts that were arriving during the sixth and seventh centuries might be expected to disclose the content of Japanese Buddhism during Tempyo. And indeed, they do give us material to envisage the dogma as it was spread by the priests. It is suggested however that, whatever new ideas Buddhism may have introduced to the illiterate classes, it never overthrew the Shinto gods so long firmly enthroned in the hearts of craftsmen. No matter how pious their attendance on Buddhist holidays, it is certain that few among such busy simple people comprehended the full implications of the esoteric symbols they so beautifully fashioned. But let there be no doubt that they were moved by the splendid dim ideas behind them all.

But the plebeians became fully aware of the power of Buddhism when they saw Emperors abdicating to receive the tonsure, aristocrats sitting at the feet of the Chinese priests invited from overseas to teach them, and — a fact that came still closer home — Buddhist temples as landholders and dispensers of patronage and of wages.

There were already six Buddhist sects in Japan during the Nara period: Sanron and Jōjitsu introduced in 625, Hossō in 654, Kusha in 658, Kegon in 735, and Ritsu in 753. "But," to quote Sir Charles Eliot, "they were not sects in the later sense, that is corporations pledged to support particular doctrines, but simply philosophical schools which expounded certain texts. How little rivalry there was between them is shown by the statement that the Korean priest Ekan, who resided at Genkō-ji introduced both the Sanron and Jōjitsu and that the Chinese priests Chitsū and Chitatsu propagated both the Hossō and Kusha. And some sects are said to have been introduced more than once."

Péri maintains that the Kusha sect never had an independent existence in Japan and that its special text was studied by the Hossō sect. But it is included by Japanese and foreign scholars as one of the Hasshū or Eight Ancient Sects.

Of these eight the Kegon, by 749, received such impetus from court circles that it might, with Shinto, have been called the state religion. It precisely fitted the needs of

those engaged in unifying the Empire. With a somewhat mechanical nicety it proclaimed the ordered hierarchy of a spiritual empire over which the Roshana Buddha of the Law is enthroned supreme in a thousand-petaled lotus. Each petal is a universe ruled by a Buddha who is an emanation of the Everlasting one, Roshana. Each of those universes is composed of ten thousand worlds ruled each by an emanation of these lesser Buddhas, made manifest. Of these myriad worlds, ours is one.

To portray this grand concept, a mammoth figure of the Omnipotent Roshana seated on his lotus throne was cast in bronze at the instigation of the priest Ryōben at Nara. The worlds and the Buddhas ruling them were engraved on the petals of the throne and the whole was roofed by the largest wooden building in the world.

Before all this could be accomplished, however, the Shinto gods, who had fast hold on the people, must be consulted and their sanction granted to foreign gods. For this purpose, in 742, Gyōgi, whose doctrine it was that there was no antagonism between Buddhism and Shinto, was despatched to the oracle of the Sun Goddess at Ise. The oracle's reply is quoted by historians because of its profound significance as an early example of the acquiescence of the Japanese Shinto gods to the presence of the imported Indian ones. The Shinto deity later appeared in a vision to the Emperor and explained with some particularity that the Roshana Buddha, whose home was admittedly in India, was in truth the Sun. Thus the foreign deity, a pure abstraction, assumed a concrete avatar on Japanese soil. Once this principle had been acknowledged by a divine being of national and imperial importance the way was clear for priestcraft to explain the presence of other Buddhist gods in a similar manner. The process went on for a full century before it became general throughout the land. By that time, except for the two great Shinto localities of Ise and Izumo (which are associated with the arrival of the descendants of the Sun Goddess on earth), all important native shrines had their Indian Buddhist alternatives in residence. And Buddhist temples were friendly to the Shinto creed, or practiced it or actually identified themselves with it.

As Sir George Sansom phrases it: "Though the erection of the Nara image raised in an acute form the problem of assimilating Buddhism and Shinto, it was a problem which had naturally been thought about for some time beforehand, and the picturesque legend of the oracle is only the representation in a palatable form of a syncretic doctrine which the Buddhist priesthood had been gradually evolving. They argued that the native gods were avatars, phases of being, of Buddhist deities; and identifications like that of the Sun Goddess with Roshana were multiplied, so that in time many native shrines were taken over by Buddhist priests and lost more or less of their original character. Buddhist priests now regularly took part in Shinto rites."

By the twelfth century the Shingon Buddhist esoteric monks recognized, named, and philosophically defined Ryōbu Shintō (*Shimbutsu Konkō*) as a fusion of the Kongō

Kai and the Taizō Kai. According to this teaching, the various Buddhist gods coming from their original homes, *honchi*, to Japan left here their traces, *suijaku*. Or, put differently, the original Indian entity finds in Japan a Shinto manifestation. Sansom further points out that as early as 765 the Empress finds it worth while to defend the seeming inconsistency of an ardent Buddhist like herself celebrating the purely Shinto festival of the First Fruits and encouraging priests and nuns to join her. Her edict goes so far as to emphasize how the sutras make it plain that the native gods must revere the Buddhist doctrine of the Three Buddhist Treasures.

It was this ingenious discovery which provided legitimate scope for the diverse religious convictions current till 1866 when, by imperial decree, the two cults were separated and Shinto declared the state creed. How nice a balance was kept during nine and a half centuries and how mercifully it preserved Japan from fratricidal wars and the black stain of *odium theologicum* familiar in the West! No one can tell how much was due to the Oriental habit of tolerance or how much to timely policy on the part of Court and Church.

No Oriental would consider such mutual concessions remarkable and it is hardly imaginable that the simple minds of the craftsmen felt the need of any elaborate justification for their mixture of beliefs and practices. The whole subject has yet to be examined by some folklorist with knowledge enough of craft ritual to comprehend its significance. Till that is done I can but suggest the implications and emphasize the neglect of Shinto by modern scholars of Buddhist and lay art. Enough non-Buddhist native practices perhaps exist today among Japanese craftsmen to shed some light on the attitude of the Tempyo period.

Thus it must not be taken for granted that the newly established Buddhist Church turned Japan into a Buddhist country overnight. Among the small proportion of the aristocracy who were literate, a few could read Chinese Buddhist texts and the Confucian classics. But there was nothing impious to those scholars when the household, incapable of reading, joined not only in the half understood Buddhist observances but also paid tribute to the more familiar local Shinto gods.

Even in the sixth century, when the Nakatomi family opposed the adoption of Buddhism to the point of violence, their argument was never that Buddhism was false in the sense that paganism is false to the Christian — that is, based on nonexistent deities. Rather the contrary, it was considered quite real enough to be resented by the native gods and to be a menace to them. The commoners at that time rose up only when it was explained by their betters that plague and bad crops were due to the presence in the palace of a Buddhist image sent by the Korean king. Then they promptly flocked to town, armed with scythes, to put an end to it.

As for the Jōdo sect founded by Hōnen Shōnin in 1175 which certainly stirred up

bitterness, Sansom writes: ". . . on the whole it is fair to say that the attack upon him was a fight for privilege rather than a battle for truth." Certainly the indecent brawls in Kyoto when the Tendai monks came to town were purely political as was the burning of Hongan-ji in the fifteenth century. It was by exception that Nichiren at the end of the thirteenth century denounced all Buddhist creeds but his own and, as Sansom puts it, "broke the tradition of religious tolerance in Japan . . . regarding all other doctrines as heretical and damned."

However limited Buddhist knowledge and Buddhist faith in eighth-century Nara may have been, the church was the great patron which liberated and enriched the arts of the nation. Thousands of citizens labored in the service of this Indian creed which was housed in Chinese architecture and served by a native clergy who had been trained by Chinese, Koreans, and Indians to perform a Sanskrit liturgy.

Buddhism paid the craftsman's wages and prescribed what he must make. Many were the townsmen and farmers who lived on church lands paying rent to one or another of the monasteries. Outside the capital, as has been mentioned earlier, whole villages had been devoted by imperial decree to the support of various temples. In such a village every household tilled temple rice fields or wove the cloth that was to be cut into priestly robes. Every household was familiar with the temple kitchens where they fetched their produce and, incidentally, absorbed something of the new doctrines through the back door. It is no wonder that such a village observed Buddhist holy days and gradually added some of the imported gods to their familiars of field and byre. Temple compounds provided the parks for common people's holiday making. The clergy's demand for fresh images, more copies of the sutras, common cloth and brocade for vestments, land rent, and food supplies, brought the Buddhist church constantly into the lives of the citizenry. And always there was a sense that the Buddhist church, now welded to the state, stood for desirable, modern, and profitable things. That the abbots were Chinese or Korean or, in some cases, Indian seems never to have been resented or thought improper. The foreigner was part of the cultural scheme and Nara took him as much for granted as it did the native nobility seen in the streets. Western historians have described these decades as the conquest of Japan by continental culture; perhaps a truer description would be that of Japan at last pushing out her skiff into the full current of Asiatic civilization.

Of course the image-maker, the gilder, the bronze caster, the lacquerer, the tile-maker, and even the lads who ran errands for them, knew more than a little about Buddhist gods. They were familiar enough with the canonical number of arms and faces, the gestures and the attributes of the icons, and something of the church liturgy which was enacted before the high altar.

Even such a householder as had no direct connection with the clergy often saw his

children growing into increasingly close contact with the established church which bulked so big at Nara. His son might be called to lend a hand with the loggers rafting timber down the Uji River to be manhandled overland on rollers and squared to fit the longest, broadest, grandest building of the known world, the Daibutsu-den. That was proof, if proof were needed, of the validity of the Roshana Buddha whose massive bronze image was being set up inside that hall. There was need for unskilled lads to mind the fires at the kilns where roof tiles for the monasteries were baked. Some, with clerkly leanings, willing to practice Chinese characters with the brush might, after a few years, become apprentices to the scribes in sutra-copying.

Calligraphy and painting, the sister arts, were enormously in demand for the copying of sutras and the preparation of sacred pictures. In 753 eight hundred and forty-three sutra copyists and a hundred and forty-three proofreaders and a hundred and seven mounters are listed on the records.

Sutra copying, *shakyō*, was attended with much the same ceremonial as in the monastic *scriptoria* of medieval Europe. Several scribes were assigned to prayer while their comrades labored and the clerks, before starting work, put on clean garments. They were obliged to forego wine, leeks, garlic, pepper, meat, fish, and evil-smelling food till the work was done.

The penmen of the day have left us a pathetic document, now preserved in the Shōsō-in, begging for better working conditions. They point out that, since there is a shortage of paper from Korea, it would be useless to enlarge the staff. They then ask for clothes, better rations, and allowance of rice wine to relieve the pain in the chest and numbness of the legs that comes from kneeling at their task. The last paragraph points out that neither boiled barley nor rice is available to the poor.

When it came to church holidays the laborers and craftsmen of Nara and their grateful wives were good Buddhists. The Lord Abbot's progress, the occasion of a court baptism before the Great Buddha, or any other splendid half-understood spectacles were opportunities to down tools and have a picnic.

So much is known, but contemporary records do not betray how sound a Buddhist the Japanese peasant and laborer had become. What did the builder make of it all as he climbed about the roof of the Daibutsu temple hanging the great tiles to their wooden pegs to keep the rain from the mountain of bronze within?

An additional advantage to the commoner was that certain priests, especially those from temples where Yakushi, God of Healing, sat enthroned, could be depended on to give out charms and foreign medicines against illness. Of course, to enter any Buddhist temple, if only to escape the rain or listen to a chant, meant that one conformed to the decent ceremony of prostration and perhaps made a gift of flowers or a part of one's noon dumpling. Thus vague Buddhist phrases became current among simple people:

BUDDHISM AND THE ARTS

"Take refuge in the Three: the Buddha, the Church, and the Law." Everyone in town knew the names of half a dozen Buddhas and Bodhisattvas if only because their temples were the biggest things on the Nara landscape and were among the great urban and rural landlords.

While such familiarity with Buddhist landmarks and festivals and sanctimonious phrases was become by degrees more common among the lower classes, the court was encouraged to study deeper. Today, reading the decrees and the Palace calendar, one might be led to believe that the aristocracy was entirely engrossed in Buddhism. But scholarship was not the rule nor philosophy much practiced by court politicians, and the mixed Mahayana and Hinayana doctrine current during the eighth century was conceived on simpler lines than the esoteric creeds introduced a half-century later. The early Japanese worshipper was satisfied by a comparatively meager pantheon of images and there was little variety in the texts that were turned out in quantity by the Sutra Copying Bureau. It is always remarked by the modern student of seventh- and eighth-century iconography that the list of Tempyo images includes only a modest score of the principal god names. Even those gods were frequently portrayed so simply that, when new texts and esoteric elaborations of ritual were introduced, the names and characters of images were easily changed. Study of the medieval iconographies sometimes almost persuades us that Nara imagers lacked the *Reinwissenschaftlichkeit* which today in the West sometimes passes for Buddhist knowledge. At any rate it was not till the last years of the Tempyo period, the beginning of the ninth century, that the high mysticism characterizing the profoundest Buddhist thought of India and China began to come to Japan in any marked degree.

But if metaphysics was at first lacking, enough was there of fresh and arresting ideas which had never been present in native Shinto. The reward of virtue and the punishment of sin were, by Buddhism, categorically insisted on. The taking of life was for the first time impious.

The new conception of sin had a profound influence on the whole Japanese point of view, their diet, their clothing, and their manner of daily living.

Transmigration of the soul, implicit as a possibility in Shinto, was now admirably and reasonably explained by Buddhism and, during the following centuries, became a part of Shinto belief.

For the Westerner to make even a beginning toward comprehension of Nara sculpture, Buddhism must be understood, for what remains from the eighth century of material culture in general and of sculpture in particular is largely Buddhist. It is more important in this study to grasp the simple fundamentals and feel drawn toward the undoubted truths that lie deep in this religion than to probe all the refinements of sectarian doctrines or learn to thread a devious path through an unfamiliar iconography.

Happily we have a large and growing store of books on Buddhism in English and other European tongues. Ignorant of Oriental languages, we can read not only the life and teachings of the historic Buddha but also doctrines, daily practices, and philosophies that had their origins in the Great Awakening of Gautama which took place under the Bodhi tree in India twenty-five centuries ago.

The powerful and gentle flood of Buddhism bore Japan irresistibly along toward its full Far Eastern heritage to join China and India where, for all the differences, Asia was One. The beneficent New Idea carried a simple people from their primitive animist beliefs and practices to broader deeps and amplitudes to find room for whatever spirit and intellect man's nature might develop.

History throws little light on how much the newly introduced creed affected the illiterate craftsmen with whom we are chiefly concerned. But if we study eighth-century Shinto, however incompletely, we find that native pre-Buddhist beliefs and forms of worship were from the very outset modified by contact with the Indian-Chinese Buddhist church. How deeply the new ideas changed the plebeian spiritual and intellectual life of Japan is a matter of guesswork.

It is obvious that early Buddhism in Japan was almost exclusively the property of the court circles. De Visser lists scores of recorded occasions during the short century of the Tempyo period when, by court order, the Yakushi (healing) scriptures and other sutras were read for days and even weeks on end, copies of them written and distributed, Buddhist images carved, modeled or cast, and pagodas or chapels constructed for the great Nara monasteries or the leading provincial temples. These decrees were usually accompanied by vegetarian feasts for the clergy, amnesties to prisoners and outlaws, and the distribution of alms to religious foundations and to the poor.

While the recorded reasons for such official acts of piety are usually stated to be attempts to allay pestilence or cure an Imperial invalid, "for the sake of the repose of the Court and the great peace of the realm," or "to promote the prosperity of the temples, the happiness of the Imperial house and the people and the purity of the country," they by no means imply that Buddhism was prescribed merely as a prophylactic or welcomed only as magic. One must remember that, although Prince Shōtoku vowed a bronze statue for the benefit of his sick father as early as A.D. 587 (it was installed in 607), his commentary on the Lotus of the Good Law is still looked upon as an important contribution of philosophical and religious profundity. There was certainly a growing number of eager souls who reached out for a spiritual enlightenment of a sort not provided by native Shinto.

In fact something was stirring during these short centuries which, perhaps for the first time, provided thoughtful Japanese with endless stimuli to both intellect and spirit. And at the same time these great verities were couched in a variety of forms and became

increasingly persuasive to the simple. Minds which craved intellectual fare, as well as those captivated by hitherto unknown concepts such as the Buddhist heaven and hell, or those content merely to fall into step with their betters, all were gathered into the fold. The craftsmen, whose lives most concern us, can not be said to have "become Buddhists," but they practiced honestly the rites, accepted as much as busy men had leisure to comprehend, and were undoubtedly benefited in constructing images for their rich patrons, the religious foundations.

As to the content and teachings of Japanese Buddhism it must be remembered that the life story of the historic Buddha and his sermons have always, in every Buddhist land, been the basis of each of the diverse creeds and sects. But the Japanese received with the first importations comparatively few of the different aspects that had been for centuries unfolding more or less separately on the mainland. It was not until the full body of the various texts and their commentaries arrived in the Middle Ages that the Japanese selected from the rich offering the half-dozen that, practiced simultaneously, can be said to make up "Japanese" Buddhism.

Nevertheless, the early and comparatively simple phase of Buddhism in Tempyo times struck deep and permeated Japanese culture at its very roots.

CHAPTER IV

T'ANG CHINA AND TEMPYO JAPAN

IF Shinto was sterile as far as the arts of painting and sculpture were concerned in eighth-century Japan, so too were the Confucian doctrines in the contemporary culture of China. But other arts, notably those of government, deportment, literature, logic, music, and calligraphy, had been nourished by Confucian studies.

Since our own immediate inquiry is necessarily confined to material objects left from the eighth century in Japan and thus limited to Buddhist images and ritual paraphernalia, and since we are being constantly reminded of the temporal and spiritual power of the Buddhist church during that century, it is all the more needful to keep in mind how strong a cultural force Confucianism has always been in Japan, albeit a force that left no visible marks on the sculpture that concerns us.

The mystic abstractions of Buddhism, the black magic of degenerate Taoism, the Shinto world of spirits, have all been tempered by a logic and a common sense that was peculiarly the virtue of Confucius' wisdom. There is plenty of evidence that the Japanese accepted easily many of his doctrines and that the government found law and order emphasized therein and the relations of ruler and subject acceptably defined.

Leaving to historians the task of demonstrating the undoubted power of the Confucian books and training in Japan during the eighth century, and of quoting chapter and verse, it is worth recording that two or three decades ago one of the wisest and noblest of Japanese elder statesmen, Foreign Ambassador, Minister of Foreign Affairs and Privy Seal, told me that the Confucian books remained for him and men of character in Japan a lodestar of conduct.

It will be remembered that during the quarter of a century of Emperor Shōmu's reign, at a time when court patronage of Buddhism was at its very height, when Buddhist temples and images were being set up all over Japan and Buddhist sutras distributed by the thousand, and the Emperor was declaring himself the humble servant of the

Buddha, he was also carrying out numberless Shinto observances. Further, this enthusiasm for Buddhism and strict conforming to Shinto were contemporary with a round dozen of the imperial ordinances concerned expressly with the promulgation of Confucianism. Even ordinances on other subjects contained more than a flavor of the Confucian texts. In 722 the annual Confucian festival, *seki-tan*, was held at court and the Emperor appeared publicly, as his predecessor had done, in robes described by Western historians as "Confucian" but perhaps merely of the classical Chinese fashion.

In the same year he endowed Confucian studies at the Daigaku, the Academy at Nara, and his broad-mindedness was evidently shared by Nakatomi no Hirome who lectured on Confucianism by court order without prejudice to his high office of hereditary Shinto Ritualist. In 739 command was given through the Bureau of Rites that all officials must attend Academy courses for special training in the Chinese language (using Confucian textbooks) and deportment and ceremonial — Confucian learning in short. Nine years later the ceremonies and liturgical utensils for the festival of Confucius were altered and improved.

Thus to be Confucian was to be Chinese, correct, and civilized. And the Academy transmitted such learning, including the Confucian subjects of archery, mimetic dancing, and music, for the reason that those subjects, like philosophy, law, and history, had been promulgated by the Master and all textbooks were written by followers steeped in his tradition.

The edicts of Prince Shōtoku, scholarly patron of Buddhism, and the Taikwa Reform, A.D. 645, are demonstrably Confucian in character, both in the principles they inculcate and in the actual phrases that express them.

New laws were needed by a rapidly expanding Japan anxious to tighten control over its restless barons, disturbed by palace intrigue, and by no means yet certain of the permanence of its Imperial House. Nothing could have been so fit for meeting these emergencies as the classical precepts evolved through the centuries by Confucius and his followers who were preoccupied, above all else, with matters of government and whose words, already a millennium old, were looked upon as the very basis of the most advanced and stable culture of the known world. Tempered by the Indian metaphysics of Buddhism which had so caught the imagination of some Japanese aristocrats, couched in the noble language recognized as the authentic medium of the highest civilization, familiar to every scholar and hallowed by tradition, it is no wonder that Confucian doctrines can be recognized in nearly every public utterance of government of that day in Nara.

Rather than quote the score of Confucian edicts found in the histories of the eighth century let us examine the baggage brought back to Nara by the famous scholar and patriot Kibi no Makibi (693–775) when he returned in 735 after spending several years

as emissary at the Chinese court. Never was ambassador more fit by character and training. The folklore gathered about his name is detailed in the most lively fashion by a master painter of the fourteenth century whose scroll depicting Kibi's adventure is now preserved at the Museum of Fine Arts in Boston. He and his luggage interest us particularly because, on his return to Japan, Kibi was promptly made head of the Japanese academy, Daigaku no suke, in which the aristocratic youth of the governing class were trained and where officials were frequently sent for postgraduate studies in protocol, law, ethics, and the elegant accomplishments.

Even the bare catalogue of what he brought from China to Nara throws light on what was needed in Japan. Every item in the list is pertinent to Confucian studies.

1 painting of Confucius and his ten disciples, of which Kibi had copies made immediately on landing.

130 volumes concerned with the ceremonial of the T'ang court, among which were many that were tantamount to a legal code as well as those dealing with palace procedure.

1 Chinese calendar with twelve volumes of commentary and elucidation which presupposed a knowledge of the Confucian books, mathematics, and Taoist lore.

1 iron sundial.

A series of bronze tubes tuned to the notes of the Chinese scale.

10 volumes on the principles of music couched in philosophical terms and including rules of deportment.

143 volumes of the history of the Eastern Han Dynasty of China.

1 wrought-iron scepter of the shape called *ju-i* in Chinese.

1 lacquered horn-backed short bow of cavalry design — a shape never commonly used in Japan even after the appearance of mounted archers.

1 lacquered horn-backed bow of the length of four bamboo joints (as is the Chinese bow today).

1 reel for bow strings.

20 helmet-piercing arrows and ten flight arrows.

Kibi is also credited with bringing the art of embroidery, the game of *go*, and the *biwa*, a four-stringed musical instrument.

In the Academy, or University as it is sometimes translated, over which Kibi Daijin found himself placed on his return, the faculty consisted of some twenty-five professors. Of these the chairs of Phonetics and Calligraphy are mentioned first, undoubtedly because they were in fact of prime importance to a country receiving its cultural spur through a foreign language and still engaged in cramping its speech into a system of ideographs never intended for it. Next come the chairs of Mathematics, Jurisprudence, Prose Composition, and the Lecturer to the Throne.

The Medical School included one professor of General Medicine, one of Acupuncture, one of Massage, one of Charms, and one of Pharmacology. In Divination was one professor of the general art, one of astronomy, and one who specialized in the calendar. Music included four dancing masters, two flute teachers, twelve for Chinese music, and twelve for Korean music, the latter divided into four from each of the three Korean kingdoms: Paekche, Silla, and Kokuli. This department alone is mentioned as having two hundred and twenty-five students, but they were presumably expected to graduate in the other departments as well.

The effect of Confucian thought so clearly seen through Kibi no Makibi and the Nara Academy was but part of the great tide of Chinese influence that included Buddhism. There are records of other personalities, notably the famed Abbot Ganjin to be dwelt on in a later chapter, that emphasize the direct impact of the latter force.

Indeed, we can hardly advance a step in our inquiry without reference to Chinese sources and the culture of China under the T'ang emperors (618–907). What has not been as generally recognized, however, is the fact that much material evidence of Chinese culture, now lost on the continent, is to be found in Japan. Thus Buddhism of the T'ang dynasty and that of the later medieval period cannot be adequately studied on the mainland or from Chinese sources alone. As for Buddhist art, there are in China stone sculptures and wall paintings of the T'ang period remaining in the cave temples, but Buddhist bronzes of the eighth century are rare on the continent compared with Japan. In the sixth-century cave temples at Kunghsien in Honan the ceiling is treated as though it were of wood; the solid rock is cut in the form of beams held together by metal studs, but no wooden buildings of the period exist in China today. Wood and dried lacquer sculptures which must have been common in both countries are, for our period, found almost exclusively in Japan. So too with much palace and temple furniture, musical instruments, and textiles, the sole remaining originals of which are preserved in the Shōsō-in treasury at Nara.

In another connection I wrote that the China of the T'ang epoch was, indeed, the Middle Kingdom — the center of the world. And yet Mohamet, Alfred, the Sassanid Kings, Charlemagne, Roland, and Harun al Rashid all mean more to us in the West than do their contemporaries Ming Huang, Tu Fu, and Li Po, in T'ang China. But to have been an educated person in the great capital of Ch'ang-an (modern Hsi-an or Sian-fu) was to have felt, however dimly, the existence of western lands. One saw the Persian Embassy go by on its way to court and bought rugs and shaggy ponies at the Turkoman bazaar or stuffs and spices from Arabian merchants.

Embassies from far lands spent months at Ch'ang-an studying T'ai Tsung's law and his military system. Within the palace gates was built a spacious library of one hundred thousand volumes where the six most famous literati of the realm wrote and read

and studied. Here each day the Emperor would come and work out a problem of chess with one or talk over a disputed passage of the Confucian Analects with another. In this library the maps were spread when he planned a campaign, and here he would interview an Arab merchant who came carrying reports of his emissaries on the Persian Gulf.

The chronicles tell that languages never before heard in China were common about the capital and that one Imperial secretary was so struck by the numbers of strange and outlandish costumes to be seen at court that he obtained T'ai Tsung's order that paintings should be made which might faithfully depict these scenes. The great caravanserais were crowded with outlanders and certain inns made a specialty of serving different national delicacies, that the Turkoman Khan might not be without his fat-tailed sheep and the Ambassador from Sinlo might feast on puppy meat.

All this is worth dwelling on for it explains why Chinese art of the T'ang period has in it elements directly traceable to the colonists left by Alexander in his Graeco-Bactrian kingdoms, Syrian designs and Persian, along with Byzantine elements and Moslem hints.

The fact is frequently emphasized that T'ang culture influenced all the countries that lie about the edges of China. But to what degree it did so in each case has not been properly gauged, nor indeed can it be, except partially in the case of Japan. Examination of what little is known about these outlying districts at that time serves but to bring us back to Japan which proved by far the most favorable soil for rooting and disseminating Chinese culture; and also, though far less extensively, to the small kingdoms of Korea, a bridge along which Chinese culture reached Japan. Kokuli and Paekche were buffer kingdoms on the road between China and Japan, useful as intermediaries, but incapable of modifying the culture they transmitted or even perhaps of appreciating what it might signify. In contrast to such kingdoms which proved themselves impotent or unwilling to use the superior T'ang culture of China, Silla lying along the southeast coast of Korea was a somewhat more apt pupil.

At first the position of Silla gave her a cultural advantage over the Japanese islands. She was much nearer to the capital of China and her marches ran with Chinese Provinces where Chinese Governors and garrison commanders held their lesser state. When the direct sea route from the Middle Kingdom to Japan was not used, men traveled from Ch'ang-an eastward and northward, through the Great Wall and beyond it, then down the whole length of Korea and across the straits. All this overland intercourse between China and Japan had necessarily to come by way of Silla. But the Koreans of this favored kingdom, though they had earlier access to Buddhism and Chinese culture and manners than did Japan, had apparently neither the desire nor the initiative to erect such a mammoth bronze Buddha as that at Tōdai-ji in Nara. Nor can it be found that they were so skillful as to elaborate further ingenious techniques for wood sculpture, bronze

casting, lacquering or tool-making as did the Japanese. It is true that the Chinese teachers resident in Korean monasteries had native pupils whose learning was sought after by Japan and who were summoned to the Island Kingdom to teach during the Nara period and even earlier, but there is no record that a great Korean literature came into being after those first scholars, nor that the Koreans turned back from Chinese mannerism to a fresh native inspiration, as was frequently the case among the Japanese. Again, Buddhism in Korea seems never to have blossomed into new philosophic beauties or merged with an indigenous cult to bring forth anything half so vital and characteristic as was, for instance, the Japanese adaptation of Zen philosophy in the thirteenth and fourteenth centuries or their development of Chinese Shingon mysteries.

In short, Chinese culture in the Korean kingdoms often consisted in transplanted enclaves centering about the headquarters of the Chinese governors from which the colonies were controlled and where could be found such scholars and artists and craftsmen as came from the mainland to settle near the local courts.

It seems to have been the culture of the early and middle T'ang dynasty of China, the seventh and early eighth century, which influenced Japan most directly after the first Korean teachers gave place to Chinese. Several times in her history she has accepted elements of Chinese material and intellectual civilization and then set to work to refine and elaborate these elements in a manner all her own. A bare thirty years after the consecration of the Great Buddha in Nara in 752, the T'ang dynasty was already far down the road to disintegration. But Japanese ambassadors were in residence at Ch'ang-an and government fellowships for study in China were granted to promising young Japanese youths. As many as five hundred and fifty priests, scholars, and others are said to have crossed the seas to China on a single mission in the reign of the Empress Genshō (715–723). We hear more of a number of such travelers on their return to Nara. At the same time teachers of the Chinese language and of a hundred crafts were invited from the mainland, and the youth at home were sent to study under them. Later as we come to the contributions of these philosophers and artisans it will appear what an essential part they played in Japanese culture. While scholars from Japan continued to go to the monasteries along the Yangtse for training in Buddhism, the temples at home were, by mid-eighth century, many and powerful. They gave opportunity for study and meditation and the practice of art and literature to thousands of Japanese. Confucian learning could still, of course, be found best in China, but at Nara Japanese criticism was being brought to bear on it and its value, social and ethical, was being modified by the islanders to suit their own temper.

In fact, the full generous stream of culture derived from T'ang, far from being cramped or diverted or lost on reaching Japan, was being given new direction and development just as the Chinese grasped much of Indian thinking that came over with

Buddhism some five centuries before, rejecting what seemed to fit them ill and giving fresh value to the rest.

In the train of every Japanese Ambassador were sent eager young aristocrats chosen for their ability. They fetched back to Nara the latest fashion in brocade for the weavers to reproduce, and the new Chinese translations from the Sanskrit of holy books for the copyists at home to distribute. Best of all they acquired the Chinese respect for intellectual accomplishment.

It was an unforgettable thing for one of these young islanders when he was invited to Court. The gilded Chinese youths who were his companions might get him an invitation for a garden party when a lute-playing contest was on or the poem game was being played with wine-cups floated down the crooked rill in the palace gardens, filled and re-filled as forfeit when the guests along the water's brink failed to cap verses. Or if Yang Kuei Fei's musicians were performing in the gardens, her beauty might for a moment be seen moving among the guests. Tu Fu's and Li Po's poems were on every lip.

By good fortune Li Po's poem on his Japanese friend Abe Nakamaro whom he trans-literates "Chao of Nippon" has been preserved. He had been sent from Japan to study with Kibi no Makibi, and was shipwrecked trying to return to his country and reported lost, hence the lament. But he made his way back to the Chinese capital where he died in 770 after thirty years' residence in China, a recognized man of Chinese letters and a poet.

THE POET MOURNS HIS JAPANESE FRIEND

Alas, Chao of Nippon — you who left the Imperial City
To sail the waters where the fabled islands are!
Alas, the bright moon has sunk into the sombre sea
 nevermore to return,
And gray clouds of sorrow fill the far skies of the south.
(after translation by Shigeyoshi Obata)

Flute, lute, and harp were heard from the groves behind the high walls where the delicious folly of the court went on. But the serious young Japanese, with a responsibility to bring back a little of all this to his less sophisticated country had still other things to ponder. Beyond the west gate of Ch'ang-an city was a huge Campus Martius with streets of gray brick barracks and long picket lines for the cavalry. There, too was the armory where slaves were working at the smithies beating out iron arrowheads or casting bronze ones by the thousand. In long sheds the fletchers worked at their deft craft, whipping with thread the feathers to the arrow shafts sent up in bundles as tribute from the provinces. If a campaign was forward there was tall talk among the subalterns concerning beleaguered cities and the management of cavalry in the open.

If the discussion of the practical accomplishments of T'ang gives the reader an idea that material improvements were all the Japanese got or asked, the emphasis is false.

Spiritual and intellectual stimulus was being received consciously and unconsciously. Every boat from China or Korea that beached at Naniwa (Osaka Bay) came freighted with imponderables as well as with priests, teachers, artisans, and traders with their bales of foreign goods and their new ways of doing things. In all history one finds, perhaps, no people so ripe for superior culture as the Japanese of that day who had been so long denied it; no people more fit to use it when it came.

Not the Renaissance in Italy nor the high brief days in fifth-century Greece can provide greater interest for the historian than eighth-century Japan and its rich background of Asiatic culture.

But the beneficent stream was becoming noticeably thinner; its sources were drying up. In China the unbearable cost of foreign conquest and half a dozen distant campaigns was perhaps the chief reason for the fall of the Chinese dynasty already enfeebled by palace intrigues and the flight of an Emperor in 756. It was the time of a debauched and pleasure loving aristocracy when the lovely Yang Kuei Fei was an empire's outrageous toast. During the very weeks of the dedication of the great bronze Buddha in the Japanese capital in 752, the year which marked the full flood of China's influence and Japan's upbuilding, South Chinese kingdoms were joining the Tibetans to beat back a large imperial force sent to suppress them and at the same time Arabs and Tibetans, lately beaten in the west, were gathering again for the kill. Only five years before "seventy-two different Hou peoples" had been brought under submission by a huge expedition of three Chinese armies, one of which went north into Tibet after topping the Pamirs at Tash Kurgan and crossing the Hindu Kush as well. The spread and the might of this T'ang dynasty of China is recorded in the annals that show its Commander-in-Chief had previously been Governor of the "Four Western Garrisons," Kashgar, Khotan, Kucha, and Karashar, and that he was born in Korea.

Though cultural and dynastic decay had begun in the Chinese dynasty of T'ang, Japanese scholars still sat at the feet of Chinese holy men or studied the Confucian art of government at Ch'ang-an, the seat of empire. But when the Tempyo period came to an end and the Japanese court moved from Nara to Kyoto in 784, the Tibetans and Mohametans were harrying the Chinese Empire at will. No wonder that the wise Japanese statesman Sugawara no Michizane, a hundred and ten years later, advised the throne that China's present state was so feeble and so divided that no good could come of dispatching a Japanese embassy to the T'ang court.

We are to imagine, then, an island race emerging from a simplicity that has elements of barbarism, eagerly turning to the neighboring continent of China to reach a culture from which they had hitherto been shut off. Ready to accept and to comprehend this culture, avid for it to an extent for which one can scarcely find parallel in the history of nations, the Japanese nature was not fundamentally changed by it. Some elements were

adopted unaltered and incorporated at once. Other elements were tested and cast aside. Still others the Japanese molded to fit their island purposes.

The insular position of Japan was in no sense that of England where Roman, Dane, and Norman fleets landed for loot or conquest and where all through the ages a short sail from Dover cliffs has brought the English to the beach of Europe. England has been conscious of a dozen different tongues and cultures. Japan, in historical times, has known but one outside her own — that of China.

The impact of Korea, her nearest neighbor, at folk levels, is not to be denied. Yet the influence she had upon Japan in the realms of philosophy and religion has seemed from the first but that of China modified.

By the end of the Tempyo period the culture of this island kingdom must be called indeed Japanese. Not that it originated on the islands, nor even because of its surface differences from that of China, but because the differences that did develop were profound. It cannot be said that the Japanese sloughed off a civilization of their own to make room for the new. Rather they were brought up by the continental Chinese and, during their adolescence, were conscious of nothing else so desirable. Keen and anxiously aware of what they wanted, they recognized immediately the good chance that had moored their islands off the coast where lived the most civilized people of the globe.

The great barrier to the new learning was of course the strange language. And, as the Japanese had no writing, they adopted the ideographs of China to express their own entirely unlike tongue. Thus the Chinese symbols which had been invented to fit monosyllables were now warped and twisted for the polysyllabic language of Japan, some for sound and others for sense. To complicate matters still more, many Chinese sounds were not those of the Japanese tongue and precise transliteration was impossible. Further, the Japanese language was still lean and ill-nourished, not yet apt for expressing abstractions or even the concrete facts of a high civilization.

Thus there was no writing but in the Chinese, and the vernacular suffered a heavy strain by reason of imported thoughts and objects for which no native words existed. Sansom in his *Historical Grammar of Japanese* gives at some length an account of the adoption of Chinese ideographs and the difficulties of trying to fit them to a radically different tongue. Direct transliteration was hopeless, and grammar, sound, and meaning — all evolved by the genius of strangers — had to be crowded like square pegs into round holes when Japan tried to write her own tongue in Chinese. In fact, so seemingly hopeless was the task and so popular the new learning, that adaptation was not the common practice. Chinese was learned and written entire, as being a more elegant expression and a juster one.

"No scholar, no priest, no courtier, and indeed no ordinary clerk or accountant," Sansom says in *Japan: a Short Cultural History*, "could get on without being able to read

a Chinese text and to write a Chinese sentence . . . everyone who valued his standing must have a smattering . . . The study of the Chinese language was, then, the chief intellectual employment of the aristocracy of Nara."

We have seen, to quote Sansom again, that "the Chinese language was not only the vehicle by which the culture was imported, it was the very foundation of the new learning and the new institutions. It was, indeed, an institution in itself and one of the most important."

After the Taikwa Reform in Japan in 645 the very laws under which people lived and were taxed had been adapted from those conceived for the Chinese social system. They fitted the Japanese ill or not at all. Sansom in the same book, devotes some illuminating passages to the subject which should be read in this connection. It is enough for our purpose to emphasize the fact that court ranks and etiquette and costume had become as nearly as possible those of the Chinese capital, and that the system of land tenure and of *corvée*, on which taxes for the commoners were based, was an experimental shifting affair vainly attempting to fit the T'ang code to island conditions. It is important to remember that such affairs were managed perhaps even less well by the contemporary European rulers Charles Martel and Pepin the Short and his son Charlemagne or even by the Saracens who were just then conquering Syria, Persia, Egypt, Africa, and Spain.

A barrier second only to the language, was the distance from Nara to the culture centers of China. It was a hazardous trip in boats of ten to fifty tons at most, and contemporary records tell of constant shipwrecks and pirates. Direct from Naniwa to the Chinese port at Ningpo where land travel frequently began, is about six hundred sea miles, but there is no clear record of such venturing. As a matter of fact one was fortunate to make a landfall on the Chinese coast in two months and spend only two months after that groping one's way along shore to the mouth of the Yangtse. From there the inland journey to the capital Ch'ang-an meant at least three months more by river scows and canal boats and over land by mule or bullcarts, through villages where one was frequently delayed by failure of transport or by the greed of local officials.

If, on the other hand, the shorter voyage across to the butt end of Korea was made with luck in a month from Nara, that was only the beginning. The thousand miles by twisting road travel up the spine of Korea to the Yalu River went through kingdoms often hostile. Rounding the armpit of the peninsula into what we call Manchuria down into China proper, some two thousand miles of springless progress by cart meant at least six months of steady travel. None of this counts breakdowns or the inevitable delays by storm, flood, and the incessant daily troubles with villagers and officials by the way.

The Japanese travelers could make negotiations for land travel on this trip only through the medium of their countrymen settled at the southern tip of Korea. But these interpreters and middlemen could arrange for only a fraction of the journey ahead and

they seem frequently to have been in league with local rascals to charge outrageously for lighterage, horse- and bull-hire and for the purchase of stores. Thus it came about that lives were often lost and that, even for the more fortunate, seldom less than a full year was consumed between Nara and Ch'ang-an. The venerable Abbot Ganjin, finally successful in 754 on, some say, his sixth attempt to reach Japan, was no exception in the number of days and disasters endured.

Far too little is known by us about early and medieval China and Japan, but the Western world is beginning, however dimly, to realize the fact that a cultivated Chinese of the eighth century lived in an atmosphere of mental stimulus which can seldom have been equaled in any country. Argosies from all the known seas were landing on his coasts. Confucian thought was being reanalyzed and presented in a form which made the dead archaisms live again and seem to have fresh import. The half-dead creed of Buddha, already outworn by many centuries in India, presented a saving grace to such Chinese minds as were reaching out for some more spiritual satisfaction than they found in Confucius. Wealth from the jade and gold-bearing rivers of Central Asia came in from the west along with the ponies and cattle that were exchanged for silk. Foreign wars were, for a time, a stimulus rather than a drain on the aristocracy. Poetry flourished with music and the other arts. Best of all, it seems to have been a time when curiosity and mental acquisitiveness (not always in other periods a Chinese trait) were the fashion.

To this splendid spectacle then, Japan looked across the narrow seas much as the colonists of North Africa must have watched Rome in the days of the Republic. The Japanese had already received the spark of Buddhism in the Suiko Period, but the enthusiasm of a limited group among the aristocracy was far from being a national awakening. However, above all things the governing class was avid for details of the culture which, they realized, made China great. Happily for them, their national character proved too strong to permit the literal imitation which they believed they had achieved. The Nara court enacted Chinese laws, adopted Chinese dress, wrote Chinese poems, and ardently practiced the Chinese-Indian religion — but always with a difference.

ABBOT GANJIN

THE story of the priest Ganjin, coming to us through Japanese records with perhaps a modicum of myth, is so vivid an illustration of the intercourse between the continent and the islands that it is worth quoting without being too zealous about verifying all the details. Legend and fact tell us that the Chinese priest whose name in religion was Chien Chên, and who is called Ganjin in Japan, was born in A.D. 687 at Yang-chou, China, of a family descended from a famous orator. As a boy in his teens he decided to become a Buddhist priest, and entered the nearby monastery, Ta Yün Ssŭ. While still a young man, he took the Buddhist vows of *Bosatsu-kai*. He traveled to the capital Ch'ang-an and to the monasteries of Lung Mên, the Dragon Gorge, in Honan province to study the *Tripitaka*. Eventually from the Ta Ming Ssŭ, at Yang-chou, he introduced the Ritsu Sect to Japan.

In the year 742, one day when he was preaching, there were present two Japanese priests, Yoyei and Fusho respectively of Kōfuku-ji and Daian-ji in Nara, both of whom had come to China in the train of the ambassador Hiranari. Deeply impressed, these priests begged Ganjin to return with them to Japan, and quoted to him the prophesy of Shōtoku Taishi: "Two hundred years after me a foreigner will come to teach you the doctrine of the Nyorai."

Within a year Yoyei, Fusho, and Ganjin, with two pupils and entourage of eighty persons, sailed for Japan. But a storm came up and played with their boat as a wind plays with a leaf. At midnight, with the storm at its height, the sailors saw four gods at the prow of their ship, and soon found themselves safe at the country called Jitsu-nan. Here they stayed while Ganjin, so the legend goes, accepted the invitation of the half-human people of that place, the Ryu-jin, to preach to them.

There is another account of this journey, or more probably of a second attempt to reach Nara. In the priest's train on this attempt were seventeen priests and eighty-five Chinese craftsmen who included jewelers, painters, image-carvers, designers of embroid-

ered banners, engravers of metal tablets, and casters of bronze. But this trip also was a failure, this time due, it is said, to the interference of Chinese officials.

Once wrecked, once pirated, once prevented by his own people, and, on other occasions, delayed and obstructed, Ganjin at last got clear of China, this time sailing from Ningpo, and landed in Japan during the first month of 754. There were nine years of labor ahead of him before he died at Nara in 763. The successful voyage was made in company with Tomo Furu, the returning secretary of a Japanese embassy. They landed at Daizaifu on the northern coast of Kyushu, and a matter of weeks later arrived at Nara. Here Ganjin was given an official welcome and temporarily installed at Tōdai-ji where the final work on the interior decorations of the Daibutsu-den had been but a few months finished. At Tōdai-ji, center of Buddhist authority and learning and greatest monastery of Japan, he found companions in the Chinese priest Dosen who had already been in residence there several years, and Bodhisena, the famous Indian pundit, known in Japan as Bodai. It was the latter who had taken a prominent part in the consecration ceremonies of the Daibutsu less than two years before.

Within a month of reaching Nara, Ganjin set about the business of constructing a *kaidan* where the rituals of baptism, consecration, and ordination might properly take place. He felt deeply the dangerous heterodoxy rife in the Nara church, not yet securely linked with the mother institution in China. To this ceremonial structure, which was of the utmost significance in the history of Japanese Buddhism, there came for consecration the ex-Emperor Shōmu, his consort, the Dowager Empress Kōmyō, the Crown Prince, and four hundred and thirty of the nobility and clergy.

Though his blindness, soon to become total, was already badly hampering Ganjin, he was not content with the temporary *kaidan* which seems to have been little more than a platform of the prescribed shape and size set up before the temple of the Daibutsu. He therefore set about rebuilding it more substantially on high ground a few hundred yards to the south where it was completed by the next autumn, on the thirteenth day of the tenth month, 755. Three times this building has been burnt down and thrice rebuilt. On one of these occasions the original bronze Four Guardians (Shi-tennō) were destroyed.

In 755, as the new Kaidan-in was nearing completion, the estate of Prince Niitabe no Oji in the western suburb of Nara was made over to Ganjin and he moved out there from Tōdai-ji with his disciples and Chinese craftsmen. The buildings already on the spot were adequate for his doctrinal teaching and to house the little colony and their Japanese helpers. The new monastery which he built was called Shōdai-ji or Tōshōdai-ji. Tō, the Japanese pronouncing of T'ang, suggests its Chinese affiliation, and Shōdai-ji is the Japanese rendering of the name of a monastery founded in China by the North Wei Emperor T'ai Wu Ti (424–452).

The construction of that vast temple, Tōshōdai-ji, and the remodeling and erection

of the many buildings that were necessary to a Buddhist monastery was done rapidly; it is said to have been completed in three and a half years. Buildings were made of wood, on high stone platforms in the Chinese manner, and the lumberyards of Nara and the available standing timber near must have been lately stripped for the building of Tōdai-ji and other shrines and palaces that had been going up so rapidly in the past two decades. Fresh lumber was felled twenty or thirty miles off, but the lumbermen were obliged to wait for a favorable freshet before it could be rafted down the shallow Kizu River and hauled by bulls and manpower to the site. It is also on record that only properly seasoned wood was accepted for temple construction; and there was a ceremony called *misogi kaji*, for the dedication of logs destined for sacred images.

The library of the new temple was stocked with sutras copied by Kenkai — the priest who later was to draw the plans for the new city of Kyoto — and to these holy texts were added a thousand or more volumes brought from China by Ganjin. In 758, only four years after his arrival in Japan, Ganjin was made Dai Wajo, or Oshō — Lord High Abbot — and a year later Tōshōdai-ji was consecrated.

It should be remembered that although Ganjin had never been to Japan previously, he had been, for a dozen years prior to his eventual arrival there, in close touch with Japanese pilgrims, students, and ambassadors in China. These had been his pupils and his traveling companions, and he had kept in mind his purpose to journey to Nara with the necessary library, liturgical gear, and the medicines which had always preoccupied him.

And thus there need be no surprise at the variety and fitness of the sacred cargo he brought with him. Among other precious objects on a list that still survives, were:

3,000 jewel relics from the ashes of the Buddha and other holy persons
 1 reliquary to contain the relics
 More than 3 bushels of Bo tree nuts for rosaries
 1 white sandalwood image of Senju (1,000-armed) Kwannon
 Images of Yakushi, Amida, and Miroku
 1 painting of Amida
 Paper doors painted with figures of Yakushi, Amida, and Miroku
 1 embroidered scroll of a Buddhist subject
 4 jade rings and crystal flasks
 1 glass jar made in India
 2 gold beads
 20 stems of green lotus
 2 pairs of leather shoes from India

The list included many books, albums, and documents of all sorts. Among them were the following:

 1 plan of the *kaidan* built by Sen Rishi of Nanshan in Kanchu
 80 scrolls of the latest translation of the *Kegon-kyō*

40 scrolls of the *Nehan-kyō* translated directly from the Sanskrit
60 scrolls of the *Shibun-ritsu* — canons of the church
10 scrolls of the five books of commentary on the above by the Chinese priest Horei
120 leaves of the book on the same subject by Koto Rissi
2 scrolls of a Chinese dictionary
12 scrolls of the *Hsi-yü-chi*, "Travels in the Western World," by Hsüan Tsang
4 volumes of the *Biku-nin*, "History of the Nuns"
1 set of the Risshi "The Nun's Penitence" by Ho Sen
2 scrolls of commentary on the above
 Nearly 90 volumes of texts and commentaries on esoteric Buddhism
11 volumes of the *Shi-dai-zen-mon*, "Gate of the Doctrine of Zen"
50 albums of calligraphy
1 album of calligraphy by Wang Hsi-chih
3 albums of calligraphy by the son, Wang Hsien-chih

These are a few selections from a long list of sacred books and commentaries adding up to a formidable total of more than a thousand volumes.

It may perhaps be surmised that the plan for the *kaidan* was put to use in erecting the structure before the Daibutsu-den, already referred to. The *Kegon-kyō* (Sanskrit, *Avatamsaka sutra*), is the principal text of the Kegon sect of which Tōdai-ji was the center. The priest Dosen had indeed brought over earlier translations from China, in 735, and they had been used in promulgating the doctrine at that temple by the Lord High Abbot Ryōben. But the arrival of a more complete and emended translation was a great event. *The Nun's Penitence* with commentary met a real need, as the Nara church had been in some difficulties on the subject of woman's place in the hierarchy. Complications had arisen from the fact that Buddhism had been enthusiastically accepted and practiced by ladies of the most exalted station.

The esoteric texts, no less than the volumes on Zen, must have been for the few rare mystics ahead of their times. Of great importance each in its own way, to later Buddhist thought and art, their mere appearance at this time is noteworthy.

Strikingly different as Ganjin's list is from that of Kibi no Makibi, its inclusion of calligraphy of the two Wangs is all the more remarkable. Wang Hsi-chih, master calligrapher of the Chin Dynasty (365–442), had long been regarded as patron saint of the art. His genuine writings were extremely rare, it is said, because the second T'ang Emperor had collected all known specimens and caused them to be interred with his body, one hundred and five years before Ganjin came to Nara. As the Tōdai-ji records also mention calligraphy of the famous Wangs, there is strong presumption that we have here Ganjin's gift to that temple.

In a list compiled for Ganjin's first abortive attempt to reach Japan, a Chinese pharmacopoeia was included, and such a list is known to have been used by him after landing. Chinese *materia medica* from the eighth century are still preserved in the precious

storehouse, the Shōsō-in, of which I shall have more to say in the next chapter. Although there is no direct reference to Ganjin in connection with these medicines, the first Deed of Gift to that storehouse dates from only two and a half years after Ganjin's arrival in Japan. Furthermore, in her preamble to that deed the Empress Dowager Kōmyō (who had been a participant at Ganjin's first *kaidan* ceremonies), mentions him as having come over the seas from China to do her husband reverence. All this is historic fact.

Dim as that brave old figure has become after twelve centuries, we know him to have been a careful person, with regard for established ritual, giving weight to the authority of the written word and deeply versed in medicinal practice. It is obvious that he compiled his list of necessaries with a fairly exact knowledge of what could and what could not be found in Japan. The book list and the icons show his purpose; and the examples of calligraphy, extremely valuable even at that time in China, bear out all other records of a day when the Japanese language was being newly rendered in Chinese script. For at that time no man could hope for preferment in State or Church without knowledge of the craft of writing and of the literary treasures locked up therein. As for Buddhism, the need in Japan was always for books, and more books, that the copyists would then reduplicate for temple libraries everywhere springing up. Books were the lifeblood of the Japanese church, necessary for teaching, for inspiration, and for daily use in the liturgy. Sanskritists were few or none, and the fresh translations from Indian texts into Chinese being produced on the mainland were avidly snapped up to be copied in Japan. A hundred years before this time Hsüan Tsang's translations had been known at Hōryū-ji monastery within twelve months of their completion at Ch'ang-an. Jiro Harada has communicated to me a statement of Dr. Mosaku Ishida to the effect that the *Tripitaka* used in Japan during Tempyo was actually more complete than that of China. Wellnigh insatiable was Japan's need for sacred literature during our period. Harada further informs us that "in the space of fifty-eight years, from 720 to 778 A.D., no less than eighteen thousand five hundred and twenty monks and nuns were ordained."

Against such a setting of religious fervor, the items of Ganjin's baggage listed above take on especial significance. Historians are happy enough if they know something of the objects possessed by the people of whom they write. But how much more happy is that chronicler who can find out what his people lacked. How the history of Europe would take on color if we but knew what objects were coveted by Charles Martel and the other contemporaries of Ganjin.

Ganjin and his priests, servants, and craftsmen brought Chinese wardrobes with them to Japan. By 754 Chinese dress and, to a less extent, Indian dress must have been fairly familiar both at court and in the Nara streets. It had been imported deliberately a century earlier for the use of officials at the time of the Taikwa Reform, and Buddhist robes

53

were of course much the same in Japan and China. In 662 the Emperor Tenchi used a Chinese headdress on ascending the throne, and again at certain Shinto festivals during his reign. In 732 the Emperor Shōmu wore a Chinese headdress and Chinese robes at his New Year's reception, after the Confucian manner, in the Great Hall of Audience. The newest fashions from the T'ang capital, the set of an abbot's shoulder knot, the cut of a Chinese ambassador's sleeve, the colors and weaves of the imported brocades — these were matters of grave weight to Nara fashionables, and to their weavers and tailors as well.

As for the humble artisans, strange clothes were scarcely of interest, for the Japanese lower classes had little enough to wear; it was their imported tools and the hundred mysteries of the crafts that mattered. Even so, Japanese steel was already superior to that of China, and the metalworkers needed but a chance to handle the Chinese knives and chisels and the weapons of the men-at-arms to reproduce them in finer metal and better finish. They seem to have rejected the straight sword of the continent, except for the use of some court dandies, and developed early their own noble curved slicing blade.

The goldsmith's art, and the delicate casting of flawless bronze for mirror-discs, the housings and fitments for horses' bridles and saddles, the metalwork for the bullcarts that creaked along bearing the nobles and their ladies, jeweled pins for the hair and whatever else the new fashions demanded were avidly taken over and developed by the Japanese artisans from the craftsmen in the train of Ganjin and the other visitors. The bald record of the arrival in Nara of such a group from China brings to mind a hundred fresh nourishments to be dug in about the very roots of Japanese culture.

The record called *Tōdai-Oshō-to-Seiden*, written sixteen years after Ganjin's death, tells with perhaps some warranted imagination of his last days. In the spring of 736 Ganjin's pupil Risshu saw, in a dream, a needle fall from the roof of Tōshōdai-ji and knew it for a portent. Hurrying to his master, he was able, before the old man died on the sixth day of the fifth moon, to execute the portrait in dried lacquer that is still preserved in the temple. At the very last, with characteristic care for the precise transmission of the holy word by which he had guided his life, the aged Abbot dictated to him three full copies of *Issai-kyō* (literally, the entire body of scriptures) correcting the early versions already known at Nara. And, "having foreseen his death," he also gave minute instructions for the use of the newly imported medicines. And the record ends with the words: "At his funeral the hills and valleys round about were crowded with people."

CHAPTER VI

LACQUER SCULPTURE

THE surviving lacquer sculptures in Nara form an extraordinary group. They are quite without parallel anywhere in the world. All are of the eighth century, and they are unrivaled even in Japan. They are a distinctive feature of Tempyo art and as such are singled out for special notice. A total of some eighty of these Buddhist images, including about ten outside of Nara, have come down to us. For the most part complete and in good condition, they vary in height from twenty inches to nearly fifteen feet.

The ingredient that sets this group apart from others is the juice from the lacquer tree, *Rhus vernicifera*. The use of this fluid for an adhesive, for a durable surface, and, when reinforced by hemp cloth, for the construction of life-size hollow images, has long been known in China, Korea, and Japan.

The tree, believed by some scholars to have been imported from China or Korea in the fifth century, and by others to be native to Japan, is closely related to the Western poison ivy, *Rhus toxicodendron*. It yields a thickish juice, highly poisonous, which hardens into a horny substance on exposure, and is perhaps the best natural adhesive known. It is resistant to heat, damp, and insects, and has shown little deterioration in twenty-three centuries. Examples of lacquered wood from China of the third century B.C. are still in sound condition, and the same is true of Chinese objects bearing first-century dates excavated from Noin Ula in Mongolia by Colonel Kozlov, and of third-century fragments found by J. Hackin near Begram, Afghanistan. Rich finds from the first centuries B.C. and A.D. have been made by Japanese archaeologists from ancient Lolang, the Chinese colony of the Han dynasty in Korea; these are mirror boxes, trays, cases of wood — one of basketry — and so on, decorated with red (cinnabar) and yellow and blue pigments mixed with lacquer applied to a black ground which seems to contain soot and vegetable oil.

In Japan the earliest remaining dateable lacquered objects were made in the seventh century when lacquer was used, mixed into a stiff paste with punk and rottenstone and molded for such surface details as bits of drapery and jewelry, and sometimes for surface protection of wood carvings. One of the two seventh-century carved wood Miroku images in Kōryū-ji, Kyoto, is so protected and is embellished with a lacquered leather scarf. Only one example of the use of coloring remains from those early, pre-Tempyo, years in Japan and that seems a doubtful one: it is the decoration on the panels of the Tamamushi shrine at Hōryū-ji, vividly portraying Jatakas — scenes of the former lives of the Buddha. There is still some discussion as to whether these are oil paintings, *mitsuda-so* with litharge on a lacquer surface topped with a transparent coat, or whether the pigment was actually mixed with lacquer juice. Also it must be added that this shrine may well have been imported from Korea. Headdresses of the courtiers were lacquered in black and coffins were sealed with the same material.

Leather armor plates and iron objects seem to have been lacquered already a century or more before Tempyo. In 629 two lacquer artists of merit were given court rank and, in 645, the first year of the Emperor Kōtoku's reign, an official named Sommi no Shukune was given the designation Urushibe (lacquerer) no Muraji. The same year a government bureau was established with a chief, an assistant chief, twenty lacquer artists, and six laborers. In 701 these artists were required to sign their work after it had passed inspection, which would indicate that a much larger output of inferior privately made wares was being produced.

So important had the lacquer craft become by the first year of the eighth century that an imperial order was issued requiring all households to plant from thirty to a hundred lacquer trees according to the size of the family. By the middle of the century, at the time of feverish activity connected with temple building in Nara, and with the increased demand for temple furnishings and dried lacquer images, a surtax was levied on every young man of a certain status making him responsible yearly for about a pint of lacquer juice which, in those days, amounted to some ten days' wages or twenty bundles of rice.

At this period hollow lacquer images were undoubtedly made in China; but examples that remain are perhaps no earlier than the beginning of the ninth century. They were made by the hollow technique here described in connection with Japanese images and, by the perfection that they had reached suggest that they may have been commoner than has been supposed and that the Chinese had reached a skill not hitherto credited to them. It seems highly improbable, however, that the custom, common in India, of carrying large figures about in religious processions, ever played a great part in Chinese or Japanese Buddhism or could account for their development in those countries.

Tableware in the form of bowls and trays were made from lacquered wood as were

the more delicate pieces of household furniture and musical instruments. Plate armor was surfaced with the same juice, applied to heated iron both for decoration and for protection against rust, much as was done in the case of "japan ware" waiters of the eighteenth and nineteenth centuries so popular in Europe and America.

Our greatest treasure trove of eighth-century lacquered objects other than sculpture is in the Shōsō-in. Built as chief storehouse of the Tōdai-ji, though long under jurisdiction of the Imperial Household, its original contents were dedicated in 756 by the Dowager Empress Kōmyō to Roshana (the Buddha Vairocana), in loving memory of her husband, the Emperor Shōmu, and for the salvation of all creatures. Doubly sacred by reason of imperial and religious associations, the thousands of art objects, whole or fragmentary, still preserved there have been withheld from profane eyes for generations at a time. Even now their viewing is possible only to the few fortunate who attend the annual ceremonial airing. Happily, a series of handsome, informative catalogues from the pen of our indefatigable friend Jiro Harada has made these treasures, mostly from the eighth century, familiar to the world.

The quality of the hundred and sixty-nine lacquered objects in the Shōsō-in and their variety and number reveal a climax in artistic skill and prove that lacquering was one of the finest of the arts of eighth-century Asia. Though many of them must be from China, or even from Korea — thanks to the cultural closeness of T'ang and Tempyo — it is quite impossible to tell offhand which are continental and which Japanese. They include musical instruments, gaming boards, mirror-boxes, and other objects of secular function. Some are overlaid with gold leaf and silver, others inlaid with mother-of-pearl. Brushwork ornamentation is of the highest quality.

The fundamental technique of lacquering today seems to have remained virtually unchanged since the eighth century. The best sap is from the eastern districts of Mutsu and Kozuke and is tapped at midsummer. The early and late juices are inferior and are used only for cheaper articles. Raw transparent lacquer juice is used largely for a finish and to prepare the other forms and mixtures. It is merely stirred in a wooden tub to aerate and slightly thicken it. Excess moisture is then driven off over a charcoal fire. When a glossy surface is desired, a little vegetable oil is added at this stage or, if black is to be produced, lamp black is rubbed into the thick juice before spreading it with a wooden spatula.

If the wooden base, like that of a box or piece of furniture or a musical instrument, is joined by pegs and glue or lacquer, the joints are emphasized by grooves which are then filled flush to the wood by a paste made of lacquer and the cotton or linen dust, *kokuso*, from the weaver's floor. Thus strengthened, the whole is waterproofed by a coat of plain lacquer which is polished when hard with rottenstone or its equivalent, whetstone dust.

Hemp cloth or silk is then lacquered to the whole surface in one or more layers. The more of these layers the stronger and more durable the object. This cloth surface is then rubbed down with stone dust to receive at least one layer of lacquer thickened with wheat or rice flour which in turn is polished and spread with plain lacquer.

The finishing coat is preceded by at least two coats of whatever color is to be the final one. It differs from them only in case a gloss is desired, in which case it contains vegetable oil.

During the seventh century, wooden Buddhist figures had been lacquered together at the joints as had boxes and coffins, but lacquered cloths seem not to have been employed by image-makers as the basis of the figure. Such details as hair, jewelry, and any lesser drapery ridges, were added to the wood in a thick paste or putty compounded of powdered clay, punk, and lacquer. These were modeled on the surface while they were still soft, and at a slightly later date they seem to have been independently made in wooden molds, left to harden, and then lacquered in place. Finally the whole figure was given a whitewash of fine china clay mixed with glue, to receive the colors and the gold with which the image was decorated. This method of embellishing carved wood images tended to lapse during the eighth century in favor of hollow dried lacquer technique. But it was resumed from the last decades of the eighth century, when lacquered wood cores gradually developed the characteristics of true wood carving spread thin with the protecting juice.

Probably no one in Japan in our day knew more of lacquering processes than my friend Mr. Chunosuke Niiro of Nara, who for many years was in charge of the preservation and repair of all sculptures classified as National Treasure. His opportunity to study the techniques of ancient sculpture was unique. In the course of his repairs he took apart scores of ancient images and put them together again. He worked in wood and in lacquer and in unbaked clay after the early methods, and applied color and gold to the surfaces in the traditional manner. As a judge of the style which characterizes the various periods, his experience made him perhaps the first among the experts. To him I owe much of the technical information on Tempyo lacquer sculpture.

So-called hollow dried lacquer, *dakkanshitsu*, was made as follows. The sculptor modeled the figure in clay. From this figure he took a mold, a procedure in which bronze casters of Tempyo must long have been skilled. The inside of this mold was then painted and smeared with lacquer in which powdered cedar bark had been mixed as a stiffener. When this inner surface was dry, hemp cloths, soaked in lacquer and numbering anywhere from seven to fifteen layers, were applied within the shell. The mold was then broken away and the figure in the round appeared and was polished with powdered horn and charcoal and with stone dust. Where ridges were not high enough or where planes needed correction, material could be added in the form of lacquer stiffened with clay or

with incense powder or sawdust. The finished surface was then ready to receive either pigments directly, or gold leaf laid over a thin glue.

Naturally the process was neither as easy nor as simple as it sounds, nor could a complicated image be constructed in one piece. Molds were made separately, lined with lacquered cloths, broken off, and the inner shells cleverly joined together by stitching which was later concealed with smears of lacquer and with colors. As plaster of Paris was certainly unknown, the molds must have been made of mud and clay or in forms of papier mâché stiffened with flour paste.

Strong though the resulting statue was, it was necessary to introduce a wooden armature through the legs or, sometimes, through a trap door cut between the shoulder blades. Parts of the armature were undoubtedly thrust into the body before the head, made separately, had been joined to the shoulders. In those four giant kings the Shitennō of the Sangatsu-dō of Tōdai-ji and in the huge Bon-ten and Taishaku-ten of that same building, a strange angular protuberance can be seen at the back. This is where the horizontal board of the armature occurs. Obviously the process of bracing was performed while the lacquer was still green and the result was that when the shell shrank the armature resisted and produced that awkward lump. Later makers of dried lacquer learned how to avoid this and it does not occur in the work of the Daian-ji and Gakuan-ji schools.

In the matter of details there is great variety, which shows that the process never really emerged from the experimental stage. Fingers and drapery were often made from square copper wire beaten out. Hands were, at the end of the period, constructed over an elaborate basketwork of tough paper strings, woven over bamboo or copper wire.

The second technique, which I have called "wood-core lacquer," *mokushin kanshitsu*, was originally a development from direct wooden sculpture. The image was made from wood and then more or less thickly smeared with lacquer. Drapery and other ridges were molded from a paste of lacquer and clay with sawdust or incense powder as a thickener. Ears were sometimes of cloth stiffened with lacquer and attached with the same substance to the head. Hair, as in hollow lacquer, was usually of thickened lacquer juice combed and molded into form. Contrary to what might seem to be the natural order of events, this technique seems not to have been extensively employed until the end of the Tempyo period. The more ingenious and elaborate system came first. That is to be explained perhaps by a Chinese origin or even an Indian one. The Indian custom of carrying about the image in procession may have been responsible for the invention of light papier mâché statues on bamboo armatures. These were made waterproof and more durable by a coat of Indian lac (a very different substance from the Chinese and Japanese lacquer) and hollow dried lacquer was the result.

Despite the apparently clear division into two techniques, there were in fact a num-

ber of variations and refinements. It has seemed practical to consider Tempyo lacquer sculpture under four separate headings, although the line is not always easily drawn.

The first and largest group is hollow dry lacquer sculpture to be considered in Section Five of Part Two. Differing sufficiently from the rest to warrant a separate category is the small group fashioned over a lattice support, discussed in Section Six. Two further categories deriving from the second of the two basic techniques, *mokushin kanshitsu*, are discussed in Sections Seven and Eight, called for convenience "lacquered wood-core sculpture," and "lacquered carved wood sculpture" respectively. Both of these varieties have the wood core. Both kinds are carved. Nevertheless, there seems a necessary distinction between the two. The final appearance of the one type depended less on the carving of the wood-core than on the building up and modeling of lacquer-soaked materials over it. The other, in contrast, depended to a greater extent on the carving of the wood — so much so that in some cases the lacquer covering was little more than a veneer. More than one of the four methods may have been used at one period or another, but the general trend seems to have been quite clearly a gradual shifting from one to the next in the order given.

In concluding this description of Tempyo lacquer sculpture, it is necessary again to refer to the Shōsō-in. Although this building contains no figure sculptures nor was ever designed to contain such, it preserves a total of one hundred and sixty-nine sculptured Gigaku masks — thirty-three of which are fashioned in dry lacquer or related technique. None from that treasury, unfortunately, were available for reproduction when the plates for this book were made, some years ago. It may be observed, however, that as a group, they are similar to those from Hōryū-ji and Tōdai-ji illustrated and discussed in the next chapter. Indeed a number of the Shōsō-in and Tōdai-ji masks were beyond doubt used in identical dramas in May, 752, at the dedication of the Nara Daibutsu.

CHAPTER VII

MASKS OF THE GIGAKU DRAMA

Flutes and songs by the Tibetans are charming,
Brisk are the dancing Mongol's tunes;
Their masks are decorated in gold and silver,
Flashing jewels swing from the dancers' dress.
(Poem by a Chinese poet of the sixth century, Hsüeh Tao Hêng)

THE Western mind, conscientiously straining to comprehend the craft of the Buddhist image-maker representing his high gods, finds positive relief in contemplating the dramatic masks of eighth-century Japan. What little abstraction they possess is merely as much symbolism as is inherent in all representation. It is quite uncomplicated by the intrusion of any abstract philosophy.

The Gigaku masks that have come down to us from Tempyo are in the modern sense not masks at all. They may be rightly adjudged true sculpture — not mere false faces but complete false heads. In this they differ from those used in the Bugaku drama during the Heian period and still more from the Noh drama masks of our own day which are mere shells fitting in front of the actors' ears. Grotesques many of them certainly are, simplified to be seen outdoors from a distance in sun or shower, or by night ringed with torches and flaring cressets. Yet every one possesses much of the nongrotesque, or normal. Rather than attempting to dissect and separate the contrasting characteristics, abstract and concrete being so expertly merged, there is satisfaction enough in noticing that naturalness is present in generous proportion. Their great size transformed the wearer to an unearthly being as he trod the stage. This effect was the more striking when, as sometimes happened, only one member of the cast was masked and he appeared among actors of normal stature. When the whole company wore them, as in surviving Tibetan parallels, spectators soon became accustomed to a world peopled by such beings. But the single figure, with enormous head and fixed features, surrounded by the human chorus,

riveted their untiring attention. Whether used singly or en masse, here was sculpture made to come alive.

Although the carver's purpose could be stigmatized as not quite exalted and his subjects shorn of certain advantages, he had the opportunity to concentrate on the heads and faces, the most vivid and expressive parts of human beings, if not of celestial ones. Here at last, as seldom among the more holy icons, the Westerner can find the emphasis on facial expression he instinctively demands from the sculptor. In this case, sculptures were not set motionless in the twilight of the temple but carried rhythmically about under the sky when the arts of the costumer, musician, and dramatist were all invoked to help him.

Restricted to the depiction of heads without bodies, the mask-maker could never deal with drapery which in Buddhist sculpture is so often the artist's most telling medium.

Really to comprehend how essential it is in the open air that noses must jut, eyes bulge or be sunk deep in the head, and wrinkles be so emphasized, one should sit on the ground and look up at the platform where the figures are posturing. This was borne in on me with great force in witnessing in 1928 the celebration before the Daibutsu at Nara. I was caught up and taken back twelve hundred years to that very spot and a similar occasion when the Daibutsu hall behind us had been a full third larger than even its present huge bulk. The great stage before the banner-draped doors was more than eighty feet square. Flag poles thirty feet high were placed at the sides and corners and a band of pipes and throbbing drums of thrice the modern numbers accompanied the sedate action. In the crowd that watched twelve hundred years ago, there had been a screened group from the palace and it was known that the Emperor himself watched from behind the curtain. Ten thousand monks stood or sat in that enormous enclosure crowding about the bottom of the stage and up against the rails of the guarded stalls where the courtiers sat. Behind and beyond and outside the gates a multitude of the people were herded, taking part in the solemn rites which they could not see.

On the stage above the audience towered a strange structure — a wooden framework covered with cloth in the shape of a white elephant. High enthroned on its back sat a figure of the god Monju glorious in cloth of gold. Then, in a huge headdress, Tamon-ten stalked in at the head of his twelve retainers bearing offerings of bows, axes, and spears. The sprites wore such headpieces as these Tempyo examples, each carved grossly in concentrated energy of a single emotion — hate, lust, terror, or cruelty. Dai Jizō approached from the other side of the stage and with him were sixteen heavenly beings scattering flowers and playing flutes and drums. They, too, were masked. Kichijō-ten led her array of sixteen with incense and flowers, and the whole concourse mingled and paced and separated in an endless contradance of elaborate windings.

In the open air on the stage above our heads on this day such headpieces and fixed set faces made it indeed a dance of spirits, not of sweating men and boys made up for the theater. The flat starched sleeves and panels of brocaded gowns seemed as carved and statuesque as did the masks that topped them.

At the beginning all these semi-religious dramas seem to have been known as Gogaku from the country of their supposed origin, Wu (Go in Japanese), the Chinese kingdom that included the present city of Soochow in Kiangsu province. But before a century and a half had passed, the name changed to Gigaku and much purely Japanese native material had been included. Still later the name of Bugaku appears and the older forms were relegated to Tōdai-ji monastery where they were performed annually only on the Buddha's birthday in April and the Return of All Souls on the fifteenth of July.

Records of the seventh century speak of professors of music in the first Japanese academy of Confucian studies; two of them taught Korean music and dancing and two the Chinese form of those arts. On the other hand, the same music is referred to in other early sources as being Indian, like the religion with which it was intimately associated. Texts of music and words are corrupt, for they were not committed to writing until after the Middle Ages and they contain few stage directions. Thus the continuity of the art depended on oral transmission in certain families and temples.

The *Nihon-shoki*, compiled in 720, records that in 612 a certain Mimashi from the country of Kudara (Paekche) in Korea came to Yamato in Japan and with his pupils Manoshu Deishi and Shinkan taught the mysteries of the mimes which he had learned in China and at the court of Wu, and that the art was encouraged by exempting its practitioners from taxes. Prince Shōtoku was especially interested and granted dancers exemption from other services. A record in the *Shojiroku* tells that a set of masks for these dances was fetched from Wu by a prince of that country, during the reign of the Japanese Emperor Kimmei (540–571). It relates that by 645, Gigaku drama was being performed at many Buddhist temples including those of Tachibana-dera, Shi-tennō-ji, Kōryū-ji, and Hōryū-ji.

In 732 a regulation was passed dealing with the numbers of musicians for the various dramatic dances accompanied by Gogaku music. It is interesting to notice that of these, thirty-nine were Chinese, twenty-six from the Kingdom of Kudara in Korea, nine from Koma (Kokuli) in Korea, four from Silla in Korea; sixty-two Japanese trained in the dance called *dora*, eight Japanese trained in the Muragata dance of the "several districts," twenty Japanese trained in the Tsukushi dance of Kyushu. Other mimes and dancers were fetched from South China, the Malay peninsula, and India. In the year 736, Naka-tomi no Nashiro returned from his travels with four learned teachers of the drama in his train, three of whom were Chinese and one "Persian."

The record *Daihorai* mentions the appointment of a professor of Gigaku drama who

was given the same rank and salary as was a member of the imperial orchestra. At the same time there were twelve masters of Gogaku, who had sixty pupils, and also four masters of the Korean dramatics and music from Kokuli and Silla.

In the seventh century, Japanese actors and musicians were confined to the aristocracy who alone were taught these arts. But by the eighth century, townspeople took part.

In the reign of Temmu Tennō (673–686) Kawahara-dera dancers were sent to Tsukushi in Kyushu to entertain Korean visitors from Shinra. On the first day of the fifth year of Tempyo (733) the festival *utagaki* was held within the palace grounds; Emperor Shōmu himself came out to the Sujaku Gate to see two hundred and forty young people dancing and singing. Princes Osada, Nonaka, and Kurusu led the party. The songs sung on that occasion were Naniwa, Osaju, and Hirose. In 749 under the Empress Kōken (749–759), Gigaku dramas were performed at Tōdai-ji in addition to other dramatic dances called Togaku, Bukkaigaku, Gosotsudenbu, and Kumeibu. In 752, sixty-six Gigaku players took part in the greatest of all Buddhist celebrations, the consecration of the great bronze Tōdai-ji Buddha, described in connection with Plates 23–26. It was attended by thousands of prelates, and by the imperial family, as well as by many foreigners.

In Japan, as in China and as in Europe of the Middle Ages when the mystery plays were performed, the Gigaku was usually the occasion for a local fair on some church holiday. There were booths and jugglers and a performing bear. The shows were presented, as they are still today, within the temple enclosure on platforms. Although nowadays the costumes are newly made after the old patterns and the music from the archaic instruments is believed to be reasonably correct, words and gestures are a mystery to the ordinary onlooker. Among the few dramas to be sufficiently intact to be comprehended today there is an occasional pleasantly bawdy touch which shows them again to be close kin to our own medieval mysteries and masques in which the clergy often came off second best and the devil had his way for a while. In neither case was the text always sacred, although it was usually concerned with sacred stories and legends. In the Gigaku called "Baramon" a dignified Brahman priest is discovered washing his baby's diapers. Scholars have suggested that so broad a humor was not acceptable to the later Japanese imbued with the almost Victorian primness of neo-Confucianism. If that is the sole reason for the decline of Gigaku, a foreigner might be tempted to believe that a great tradition was lost for small gain. Traces of one of the eighth-century plays have survived on the streets of modern Japan and in China as well. It is the Shishimai, when the lion's head is fitted over a boy, and others follow draped in the skin of the body and tail.

Some of the remaining titles of masks are recognizably the names of demigods in-

64

corporated with Buddhism during its journey from India through Central Asia, China, and Korea. Others we can only guess at from the meager book of instructions called *Kyokunsho*, written in the thirteenth century. This book, and records of the monasteries of Hōryū-ji, Saidai-ji, Kōryū-ji, and Kanzeon-ji, yield a number of names of Gigaku masks, and titles of the sacred dances.

Of the whole body of Tempyo sculptures that has come down to us, the dramatic masks make by far the largest single group, at least two hundred and twenty including a few earlier examples according to my reckoning. I believe that from the storehouse of Tōdai-ji and possibly from Hōryū-ji one or two more will be added and a few others, perhaps, from private collections. Perhaps some of those on my list may be struck out as being demonstrably later than the eighth century. However, Harada's estimate is "no less than two hundred and fifty" masks made in the seventh and eighth centuries.

The group is of prime importance because of its size and because of its variety. No other sculpture left from the Tempyo period compares with these masks for individuality and humanity. Fifty-four examples, including a few earlier and one later than Tempyo, are reproduced here by the courtesy of the Imperial Household Museum (now the Tokyo National Museum), of Tōdai-ji and Hōryū-ji. All those from the museum collection were originally preserved at Hōryū-ji where they had presumably been housed from the beginning. It is among them that the earliest examples occur. There are also half a dozen of the rare smaller masks made to fit the heads of children and, in addition, two examples that have been only partly finished. All the Tōdai-ji masks illustrated have been loaned for exhibition and care to the Nara National Museum. From the same temple, Harada informs us the Shōsō-in preserves "164 examples, a great number of which were perhaps made for and used at the Eye-Opening Ceremony of 752."

It is noticeable, even among the smaller group of early masks here illustrated, that there are some ten at least which are not grotesque but extremely natural and lively individuals. All of these, including even the two formal ladies (Plate 208a, b) who are ideal representations of court beauties in the eighth-century taste of China and Japan, are portraits in the same sense as the figures of Ganjin, Yuima, and Gien (Plates 123, 150, 159). In these human masks and those three other figures, humanity and individuality are epitomized in quite the way it was done in the West by the Romans and by the Italians of the Renaissance. A further inquiry into portraiture might put an end once and for all to the fallacy that Orientals are not interested in individuals nor capable of representing humanity as adequately as we have done.

Two characters of which the names are now forgotten are always referred to as "big young man." These have neither wrinkles nor grotesque noses and are among the limited number that most suggest portraits. Lacking deep shadows for emphasis such

subjects have less carrying power under the open sky and have perhaps therefore been rendered larger than the others. Wrinkled ancients, on the other hand, with their hooked noses have a bird-like piquancy that must have riveted the crowd's attention. The names of the characters they represent are frequently lost and always subject to doubt.

Examples have been preserved that are made of *kusu-no-ki*, camphor wood, of *kiri-no-ki*, *paulownia imperialis*, of dried lacquer, and of cloth lacquered to clay. Where color remains it is usually laid over a thin layer of gesso made from China clay, whiting and glue. The pigments used are vermilion, *shu*, verdigris, *rokusho*, and red ocher, *taisha*. The whites of the eyes are sometimes gold-leaf over gesso. The hair on the head was usually painted but beards were tufts of palm fiber stuck into holes (Plate 214 a-d). The few crowns or parts of crowns that still adhere are of thin gilt bronze (Plates 204 b, 205 a).

The dried lacquer examples (Plates 211 a, b; 212 a) are of peculiar interest since their construction does not correspond precisely to that of contemporary statues in that technique. Since they were made with no idea of permanence, and weighed as little as possible, there are but two or three layers of cloth lacquered together, the lower ones coarse and the outer fine. Protruding details (noses and ears) are not added in the solid lacquer paste used by image-makers. The cloth is simply molded for a nose, as in a starched cheesecloth pouch, cut in gores to shape it, and with its flanges securely lacquered to the cheeks. The ears one might have expected to be similarly fashioned, but they were modeled out from the edges of the lacquered cloth before it became stiff. The opening into which the actor's head was thrust was edged with what seems to be tough straw lacquered to the cloth. In one example fragments of the original clay mold still remain, round which the lacquered cloths were shaped while still flexible (Plate 212 a).

As for dating specific examples, the same standards must be used as for other early sculpture. Happily, even among the fifty-four reproduced, eleven are inscribed with the date corresponding to 751 and 752 (Plates 212 a; 217 b, c; 213 c, d; 214 a, b; 216 b, c; 217 b, c). Since these have always been kept in Tōdai-ji they are almost certainly among the properties made at that time for the dramas celebrating the consecration of the Great Buddha. Other examples are inscribed with the name of the temple (Plates 205 d; 212 a, b; 216 c, 205 d) and three others with the name of the artists who made them: Sori Gyōsei (Plate 212 a), Shamokushi (Plate 213 a, b), and Kiyeishi (Plate 216 b, c).

A few, notably Plates 204 b; 205 c, d; 206 a, c, d; and 207 a, d seem, judging by their style, to belong to the pre-Tempyo period a few decades before 710 and one or two have been called Suiko, earlier than 645.

While a tradition persists that some of these presumably early examples were imported from the Kingdom of Kudara in Korea, it seems to me that even those are of Nara workmanship. However, one of them (Plate 212 b) has the clean-cut long upper lip and

eyeline of the Yumedono Kwannon and another (Plate 204 b) seems to have come from the workshop of Tori Busshi which, after the master's death, produced the four guardians and the phoenixes of the Kondō at Hōryū-ji.

Very few of the entire series of Gigaku masks can be said definitely to recall the contemporary sculpture of China as we know it. On the contrary, if we omit the primitives and the single Kamakura example, they bring to us collectively and individually the very face of Tempyo.

CHAPTER VIII

THE ESSENTIALS OF IMAGE-MAKING

THE sculptures that concern us were made to serve the Buddhist church of Japan in the eighth century. They were in conventional mold and hieratic almost beyond Western comprehension today. To catch their full symbolism would require a store of factual information and high mysticism such as few of us achieve.

And yet they have in common a unity that every lover of pre-Renaissance Europe will recognize. They retain their deep appeal even though today in the West we can make no practical use of them and may not share with the artist an intimate knowledge of the manner of their making — a manner inherited after centuries of development in Central Asia and China from Indian models.

Certain important strains of culture undoubtedly came to Japan indirectly from China through the T'ang colonies in Korea. Yet the precise value of this Korean influence will always be a matter for discussion. In art and literature and the crafts we find Koreans and Chinese working side by side with their eager Japanese pupils. Objects of worship and practical use in daily life were fetched to Nara from both countries. But when such objects were reproduced on Japanese soil — even by imported craftsmen — their design had undergone a sea-change. By the time these foreigners had been two short generations in the islands, the inevitable alchemy of climate, mental attitude, and mixed blood had completed the change and the work of their hands became Japanese in very truth.

But, had the Japanese received this tradition from China in its earlier form or at a later date than they did, we can be sure their sculpture would never in the eighth century have contained that particular appeal which, for want of a better word, I shall call nobility. Starting with that great heritage, Japanese sculptures grow infinitely more elegant in the eleventh century, by the fourteenth they are clever and lifelike, by the sixteenth they become vapid.

Of course this eighth-century quality is the result of the sculptor's combined intel-

lectual and physical approach to his task. When making the figures of the high gods he was never vexed by the idolatrous idea that his work might serve any purpose other than re-presentation of concepts that were wholly abstract; they were to be purely supports for worship and contemplation.

With the lesser gods it was somewhat otherwise, but even those are far from being idols for direct worship. They are attendants, temple furniture, guardians of the gate, devils to be trampled; they explain the functions of great gods; embellishments that further clarify the worshipful main idea. The fact that so high a concept has not always been preserved by all Japanese Buddhists down the ages or by icon users everywhere does not affect the principle.

Saved from making idols to be worshipped directly on their own account, the artist's preoccupation was with symbols, and these must have only enough likeness to human shape that the human brain could fasten on them and associate them with the sacred texts. In these texts the ineffable verities, Divine Hope, Divine Mercy, Endless Light, appear as the gods, who expound themselves for the benefit of human beings through human speech and gesture, their only avenue for contact with us. Some of the scriptures describe holy gatherings about the feet of a Buddha or a Bodhisattva in Paradise where are symbolic lotus petals. As much of this scene as may be caught by the sculptor and the builder and the maker of temple paraphernalia is represented on the altar and on the surrounding walls.

Such was the intellectual task allotted to Buddhist sculptors. The approach to their material was equally direct and was fixed as narrowly by the only tradition known to them. A log fetched in from the forest was sawn to a proper height for the dais on which it should stand and, according to canon, was measured into six units of which the head measured one. If unbaked clay was to be the medium, or hollow lacquer, the supporting armature was erected after the same canon of proportions. If bronze was used, the clay matrix was set up in like fashion and then overlaid with a layer of wax and, outside that, with a thick clay mold to hold the moulten bronze replacing the wax.

Whether the image was carved in wood or modeled in clay, or formed of a shell of bronze or hollow lacquer, the erect statue presented always a columnar bulk and even the figures seated with crossed legs were essentially trunks with flat laps set before them. Drapery folds on these simple forms were not deep enough nor, though they had the necessary quality of being convincing, were they particularly natural. There was, for instance, no lively suggestion of the haphazard; they were arranged, calculated, and repetitious. The charm is therefore never dependent on any likeness to nature nor to any prettiness of curve, but rather there is a regularity without dull sameness, an over-all consistency to prevent one from singling out either face or robe for special delight. Posture, established proportions, and complete absence of such individualities as sex and youth

or old age or human beauty or ugliness, produce an effect of benign potential power beyond the effects obtained or even desired in our Western emotional faces and arrested gestures. Perhaps Michelangelo in his "Dawn" and "Evening" on the Medici tomb, in spite of the difference from Buddhist aims, may suggest something, a far less universal or religious something, of what the Buddhist sculptors aim to achieve. But the Western parallel is only a suggestion because it was in the genius of the European Renaissance to desire a kindred humanity and correct musculature and grace. Naturally the gain in all these things is ours unless we are asking for religious or philosophical abstractions.

Schools, periods, and special trends in Japanese sculpture must not be the scholar's prime concern. In fact, those subdivisions tend rather to obscure his subject unless they can be postponed till fundamentals become clear. For sacred images, made for the uses of a unified society such as the cultures of the Far East or medieval Europe, are significant not as isolated specimens however beautiful but when considered as entire groups. Later, it becomes useful to dissect them into separate members to find what knowledge may be shed on the whole living body through lapses of time, or by different local schools, or by the slight shifts in purpose emphasized by differing creeds.

Precisely what native aptitudes and what acquired skills the Japanese brought to the practice of the new arts cannot be accurately determined. In a book on the earlier Suiko sculpture I have discussed that subject. The fact is that the eager islanders, who had been for geographical reasons late in their contact with the flame burning on the continent, caught fire from China. When their own torch was kindled it blazed out as nobly but with different light. Or, to shift the metaphor, Chinese Buddhism, freighted with a portentous cargo picked up in India and Central Asia, was the vehicle by which the continental heritage reached Japan.

To shift the metaphor again, now in the eighth century we arrive at the sudden flowering. It was fertilized by a wind off the mainland and supported on the strong stem of the homely native religion of Shinto in which the little real gods who are the very nature of a Japanese artist's materials and tools must be taken into account. So too we must reckon with the training of the peasant boys who became the master Tempyo craftsmen. A westerner of the twentieth century may be somewhat naïvely shocked to find them ill-clad, ill-fed, flocking at sunrise each morning out of floorless thatched huts with their few tools toward the temple workshop. And yet it cannot be denied that the things these lads made when they became master-craftsmen equal the great sculpture of continental China. In certain techniques indeed, the Japanese craftsmen were supreme.

In Japan as elsewhere, the sculptors were creatures of ingenuity and contrivance, directed to the single end of making admirable figures that would stimulate worship and suggest divine abstractions. When they succeeded it was for precisely the reasons that other artists in other times and countries have succeeded, because they practiced till they

were masters of their craft, and when mastery was achieved the noble message was made clear and ready to be recognized.

Orientals have always had a point of view toward art more like that of our Middle Ages than that of European post-Renaissance and the Reformation. Both Oriental and medieval Western cultures, integrated, religious, intent that what they made should adequately fill its human purposes rather than provide mere sensory enjoyment or playful novelty, produced sculptures that in some respects resembled one another. Nor should we be surprised. For those resemblances result from several facts: that Buddhism, like Christianity, must have symbols for pure abstractions; that both faiths made use of anthropomorphic shapes; and that the craftsmen were in neither case encouraged to express their individual aesthetics. What, we may ask, would Chartres cathedral look like if the individual workmen had indulged their own ideas? Preoccupied with the difficulties of the task, free from the urge to produce novelties, both cultures soberly developed techniques appropriate to their raw materials. Since these materials were not unlike, East and West, similar tools were required. And hence, till Western individuality acquired arrogance with the Renaissance, figures carved from tree trunks all over the world were columnar, unbaked clay figures were too brittle to support spreading gestures, and hollow bronze was still a matter of tubes and rounded protuberances. Drapery was shallow embellishment of the surface or thin addition to it, always true to the stuff of its structure, and subservient to the symbol that it clad.

Since the precise purpose of eighth-century Japanese sculpture is hardly known by Westerners today, we can reach some comprehension of them only if we understand the manner of their making and the conditions under which they were conceived and produced. That then is the subject of these essays. We must know the tools and training, the stimuli and handicaps of the artist. Of course dates and names and schools of art help us insofar as they have been recorded. But the main purpose of the historian of art is to examine the objects themselves in the light of their purpose and to relate them to their natural background.

Since our preoccupation will be with various kinds of man-made objects it is necessary to establish a method of examination which may serve equally well to test a poem or a sword or a statue or a pair of shoes. This is harder to accomplish than one suspects. We literally do not see the essential thing we look at if we are prejudiced for or against it.

Four essentials are used by Aristotle in another connection and have been translated into English as "The Causes." But, for modern non-philosophical English, perhaps "The Essentials" serves us just as well.

Neither I nor Aristotle have hitherto discovered any essential held in common by all man-made objects in addition to these four. I often have thought that I had discovered another essential, but always it has eventually fitted perfectly under one of the Four.

Often I have said that one transcended the three others in importance and should head the list, but so far as I know they can be written in any order of significance. Omit any one and there is no thing made. Slight any one and the thing made is warped or faulty. In fact to examine a work of art with these in mind is to come near to comprehending it and to discovering where the artist has failed or succeeded in using each essential to perfection.

The four essentials are simple:

(1) The Final Cause, is the end or essential purpose for making the thing. It can usually be plainly stated, and the adequacy of any object for its end tests its perfection — shoes to wear or holy pictures to venerate.

(2) The Material Cause is merely the raw stuff, the essential material from which man makes things. Without any material — the column of air for the tune on the flute or the granite block for the statue — nothing is made.

(3) The Efficient Causes are the hands and tools of the artist, and by extension his essential skills.

(4) The Formal Cause is the main idea in the artist's head, not only of shape and color but of function — the essential form imagined.

This last, the Formal Cause, includes the other three. In examining an object and trying to imagine what it looked like to the artist before he made it, one is led into all sorts of studies — even to dates, for one should know that one Egyptian statue was cut before metal tools had been conceived and another one pictured by the artist from the outset as being cut out with iron. The Christian artist knows that the Virgin wears a blue robe, and it is one of his formal essentials or causes which we too must know in examining Christian art. Thus religion, philosophy, the development of techniques, and the flow of ideas and prejudices and a score of other things must be studied to comprehend the Formal Causes of another people's art. We frequently are blocked in trying to recapture the idea inside the head of a foreign artist long dead. But we can always discover a great deal concerning the material essential to his work, and his essential skill (the Efficient Cause) in manipulating that material toward his desired end (the Final Cause). As to that intangible but essential image originally in the artist's mind — the Formal Cause — is it indeed so hard for us to recapture if in the object of his art he has given us a tangible replica thereof?

Nor is aesthetics left out of it. Was it not a part of the Buddhist sculptor's thought and end and art to draw the observer toward his finished work? Would not the sinuous drapery curves delight the eye? Would not the golden visage bring forth wonder? Would not the heavenly smile, benign, strike to the heart?

The only hardship we Westerners must face in trying to get full value from the rich store of Far Eastern sculpture is the wrench that comes when prejudice is to be lopped

off. If we can bring ourselves to look squarely at the things themselves, as Eric Gill has urged, and forget for the moment all that predisposes us to like or to dislike, and all our distrust of the merely unfamiliar, we shall find the job done. We are at once made free of a whole fresh country of delight.

Plainly enough, things that have been too often labeled scholarship — dates and names and biographies of artists and lists of their pupils — cannot by any stretch of the imagination be labeled Japanese sculpture. That is manifestly clay or wood or bronze or lacquer, as the case may be, wrought into shape for a symbol. The true scholarship, the lean hard thinking, must be directed to the things in themselves rather than to a store of dates, dynasties, and foreign names.

I should prefer to practice this most difficult approach in the presence of the actual sculptures of the Tempyo period, but as the reader and I cannot move suddenly to Japan, we must be content with photographs. No insensitive man can go far on the road to understanding. But the sensitive man who follows that road will be brought up against high beauty and poetry and deep philosophical concepts. He will be forced to contemplate a mysticism that none but noble and adept spirits may share.

So it is that all our Christian heritage will be evoked. We shall need sound comprehension of our own medieval background. We must keep our spirit undismayed by strange shapes and persevere in the search for understanding. Though Japanese sculpture of the Tempyo period is separated from us by oceans and continents and centuries, the really surprising thing is the kinship that we shall discover. I take this as proof that art, the making of things, is indeed a *lingua franca*. The modeling of clay, the casting of bronze, the cutting of wood with knives are today the same in the West as they have always been in Japan. It rests with us to discover the life and the purpose and the symbols of the artist, and presently we may have so disciplined our scholarship that we can see his mental images.

Without stuff to shape and tools to shape it, nothing can be made by man, whether sonnet or icon or cookpot. There is in the volcanic islands of Japan little rock fit for the chisel, and Japanese sculptors turned to bronze-casting and wood-cutting. The noble conifers of their groves were used in sculpture as well as building, and the islanders, except for simple roadside gods, soon put aside the stone tradition they had inherited from China and became masters in wood. Their genius, or the genius that lives in the wood, began to show itself; men comprehended what the grain of a tree demands. Steel knives of a quality superior to those made in China were at the same time invented. Craftsmen cast aside the short choppy mallet strokes of the stonecutter that have always hampered Chinese woodworkers. The Japanese became true carvers and ran their keen knives along the consenting grain of cypress and smoothly, more reluctantly, across it. So it was that the whittler's swoop and curve appeared in Japan and long log proportions were never

lost. On my last trip to Japan I stood spellbound watching the carpenters at work shaping the delicate entasis of the great columns that were destined to support the new Kondō at Hōryū-ji; they were as skillful and perceptive as great artists anywhere, and the beautiful long-handled knives seemed to flex in their hands. Among other tools the Japanese carvers in the eighth century developed a knife of which original examples are still preserved. Shaped like a willow leaf, bent slightly forward and sharp at both edges, it is sensitive to the grain of wood and yet, in a long swift stroke, it can be directed to slant across it. For the scoop of shallow drapery and the definition of long edges it would seem the perfect instrument.

When the student of Nara sculpture sits down to his list of dates — compiled with so much difficulty — and to the tale of sculpture that is left us, he is in danger of fitting the sculptures to the dates of the temples where they are now to be seen. But that would be far too simple. It is gradually borne in on him that not only were images hastily carried elsewhere when their shelters burned, but that they were frequently shuffled about for other reasons.

The Nara period was one of overproduction in sacred foundations. Various members of the imperial family, courtiers, and rich priests vied with each other in making endowments. But funds were apt to peter out and there were not always priests enough to go round nor builders nor image-makers to do the work. Temples, shrines, and monasteries, tax-free but sometimes ill-endowed, were cheek by jowl in the capital elbowing out the householders who, in the end, must support them.

Thus it came about that the religious establishments frequently joined forces. One, with an empty building, embraced another that had no shelter for its image; or a fane, with no priests to tend it, came under the protection of a populous monastery nearby. It is often impossible today to make sure that three institutions of different names and histories were not, in the Nara period, presided over by a single Abbot and often interchanged their images, their liturgical apparatus and their libraries.

The opposite sometimes happened, though less often, when a holy man resident in a side chapel of some great monastery would, by degrees, make of it a separate establishment with its own income, jealously guarded, and its separate individuality. This, having lasted for a generation or two, might perchance be forced back by economic or other pressure into the original fold or that of a neighbor.

Later periods of neglect, after devastating local wars, were further productive of confusion for the historian. The property of the Nara temples, even their very land boundaries, became hopelessly tangled.

To return to the matter of images it was once borne in on me that to identify one's self with the subject of one's image was entirely possible even without religious ecstasy. This was when I heard a nonreligious but skillful Japanese painter say, when outlining

a tiger, "I can't draw these whiskers convincingly unless I bristle, myself, like a whisker." An American locksmith, engaged in the prosaic task of repairing a lock that was new to him told me, "A man has got to *be* a lock to get the right sense of what's bothering it." And a rat-catcher, who was neither poet nor maker of religious images, said, "There's times I think I am rats, else I couldn't outwit 'em." In other words, the artist has to become one with his goal.

Such vulgar modern instances may throw some light on the recorded fact that Chinese masters have always found it necessary to instruct their pupils how to *become* the trees and rocks they painted and, in the next breath, laid down the prosaic laws of perspective and the technique of brushwork. It is obvious that a nonreligious age is not to be persuaded that sacred pictures are best painted by the devoted few who are able to become the god they represent or that the rat-catcher must be rats before he can outwit 'em, or, still less, that the making of a chair can, by any stretch of imagination, be thought to have anything sacred in it. And the nonreligious are partly right. For we got on, somehow, to our own great self-satisfaction, making chairs that are "good enough" without such fancies. But how much better would it be for craftsmen and craft, and for the objects made, if we were persuaded that these fancies are indeed right and necessary. Possibly that is all the machines lack today, to be geared with man and his God.

In any investigation of this sort, it becomes quickly evident that eighth-century Japan yields fewer artists' names than, for instance, Greece in the fifth century B.C. This may be partly because the Japanese sculptors were not high in the social scale, but mainly it is because Oriental craftsmen have never been considered as men especially endowed or set apart from the normal lives of their busy fellows. Their product was in demand precisely as were the products of the builders and the weavers and the dyers. What counted was the things made, not the makers' names. We are thus forced today, when individuality and biography loom so big, to assume an attitude toward them more normal than the present fashion would suggest. We can find no delightful scandalous boasting Cellini, no mad misunderstood van Gogh to be hauled out for psychoanalysis. Perforce we look at the holy images themselves and forego the romance of biography which so often diverts the student of art into recording the personal history of artists. But artists' biographies, properly used, throw light on certain essentials of what the artists make. And if we had the facts we would gladly study their lives and equipment to discover how and why their art took the precise form we know.

Lacking evidence concerning individual artists, however, we must fix the general place in society of that particular class of which they were a part. We must inquire into their religion and their aspirations, their manner of work and leisure, how they were fed, clothed, housed, wed, and buried, and who were the patrons of their work. All this should suggest something concerning their limitations and their triumphs.

PART TWO

THE SCULPTURE

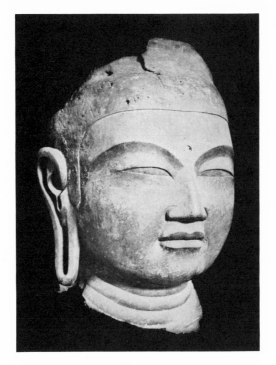

Figure 1

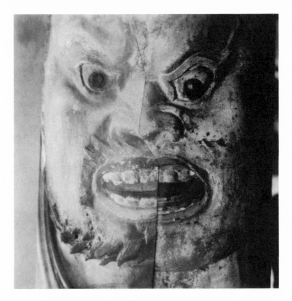

Figure 2

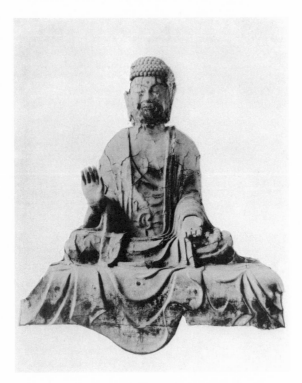

Figure 3

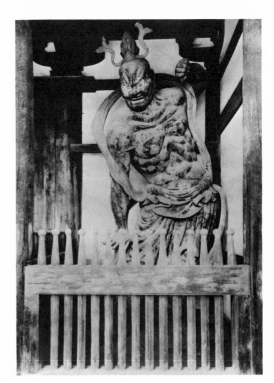

Figure 4

Figure 1 Head of Buddha, bronze. Cast perhaps for Yamada-dera between 678 and 685 and moved soon after to Yakushi-ji. Discovered in 1937 under the dais of the Tō-kondō of Kōfuku-ji. See pages 79, 80 and 83.

Figure 2 Composite photograph made from face of the clay Shukkongō-jin and lacquer Misshaku Rikishi, both of eighth century, from the Sangatsu-dō of Tōdai-ji. See pages 101 and 114.

Figure 3 Yakushi Nyorai, clay, eighth century. In the Jiki-dō of Hōryū-ji. See pages 103 and 105.

Figure 4 One of the Ni-ō, guardian pair. In the Jumon, Central Gate of Hōryū-ji. Head clay, seventh century. See page 113.

BRONZE (HAKUHO PERIOD, 645–710)

PLATES A–B, 1–21

Yakushi Nyorai ("Kō-yakushi")

Plates A–B

Bronze, gilt

H. 2′ 4¾″

Kōyakushi-dō of Shinyakushi-ji, Nara

Just below the deer park in Nara, overlooking the terraced fields to the south, stands Shinyakushi-ji.

This now modest establishment preserves from the eighth century the present Hondō or Main Hall, a bronze bell, and eleven clay guardians arranged in a circle about a huge ninth-century seated Yakushi in wood. In the later Kōyakushi-dō stands the gilt bronze Yakushi Nyorai shown in Plates A and B. Known locally as "Kō-yakushi," the "Fragrant Buddha of Healing," it probably antedates the temple and is usually assigned to the seventh century. The youthful head is strikingly like that of the great damaged Buddha head discovered in 1937 under the main dais of the Tōkondō of Kōfuku-ji. The latter (Figure 1) has been identified as a relic of a colossal image of Yakushi Nyorai originally cast for the Yamada-dera between the years 678 and 685. These belong in style to the small group of surviving Hakuho Buddhist bronzes that stand half way between the primitive sculptures of the Suiko period and the freer, more sophisticated works of Tempyo. The simple abstraction of the folds of the garment and the gentle smile link this image to certain bronzes at

Hōryū-ji, notably the Lady Tachibana's Amida trinity and the "Yumechigai" Kwannon. (Plates 13–17 and 18)

The neck and right forearm of the Yakushi have suffered repair and the lotus pedestal is not original, but the right hand is fortunately replaced in the *abhaya mudra* — meaning "Fear not" — a gesture of welcome to all who approach.

Shō Kwannon

Plates 1 and 2

Bronze

H. 6′ 2¼″

Tōin-dō of Yakushi-ji, Nara

Of the religious foundations built in the Vale of Asuka during the Suiko period, Gangō-ji, Daian-ji, and Yakushi-ji were all later moved to Nara. Gangō-ji burned down but the East Pagoda of Yakushi-ji, which was erected late in the seventh century, still stands. It had been built by the order of the Emperor Temmu in thanksgiving for the cure of his Empress. The Emperor died in 686 before the temple was finished, leaving its completion to his widow and to her successor the Emperor Mommu.

The annals of Yakushi-ji monastery record that the building called the Tōin-dō was built by Princess Kibi in honor of Empress Gemmyō. The present building dating from the late thirteenth century contains the re-

markable Shō Kwannon (Plates 1 and 2) undoubtedly inherited from preceding structures.

In view of the fact that the Emperor Kōtoku (646–654) is said to have built his court "in the Korean manner" and to have employed Korean workmen, it is perhaps significant that this bronze Kwannon, according to a temple tradition, was brought from Korea. There is nothing to disprove this, but it must be noted that nothing remaining in Korea is like it.

Many Japanese scholars have pointed out that the Bodhisattvas of the wall paintings of the Hōryū-ji Kondō are important parallels, allowing for the differences between line drawing and bronze sculpture, but there again the date is uncertain.

Lacking a precise record, the far less satisfactory method of stylistic comparison must suffice. The restraint of the face — the lower drapery folds and ripples — and the rigid inward turning scarf-ends all seem carried over from Suiko. It leaves us with little doubt that this Shō Kwannon was made shortly before Nara city became the fixed capital in 710. The loss of the original halo may have occurred when it was being moved to safety during the burning of the Tōin-dō which caused its rebuilding in 718. One has but to compare this large image with the smaller Hakuho examples to feel convinced of a kinship, despite its aloofness and monumentality. Its erect stiffness as compared to other swaying Kwannon figures is presumably because it was designed as a principal object of worship rather than as an attendant deity.

The gilt wood halo is comparatively modern, made early in the seventeenth century.

Yakushi Triad Plates 3–10
Bronze
 Yakushi Nyorai Plates 4, 5
 Nikkō Bosatsu Plate 6
 Gakkō Bosatsu Plates 7, 8
H. 8′ 2¼″, 10′ 2⅜″, 10′ 2⅜″ respectively

Details of Reliefs on Dais Plates 9, 10
Kondō of Yakushi-ji, Nara

In 697 it is recorded that a Yakushi triad had been installed in Yakushi-ji before the decorations had been completed. Many including myself once believed the bronze group illustrated here to be that very one. But the theory is no longer tenable if, as now seems certain, the huge Buddha head secreted at Kōfuku-ji (Figure 1) is a relic of that group. The restrained abstraction of that Buddha face is in fact more in accordance with our idea of Hakuho — and the sophisticated modeling of faces, figures, and drapery of the present group is more typical of early Tempyo. Opinion is still divided, but tends increasingly toward the later dating.

It is believed by some that the triad was not gilded until 748–749 when gold was reputedly discovered in north Japan. But this by no means implies that they had not been cast long before, since previous to the supposed discovery — or fresh importation — the scant supply of gold from Korea had to be strictly limited to the embellishment of small objects, and presumably could not stretch to the large surfaces of four heroic bronzes. The breaks that show on the figures may have occurred on one of the two occasions when the Kondō that sheltered them was blown down (in 1446 and 1524) or when it was burnt in 1529 during the civil wars.

A theory that the figures might have been made in Korea cannot be quite dismissed. It seems improbable, however, in view of the hazardous haul from Kyong-ju, the capital of Silla, center of bronze casting at the end of the seventh century, across the straits and through the Inland Sea to Naniwa (modern Osaka). Further it seems certain that such an event as the arrival of the largest bronzes in Japan, destined for an imperial establishment, would have been mentioned in the chronicles of the day.

The somewhat Indian look that is so often noticed in these colossal figures was the mark

of early T'ang sculpture in China. Notably at the rock grottoes of T'ien Lung Shan in Shansi we find parallels to these proportions, these full oval faces, plump swaying torsos, columnar thighs, and flowing scarves. We know that Chinese and Sino-Korean craftsmen were at work already during the Hakuho period (645–710) at Nara with their Japanese apprentices, and that they continued to ply their craft in Tempyo.

The great triad of Yakushi-ji composes perhaps the most accomplished group of bronze sculpture in the Far East and as lovely as any in the world. Certainly China has preserved nothing in bronze to compare with them. The earlier stone figures of the continent possess more austere simplicity comparable with that in Egypt and Mesopotamia; one or two of the extant clay T'ang figures of western China have a spiritual quality and a beauty of surface like that of the Yakushi group. But, take these bronzes all in all, they combine holy significance with perfect artisanship as well as any sculpture in any land.

The erect figures are more easily seen and appraised than the equally marvelous main figure seated between them. Their polished skin is drawn evenly over a lovely human plumpness in a way that is nothing short of a sculptural triumph. The girdle actually folds and compresses the firm waist, and seems to support the skirt dropping down generous and heavy as brocade. Elaborate jewels rest solid against the skin and are forced forward by the breast. Formerly gilt, the surface today is mirror-black and it somewhat defeats the sculptor's aim because its gleam reflects upward on the face to make unnatural highlights illumined from below. But the gesture of grace, the easy hips, and the timeless placidity triumphantly remain.

Plates 9 and 10 show details of the massive bronze dais and include one of the earliest representations of the grape to appear in Japan, closely contemporary with its appearance in China. The small curly-haired figures, peering from their strange niches, suggest a literal representation of some of the wild tribes of India who brought their simples to the Indian herb doctors and thus became associated with Yakushi, the god of healing. On the north side is represented the eternal struggle of the tortoise and the snake, and, on the other three sides, the phoenix, the dragon, and the tiger, from the pre-Buddhist canon, ancient Chinese Spirits of the Four Quarters, later incorporated into the Greater Vehicle. The oval and oblong studs in rows below the animals represent Indian precious stones in gold settings.

The dais seems to have been cut short at the top. And because of mishaps in the past, its corners are damaged. The original halos are long since lost.

Pagoda Vane Plate 11
Bronze, gilt
H. *circa* 4'
Pagoda of Yakushi-ji, Nara

At Yakushi-ji, the East Pagoda and four great ancient bronzes remain. The temple was originally established in 680–681 at Takaichi near what remains of Oka-dera. In 697 in the seventh month it was completed and dedicated a year later, only to be taken down twenty years later and rebuilt in 718 on its present site in grander form with the addition of several buildings, among them a second pagoda, since destroyed. Happily, the pagoda that remains, standing one hundred and ten feet high, is the older, and, on the bronze rings which top it, can be read the dates of its foundation and its rebuilding. At the latter occasion, or later, two additional roofs were added beneath the original highest and middle roofs respectively.

Thus the appearance of a five-storeyed pagoda was given to a three-storeyed one. A foursquare "curtain wall" was added under the lowest roof. The pleasing relation of these jutting roofs to each other is quite unlike anything else that remains to us in Japan or China.

The ink rubbings here reproduced were

81

made from two flanges of the vane fixed on top of this pagoda when it was taken down for repair some years ago.

Close examination of them shows that the flying angels, though drawn in archaic manner, have already advanced further toward the style of Tempyo than those on the Suiko pierced bronze banner at Hōryū-ji with which they may well be compared. Their drapery no longer shows that quick turn into fishhook shape so characteristic of Suiko bronzes and the brows, eyes, and ears resemble those of T'ang China. On the other hand, made to be seen from the ground far below, they are much larger and bolder than their cousins on the bronze screen of the Tachibana Shrine (Plate 15). Comparison with these two sets of bronze angels at Hōryū-ji reveals the Yakushi-ji vane as stylistically between the two.

The graceful, wingless flying creatures, *hiten*, with their swirling scarves are of a type developed in the primitive art of Wei China from an Indian concept, the *apsaras*.

Tachibana Shrine, Painted Wood
 Plates 12–17
Amida Triad Plates 12, 13
 Amida Nyorai Plate 14
 Seishi Bosatsu (left) Plates 12, 13
 Kwannon Bosatsu (right) Plates 12, 13
H. 1' 1⅜", 10¾", 10¾", respectively
Screen and Halo (H. 1' 10½") Plates 12, 13,
 15, 16
Lotus Pond (2' 7¼" × 1' 8½") Plates 13,
 17
Bronze
Kondō of Hōryū-ji, Nara

Few things left in the art of the Far East delight us quite so much as this little shrine and its contents, made for the Lady Tachibana, a member of the Imperial Household. The shrine itself is a plain wooden structure, seven feet nine inches high. Its panels and pedestal were embellished with sacred paintings now

almost obliterated. If the shrine alone were left it might be attributed to the Suiko period, together with the Tamamushi shrine on the same dais and the baldachins overhead. To all of these it bears points of resemblance. But within it flower (and the word is no hyperbole) three holy figures seated on long-stemmed lotus thrones as different from the stony sculptures of Suiko as they are from the elaborate excrescences on eighteenth-century Nikko temples. The lotuses on which they sit rise from the surface of a cast-bronze pool which has not its equal for prim charm in all the waters drawn by the fluid brush-strokes of the Far East. Ripples run across this water impelled by an odd little wind, orderly yet playful. The lily leaves that float there ride out the miniature gale, curling like the ripples that stir them. Back of the trinity on the lake is set a screen, also of bronze. Here are the choiring attendant spirits, and they are without fleshly heaviness. Nor do the tender lotus stems bend beneath them. Their scarves are carried looping up higher and higher by the very draughts of heaven, and they kneel to pray and praise, spirits caught for an instant in a semblance of lovely human form. As though to prove that this is indeed paradise where no earthly laws control, there are unmistakable salt-water cuttle-fish crawling up from the fresh-water lily pond below. Serious scholars in Japan, when this phenomenon has been pointed out to them, seemed distressed at being unable to find precedent for it either in nature or in the holy books. But the reason is not far to seek. These shapes were symbols. The artist desired those symbols in that place and put them there. How splendidly their horrid writhing forms contrast with the serene Dhyani Buddhas floating high above with their crown canopies!

No word can describe the perfection of the openwork halo behind Amida's head. And one can only imagine the complete original glory of the group, for evidently smaller matching halos were once attached to the

screen behind Kwannon and Seishi, his two attendants.

Kwannon ("Yume-chigai" Kwannon)

Plate 18

Bronze
H. 2′ 3⅜″
E-den of Hōryū-ji, Nara

This erect bronze can hardly be as late as the full Tempyo period beginning in 710, if only because of its flat arched eyebrows and tape-like scarves, the free-hanging parts of which are unfortunately lost. The hands are perhaps as beautiful as those of the "Kō-ya-kushi" (Plate A) and the Kaniman-ji Shaka (Plate 43) but the figure is undoubtedly later than the first and earlier than the second.

The popular name for this image, "Yume-chigai" (or "Yume-tagae") "Dream-conjuror," refers to its understood power to change nightmares to auspicious dreams.

Kwannon

Plate 19

Bronze
H. 2′ 8¹³⁄₁₆″
Taishi-dō, Kakurin-ji, Hyōgo

The popular name of Taishi-dō, the "Prince's Hall," associated with the unit of Kakurin-ji that houses this bronze would seem to substantiate the tradition that it was founded in memory of Shōtoku Taishi, who died in 622, by his son, and it is possible that

the figure of Kwannon has been there from that time.

In style it is linked on the one hand with the sculpture of Suiko before the middle of the seventh century, and, on the other, it presages that of Tempyo. Thus the flatly curved eyebrows and wedged nose and the presence of long narrow scarves from shoulder to pedestal seem early. But the gentler modeling of those scarves and the full oval of the face are almost those of the eighth century. Half a century ago Kakuzo Okakura attributed the figure to the Hakuho period, and all the evidence is in support of his opinion.

The right hand is a later restoration.

Shaka Nyorai

Plates 20, 21

Bronze
H. 2′ 5½″
Jindai-ji, Tokyo

Far away from its nearest parallels, this seated bronze image of Shaka Nyorai was discovered quite recently in Jindai-ji, a temple in the environs of Tokyo, but we have no evidence as to its originally belonging there. Most scholars believe it dates from the late Hakuho or early Tempyo period. But some whose opinions have weight hold that it may be an archaism from the Kamakura period. Its style seems to me, however, to suggest the early eighth century. Its head is remarkably close to that found at Kōfuku-ji (Figure 1). With all the conflicting opinions, I include it in this volume not only because I should be at a loss to place it elsewhere, but because it is so important a bronze.

TEMPYO TEMPLE INTERIOR

PLATE 22

Main Dais Plate 22
Sangatsu-dō (Hokke-dō) of Tōdai-ji, Nara

This photograph of the entire main dais of the Sangatsu-dō is important as a means to correct the false impression given by so many illustrations of individual figures stark alone with no suggestion of the companies and hierarchies among which they stand and without which their reality is all but nullified. The picture was taken from the southeast corner of the eighth-century half of the building and is presented here to give the reader an understanding of eighth-century sculpture in its proper setting.

About 746 two square miles on the slope at the west side of Nara was set aside to become the enormous institution then for the first time called Tōdai-ji. The big park already included more than one small group of religious buildings with storehouses, priests' residences, and fanes. In one such group, then called the Kenjaku-in, the Sangatsu-dō was built by the Emperor Shōmu (724–748). This building and one of the treasure houses called the Shōsō-in are the only eighth-century structures of the great establishment which have escaped destruction by fire.

The building is popularly known as the Third Month Hall (Sangatsu-dō), because it is in that month that the priests gather there to read and celebrate the Lotus Sutra (Hokke-kyō). The true name of the building, however, is Hokke-dō, though originally it was called Fukū-kenjaku-dō from the great Kwannon which I believe to have been brought into it about the time of the completion of the building.

The separate claims for this deity and for the raw clay image of Shukkongō-jin as the original *honzon*, or principal image, are a matter of some interest. Their solution would probably give a more precise date for the founding of the Sangatsu-dō — which may be as early as 733 — and at the same time determine answers for half a dozen other problems.

Of the fifteen examples of eighth-century sculpture that remain in the building, nine are of dried lacquer, five of unbaked clay, and the small Buddha in the Kwannon's crown is of silver. Although many bronze and wood images were made in the Tempyo period, the Sangatsu-dō includes none in either medium. This fact is worth noticing because it suggests a unity of modeler's techniques in distinction from those of the carver and the bronze caster, a unity that might well be characteristic of a single workshop such as we believe must have controlled the style of Tōdai-ji, and of the Sangatsu-dō in particular for at least two generations after 728.

It seems probable that all the figures originally made for this temple were of raw clay and made a perfect unit in details of style and of size. I suggest that the present main image, the great Fukū-kenjaku Kwannon, was installed early in the building's history but not long before 756 and not in time for its pro-

8 5

portions to be taken into account by the architect. Indeed the disproportionate size of all the lacquer figures argues for an original housing in some larger structure. (Further discussion of this point will be found in connection with the clay images of Bon-ten and Taishaku-ten, Plates 60–63.)

The important fact remains that local worshippers, pilgrims from across the valley, or strangers from overseas can step into the Sangatsu-dō today and behold sacred eighth-century sculpture in an eighth-century sacred setting.

BRONZE (TEMPYO PERIOD, 710-794)

PLATES 23-47

Lotus Petals, Throne of Roshana Butsu ("Dai-
 butsu") Plates 23-27
Bronze
H., each petal, 7' 5"
Daibutsu-den of Tōdai-ji, Nara

It is impossible to discuss bronze sculpture of the Tempyo period without discussing one piece that no longer exists — the original Roshana (Vairocana), familiar to all as the "Daibutsu" or "Great Buddha" at Tōdai-ji in Nara. Much is known about the casting, and the records give the names of carpenters and casters, and of the sculptor who directed them. We read that copper was discovered in 708 in the Chichibu Range, and that nine hundred and eighty-six thousand Japanese pounds of it were used for this single image, in addition to lead and to nineteen hundred and fifty-four pounds of mercury and sixteen thousand eight hundred and twenty-seven pounds of tin. Five hundred pounds of gold were used in gilding. The image, seated, was fifty-three feet high; the halo, one hundred and ten feet high and ninety-six feet wide. There were seven unsuccessful attempts to cast the image, but in 749 the thing was done. The making of the halo took nine years, and was completed in 771. Two great fires in 1180 and 1446 destroyed the first building and another built in the Kamakura period on a smaller plan was burnt down in 1567, and the Tempyo colossus was lost to posterity. We see today the head of a seventeenth-

century Daibutsu, the shoulders of a four-teenth-century Daibutsu, the back and patches of the robe of another fourteenth-century Daibutsu; but from the Tempyo period there remain only the lower petals of the throne and the lower part of one knee of the image.

Yet the Daibutsu is an essential part of the history of sculpture in the Tempyo period. No work of art of the eighth century bulks so important as this bronze image of Buddha the Illuminator, Roshana Butsu, seated under the greatest wooden roof-spread in the known world. No doubt it did its part in summoning to the islands teachers and craftsmen from the continent. No doubt the very court itself benefited from its reflected glory and the mere size of it. Many of the carved masks, textiles, documents, and other treasures lodged today in the nearby Shōsō-in were made in its honor, and the temple over it is a somewhat restricted though impressive replica of the original building.

On the petals of the throne are engravings — perhaps better thought of as line drawings in the original wax core for the mold — which remain to give us as close a parallel as we shall find in Japan to the masterpieces of T'ang drawing. Tempyo painting and draftsmanship can be studied in the light of these drawings in metal. The painting of Kichijō-ten in Yakushi-ji, the engraved pictures on the Nigatsu-dō halo, the panels of the great lantern before the Daibutsu, the screens in the Shōsō-in, and the basin of the Tanjō Butsu at Tōdai-ji are almost

the only remaining comparable material. Later than the painted panels of the Tamamushi shrine and the murals in the Kondō at Hōryū-ji, they express the very fullness of the T'ang culture. Their next of kin are engraved on the stone lintels of the Ta Yen T'a (Great Wild Goose Pagoda) at old Ch'ang-an, capital and heart of the T'ang Empire, and painted on the grotto walls of Tun-huang and Wan Fo Hsia at the far western end of the Great Wall.

The idea of such a colossal image had been a common one throughout Buddhist Asia and, when Japan undertook this task, it was one more proof that she was but stepping out into the full stream of Asian culture. The largest and oldest example of these great statues which remain on the continent is that dating from the middle of the fourth century cut in the rock cliff at Bamian in Afghanistan. Just there the great western road from China dips down after crossing Central Asia to be joined, on its way to Tyre and Sidon, by the trade route up from India and the Punjab. The Chinese had adopted the same idea in the fifth century and cut such a figure in the cliffs of Yün-kang, at Tun-huang, at Pin-yang, and in 672 at Lung-mên. Further east they and their local converts constructed one, albeit of lesser scale, at Sok-kul-an (Japanese, Sekketsu-an) in Korea that was completed, within two years of the Nara image, out of granite blocks where no cliff provided the stone in place. All these were of stone, all but the last one were cut out of the cliff face. But in Japan there is little rock fit for the chisel. It is characteristic of the islanders that they were not deterred by this problem. Bronze it must be, although there seems to have been no precedent for so tremendous a task in that material.

In the twelfth year of Tempyo (740) the Emperor Shōmu visited Chishiki-ji near Osaka, where he worshipped the Roshana Buddha. In the tenth month of the year 743 he vowed to have a mammoth image of Roshana made for his capital city Nara. The story goes that he sent the Abbot Gyōgi traveling over the countryside with his followers, to make known the imperial plan and to gather subscriptions from the people, in money or in kind, be it ever so little, "be it herb or earth."

In fulfillment of his vow, the Emperor had set men to work and at a temple at Koga, in Omi (now Shiga prefecture), he himself took part in the ceremonies of erecting the model, even laying hands on the rope when the craftsmen pulled the main pillar of the armature erect, while representatives from Daian-ji, Yakushi-ji, Gangō-ji, and Kōfuku-ji looked on. The Emperor chose to honor the Law of the Buddha Roshana, not in order to emphasize strictness and severity of punishment, but rather that the grace of the Buddha should be potent to prevent transgressions.

In 745, the work was transferred from Omi to Nara, for the casting of the bronze must soon begin and must needs be done at Tōdai-ji where the final figure was to be set. The seated figure was to be fifty-three feet high; not a thing to be shunted in from the provinces. But the great size created great problems, and seven times the casters failed. In the autumn of the nineteenth year of Tempyō (747) the casting of the lower plates of the image was begun at Nara, and in the winter an imperial decree again called the attention of the people to the need of help from them. It was pointed out that a Pagoda, a Golden Hall (Kondō), and dwellings for the monks must be completed during the next three years. And it was promised that those men who joined in the work or subscribed to it should have offspring and be granted government position.

In 748 in the fourth moon the Emperor went from the Palace to the monastery of Tōdai-ji where the Daibutsu was nearing completion and temple buildings were rising on every hand. Gold was reported to have been discovered in Mutsu province, and gold was needed for the surface of the bronze. The Emperor brought with him the Empress and the Crown Prince, and it is worth remarking that he stood before the god facing the north, which is the position of a vassal. Much is made

of this by the Japanese to prove the power of Buddhism in eighth-century Japan; but as the great image faces south, he had small choice where to stand unless he wished to address its mammoth back. Nevertheless, three months later the Emperor abdicated to become a priest.

Early in 751 the huge building itself was finished, but the interior decoration was not completed for another fourteen months. On May 26, 752, there was held the Eye Opening Ceremony (*kaigen*) in which the eyes of the Buddha were opened by painting the pupils, and the living spirit of the deity took possession of the bronze image. Celebrations similar to those of the New Year's court were arranged, but on a grander scale. Court officers down to the fifth rank were commanded to wear ceremonial robes and those below to attend in their usual garb. Ten thousand priests were invited and the religious dramas of the various temples were performed. It was perhaps the most important religious gathering since Buddhism came to the Far East.

On the ninth day of the fourth month (May 26, 752) Hatano Imiki and Inukai Komaro led the procession of priests through the huge South Gate of Tōdai-ji, down the long avenue, past the library and the carp pond, between massed crowds of guests wedged close together over the acres about the greatest wooden building in the world. In the procession were abbots of provincial and foreign temples who paced under canopies held by acolytes. They wore Chinese brocades of Ningpo and embroideries of India and robes that had been spun, woven, dyed, and stitched by the women of Japan to pay their household tax. Chinese, Koreans, and visitors from the independent states of Central Asia walked in that line and passed through the gigantic doors through which could be seen the mountain of bronze lotus petals and the colossal knees of the seated figure.

The pillared front of the building, over two hundred and ninety feet long, was hung with twenty-six streamers that dropped from the eaves and lay on the ground some yards before

the entrance. The eight-sided bronze lantern (Plates 37–40) stood high on its stone base; on its open grilles Heavenly beings play perpetual unheard music before the god.

Through the East Gate another procession advanced escorting the Indian pundit Bodai, the Spiritual Father, who came walking below a snow-white canopy to preside over the ceremony. He was met by a similar procession headed by the priest Ryūson who was to give the sermon of the day. When the imperial family together with their court and their chaplains had taken their places, Bodai (one record says the Emperor) laid hold of an enormous brush, smeared it with perfumed ink from China and touched the eyeballs of the bronze figure so high above the heads of the crowd. To the lacquered handle of the brush silk cords had been tied, and they led down and out to the hands of the priests and laymen who, grasping them, participated in the culmination of an act for which the court and the nation had been preparing for ten years. The four great monastery temples of Nara — Daian-ji, Yakushi-ji, Gangō-ji, and Kōfuku-ji — made offerings of "rare things" before the great image.

But far into the spring night music and dramatic dances were performed on platforms outside the big doors. By dusk cressets and torches had been lit so that the crowds, sitting on their mats, looked up at the lighted features of grotesque masks worn by actors who strutted and gesticulated above their heads. Thus went exorcism with prayer and praise and the purification of a nation with the consecration of a mighty deity in bronze.

Nimbus Fragments Plates 28, 29
Bronze, engraved. Originally gilt
H. 7' 7⅜" W. 4' 5"
Nigatsu-dō of Tōdai-ji, Nara

The Nigatsu-dō, in which this fragmented bronze relic has been preserved, was founded, according to tradition, by Jitchu Oshō, a dis-

ciple of Ryōben, in 752 and consecrated by a ceremony in honor of Ju-ichi-men Kwannon. Originally called Kenjaku-dō, it earned its present appellation, meaning Second Month Hall, from the annual rituals in February in connection with the drawing of holy water from its sacred well. This building escaped the disastrous Tōdai-ji fires of 1180, 1446, and 1567 only to succumb to flames as recently as 1667. The image of its principal deity — Kwannon of the eleven faces — has always been held too sacred to be looked upon. It is not known to have been photographed or seen by any man now living, though conceivably it may have fared no worse than its bronze nimbus. The nimbus was saved in some sixty-seven fragments and is now reassembled and on view in the Nara Museum. Behind glass its beauties cannot be detected, but both sides are exquisitely chiseled with Buddhas and Bodhisattvas and scenes from Paradise.

The only Japanese work that resembles it in technique and beauty we have already described — the engraving on the petals of the lotus throne of the Daibutsu in its enormous hall a few hundred yards away. There is some reason to believe that the same bronze workers engraved them both or at least that the cartoons were by the same hand. In making comparisons, a difference in scale must be taken into account. Some say that they prefer the little figures on the broken nimbus to the better-known ones engraved on the petals of the Daibutsu throne. But it must be admitted that the minute size of the nimbus engravings makes them hard to decipher, a fact obviously felt by the artist himself who peppered the background of the obverse side with punch marks in an unsuccessful attempt to produce contrast.

Formerly, however, it was overlaid with gold and the engraving must have come clear and have been even more spirited than those on the few solid gold vessels similarly embellished that have come down to us from T'ang China. Dull as the list of deities appears, volumes could be written on the significance of

the paradise and the purgatory illustrated and on this unusually early evidence of esoteric doctrines. For this is The Vehicle according to Jitchu Oshō, forerunner of the great Kōbō Daishi (Kukai).

Here are engraved a host of Buddhist figures usually associated with the name of Kōbō Daishi who did indeed fetch the sutras from China and make them popular in Japan fifty-four years after this splendid aureole was cast — one more proof that the introduction was not a sudden matter nor the work of a single man.

There are shown Buddhas, Bodhisattvas, Devas and Apsarases, trees, flowers, clouds, heavenly orchestras, and the Vulture Peak surrounded by the oceans of the world. It is a cosmography in fragments blackened by fire and with gaps in the design but still a series of heavens in little. We illustrate but two of these fragments. Examining all that is left of the original, however, we see that the front is divided into two outer bands and an inner oval. At the top is a seated Buddha preaching with two companion Buddhas whose hands are clasped in the *anjali mudra* of prayer. About them were forty Bodhisattvas. On the second band at the top is another seated Buddha in a cloud of Bodhisattvas who pray and sing and sound their instruments. The inner panel contains a similar seated Buddha with three Bodhisattvas beside him and fifty-two Buddhas in squares below.

The center was occupied with what, from the remaining fragment, must have been an exquisite figure of Senju Kwannon (Thousand-armed Kwannon) standing among scores of small Buddhas and with seven slender Bodhisattvas erect beside him. Nearby were eight figures in whose crowns were the Heavenly Kings. At the sides and below were Bonten, Taishaku-ten, Four Heavenly Kings, *monshu* (apostles), and *busshu* (Deva Kings).

On the back, where the pockmarked background is happily lacking, the outer panel shows three Buddhas seated with their hands in the preaching *mudra* flanked by sixteen

seated Bodhisattvas, two angels with flowers and incense, and eight more Bodhisattvas.

The next panel at the top has a seated preaching Buddha and six Bodhisattvas at his left and right. Below are parallel lines with graceful clouds between them and many figures of Bodhisattvas appearing only down to their waists as they do on the Daibutsu lotus petals. Below again is the Sumeru mountain from the middle of which spring two human arms holding one the sun and other the moon. The "Seven Gold Mountains" and the "Eight Great Seas" appear in the traditional manner. Below them are scores of little flames in each of which a damned soul is dancing in frenzy.

Neither photographs nor rubbings can begin to be as rewarding as a firsthand study of these rare engravings.

Sunburst above Fukū-kenjaku Kwannon
Plate 30
Wood painted and gilt, with bronze mirrors
Sangatsu-dō of Tōdai-ji, Nara

Flat on the ceiling above the crown of the high Kwannon in the Sangatsu-dō hangs the *tengai*, the most splendid and elaborate horizontal sunburst that has been preserved from the Nara period. A gilt wood disc, a foot in diameter, is the center of a carved and painted lotus, and from the edges of the petals extend, on gilded rods, eight smaller golden lotuses each with a seven inch bronze mirror for its center.

Before the polish was gone from these mirrors, or the gold was dim, the altar lights must have been reflected with telling effect from the dark above to the dark below. In addition to the eight mirrors and the central gold disc there spread out from the center, crossing the middle lotus and the lesser ones to fracture the glitter and point to the horizon, no less than forty slender gilt rods. These are evenly spaced between eight slightly thicker ones directed to the Four Quarters of the universe and the four airts between them. Nine

feet and ten inches is the span of this delicate lotus burst, symbolically set, like the great gnomon of a sundial, in accord with the quarters of the world.

The backs of two of these mirrors are reproduced on Plate 30 b. When they were removed for cleaning some years ago, they could be examined for the first time in centuries. It is of interest that both, though of familiar T'ang style, suggest the native Japanese technique of the period. They were probably cast in Nara by the *chokuban*, open mold, method.

Four Demons (Ama-no-jaku) Plates 31, 32
 Demon under feet of Jikoku-ten Plate 31 a
 Demon under feet of Zōchō-ten Plate 31 b
 Demon under feet of Kōmoku-ten Plate 32 a
 Demon under feet of Tamon-ten Plate 32 b
Bronze
Shio-dō of Saidai-ji, Nara

In 764, the year before the retired Empress Kōken, posthumously known as Shōtoku, resumed the throne for her second reign, she vowed the monastery of Saidai-ji, the Great Western Temple, counterbalancing the Great Eastern Temple, Tōdai-ji, founded thirty-six years before. And for this she vowed four guardians seven feet high. Building was commenced the next year and completed during the early years of her reign (765-769) together with the four huge figures of the Heavenly Kings, Shi-tennō, as guardians. It is recorded that the first three were cast without undue difficulties but the fourth, that of Zōchō-ten, was a failure even after six separate attempts. Before the seventh casting the Empress, after prayer, went to the furnace and stirred the molten metal with her bare hand saying, "If I am unhurt it may be for an omen that I am to be reborn a Buddha." Her delicate hand was quite unscorched and the seventh pouring of the metal was a success.

In 860 the monastery was consumed by fire and it has been damaged and partly rebuilt more than once since that time. Three of the four Heavenly Kings were destroyed in the first fire and the fourth King early in the sixteenth century. Thus we have lost what probably were the finest and largest bronze guardians in Japan. But there remain the four groveling gnomes on which the Kings trod and they seem to be the only representations of these sprites left in bronze from the eighth century.

These little figures are fetched in from the Nara rice fields to serve in the temple; deep chest, powerful thigh, and muscled arm, but — and here is the terror — only three fingers to each horrid hand! The globular heads too, that top the natural stocky bodies, are big and bony and no proper cultivator ever wore so wide a grin, such goggle eyes, or such a devilish screw of hair.

Much marred by repeated fires though they are, it is of interest to compare them with similar figures in dried lacquer that were made during the previous decade and that can be seen under the four guardians in the Sangatsu-dō of Tōdai-ji a few miles to the east (see Plates 112, 115, 116 b). While both are plastically conceived, the use of different materials — dried lacquer and bronze — seems to accentuate differences rather than similarities.

Ashuku Nyorai Plate 33 a
Bronze
H. 1′
Jizō-in, Uji, Kyoto Prefecture

This small figure is now known as Ashuku Nyorai, the Buddha Aksobhya in Sanskrit, but we cannot be sure of its original name. It must almost certainly have been cast prior to the Tempyo period. Its big and almost primitive head, ample cheeks, and thick lips, give it a certain resemblance to the bronze Shaka of Kaniman-ji (Plates 43, 44). As with that figure, we see here, too, a contrast between the simplicity of facial features and the ele-

gance of the modeled drapery. The manner in which both hands grasp the garment folds is unusual.

Yakushi Nyorai Plate 33 b
Bronze
H. *circa* 1′
Hannya-ji, Nara

Hannya-ji is said to have been built in the eighteenth year of Tempyo (746) by Gyōgi Bosatsu (670–749) at the command of the Emperor Shōmu. Inside its thirteen-storeyed pagoda this figure stood as principal image. While the pagoda is known to have been of stone, and was perhaps a unique structure in the eighth century, there is one theory that it was not built until 1264 or 1274, and another that restorations were made at these later dates.

Despite the apparent Tempyo style of the present figure, we are today certain that it was made in the Kamakura period, when many images, especially in bronze, were made in the style of the Suiko and Nara periods. Among these Kamakura examples, the Yakushi of Hannya-ji is the most representative and the most famous.

Allowing for a humanizing of the stance and facial features, we see in this Buddha image a carry-over of an essential Tempyo character not quite realized in the Jizō-in figure just discussed.

Infant Sakyamuni (Tanjō Shaka) and Basin
 Plates 34, 35
Bronze
H. 1′ 6½″; d. of basin 2′ 11¼″
Tōdai-ji, Nara

The birthday of Gautama, the historical Buddha (Shaka), is celebrated throughout the Buddhist world on the eighth day of the fourth month. On this day the *kan-butsu* ceremony, as the Japanese call it, is held. It consists, among other things, in reading the story of the miraculous birth, and in lustration of the image of the newborn Shaka which

is placed in a bronze basin to commemorate his first bath.

Nothing is known of the origin of this image or of the engraved basin in which it stands. They have long been kept in the treasury, to be brought out once every year for the ceremony. This is the largest example known in Japan and the style seems definitely to be that of the middle of the eighth century.

The ponderous basin is nearly three feet in diameter and is engraved on the outside with horsemen, fabulous beasts, birds, and insects in a landscape typical alike of T'ang and Tempyo. Its great size makes it seem probable that it was cast for the Daibutsu-den about the time of the Daibutsu's completion in 752.

This figure is the largest of the half-dozen known Japanese examples of Tempyo or earlier. The unvarying iconography stems from the story that the newly born infant took seven steps forward with the right hand raised to Heaven and the left hand pointing to Earth proclaiming his mission.

Infant Sakyamuni (Tanjō Shaka) Plate 36
Bronze
H. *circa* 11″ (?)
Zensui-ji, Iwaneyama, Shiga

Though not so tall as the Tanjō Shaka at Tōdai-ji (Plate 34), this figure resembles it closely. It lacks the smile of the other and the adequate modeling of the hands. It, too, must once have stood in a basin for the annual ceremony of lustration. Legend says that it was brought from China in 858, but stylistically it is a century earlier and almost surely native Japanese.

The temple at Iwaneyama is also known as Iō-in. It was known too as Wadō-ji from the fact that it was built under Gemmyō Tennō in the Wadō era (708–715). Its name of Zensui-ji, "Holy Water Temple" arises from the fact that in the Enryaku era (782–806) Dengyō Daishi sent healing water from here to Kammu Tennō and cured him of an illness.

Lantern Plates 37–40
Bronze
H. with pedestal 15′ 2″
Daibutsu-den of Tōdai-ji, Nara

A proof of the attendant glories and embellishments that must have been lost with the burning in 1180 and 1446 of the original Daibutsu-den is the great bronze lantern on its engraved stone pedestal. It stands at the foot of the steps leading up to the massive doors that open before the knees of the god within. It is the finest and most renowned lantern in the Far East.

The panels of the eight sides are cast in bronze grilles of great beauty in the full, developed manner of T'ang China and of Tempyo Japan. The double doors show four lions on each, descending among clouds. The fixed panels, alternating with the doors, show each a Heavenly musician treading on lotuses and playing a musical instrument, flute, cymbals, or pipe. One lion panel has long been missing and the jewel on the roof was replaced in 1101.

The figures are in high relief and are larger and of far richer detail than the divine beings — Buddhas and Bodhisattvas — engraved on the petals of the lotus throne of the Roshana Daibutsu in the temple (Plates 23–27). But the kin of these lantern musicians are found amongst the donors on the grotto walls of Kansu, China, on the feather screens preserved in the Shōsō-in a hundred yards off, and among the hundreds of pottery figurines dug from Chinese graves. For theirs was evidently the type of human beauty most admired on the continent during the period.

Gong Stand Plates 41, 42
Bronze
H. 3′ 2¼″, D. Dragon Rim 1′ 2″
Kōfuku-ji, Nara

Perhaps no other Chinese or Japanese bronze from the middle of the eighth century dis-

plays so perfectly the peak of the modelers' and casters' skills combined with beauty of design as this gong stand, called the *Kagen-kei*. An hexagonal pillar rises from a lotus set on the back of a couchant lion. Around the pillar clutch the involved hind legs and scaly tails of two pair of dragons that part above in a generous circle closed at the top by the tight hug of their forelegs. The four horrid heads strain apart to escape the rigid embrace. Amid the taut tangle of limbs, one foreleg clutches the neck of the opposite creature, and the legs of two others are thrust up to support the disc on which, presumably, was set the flaming jewel of the Buddhist church. Such a balance of powerful strains can hardly be discovered elsewhere among the bronzes of the world, nor any greater mastery of the combined arts of modeling and casting.

The gong, *kei*, is hung by a cord of silk to separate it from other metal and insure a pure tone. And it is a delight to the critic's eye when he realizes how its knot and its four corded strands are no more and no less expressive of strain than the tense modeled bronze cords of the dragon's claw running below the silk to force closer the two bronze necks.

The gong hangs in the round gap between the serpent bellies, a flat disc with a lotus center and prim tendrils in low relief calling to mind a T'ang mirror or halo, if not indeed the Gupta prototype. By what seems the height of appropriate designing, one's eye is excited by the violent struggle, and barely realizes that the flat surface has been disturbed by any ornament. But its weight seems to drag down closer the four necks from which it hangs.

A temple tradition records that this bronze Kagen-kei was brought across to Kōfuku-ji monastery by the priest known in Japan as Mondōshi as a gift from his Emperor in Ch'ang-an. Some scholars ingeniously have tried to prove that this gong is a substitute for an original stone disc, since Kagen is the Chinese Hua Yuan district which yields a famous sonant stone preferred for musical instruments. But others see no contradiction in transferring the name to a sounding bronze. In any case the present gong is now believed to date only from the Kamakura period, perpetuating, as our rubbing shows, a T'ang design.

Shaka Nyorai Plates 43–47
Bronze
H. 8′ 8″
Kaniman-ji, Nara

The present temple of Kaniman-ji that shelters this ancient bronze is a nineteenth-century structure, all that is left from the large establishment called Kōmyō-ji that stood further up the Kōmyō hill to the east. While it is usual to associate the colossal bronze Shaka with this temple from the time of its foundation, tradition hinders rather than helps to establish the date of its casting. One set of annals point to the foundation of the temple after 806 when Shingon Buddhism was introduced from China, but it would be surprising indeed if at that period so grand an affair were cast when all resources of cash, bronze, craftsmen, and even interest in new foundations, were being drained from the Nara region in favor of the new capital at Kyoto. The temple was known from its beginning until the seventeenth century as Fumanzen Kaniman-ji from the Kwannon sutras to which it was devoted, and its principal image was a Kwannon that was destroyed in the seventeenth century. Hence, lacking all historical reference to so important and massive a bronze as this great Shaka, one would expect evidence that it was brought to the spot after its original temple was burnt, but no hint of it having been elsewhere has turned up.

Every detail of stylistic evidence is in favor of a date for the image earlier than that accorded to the temple. Nothing so late as the beginning of the Heian era (794) resembles it in the cross section of the drapery, the peculiar curve of the eyebrows, the fingernails

shorter than the flesh behind them, the proportions of head to body and hair to face, and finally the spreading curves of the huge earlobes and grooves on either side of the mouth.

Yet we have no dependable evidence concerning the date of its production. It is comparable in style to the Yakushi Nyorai of Yakushi-ji, and may be of approximately the same date, if indeed this is not the earlier of the two. Yet strangely enough we have no literary references to this masterpiece.

The image went through a fire and lost its original gilded surface, together with its halo and pedestal. The robe that spread upon the pedestal is curled up and the figure itself is badly damaged. Nevertheless such is the perfection of this bronze image, even in its present condition, that I would repeat here my earlier pronouncement that few examples in this medium, East or West, equal it — and possibly none surpass it.

Two plates are devoted to the superb right hand. The webbed fingers accord with the traditional sacred signs of Shaka.

CLAY

PLATES 48–86

Bodhisattva (so-called "Hōshō Nyorai") Plate 48

Wood core for clay figure
H. 8′ 3½″
Tōshōdai-ji, Nara

A more forbidding figure than this wooden core cannot be found in Japanese sculpture. But it is all the more instructive when one realizes that it was in truth nothing but the support for a plastic modeled surface of raw clay and when one compares it with the better preserved clay figures that are so lively.

Judging by what remains of the clay surface in the deep folds of the skirt it was no mere skin that followed slavishly the carver's ridges, but in many places it was laid on a full two inches thick, quite enough for deep modeling to become the controlling medium and submerge the look of carved wood.

Several wood cores remain from lacquered figures in the same monastery and they, like this one, were fashioned, trunk, head, legs, ankles, and base, from a single timber. But this has none of their grace, probably because the craftsman depended on the thick layer of clay, now gone. It is of interest to compare it with the lacquered wood-core image of Shō Kwannon (Plate 161) from this same temple.

Miroku Nyorai Plate 49
Clay, lacquered
H. 7′ 2½″
Kondō of Taema-dera, Nara

Losses and restorations have not destroyed the effect of this huge seated figure. Lacquering on raw clay, a later addition here, seems never to have been a successful technique. The older method, that of painting the clay surface with pigments and glue, gives a more consistent surface than to add this brittle lacquer film which never penetrates and tends to contract and flake away. Scholars formerly held that this figure must antedate 710 and be even earlier than the small clays of the Hōryū-ji pagoda (Plates 50–57). Such however is probably not the case, for the modeling of the figure suggests fully developed Tempyo. The style of the remnants of painting on the clay base, which represents Mount Sumeru, I have never been able to examine with success. Once thought to be Hakuho, the latest opinion puts it later than Tempyo — and is of no help in dating the image. Traces on the dais of two attendant figures suggest that it may originally have been the central figure of a triad.

The hands and the gold lacquering are not original, but it is the best preserved of three clays in the same posture; the two others are the Miroku Nyorai at Kōryū-ji and the Nyoirin Kwannon at Oka-dera (Plates 85, 86).

A theory has been elaborated that the art of modeling in clay was brought from the continent to Japan and that its origin must be looked for in Central Asia or in India. We need hardly be at such pains. The instinct to model in mud is universal, and sculpture in

97

raw clay was probably as common in early Japan as it is today in China, Turkestan, and India. It is true however that only *haniwa*, hollow baked clay figures, remain to us from pre-Buddhist Japan and they show neither stylistic nor technical resemblance to the raw clay figures of the eighth century.

Sixth-century rock grotto walls at Tun-huang, China, are lined with mud and support bas-reliefs of the same material which need no armatures or special support other than the wool or hair which, on the continent, usually reinforces the clay wall as it does Western plaster. In Central Asia, where timber for building and fuel for burning were scarce, adobe structures encouraged the image-maker in a similar technique.

The raw clay figures that come down to us alike from eighth-century China and Japan, standing free and erect on their pedestals, show such competence in handling the heavy and delicate material that one scarcely needs further proof of past experience in their respective localities.

Common alternative renderings of the temple name are Taima-dera and Taima-ji.

Four Buddhist Scenes Plates 50–57
Clay, polychromed
H. (individual figures) 1′ to 1′ 4″
Pagoda of Hōryū-ji, Nara
 West Group: Division of the Relics, Plate 50 a
 East Group: Colloquy between Monju and Yuima, Plate 50 b
 North Group: Nirvana of Shaka, Plate 50 c
 South Group: Paradise of Miroku, Plate 50 d
 Plate 51 Bodhisattva (East Group)
 Plate 52 Kentatsuba (North Group)
 Plate 53 a Monju Bosatsu, b and c Two other Bodhisattvas, a and c (East Group), b (North Group)
 Plate 54 a Bodhisattva (North Group), b

and c Two female figures, d Yuima (East Group)
 Plate 55 a Bodhisattva [identical with plate 53 b], b Reliquary (West Group), c Female figure, and d Boy (East Group)
 Plate 56 a Dragon King, Ryu, b Six-armed Ashura, c and d Arhats (all, North Group)
 Plate 57 a, c, and d Arhats, b Giba Daijin (?) (all North Group)

Four unconnected chambers in the base of the five-storeyed pagoda of Hōryū-ji open to the cardinal points. In each is represented, by unbaked clay figures and landscape in relief, the scene of one of the four great moments of Mahayana Buddhism. On the west side (Plate 50 a) the Division of the Relics of Shaka (Sakyamuni, the Buddha of history); on the east side (Plate 50 b) the Colloquy between Monju (Manjusri) and Yuima (Vimalakirti); on the north side (Plate 50 c) the Nehan (Nirvana) of Shaka; on the south side (Plate 50 d) the Paradise of Miroku (Maitreya). These four scenes illustrate texts from among the sutras available in Chinese translation in contemporary Nara, and their selection for the pagoda at the most important Buddhist academy of the day is extremely significant.

It will be noticed that the scenes on the north and west, those reached last in one's circumambulation of the pagoda, deal with Shaka in his historic earthly manifestation. They have been the common property of all Buddhists of both the Greater and the Lesser Vehicles from the beginning. For they show the two great moments, his Nirvana and the Division of the Ashes after his death which disseminated the faith to the peoples of the world. They were a natural choice in the days of Japanese evangelizing, just as it was natural to a Christian missionary to select texts of the Crucifixion and of the sending out of the Apostles to preach.

The scenes on the south and east sides, which are first approached, both illustrate the *Yuima-*

CLAY

kyō, the sacred text which has been pecul-
iarly the property of the Greater Vehicle
since the time when it reached Japan in its
Chinese translation and became one of the
texts to which Prince Shōtoku, even before
the construction of Hōryū-ji, had been par-
ticularly devoted. He chose that text for his
dissertations and wrote his famous commen-
tary on it five hundred yards from this pagoda,
and Hōryū-ji at Nara is the monument im-
mortalizing his memory. Five minutes' walk
to the west was Prince Shōtoku's palace al-
ready incorporated with Hōryū-ji by the time
the scenes were being modeled for the pagoda,
as history records in 711. If it had not been
for the peculiar emphasis placed on the Yuima
text by this devout Prince the stream of Jap-
anese Buddhism might well have flowed a
different channel. Indeed, few Japanese traced
the intricacies of this subtle doctrine nor was
metaphysical inquiry much to the taste of
Shōtoku's active-minded subjects busy with
the material structure of their new civiliza-
tion. Six centuries later the Zen sect from
China, with renewed interest in the same book,
based their doctrine largely on it and found
their new teachings easy of acceptance in
Japan because it had been firmly established,
constantly taught, and frequently illustrated
since the Prince's day.

In the south face of the pagoda the group of
little clay figures shows Miroku enthroned
among the hills of his Tusita Paradise, attended
by Bodhisattvas and guardians. He is the
Buddha of the Future, yet he represents him-
self, in the Yuima text, as being unfit to cope
with Yuima's true comprehension of the en-
lightenment. In the east face of the pagoda
Monju, the wise deity sent by Miroku, seeks
knowledge from Yuima.

It would be valuable to trace the origin and
spread of such sculptured clay groups down
the history of Buddhist art, but unfortunately
no example earlier than these at Hōryū-ji is
known in China or Japan. Perhaps the sixth- to
eighth-century stone reliefs at Lung-mên,
Ta-t'ung, and Kunghsien in China may have

similar origins for they too portray scenes
enacted by several figures and they too were
undoubtedly polychromed. Although Hōryū-
ji examples are certainly not the first of their
sort, they may well be among the earliest.
And indeed painters and sculptors too have
kept it up in China ever since. For Buddhist
and Taoist temples in China still display Heav-
ens and Hells peopled, on a similar scale and
in the medium of mud or wood, with figures
disposed among modeled landscapes of hills
and clouds and buildings.

Among the hundred-odd figures still in place
in these four chambers, sixty-six are in my
opinion original; one in the south chamber,
fifteen in the east, twenty-three in the north,
and twenty-seven in the west. But several,
even among these, have suffered restorations
that mar them; some heads are medieval and
some bodies patched. There are in addition
four or five fragments that show how the
modeler worked, by first constructing a bare
clay body more or less detailed, and then
fashioning clay garments over it. Some of the
larger figures are supported by vertical wood
armatures rising from a platform of wood.
Some arms are carved entirely from wood
and some fingers are of clay supported by
wires. The material is the local clay well
worked and free from impurities. The mica
flakes that temper it may have been intro-
duced for ease of handling, and it is reinforced
by the same shredded paper mulberry bark
which is often found in the clay walls of
Japanese houses along with wistaria root
threads. The polychrome is the usual pig-
ment of the period mixed with seaweed glue.
An enumeration of pigments will be found in
the discussion of the Sangatsu-dō Ni-ō, Plates
119–122.

The frontal arrangement of scenes is pre-
sumably quite unlike what was originally in-
tended, and the position of the figures has
been shifted once even during my own gen-
eration. We have a right to presume that the
little figures were arranged as a painter would
place his group, engrossed in what they came

99

for, facing the Buddha and some quite frankly with their backs to the audience.

In fact, the known date for the figures encourages comparison with the larger Chinese clays at the Tun-huang grottoes that so significantly resemble those of Hōryū-ji.

A few of the original small figures are known to have been removed from the temple and to have found their way into private collections.

Shukkongō-jin Plates 58, 59
Clay
H. 5′ 2½″
Sangatsu-dō of Tōdai-ji, Nara

The most lively and perhaps the most accomplished of all surviving Tempyo sculptures in raw clay is this life-sized guardian, Shukkongō-jin. It is intimately connected with the founding of Tōdai-ji and of the Sangatsu-dō in particular, where it stands sealed in its shrine at the back of the high altar. During the middle ages and even earlier it was a palladium of the imperial family and hence of the nation. For twenty days at the time of the Masakado or Taira Rebellion (940) the astonished priests found its shrine empty. But, before the news of the outcome of the battle could reach Nara, it was back in place, sweating, with the right side of its head-dress shot away and arrow wounds on the body. Imperial guards, later returning victorious, reported that their battle line had been led by the god Shukkongō-jin incarnate. They had watched the ribbon from the god's hair turn into a swarm of angry bees which attacked the rebel archers and spoiled their aim. In later days the image was called "Hachi-no-Miya," "Bee God." Its shrine of the seventeenth century, dedicated between 1624 and 1644, and the iron lantern beside it are embellished with bees in honor of the victory.

The eyes are black, presumably made of obsidian like those of the Four Kings in the Kaidan-in. The colors are those familiar to the Japanese painter since earliest times. The breastplate and greaves are covered with *taisha*, red ochre, on a ground of powdered gold. The interior of the open mouth is scarlet *beni*, vermilion. Thus Shukkongō-jin stands, shouting down the centuries and brandishing his thunderbolt against the enemies of Church and State.

It had formerly been my casual impression that the body of the Shukkongō-jin was in violent motion and thus out of keeping with what we know of Tempyo sculpture, particularly that in the Sangatsu-dō. But in reality the trunk is no further off the perpendicular than that of the stark Jikoku-ten of lacquer in the same building. One is deceived by the sash that sways below the waist and floats, a tense ribbon, back of the shoulders. This swinging drapery is supported on iron wires, and the raised right arm has a wooden armature braced at an angle from the horizontal board within the shoulders, which has not prevented it from sagging several inches out of place. The left arm, tense with clenched fist, balances the other as the left arm of the shot-putter balances his right. Thus one returns to the face to find ferocity and threat enough to deceive one into believing the whole body is in violent action.

The making of the Shukkongō-jin has always been so closely associated with the beginnings of the Sangatsu-dō in which it stands that one can do no better than to accept the date of the building as that of the image. From the welter of medieval folklore three dates emerge, happily only fourteen years apart, any one of which may be that of the foundation; scholars today believe the earliest, 733, to be the most likely. One may remark that the span of fourteen years might well include the announcement of plans for the building and its contents, the collection of funds by the priest Ryōben (689–773) and other holy mendicants traveling from village to village and the final dedication of the structure with its images including the clay guardian in question.

CLAY

Several extant versions of a long and rather contradictory folk tale describe the making of this deity by a half-mythical monk named Konshu Gyōja, who seems, in the tenth-century accounts, to be none other than the famous Ryōben. His very name would perhaps be regarded as a medieval interpolation but for the known fact that it is embedded in the eighth-century name for the Sangatsu-dō, Konshō-ji.

Another tradition is that the carving was done by "a simple priest named Ryōben" and that it was brought to the attention of the Emperor Shōmu by rays of light issuing from the newly completed statue in Ryōben's poor hut under the hill called Mikasa, where now the Sangatsu-dō stands. Funds from the privy purse were allotted to build and furnish a temple to house the figure. But no lone, poverty-stricken, inspired priest made this richly gilt statue and its companions which can be demonstrated to have come from the same workshop. Or if Ryōben did so with his own hands he could hardly have been the man who had time and talent to be pupil of the learned Chinese, Dōsen Bosatsu, as well as sponsor of the greatest building and the greatest bronze statue in the world, Imperial Tutor, Chief Priest of Tōdai-ji, and, in 748, Lord Abbot. This image and its group must have been turned out from an atelier which included professional modelers in clay and lacquer, carpenters, joiners, and painters trained in the canons of art and in the Chinese fashion of the day.

It has been uncritically taken for granted that this image is considerably earlier than its companions on the great dais of the Sangatsu-dō. But examination proves it to be precisely in the manner of the two guardian gods and the Four Heavenly Kings, all of hollow lacquer (Plates 112–122) in the same temple. In fact so close is the detail and manner of making, in spite of the different material, that I believe it to be demonstrable that they are all from the same workshop. Shukkongō-jin is the type, but by no means the prototype. It may, of course,

have been the first of the group, but a group they undoubtedly are and there must have been still earlier examples of their splendid sort.

It has been noticed in connection with the sculpture of the previous Suiko period that, scanty as the material is, it can be grouped logically in such a way that the work of separate schools or ateliers may be distinguished and, in one or two cases, we have two examples which are undeniably by the same hand. By the eighth century, as one would expect, that state of things is even more true. Here are six hollow lacquer images by the same hands, forming what the art historians call a school, the first recognized in the history of Japanese image-making after that of Tori Busshi of Hōryū-ji in the seventh century.

To demonstrate the close kinship of the clay figures of Shukkongō-jin and the six lacquer guardians in the Sangatsu-dō I have assembled a composite illustration (Figure 2) showing the left half of Shukkongō-jin's face fitted to the right half of the face of Kongō Rikishi (Plates 120, 121). This shows convincingly that the technical and stylistic details in the two are identical, for a single face emerges. Such evidence is perhaps all the more conclusive when it is remembered that the figures are rendered not only in different media, but to different scale. Shave the face of Kongō Rikishi and it at once becomes Shukkongō-jin. The triangular eyes, the tense drag of the nasal muscles and the lips in an angry grin, but above all the same surface texture and subtle meeting of plane with plane, give strong demonstration of a single shop. Later we shall find another group which were turned out by a workshop attached to the nearby temple of Shinyakushi-ji.

The javelin-like thunderbolt pointed at both ends is the weapon of Vajrapani (the *vajra* bearer) whom our god represents. That shown in the photograph is a restoration and I believe the original is that which was formerly in the private collection of Mr. Noda at Nara. The free-flying scarf fashioned in clay over

a wire support is unique. Its preservation in contrast to the lack of the same feature in other clay guardians, for example, the four of the Kaidan-in, is doubtless due to the extraordinary secrecy and care accorded to this individual image.

Bon-ten and Taishaku-ten Plates 60–63
 Bon-ten (Brahma); so-called "Gakkō"
 Plates 60, 62 a, 63 a
 Taishaku-ten (Indra); so-called "Nikkō"
 Plates 61, 62 b, 63 b
Clay, originally with polychrome
H. *circa* 6′ 9″ each
Sangatsu-dō of Tōdai-ji, Nara

This pair of attendant deities, each with the headdress but none of the other appurtenances of a Bodhisattva, flank the main image of Fukū-kenjaku on the dais of the Sangatsu-dō.

The case against their identification as Nikkō and Gakkō seems conclusive since those divinities are properly attendant on Yakushi rather than on Kwannon, and the costumes and postures of this pair are quite appropriate to Bon-ten and Taishaku-ten — the Indian deities Brahma and Indra whom they resemble.

The change of names can be accounted for, since the two great figures of hollow lacquer that now stand on the same dais and are correctly called Bon-ten and Taishaku-ten (Plates 105–106), seem to have been brought there for shelter, perhaps when the Daibutsu-den nearby burned down. By reason of their overshadowing bulk and the importance of their origin they kept their proper names and pushed aside these unassuming images which, since more than one set of the same divinities was unthinkable, became Nikkō and Gakkō in the course of time. Unfortunately nothing is known of the image upon which this pair must originally have stood in attendance, and no explanation can be offered of why the gestures of adoration, *anjali mudra*, which they both assume, should differ from all other Tempyo representations of these two deities.

My friend Mr. Manso Tanaka called my attention to the fact that in workmanship their nearest of kin are the four famous Heavenly Kings in the Kaidan-in of Tōdai-ji (Plates 68–73). This likeness, noted nowadays by Japanese scholars, had previously escaped their notice, because of the great difficulty in comparing the serene with the violent images, even when they are out of the same workshop. Attitude, proportion, and particularly the modeling of eyes and mouths (usually the surest test for comparison) all seemed different in the two pairs. But scarves and folded drapery provide true likeness. Examine the inimitable sash falling from its knot round Bon-ten's waist (Plate 60). There is nothing more subtly elegant and restrained in eighth-century sculpture, mere ornament though it is. Compare the mechanics of its modeling with that on the shorter, tighter sashes and their knots, worn by the warriors (Plates 68, 69 and 71, 72). Here, and in the delicate hands and the fabric sleeves emerging from the armor of their shoulders, lies the plain evidence of a common workshop. Some trace remains on all these figures of flesh color and textile designs on the robes.

Even if detailed comparison with the Four Guardians were, indeed, impossible, one cannot escape the fact that in them and our two demure clay spirits, the sense for human proportions reaches for the first time its complete expression.

This may not be the place to discuss elaborate pros and cons but it should be stated that a case can be made for the theory that all the figures of the Sangatsu-dō were clay, excepting the *honzon* — the central Fukū-kenjaku Kwannon (Plates 108–111) — probably not originally made for this building either. Substitute for the present oversize dried-lacquer Bon-ten and Taishaku-ten (Plates 105, 106), which are so out of scale, this clay Bon-ten and Taishaku-ten pair. Banish, too, the four huge lacquer kings (Plates 112–118), exchanging them for the four clay kings from the Kaidan-in. The result is that the group becomes a proper unit in style, in size, in ma-

terial, and in iconography. Such moves were originally suggested by historical evidence or tradition but it is significant that they result in such convincing unity. The reassembled attendants, all in clay, would stand around the high lacquer Kwannon (or other main deity — which might in fact have been of clay): Bon-ten and Taishaku-ten and the Four Kings (Plates 68–73), with Shukkongō-jin guarding the north, the quarter from which the most potent evil forces always approach. Not only does the Sangatsu-dō then seem more appropriately furnished but the giant lacquer guest gods are moved back to their rebuilt home, the Daibutsu-den.

Whatever the exact disposition of these various figures in clay and lacquer, to the best of our knowledge none of them has left the environs of the Nara Deer Park in twelve hundred years.

Bon-ten and Taishaku-ten Plates 64, 65
 Bon-ten Plate 64
 Taishaku-ten Plate 65
Clay
H. *circa* 3′ 6″ each
Jiki-dō of Hōryū-ji, Nara

This pair had been for centuries associated with the now sadly damaged clay Yakushi (Figure 3) of the Jiki-dō, refectory of Hōryū-ji, until they were moved to the Nara Museum. They have traditionally been assigned to the second decade of the eighth century, but rather than attempt such precision I can only place them within a series that I believe to be their kindred.

Their proper subdivision therein is that of the most serene attendants, six in all, including the pair just described (Plates 60–63) and the less familiar pair, Kichijō-ten and Benzai-ten, both latter pairs from the Sangatsu-dō of Tōdai-ji. But these three serene pairs are, in reality, only part of a larger series of twenty-eight extant figures.

This pair, the Bon-ten and Taishaku-ten of

the Jiki-dō, wear armor to the extent of a warrior's cuirass; but their military air is tempered by skirt and shawl, nor do they carry weapons. Their visages have the mild expression worn by the high gods in contrast to the terrific grimaces of guardians. Such a different purpose and meaning has often served to disguise true resemblance of style, but one should not be misled by violent gesture or by facial contortions. Underlying likenesses or differences are seen, rather, in the modeling of drapery edges, in the depth of grooves and their telltale cross section, in the relative proportions of trunk to head and arms, in formal ornament, and especially in all small corresponding angles, surfaces, and curves which the practiced modeler always makes in his own individual manner.

It is worth contrasting these two figures at Hōryū-ji with the Kichijō-ten and Benzai-ten now in the Sangatsu-dō of Tōdai-ji (Plates 66, 67). For these latter by all comparisons would seem to be the earlier by a generation. Both pairs, however, were modeled with a certain amount of detail below the outer surface. Thus the Hōryū-ji Taishaku (Plate 65) shows the left foot, where the shoe has broken away, fully carved in wood beneath, and both Hōryū-ji figures, where the surface is lacking, reveal clothes underneath running quite counter to the outer ones.

Also to be considered for comparison of date, which can hardly be very remote, is the other pair from the Sangatsu-dō, already described, the noble Bon-ten and Taishaku-ten, wrongly called Nikkō and Gakkō (Plates 60–63). Here the condition, except for surface color, is nearly perfect and one can observe that the faces, though in the same tradition, differ in plumpness and in the construction of the mouth. Of the two sorts, that at Tōdai-ji is the more accomplished. Bon-ten's lovely scarf, knotted at the waist, divides and comes together again and spreads in tassel ends that are quite unlike the flat tape-like scarves at Hōryū-ji.

Closer in style than either of the gentler

pairs are the Four Heavenly Kings (Plates 74, 75) in connection with which all the Jiki-dō clays are discussed.

Kichijō-ten and Benzai-ten Plates 66, 67
 Kichijō-ten Plates 66 a, 67 a
 Benzai-ten Plates 66 b, 67 b
Clay
H. *circa* 6' 6" each
Sangatsu-dō of Tōdai-ji, Nara

A hint as to the date and original placing of this pair is given in the temple annals of Tōdai-ji where it is recorded that the annual ceremony called *Kichijō-gekka*, which celebrates these divinities, was first held at Tōdai-ji in the year 722, a fact that may well mark the year of the consecration of these particular images.

Close examination tends to contradict the previous idea that they are in a style later than that of the other clays and the dried lacquer of the Sangatsu-dō school. Although badly wrecked, they can be seen to be in the manner of the Bon-ten and Taishaku-ten (Plates 64, 65) from the Jiki-dō of Hōryū-ji. Owing to the character of the deities they represent, they should be included with what I have called the "serene" division in contrast to the violent. They are in the proportion of eight faces high (exclusive of topknots) and have the narrow level eyes and the cupid's bow upper lip of the placid deities in those decades.

The modeling of the knotted ribbon on the waist of Benzai-ten shows a similar gentle droop and spread to that of the clay Bon-ten standing in the same building. This Benzai-ten has but six of its original eight arms and none of the attributes the hands once carried, which were bow, arrow, sword, trident, ax, *vajra*, Wheel of the Law, and rope.

As in the Bon-ten and Taishaku-ten of Hōryū-ji (Plates 64, 65), where fragments of their clay garments have fallen away, the break reveals folds modeled below, quite indepen-

dently, suggesting that there exists a complete set of undergarments.

In the record known as *Tōdai-ji yoroku*, No. 4, written in the Fujiwara period, there is mention of the fact that the Kichijō-dō was burnt down in the eighth year of Tenryaku (954) and that these two images, the main deities there, were brought as guest gods for shelter to the Sanagatsu-dō.

Kichijō-ten, giver of joy and riches, springs from the Hindu concept of Sri Devi; Benzai-ten is none other than Sarasvati, Goddess of Language, Music, and Knowledge.

Four Heavenly Kings (Shi-tennō)
 Plates 68–73
 Zōchō-ten Plates 68, 70 a
 Jikoku-ten Plates 69, 70 b
 Kōmoku-ten Plates 71, 73 a
 Tamon-ten Plates 72, 73 b
Clay
H. *circa* 5' 4¼" to 5' 5"
Kaidan-in of Tōdai-ji, Nara

The present building that houses these Four Guardians, though the third on the site, is of great significance in the history of the development of Japanese Buddhism. The original Kaidan-in was planned in the third month of the fifth year of Tempyō Shōhō (754) by the famous priest Ganjin who had come over from the T'ang capital after shipwreck and pirates and official jealousy had stopped his several earlier attempts.

Almost his first act on landing was to superintend the construction of a *kaidan* for the proper baptism and ordination ceremonies into the Buddhist priesthood. For he felt deeply the dangerous heterodoxy that was rife in the Nara church not yet properly linked with the mother institution in China. Ganjin was invited by the court of Nara to establish the canon and correct the loose practices that had risen among the island converts who, anxious as they were to conform to the correct procedures, had been receiving instruction from

diverse Korean and Chinese and even Indian sources emphasizing various creeds.

In front of the steps of the great Buddha temple a platform, the *kaidan*, was erected, and on it the ex-Emperor Shōmu, his consort and a large number of their court were properly baptized and many priests were ordained.

We still have the precise catalogue of the great Buddhist library in a thousand volumes and the store of liturgical gear, plus what must have been a plan of this very *kaidan*, that Ganjin brought with him from the old country. Though his blindness, soon to become total, was already badly hampering him he was not content with the temporary *kaidan* which seems to have been little more than a platform of the prescribed shape set up before the Daibutsu-den. He therefore set about building it more substantially on high ground a few hundred yards to the south where it was completed by the tenth month of 755. Three times — in 1100, 1446, and 1567 — this building was burnt down and built up again.

It is known that in 755 the original four Guardian Kings who stood here were of bronze as was the small *tahōtō* (pagoda-shaped reliquary) they guarded. This present set, if not made to replace the lost bronzes, must have come ready made from another building.

It has been pointed out, in connection with Bon-ten and Taishaku-ten (the so-called Nikkō and Gakkō) in the Sangatsu-dō, (Plates 60–63), that this set of Heavenly Kings is closest to them in style among all the remaining Tempyo clay figures and that they may originally have stood together forming parts of the same assemblage of attendants. At any rate there is reason to believe these four to have been moved into the Kaidan-in after one of the fires that consumed the two preceding buildings.

That they are among the most perfect and most appealing of mid-eighth-century clays will be obvious from study of the illustrations. Color, once brilliant, is largely fallen or has been rubbed off but examination discloses that

the skin was a natural flesh tint and that the patterns on the armor and clothes were of red, vermilion, brown, green-blue, indigo, and black together with gold paint and cut gold leaf. The pupils of the eyes are presumably black obsidian like those of the Shukkongō-jin.

Always an important feature of Japanese Buddhism, the Four Heavenly Kings are guardians of the Universe. Jikoku-ten and Kōmoku-ten respectively protect the east and west; Zōchō-ten and Tamon-ten, the south and north.

Four Heavenly Kings (Shi-tennō)
Plates 74, 75

Jikoku-ten	Plate 74 a
Zōchō-ten	Plate 74 b
Tamon-ten	Plate 75 a
Kōmoku-ten	Plate 75 b

Clay
H. 3′ 3″ to 3′ 7″
Jiki-dō of Hōryū-ji, Nara

In the Nara Museum today stand four clay figures which formerly guarded the clay Yakushi (Figure 3) and the Bon-ten and Taishaku-ten (Plates 64, 65) in the Jiki-dō at Hōryū-ji — a remarkable set of seven eighth-century clay images preserved in an eighth-century hall. The *Honzon-reiho* catalogue states that they were made out of clay brought from China by Tori Busshi during the seventh century. Another temple tradition relates that Soga Umako caused them to be made after the arrival, in 584, of the first Buddhist images from the Korean king. Study of the style of the figures makes either date incredible. In spite of their broken condition and the ill-judged repairs in the past, it seems quite possible that they may form an original group with the Bon-ten and Taishaku-ten (Plates 64, 65) of the same temple and hence that they are mid-eighth-century. It is thought less likely that the Yakushi is the original central figure.

Although their clay boots were probably not modeled over carved wooden feet like

those others, the fingers are supported by similar sticks. Such details as the flower-shaped studs on the armor seem to have been made in the same mold as those worn by Bon-ten (Plate 64); the double-cusped corselets have identical curves and two of the guardians wear double cords knotted below the breast and circling the waist like those of the Bon-ten and Taishaku-ten. But clumsy repair of the draped scarves has changed the cross section that lends elegance to the others. Where original color appears at all it is to be seen only between patches of the rough surface that has been added or abraded. In brief, the figures present a stodgy appearance, with leather armor like hot woolen and with helmets as heavy as those of the Jogan period of which the images remind one in their present state.

Twelve Guardians of Yakushi (Jūni-jinshō)
 Plates 76-84
Hondō of Shinyakushi-ji, Nara Plate 76
 Bikara Plates 77, 78
 Haira Plate 79 a
 Santeira Plate 79 b
 Indara Plate 80a
 Bajira Plate 80 b
 Shindara Plate 81 a
 Shōtora Plate 81 b
 Anira Plate 82 a
 Anteira Plate 82 b
 Magora Plate 83 a
 Mekira Plate 83 b, 84
Clay
H. 5′ 2″ to 5′ 7″
Shinyakushi-ji, Nara

Of the twelve clay warrior guardians (Jūni-jinshō) surrounding the great Jogan wood image of Yakushi, all but one survive from Tempyo, and that lost one, Kubira Taishō, has been admirably supplied in wood by a modern sculptor.

Though often seen in paintings, sculptured groups of such complication and magnitude were rare. It is of prime importance not only

for the mass of detailed stylistic evidence provided by a single group of eleven large images, but because it demonstrates the limitations and opportunities of unbaked clay. Being guardians, they try to gesture ferociously and in some cases nearly succeed in giving the effect of bodily violence. But the brittle raw clay must depend on a wood armature within it and one can see that the artist, despairing of much action, has been driven to concentrate on the visage (Plates 78, 84). And, without abandoning the formula developed during the previous eighty years for the faces of ferocious demigods, he has achieved perhaps the summit of ferocity reached in Japan. Even Unkei's twelfth-century woods never reached such heights. The Shukkongō-jin of the Sangatsu-dō (Plates 58, 59) though of the same school, is scarcely more successful.

Distorted by patches of color that remain, scarred and marred, joined to bodies that must remain stiffly vertical and can branch out their arms or stamp only in hesitating fashion, these sullen or grimacing faces are proof that Oriental modelers, when the subject required, were masters of expressive humanity comparable with the best of the European Renaissance.

The eyes of these warriors, as of Shukkongō-jin and the four guardian gods of the Kaidan-in, are obsidian.

Miroku Nyorai Plate 85
Clay, lacquered and gilt
H. 2′ 8″
Kōryū-ji, Uzumasa, Kyoto

The shapeless knees of this image are restorations as is much of the remaining surface lacquer and gilt. But enough is left of the clay drapery and the shawl over the right shoulder (shaped, according to the canon, like an elephant's ear) to warrant including it here. Scholars who believe that the Kōryū-ji records are wrong in calling this "Miroku" do not, so far as I know, question the iconography of the similar, if larger, figure at Taema-dera

(Plate 49) in the same position and with the same gestures of the hands. The hands, incidentally, have been restored.

It was written in the record known as *Kōryū-ji shizai-kōtai-jitsuroku-chō* (859–876) that Kōryū-ji possessed a gold image of Miroku seated, two *shaku* eight *sun* in height. Although there was a destructive fire in 818, it is thought that this figure may be the one mentioned and may antedate the fire. By style and technique and size, it could be placed in the last quarter of the eighth century.

Nyoirin Kwannon Plate 86
Clay
H. *circa* 14' 10"
Oka-dera, Nara

Compared with the two similar unbaked clay seated figures at Kōryū-ji (Plate 85), and Taema-dera (Plate 49), this one has suffered drastically from restoration; so much so indeed that its appearance offers little chance to judge the original style. There is reason, however, to include it in spite of the clumsy alterations in the thickness and cross section of the drapery and the apparent fact that the scarf over the right shoulder, preserved in the other two, was in this case shifted in a meaningless way. It is believed by some scholars once to have been lacquered like the others and like them to have represented Miroku or possibly Yakushi. If such was the case the headdress must be a complete addition.

Oka-dera, of which the true name is Ryūgai-ji, was founded in 703 by Gien Sōjō, seen in effigy in Plates 159 and 160. A temple tradition says that Keishu Kun, the sculptor, presented a small bronze Nyoirin Kwannon in memory of Dōkyō who died in 772. Kōbō Daishi was at the temple while the big clay image was being made, and is said to have put Keishu Kun's small bronze inside the clay.

Thus the great clay may antedate the Jogan period and be included in our Tempyo list though today what meets the eye is a surface and modeling undoubtedly later.

SECTION 5

HOLLOW LACQUER

PLATES 87–133

Bodhisattva Fragment Plate 87
Hollow lacquer
Approximately life-size
Yakushi-ji, Nara

A solitary fragment is all that remains to us of Tempyo hollow lacquer from the Yakushi-ji. In the early seventies of the last century, word came from Tokyo that Buddhist establishments were no longer to receive subsidies from the government. Zealous officials and even ecclesiastics in some communities mistook this for orders that Buddhism was abolished by decree. At Yakushi-ji a bonfire was lit and on it were piled images and temple gear of an importance we shall never be able to reckon. A young priest was standing watching the sacrilege when a hollow dried lacquer figure on the fire exploded by reason of the vapors inside its tight shell and shot the face quite off the head to where he stood. He quickly took it up, scorching his fingers, and hid it in his robe.

Today we recognize it as a fragment from what must have been one of the most beautiful lacquer images and as dating from the first third of the eighth century. It is now registered with the National Treasure.

Four Heavenly Kings (Shi-tennō)
 Plates 88–92
 Jikoku-ten Plate 88 left, 90 b
 Zōchō-ten Plate 88 right, 89, 90 a

Kōmoku-ten Plate 91 left, 92
 Tamon-ten Plate 91 right
Hollow Lacquer
H. 7′ 2″ to 7′ 3″
Kondō of Taema-dera, Nara

This series of Guardian Kings is quite unlike others of the period. It is known that the figure of Tamon-ten reproduced on the right of Plate 91 was carved in the Kamakura period to replace the previous figure that was wrecked. Its fellow on the left of the same plate is also of later wood except for the ancient head and collar, and one hand and the long sleeves. The right leg of Jikoku-ten (Plates 88 left, 90 b) is restored in wood as are both shoes and part of the topknot. Zōchō-ten, his companion, shown on the same plate, lacks much of the original body below the belt, his sleeves, and parts of the demon below (Plates 88 right, 89, 90 a). Each of the four holds new weapons, and the nimbuses are restorations.

It is interesting to notice that the two demons which sprawl in contorted action (Plate 91) are both of the thirteenth century and that those which are original (Plate 88) crouch doubled-up much more like those of the seventh century in the Kondō of Hōryū-ji.

Perhaps it is this fact, and something in the shapes of the folds of the garments that remain in original dried lacquer, that account for one theory that would attribute a Hakuho date (645–710) to these figures. In fact, the

great Miroku of unbaked clay (Plate 49) guarded by these Kings sits on a clay base on which the remnants of painting strongly suggest the last quarter of the seventh century. This makes it seem probable that the whole group is contemporary with the moving of Taema-dera in 682 to its present site.

Whatever else may eventually be discovered concerning these figures, I suggest that the continental origin of their style was a different one from that of others that reached Japan, particularly from that brought over by the artist-craftsmen in Ganjin's train in 754 who came to work on the temple of Tōshōdai-ji and its fittings. For this Taema-dera style shows itself nowhere else in Japan, except perhaps for a hint at Hōryū-ji, and seems to have died away without issue on Japanese soil.

Despite restorations, this group of four may without hesitation be said to rank with the eight devas and six disciples of Kōfuku-ji, the groups in the Sangatsu-dō and the Hōryū-ji Dempō-dō, the portrait of the priest Gyōshin in the Yumedono, and the Roshana Butsu of Tōshōdai-ji.

Eight Deva Kings (*Hachi-bushū*)

Plates 93–99

Kinnara H. 5′ 3⅛″ Plate 93 a
Guhanda H. 4′ 11⅜″ Plate 93 b
Shakatsura H. 5′ ½″ Plate 94 a
Hibakara H. 5′ 1½″ Plates 94 b, 95
Ashura H. 5′ ¼″ Plates 96 a, 97
Kentatsuba H. 4′ 10¾″ Plate 96 b
Karura H. 4′ 11″ Plate 98
Gobujō H. 4′ 9½″ Plate 99
Hollow lacquer
Sai-kondō of Kōfuku-ji, Nara

This remarkable group and the following six figures have for some years been on public display in the museum (now called the Nara National Museum) just a few steps into the Deer Park across the road from Kōfuku-ji, their original home.

Six of Ten Disciples (*Jū-daideshi*)

Plates 100–104

Subodai H. 4′ 9¼″ Plate 100 a
Kasenen H. 4′ 9¼″ Plates 100 b, 101
Ragora H. 4′ 10½″ Plates 102 a, 103
Furuna H. 4′ 11″ Plate 102 b
Sharihotsu H. 5′ 1½″ Plate 104 a
Mokukenren H. 4′ 9¼″ Plate 104 b
Hollow lacquer
Sai-kondō of Kōfuku-ji, Nara

This series, together with the preceding, once totaling eighteen figures and now reduced to eight kings and six disciples, form the largest group left from the eighth century definitely assigned to one workshop. It is all the more interesting therefore that they should be among the earliest examples of the hollow dried lacquer technique left and that there should be only one other complete series of the Eight Devas — the small clays in the Nirvana group in the north niche of Hōryū-ji pagoda. Although these latter are scarcely discernible in Plate 50 c, three individual figures are seen in Plates 52 and 56 a and b.

The Deva Kings reproduced in Plates 93 to 99 stood originally in Kōfuku-ji's Sai-kondō (West Golden Hall), dedicated in 734 by Empress Kōmyō for the repose of the spirit of her mother, Tachibana Fujin. They were a part of a Shaka Jōdo Hen paradise scene and were presumably contemporary with the building. There are records of a similar series at Daian-ji and in the Chu-kondō (Central Golden Hall) of Hōryū-ji and in the pagoda of Kōfuku-ji that stood a few yards beyond the Sai-kondō, but the subject could hardly have been a common one in sculpture because of the labor and expense of their construction. We know how particularly tedious and costly hollow dried lacquer work was and how it had to be entirely abandoned before the end of the century. Later it seems to have become obvious that such assemblages were subjects more appropriate for the painter than for the maker of images in the full round.

The names attached to individual figures

seem to have been shifted about among them and the priests today do not follow the temple records or even agree with each other in some cases. This is the less surprising since several of the figures have no individual attributes nor specific postures by which they are to be recognized. Buddhist iconographies compiled in the last few centuries show figures associated with these names that sometimes serve but to confuse us the more. Some of the names are recognizable corruptions of Sanskrit or transliterations from Sanskrit to Chinese recorrupted in Japan. Their significance in any case is that of groups — Ten Disciples of Shaka or Eight Devas — never as individual deities. Two of the disciples became separated from the original group of ten and found their way into a private collection in Tokyo during the uncertain days of political reform early in the 1870's — and were lost there during the great earthquake and fire of 1923.

Of the two traditions that concern their origin and date, the less probable attributes them to an Indian (?) sculptor named Mondōshi of the early eighth century. The other is a record in the Shōsō-in which says that they were made by Shōgun Mampuku, presumably a Korean, in 753 for the Lady Tachibana.

Taking it for granted, as some scholars do, that these and the Four Heavenly Kings of Taema-dera (Plates 88–92) are the earliest hollow dried lacquer figures remaining, every detail about them that does not obviously originate in the repairs of 1232 becomes of great interest. Their liveliness, the sense of portraiture they show, and even the exceptional fact that one (Hibakara, plate 95) is bearded, all these things and more should be examined with care to find likenesses and differences in the Taema-dera and Kōfuku-ji styles.

Bon-ten, Plate 105 Plates 105–107
Taishaku-ten, Plates 106, 107
Hollow lacquer
H. 13′ 4″
Sangatsu-dō of Tōdai-ji, Nara

This tall pair have been considered by some Japanese scholars to be not only the earliest representations of these deities in Japan but to be the oldest remaining hollow dried lacquer figures. Their gaunt height, though to a lesser degree than the Fukū-kenjaku Kwannon (Plates 108–111) whom they attend, impresses one as out of scale with the temple and with the rest of the company in which they stand. There may be ground for the belief that they were brought here after the first burning of the Daibutsu-den nearby, but they may well have been made as guardians of the holy buildings, and many Japanese scholars today believe that this is the case.

There is an odd ridge along the back of the shoulders, possibly the result of green lacquer shrinking over the wood armature. Perhaps this means that the technique was still an experimental one. Another interesting detail in this pair is that there are traces of a square trap door cut in the middle of the back of each figure. Its edges have been carefully lacquered together to hide them. It is said that wood braces for the armature were inserted through these doors, somewhat as the sailor contrives his full-rigged ship in the whiskey bottle. But whether this was done as a reinforcement after the completed figure showed signs of sagging, or why an entire new armature was needed, or how it could have been ingeniously jointed to be set up through the foot-square hole is not known.

Stark and expressionless the bodies undoubtedly are, compared with the graceful images of the time. But the faces are beautiful, grave, and considering beyond any of their companions.

Fukū-kenjaku Kwannon Plates 108–111
Hollow lacquer
H. 14′ 5½″ with pedestal
Sangatsu-dō of Tōdai-ji, Nara

The spring of the year 746 is a probable date — whenever it may have been started — for the completion of the Sangatsu-dō in which

this illustrious Kwannon has for centuries been the principal image. But to associate the completion of the image with that year or take it for granted that it was made for its present place seems unjustified. Obviously the image was not planned for the building nor the building for the image, though it now stands in the central position under the horizontal sunburst on the ceiling.

The first and most cogent proof is that the great halo supported on a post behind the figure has been set some six feet below its intended position for lack of room under the roof. This brings the central lotus sun, from which the light rays all spring, behind the waist of the Kwannon blocked by the massive body. It should, according to every canon, all other known examples, and every conception of the "Source of Divine Radiance," be behind the head where it is usually visible even to the worshipper directly in front. If the golden arrows and the flames that flicker from them were properly placed under a higher roof, they would penetrate the murk among the rafters.

How great the loss was when the halo was cramped down in its present building can be demonstrated by lifting it in imagination. Set the sunburst behind the head, and a generous oval of sparkling detail would make a perfect limit and frame behind the outstretched hands and the elaboration of detail on the upper body. The columnar legs would be left, hard outlined, as a simple support. Japanese scholars do not agree with me in this matter, and certainly I accept their theories while putting down what was my belief a score of years ago. They tell me that the platform was raised long ago, thus shortening the halo, and that the figure was undoubtedly made for this particular hall.

Concerning the colossal image itself, it is worth recording that it is the largest and best preserved among the hollow lacquer figures that remain. It is constructed in some parts with no less than thirteen layers of hemp cloth lacquered together; the number of cloths applied varies according to the place covered, being thick in some places and rather thin elsewhere. Its eight arms with hands holding their lotus, rope, and staff of six rings, and gesturing in their sacred *mudra* may disturb the Western eye and seem to cheat us of the simplicity it is our fashion to require. For that reason I show here details which should serve to correct any sense of overelaboration.

So far as I know the solid silver image of Amida (Plate 109 a), nine inches high, set in the crown, is unique by reason of its own material and its perfection. It stands erect, backed by its own full length halo with the sunburst behind the head, the spiritual progenitor of the Kwannon below. In the same illustration can be seen the *magatama*, those comma-shaped stones and crystals of mysterious non-Buddhist origin, perhaps neolithic Korean or Japanese. On their strings of glass and pottery beads they were presumably offerings of the precious objects of the time, no less appropriate enrichments to a Buddhist image for being associated with primitive nature gods.

Below the Third Eye of Wisdom, vertical in the brow of Fukū-kenjaku, is set a large black fresh-water pearl, the *urna*, usually in itself sufficient emblem of that third eye.

As for the emblems held and the attitudes of the eight hands, so much is symbolized that one can only repeat here that this figure epitomizes the most occult and intricate esoteric Buddhism usually considered to have been introduced only when the two learned doctors, Kōbō and Dengyō Daishi, returned from China in the first decade of the ninth century with the doctrines of Shingon and of Tendai. But that occurred six decades after the making of this image whose existence in the middle of the eighth century is proof that the texts of esoteric doctrines had been already brought from the continent and there was need for material icons of greater complication.

HOLLOW LACQUER

Kōmoku-ten Plate 115 a, 116 a, b, 117 b
Tamon-ten Plate 115 b, 118 b
Hollow lacquer
H. *circa* 10' each
Sangatsu-dō of Tōdai-ji, Nara

It is believed by some people that these giants in lacquer — the greatest of the Shi-tennō — were made in the fourteenth year of Tempyo (742) and that the special celebration of the *Konkō-myō-saishō-ō* scripture in that year was held in honor of the event. In spite of repairs (which show as lighter unpigmented areas on the armor) this group preserves for us a series of hollow dried lacquer images at the height of the art, constructed for the richest, most important monastery in Japan during the half-century while it enjoyed to the full both imperial patronage and the service of a group of unparalleled artists. They are all the more significant because they are merely attendant deities and are four out of at least fifty images, most of them now lost, modeled from lacquer or clay to make up the groups standing to serve and guard various higher gods. The workshop that modeled this series seems also to have worked in clay (compare Shukkongō-jin, Plate 58) and to have been the one closely associated with Tōdai-ji monastery for fifty years. No less than twenty-one examples of their recognizable style remain within the radius of a mile.

The modeling of the small gnomes on which the Kings trample is perhaps unsurpassed in the Orient for grotesque liveliness (Plate 116 b). In some parts as many as eleven layers of hemp cloths lacquered together are used in their construction.

Two Guardian Kings (Ni-ō)
 Plates 119–122
Misshaku Rikishi Plates 119, 122 a
Kongō Rikishi Plates 120, 121, 122 b
Hollow lacquer
H. 10' and 10' 6"
Sangatsu-dō of Tōdai-ji, Nara

Sculptured figures of the Ni-ō — literally the Two Kings — are often found in Buddhist temples; they appear in China as early as the period of Six Dynasties, and the pair carved in stone at Bukkoku-ji in Korea are said to date from the year before the dedication of the Nara Daibutsu. The earliest in Japan are the little headless wooden Suiko pair from Hōryū-ji, restored in Kamakura and now kept in the Nara Museum. Then follow the originally clay pair that have guarded the main enclosure of Hōryū-ji since 711 (see Figure 4), today patched up, restored, repainted, yet very much alive.

The Ni-ō in the Sangatsu-dō are superb examples of hollow dried lacquer sculpture. In other temples Ni-ō are not commonly found near the main altar within a fane guarded as is the Sangatsu-dō by the Four Heavenly Kings, the Shi-tennō. The Sangatsu-dō never had a special gate, and the brilliant colors on the lacquer figures do not suggest that they ever stood in the miserable shelter of a gateway, exposed to wind and rain. They are supposed to be in action, or prepared for it, but the bodies are not active in reality. It is only the arms and the turned heads which suggest motion, and the legs advanced though not to walk. These legs, placed high on the present platform, are shapeless in their greaves and make for the uncomfortable effect of stiffness. But that impression cannot last if the visitor is privileged to clamber on the platform and bring a light with which to see the faces. There, and in the amazing beautiful hands, are the proofs of the sculptor's skill. For Misshaku stands lightly drawn back, ready to defend the altar with his wicked knife held in that particularly ugly posture with the blade projecting from the bottom of the fist. His other hand is clenched. On his firmly compressed lips the expression of chill defiant hate is enough to haunt one. Misshaku's lips are shut to express the fatal *OM* — the last letter of Sanskrit in Mikkyo Buddhism, the syllable that destroys. Kongō's lips are open to utter the first syllable, *AH*, from which all things

113

are created. If Misshaku is ready to strike, Kongō, though his *vajra* is missing, seems not content to wait even so long. His visage is neither chill nor has it time to hate — it is afire with terribleness. His hair in twisted spikes stands erect, his beard and mustache dart like adders' tongues. In another second he will be upon you.

The armor here, like that worn by the Shi-tennō of this same hall (Plates 112–118), the Jūni-jinshō at Shinyakushi-ji (Plates 76–84), and the Shi-tennō of the Kaidan-in (Plates 68–73), seems to represent leather and cloth, the one painted or embossed, the other presumably brocade or embroidery. The colors in many places are still amazingly fresh. The pigments used were verdegris (*rokusho*), blue lapis (*gunjo*), red ochre (*taisha*), vermilion (*shu*), white from shell and lead (*gofun*), gold leaf, and gold powder. The lacquer ground makes an excellent surface to receive color and is the best possible base for gold leaf.

The close kinship in style between the lacquers and the clays in the Sangatsu-dō, is made very clear in the composite head shown in Figure 2; one side of the face is from the hollow lacquer Kongō, the other from the clay Shukkongō-jin.

As with the preceding set of Four Kings (Plates 112–118), the Ni-ō show in parts of their construction as many as eleven layers of lacquered hemp cloth.

The Abbot Ganjin (Ganjin Oshō)

Plates 123, 124

Hollow lacquer
H. 2′ 8¼″
Hōssō of Tōshōdai-ji, Nara

The Chinese priest Chien Chên (in Japanese, Ganjin) is known to have come to Japan upon invitation of the Emperor Shōmu and presumably should have attended the Eye-opening Ceremony at Tōdai-ji had not misfortune intervened. Although he has been dealt with more extensively in Chapter V, a few pertinent details are given here. After suffering repeated hardships including shipwreck, capture by pirates, and almost total loss of eyesight, he reached Nara early in 754. In the same year he caused a great platform to be set up before the Daibutsu-den of Tōdai-ji on an axis with the temple gate. Here he baptized hundreds of the clergy, court, and members of the imperial family according to the canon of the Ritsu sect which he introduced from Ta Ming Ssŭ (in Japanese, Daimyō-ji) of Yang-chou in China. A great figure during his eight years or so in Japan, he founded the vast temple of Tōshōdai-ji. Among other things he became famous for his skill with Chinese medicines.

At Tōshōdai-ji there is preserved his image in lacquer shown here, one of the few portraits remaining from the Tempyo period. It may well have been made shortly after his death in 763 by an artist who was familiar with his features. The beloved old Ganjin in his last years had become totally blind, and the inward concentration of a sightless man has been caught with peculiar skill.

Technically, this figure is of particular interest for the fact that it is of hollow dried lacquer without inner supports. It must have been constructed by overlaying a model of clay with lacquered cloths to form the stiff shell from which the clay was later dug out. Japanese authors formerly spoke of the figure as having been made of lacquered hollow papier mâché, but that seems to have been an error made because the material is so thin — in places only two layers of hemp cloths are used — and because of paper used in minor repairs to the right knee.

Scholars have pointed out that the figure has long pierced ears, attributes properly of Arhat or Buddha, but this may have been less a rendering of actual likeness than a symbol of his spiritual identification with the Buddha. The wistful placidity of that aged blind face has always seemed to me a portrait, posthumous possibly by a year or two, yet faithful to the story of Ganjin's life.

HOLLOW LACQUER

Four Heavenly Kings Plates 125, 126
 Zōchō-ten Plate 125 a
 Jikoku-ten Plate 125 b
 Kōmoku-ten Plate 126 a
 Tamon-ten Plate 126 b
Hollow lacquer
H. 4′ 5⅜″, 4′ 4¾″, 4′ 6″, 4′ 4½″, respectively
Hokuen-dō of Kōfuku-ji, Nara

The figures in this group are of much smaller size and less significant modeling than the mighty guardians of the Sangatsu-dō. Perhaps the scale is less fortunate, perhaps the armor and raiment too ornate. The gnomes they trample (partly restored, it is true) are far less convincing than those of the larger group. Though they are of the same school, the faces here seem more like grimaces than visages of demigods exploding from wrath or spite.

Vague as such criticisms must seem they bear out the established theory that the whole group was made in 791 when the Tōdai-ji workshop was past its prime. The dried lacquer is very thin, and the figures are more like wooden sculpture. Still the workmen knew how to construct the hollow lacquer and still the old formula for the bulging eye in its triangular socket and the snarling mouth were preserved, but one guesses the master was dead.

On the bases of the figures of Tamon-ten and Zōchō-ten there are inscriptions to the effect that they were made at Daian-ji in 791 and repaired in 1285 by a priest of Kōfuku-ji named Kyogen.

Two Bodhisattvas of first Amida Triad
 Plate 127
 Kwannon Bosatsu Plate 127 a
 Seishi Bosatsu Plate 127 b
Hollow lacquer
H. 5′ 1″ and 5′ 2¼″
East Wing, Dempō-dō of Hōryū-ji, Nara

These two erect Bodhisattvas now stand as attendants for a seated Amida of wood core (Plate 142). The fact that they are of hollow lacquer without a wood core might suggest that they were not originally made as its attendants. But if they were, the group shows an early stage of the transition from hollow lacquer to wood core, both methods being employed for a single triad, the main figure in the new fashion and the attendants in the old. See discussion for Plate 142.

The pedestals seem to lack proportion since they have lost the great lotus petals that, fashioned individually, sprang from the sides of the top member. The chignon of Seishi is missing.

Four Deities Plates 128–133
 Bon-ten Plate 128 a, 129
 Taishaku-ten Plate 128 b
 Gudatsu-Bosatsu Plate 130
 Gigei-ten Plates 131, 132, 133
Hollow lacquer heads
H. *circa* 6′ 8″
Akishino-dera, Nara

Akishino-dera was built by Zenshū Sōjo around 780 by imperial command, and the heads of these four figures may be of that date; the bodies are of the Kamakura period.

For a number of reasons these figures at Akishino-dera are of absorbing interest to the student of techniques and of their effect on style. Of all eighth-century faces, that of Gigei-ten seems to Westerners the most immediately charming.

This and the other three heads are hollow shells of lacquered cloth, as may be seen at the ragged edge of the neck in the photograph of the Bon-ten head (Plate 129) made during repairs at the beginning of this century. Presumably the original bodies were lost in the conflagration of 1135 when the temple was destroyed. They are fine specimens of a successful combination of two materials and techniques and two widely separated dates. For the Kamakura wood carvers made no attempt to

115

copy the mannerisms of the Tempyo modelers nor were they interested in archaeologically correct restoration. The result is an honest and proper unity of lacquer head with wood body, and differences that seem appropriate enough between face and clothing.

In Plate 23 of my *The Craft of the Japanese Sculptor*, the image here called Bon-ten was labeled Taishaku-ten. But the name Bon-ten is traditionally given to this image. A single inscription on the wooden body of this figure reveals the date 1289 — clearly applicable also to the bodies of the other three. Some details

such as the arms of Bon-ten and the topknot of Taishaku-ten are later still. The armature for the original lacquer torso of Bon-ten is preserved in the Nara National Museum and its lacquer feet were formerly in Odawara in the collection of the late Baron Masuda. Ancient dry lacquer fragments have been discovered within the figure of Taishaku-ten.

The figure of Gigei-ten is iconographically rare in Japanese art and unique in Tempyo as a representation of the Deity of All Skills. It must have been held in special reverence by the craftsmen of Tempyo.

HOLLOW LACQUER WITH LATTICE SUPPORT

PLATES 134–139

Yakushi Nyorai ("Mine-no-Yakushi")
Plates 134, 135
Hollow lacquer, lattice support
H. 8′ 1″
Saien-dō of Hōryū-ji, Nara

This great image, sometimes called "Mine-no-Yakushi," ("Yakushi-on-the-Hill"), is of a technique seldom used. It is constructed from lacquered cloths draped over a stout lattice-work cage of wood carefully fashioned to conform to the outline of the finished image. Two others are the Roshana Butsu at Tōshōdai-ji (Plates 136 ,137), and the Gyōshin portrait in the Yumedono of Hōryū-ji (Plates 138, 139).

This method was an attempt to provide greater all-over rigidity than the formal branching armature in the hollow lacquer figures supporting the outer shell at comparatively few points and, in some cases at least, causing the skin to bulge before the lacquer had set. The fact that this technique was not continued suggests some essential disadvantage. Whatever may have been the date of the other two images in the same technique, this Yakushi was probably made as early as 718, which is the year of the erection of the Saien-dō by Tachibana Fujin, mother-in-law of Shōmu Tennō.

On the twenty-third day of the fifth month of 1047, the building was blown down and the image injured. Though rebuilding of the tem-ple was begun in the tenth month of the next year, this figure seems to have remained as it was until 1283 when Genkei repaired it. Mr. Chunosuke Niiro has demonstrated that the elaborate dais, formerly believed to be entirely Kamakura restoration — like the building itself — dates in large part from the eighth century.

Roshana Butsu
Plates 136, 137
Hollow lacquer, lattice support
H. 11′ 1⅛″
Kondō of Tōshōdai-ji, Nara

This colossal seated Roshana (Vairocana), even larger than the preceding erect Yakushi, is of the same technique. When it was being repaired, the workers found under the thirteen layers of lacquered cloth no armature but a lattice cage of nicely mitred square wooden rods, like a modern dressmaker's form. This is no angular framework, but conforms with some accuracy to the rounded contours laid above it, which it supports at close intervals below the cloth skin. The hands seem to be carved wood over which is modeled a paste of sawdust, fiber, and clay mixed with lacquer. The great curls, traditionally "like snails," are of wood and so are the thousand small Buddhas fixed to the halo. Of the original Buddhas, three hundred and twenty-two remain, and the rest are of the Kamakura and Momoyama periods. They are of peculiar interest, for,

though at first glance these miniature images seem alike, the styles of the eighth and fourteenth and early seventeenth centuries can be distinguished.

Tradition attributes this colossal Buddha and its two gigantic wood-core companions, Senju Kwannon and the standing Yakushi (Plates 155, 156, 167) to the year 759, when the Chinese scholar-priest Ganjin founded Tōshōdai-ji and erected the Kondō, where they stand. But the Japanese names of Chinese sculptors whom Ganjin brought with him are perhaps less certain. According to the temple record *Shōdaiji-konryu-engi*, Gijō (in Chinese I-ching) modeled or superintended the modeling. Donjō (T'an-ching) and Shi-taku (Ssŭch'a), pupils of Ganjin, are said to have made the inner framework. But on the lotus base of the image are inscribed the names of two Chinese priests: Jōfuku and Ijō, together with those of two Japanese sculptors, pupils of Gijō: Oto-maro and Hirotari. The importance of the casual records and inscriptions is less a matter of individual names than it is proof of the integration of sacred and secular activity, with Chinese and Japanese working together toward a common end.

Iconographically unique among surviving Tempyo images, this Roshana is seen in its proper eighth-century setting. Standing in the Kondō before it today, one is enveloped by the very atmosphere of Tempyo and, as nowhere in China, one is able to conjure up the grandeur of the lost temples of T'ang.

Gyōshin Sōzu Plates 138, 139
Hollow lacquer, lattice support
H. 2′ 11 3/5″
Yumedono of Hōryū-ji, Nara

Gyōshin lived at various times at Yakushi-ji and at Gangō-ji. He was made Risshi (Bishop) in 738 and in 747 Dai Sōzu (Lord Abbot). Three years later he died at Yakushi-ji in Shimotsuke no Kuni where he had been banished because of his "evil character" and mysterious powers. In 739, where Shōtoku Taishi's palace, hard by Hōryū-ji, had fallen into decay, he built the Yumedono to house the incomparable Suiko Kwannon that, rarely shown, is still enshrined there. His name has always been associated with the whole Tō-in group of which the Yumedono is a part, and it was there that his pupil Kyonin performed ceremonies in his memory in 767–769. Though history is silent on the subject of the portrait statue it may have been made for those same ceremonies.

Within the last few years, Mr. Kobayashi of the Museum at Nara has thrown some doubt on this simple history. He points out that, though the figure is of dried lacquer in the approved Tempyo manner, and like the Roshana at Tōshōdai-ji and the Yakushi of the Saien-dō at Hōryū-ji was made over a wooden cage, it is not in proper Tempyo style. A cross section of the drapery, for instance, seems more like that produced a century or so later than of the date commonly ascribed to the portrait. The question is still unsettled.

LACQUERED WOOD CORE

PLATES 140–164

Miroku Bosatsu and Halo Plates 140, 141
 Miroku Plate 140
 Wood core, lacquered
 H. 2′ ⅝″
 Halo, reverse side Plate 141
 Wood with lacquer appliqué
 H. *circa* 2′ 4″
Kofuzō of Hōryū-ji, Nara

Although this image is of unknown date, some scholars have believed it to be the earliest example that remains in the solid wood core technique. The process seems to have begun about the middle of the eighth century. A rival claimant — and certainly earlier — is the later of two Suiko Miroku at the Kōryū-ji, Kyoto, hand against cheek and one foot suspended, which wears a lacquered leather scarf. But that is perhaps the prototype — a wood carving with lacquer incidental. Here, however, the core was not fully carved in detail, for the scarves and other protuberances were added by the modeler in lacquered cloth over plain surfaces. The necklace and hair are rendered in lacquer paste, as was always done on lacquer covered figures.

 The halo is unique. The reverse side is elaborately embellished with a design immediately recalling Chinese bronze mirrors of the fully developed T'ang style, a phoenix swinging a bejeweled ribbon with its beak. That the symbol was a favorite one in the imperial household we know from its frequent occurrence on brocade, musical instruments, hair ornaments, and other objects as well as mirrors in the Shōsō-in. Examination will show that there was no wood carving at all beneath the lacquer putty decoration and the folded cloth, for in places they are missing and show the flat surface of the board below.

Amida Nyorai (central figure of the first
 Dempō-dō Triad) Plate 142
Wood core, lacquered
H. 3′ 11″
East Wing, Dempō-dō of Hōryū-ji, Nara

It is on record that in 739 — the same year he erected the Yumedono — the priest Gyō-shin (Plates 138, 139) built the Dempō-dō within the confines of the palace given by Tachibana Fujin for sacred uses. The great lady's bequest had followed that of the widow of the saintly Prince Shōtoku whose palace, not a bow-shot distant, had become a nunnery. This building was at first called the Kōdō of the Tō-in group that lies about three hundred yards from the main enclosure of Hōryū-ji monastery. The Hōryū-ji *Tō-in-shizai-chō* records that the original name was changed to Dempō-dō on the first day of the tenth month of 761. Three Amida trinities now in that hall are likely to have been in place on that day, and the twenty-one-year interval between the foundation and the change of name supplies an uncommonly precise date for the group.

Of the two Amida Nyorai of the East Wing, one (Plate 142) is the central figure of a triad with the hollow lacquer Kwannon and Seishi already described in Plates 127 a and b, and despite difference in technique may form an original group with these. Not only do they all possess the proper proportion each to the other, but they exhibit a kinship in dignity and refinement and a common fluid quality in modeling and drapery treatment. Furthermore their pedestals are of like design.

This Amida and all six figures that comprise the other Dempō-dō triads are in the transition stage of lacquered sculpture. Instead of a hollow shell supported by a branching armature, a solid wooden figure is carved, and over it lacquered cloths are laid, sometimes in as many as four layers, above which again details — such as hair and jewelry — are added in lacquer paste.

These seven solid examples (Plates 142–148) — or eight when the figure of Yakushi (Plate 149) is added — still depend for their outward appearance on the modeler's rather than the woodcarver's technique, and the modeler's curves and edges are obvious. No other group quite like these is found in the Nara temples, so that the "Dempō-dō style" is sometimes referred to as unique.

Amida Triad (second) Plates 143, 144
Wood core, lacquered
 Amida Nyorai Plate 143
 H. 3′ 10″
 Kwannon Bosatsu Plate 144 a
 Seishi Bosatsu Plate 144 b
 H. 5′ 3½″, and 5′ 2″
East Wing, Dempō-dō of Hōryū-ji, Nara

This second Amida triad of the Dempō-dō is all of the lacquered wood core method and, with a shade less of sophistication, hangs together in style as convincingly as the triad just described. Here again the proportions as we see them today are injured by the fact that the lotus pedestals lack their original petals

— and also by the addition, in the Tokuwaga period, of a cumbrous halo.

Stylistically the affinities of these three figures are definitely with the third rather than the first of the triads, the pairs of Bodhisattvas (Plates 144, 146) particularly being almost interchangeable.

Something of the appearance of the original lotus pedestals for all the Dempō-dō figures may be gained by reference to that of the little Kokuzō at Gakuan-ji (Plate 154), though it is known to have been restored in the Kamakura period.

Amida Triad (third) Plates 145–148
Wood core, lacquered
 Amida Nyorai Plate 145
 H. 4′
 Kwannon Bosatsu Plate 146 a
 Seishi Bosatsu Plate 146 b
 H. 5′ 1″ and 5′ 2″
 Pedestal Plate 147
 Halo Plate 148
 H. 3′
West Wing, Dempō-dō of Hōryū-ji, Nara

Like the other triads in the Dempō-dō (Plates 142, 127 a–b, and 143, 144), these three figures — again Amida, Kwannon and Seishi — are all suited each to the other in style and proportion. They are all brilliant with gilt, some of which seems to be original.

The pedestal of the main figure is shown (Plate 147) to illustrate the embellishment of the central drum and of the top step with a flower design that is close kin to the stone carvings of contemporary China. As in the other two triads, this pedestal has lost the painted wood lotus petals that once were fixed in the holes of the upper unit.

Traditionally the elaborate gold lacquered halo is assigned to the Amida of this third triad, though it may be by a different hand from that of the image. In any case enough remains of the masterful openwork design of creeper, lotus flower, solar ray, and flaming

tendril, to show Tempyo decoration equal to the best work of T'ang. Allowing for scale, it closely resembles the flaming floral motifs of the great halo of the Sangatsu-dō Fukū-ken-jaku Kwannon (Plate 111 a).

The survival of this beautiful, if fragmentary, halo enables us to imagine the glory of these three Amida triads in wood, lacquer, and gold. It is of some significance to remember that they consecrate a spot associated with the Lady Tachibana whose miniature bronze shrine dedicated a century earlier to the very same trinity (Plate 13) is also preserved in the Hōryū-ji.

Yakushi Nyorai Plate 149
Wood core, lacquered
H. 2′ 8″
East Wing, Dempō-dō of Hōryū-ji, Nara

This single image of Yakushi, without attendants, is closely related to the Amida trinities in the same hall. With the central figure of the first and all figures of the second and third, it brings to a total of eight the lacquered wood core images found in the Dempō-dō.

Despite the fact that the modeling of the upper torso suggests that of the Jogan period, and although in the past it has been labeled "Fujiwara" by the Nara Museum, associations of craftsmanship have led to its inclusion here.

Yuima Koji (Vimalakirti) Plates 150, 151
Wood core, lacquered
H. 3′
Hokke-ji, Nara

If anything were needed to contradict the Western idea that Far Eastern artists were not interested in representing humanity and therefore were incapable of it, this figure of an old Indian sage would suffice. For here is a true portrait, not of course taken from life, since he lived in India a thousand years before Tempyo, but from the vivid knowledge in the

artist's mind how to recall his own impression of a layman so wise that he was selected by the god Monju to persuade the uninitiate. The hands, now empty, held the long curved sceptre which Buddhist abbots sometimes carry and which seems to have been the symbol of one explaining the Law or delivering a discourse.

Of all the stories and marvels in the Buddhist sutras, that in the Lotus of the Good Law which tells of Yuima has been used in Japan more often than any except those of the life of Buddha himself. The text that recounts Yuima's converting the thousands who gathered, without crowding, in the little four-and-a-half mat room is a favorite of the Zen sect and has been taken over by the adepts of the tea ceremony to express their fundamental principle. Zen and tea, both coming into popularity much later than the making of this portrait, are perhaps the most adequate expressions of certain characteristics that make Japanese history. It is important to find, so early as the Tempyo period, the germs of it in one of the most significant and vivid of their works of art.

Two formal blocks of wood form the core of the seated figure, one set upright and the other, which is the flat lap, laid horizontal before it. All the drapery and the modeling is superimposed on the wood in layers of thick lacquered cloths worked while still plastic. Hence the figure is an example of the pure manner of the modeler and its surface owes nothing to the carver of wood. The head covering and right knee show some repair. The date of making of this figure is quite uncertain, though the year 747 has been suggested. Whether one can be so precise or not, it is one of the earliest in this technique and not very long before the middle of the eighth century.

Two other great portraits, those of Gien (Plates 159, 160) and Ganjin (Plates 123, 124) have similar poignant individuality and power. Both of them are surely later than this of Yuima.

Hokke-ji was founded by Kōmyō Kogo's order on the twenty-third day of the twelfth month 759. But there is neither history nor tradition which associates this statue of Yuima with Hokke-ji in early times. The fact that the temple records do not mention it rather suggests that it was brought there for shelter when its proper temple burnt. The nuns of Hokke-ji who hold it in custody today regard it with especial reverence.

Nikkō Bosatsu Plate 152
Wood core, lacquered
H. 2′ 6½″
Tokyo National Museum; formerly in Kōzan-ji, Kyoto

Studied in relation to Gakkō, its companion (Plate 153), the formal construction of this image is clear. By reference to the more wrecked example one sees at once that the supporting armature has by no means taken over control of the surfaces from lacquered cloths. A generation later the completely carved wood surfaces are overlaid by cloth dipped in lacquer, and at length by lacquer alone.

One interesting detail can be noticed in the hanging foot where the missing toes expose a horizontal wood shelf supporting modeled toes of lacquer and clay and sawdust over which is the lacquered cloth skin. The gown where it falls abruptly over the edge of the seat has no wood core but was made of hemp cloths lacquered together and convincingly molded while the stuff was soft.

There seems every reason to accept the ingenious idea of modern Japanese scholars that this figure and its companion once formed a trinity with the better preserved Kōzan-ji Yakushi Nyorai (Plate 174). The theory does not necessarily imply that they were originally such — and the somewhat different technique of the Yakushi would argue against it. The Nikkō and Gakkō were indeed at one time together at the temple. Of the history of

the Yakushi nothing is known. As for the temple itself, it was founded by Myō-e Shōnin (Kōben) in the Kamakura period on the site of the Jingō-ji Jugu-ji-in which was built at the end of the eighth century and later destroyed. It is quite possible that these images, all or in part, were inherited from the earlier monastery.

Gakkō Bosatsu Plate 153
Wood core, lacquered
H. 2′ 6¾″
Tokyo Art University; formerly in Kōzan-ji, Kyoto

This figure, wrecked except for the head, preserves none of the splendid poise and contour it once had and which mark its companion (Plate 152) now exhibited at the National Museum across the Park in Tokyo. If our chronology is correct they were made by the eighth-century Nara artists somewhat later than the mid-century dried lacquers of the Sangatsu-dō. For those are supported by simple uprights and crosstrees typical of early examples, whereas these figures are more fully carved and have a thicker upright support; the thicker arms are fully shaped and the wood core begins to control the outer appearance. Lacquered cloths are no longer hung on an armature; they follow the wood contours or at least the surfaces rounded by lacquer paste over wood.

Kokuzō Bosatsu Plate 154
Wood core, lacquered
H. 1′ 8½″
Gakuan-ji, Nara

One of the smallest lacquer images of any type to have come down to us from Tempyo is the Kokuzō owned by Gakuan-ji. According to an inscription on the pedestal, added in 1282 when the figure was restored, recolored, and reconsecrated, it was brought from China

in the Tempyo period by the priest Dōji. There is, however, a tradition to the effect that it was made in Nara at Dōji's order.

It is not rare in Buddhist art to meet with the assignment of the source of a sacred image to the Holy Land — be it China, India, or Heaven — even though the materials of its construction might be recognized as locally derived. See story of the divine origin of the Senju Kwannon (Plate 155). It seems probable on stylistic and technical grounds that this figure was made in Japan.

All sculptural detail is that of the modeler with lacquered cloths, the hidden support is merely a core of wood without detail. The drapery about the knees is repaired and lacks the extraordinary delicacy of the scarves above. (The lotus throne dates only from Kamakura.)

Senju Kwannon Plates 155, 156
Wood core, lacquered
H. 17′ 6″
Kondō of Tōshōdai-ji, Nara

According to one legend, a divine spirit descended to the earth to take its abode in the living body of one Takeda Sakome. With the human hands of Takeda, the spirit made for the Kondō of Tōshōdai-ji the astounding image of Senju with its thousand arms.

It stands over seventeen feet high and provides a study of profound interest. Its bristling arms, said to be a thousand and now actually nine-hundred and fifty-three, seem to frame the upper part of the body in a complicated nimbus so unnatural as to be almost repellent to Western eyes. Thrust out from among the nine-hundred and eleven smaller stiff wooden arms with their spatular hands, are forty-two longer hollow lacquer arms holding the variety of attributes associated with the Senju Kwannon. These hands are exquisitely carved and gold lacquered. The objects they carry, all restored, are the symbols enumerated in the texts: the rope, the swastika, sun and moon,

ax, arrows, mirror, holy water flask, *vajra*, sword, fly whisk, begging bowl, wheel of life, staff with jangling rings, lotus bud, and the rest. On the crown are nine small heads and a full length statuette (restored) of Amida, the spiritual progenitor.

Behind the tall figure and lost to sight behind the maze of arms is an elaborate halo of pierced gilt woodwork which is said to have been interchanged by mistake with that behind the nearby Yakushi Nyorai (Plate 167) at the time of the last repairs in the seventeenth century. A rubbing made from this halo is shown on Plate 203 b.

An inscription of 1185 on the foot records the overthrow of the image in the seventh month of that year and its repair two months later. Further repairs were made in 1270 and by Seikei in 1395. The present over-all effect, however, cannot be thought to be essentially different from its appearance in the eighth century.

Three of Twelve Guardians of Yakushi (Juni-jinshō) Plate 157
Wood core, lacquered
H. *circa* 3
Yakushi-dō, Takatori-mura, Shiga

There have come down to us from Yakushi-dō at Takatori-mura, Shiga Prefecture, three wrecked late Tempyo woods, individually unidentifiable, from a series of the Twelve Guardians of Yakushi. The bold carving and latent power in the heavy-set bodies of these all but armless three show that the sculptors of Japan had lost nothing of their life-giving touch. They retain enough of their original lacquered cloth surface and are carved in enough detail to suggest that they were made at the close of the period of transition from roughly shaped solid supports for lacquer sculpture into completely carved woods. All such details as armor, scarves, and hair in these figures can be clearly seen in their breaks to be of lacquered cloth. In stance and proportion

and in the fact that the pedestals are one with the figures, there is further stylistic and technical evidence for attributing them to the last quarter of the eighth century, or perhaps a year or two into the ninth when the deity they guard (Plate 192) is believed to have been made.

Two Heavenly Kings Plate 158
Wood core, lacquered
H. *circa* 3′
Tōin-dō of Yakushi-ji, Nara

Similar to the Yakushi-dō examples (Plate 157), but in a worse state of preservation, are two kings or guardians of uncertain iconography from the Yakushi-ji Tōin-dō. Their comparatively clumsy appearance may be due to almost complete loss of lacquered covering. On close examination, however, it is seen where such details as breastplates and greaves were attached. From the condition of these two and the preceding three figures one can see how the carver of the wood core approximated the final image and how the lacquerer perfected it.

Gien Sōjō Plates 159, 160
Wood core, lacquered
H. 3′ 3⅜″
Oka-dera, Nara

The *Genkō-shakusho*, written by Kokan Shiren in 1321–1323 gives the following account of Gien Sōjō. "The Abbot Gien was born in Yamato in the middle of the seventh century. . . He became a disciple of Yuishi-ki, and went to China where he studied the Hossō mysteries. On returning to Japan he preached the Hossō texts and among his many disciples were the famous scholars Gyōgi, Dōji, Gembō, and Ryōben. He was not only a scholar, but was interested in the building of temples, having some skill in their actual architecture. He built Ryūkai-ji, Ryūmon-ji and Ryūfuku-ji. In the third year of Taihō (703) he became Sōjō (Abbot) and died in 728."

It is interesting to speculate on the attitude of the iconographer who made a portrait statue of a man whom he probably never saw and who added to that human wrinkled visage, the enormous pierced ears that so often mark divinity. The image was undoubtedly intended for respect and even for periodic offerings and services on appropriate anniversaries, but one wonders whether it was meant for such worship as icons of the gods receive. The portrait was made at least seventy-five or more years after his death and may even be of a later date than the Tempyo period.

Unlike the other memorial portraits of priests in lacquer (Plates 123, 138), this one has a solid wood core, but the superimposed layers of lacquered cloth transform it into a plastic rather than a carved figure.

Shō Kwannon Plate 161
Wood core, lacquered
H. 6′ ¾″
Kōdō of Tōshōdai-ji, Nara

By its very wrecking, this wooden figure, originally covered with lacquered cloth, is of the greatest significance to the student of the development of lacquer techniques during three-quarters of a century. For the lacquer and cloth are, in parts, missing and expose the roughly shaped wood core on which had been painted lines of white to guide the lacquerer when he came to fold his cloth into the drapery ridges on the surface. These white lines can be seen at the garment's edge between the feet. In certain details the guides run counter to the folds above, showing that the carver's plan was changed by the lacquerer.

This technique represents a stage earlier than that of figures so completely carved that the cloth and lacquer had become a mere skin.

Bodhisattva Plate 162
Wood core, lacquered
H. 6′ 1⅛″
Tōshōdai-ji, Nara

LACQUERED WOOD CORE

This Bodhisattva, having lost its attributes, can no longer be identified. Here again the wrecked condition permits study of one of the important techniques of the late decades of the eighth century. The arms were mortised just below the shoulders and again at the elbows. Long flat slats shaped into scarves were originally tacked to shoulder and elbow, reaching the pedestal. Except for such details, the figure remained essentially a single trunk of *hinoki*, the cypress-like conifer that is possessed of the admirable straight grain and soft quality for carving. The top member of the lotus pedestal was part of the whole image (a fact more easily observed in the preceding figure), and one can visualize apprentices sawing the deep crosscuts above the level pedestal top, below the bottom hem of the gown above the feet, and a similar cut for the square shoulders. Later the master shaped the feet, the formal lengthwise ridges that he had spared from the trunk for scarves and skirt, and last of all the head block.

Ju-ichi-men Kwannon Plates 163, 164, 166b
Wood core, lacquered
H. 6′ 11″
Shōrin-ji, Nara

This splendid image of Ju-ichi-men — the Eleven-Faced Kwannon — once graced a temple under the jurisdiction of Omiwa-jinja, a Shinto shrine where it had been the principal Buddhist image in the Ryōbu-shinto ritual. At the time of the disestablishment of government support for Buddhism in the early 1870's and coincidentally with the destruction by fire of others at the Yakushi-ji not many miles away, this image was cast out into the road where for some time it remained shelterless. Horrified at the sacrilege, a number of the local people spirited it away and it was taken in by the Shōrin-ji, a nearby temple, where it is now the principal object of worship.

It is a pity that no record remains of the origin of Omiwa-jinja — we know only of its hoary antiquity as a Shinto shrine. Of the Buddhist side of the story we know nothing.

The solid wood column from which the figure is constructed is tempered in its starkness by three scarf loops, one tucked in at the chest, two dipping down across the thighs, and by the deep rippled molding of the skirt below the knees. An effect of lightness is achieved through the long scarf ends that fall free from the arms and curve in at the pedestal. It is fortunate that, despite vicissitudes, this image still retains these original scarf ends of lacquered molded pleats on wire ribs, for they bring to mind a similar feature of the noble Fukū-kenjaku Kwannon of the Sangatsu-dō (Plate 108). The scarf loops and other drapery on the body parallel like details on another image, the lacquered wood Ju-ichi-men of the Kwannon-ji in Kyoto (Plates 165, 166 a).

Less fortunate than the image itself, the remarkable halo (Plate 164) is but a sad relic of its former elaborate glory. It is of wood strapped with iron. Some of the petals (above the crossbar) were deeply and elegantly carved in wood. Others (falling over the crossbar) were thick layers of molded lacquered cloths with no carving beneath. Still other techniques are shown in the same plate by the fragments above and below. They are parallel wires (upper left) webbed with twine over which lacquer was spread to make a broad ribbon, and single wires (lower right) along which lacquer paste was pressed to represent cords. Altogether with its multitude of ingenious techniques and complicated assemblage and the spirit and delicacy of its carving, this halo no less than the deity which it enhanced represent the Tempyo period at its very flower.

125

LACQUERED CARVED WOOD

PLATES 165–176

Ju-ichi-men Kwannon Plate 165, 166 a
Carved wood, lacquered
H. *circa* 5′ 9″
Kwannon-ji, Fugenji-mura, Kyoto

According to tradition this temple of Kwannon was built by Ryōben for Shōmu Tennō in the sixteenth year of Tempyo (744), a year or two before the completion at Tōdai-ji of the Sangatsu-dō.

The eleven-faced Kwannon of this temple, a fine example of lacquered carved wood sculpture, was restored in 1908 by Chunosuke Niiro. Scarf ends, right hand, and appurtenances including headdress are new. The wooden figure itself is well preserved, so that comparison may be made with the Fukū-kenjaku Kwannon, despite its being twice as tall, as well as with the Shōrin-ji Ju-ichi-men nearer in size and identical in iconography. The similarities in these three figures (compare for instance their noble faces as seen in Plates 109 a, 166 a, and 166 b), emphasize existence contemporaneously in the middle of the eighth century of the three principal lacquer techniques: hollow lacquer, wood core with built-up lacquer surfaces, and lacquered carved wood. There was undoubtedly, however, a gradual shifting in popularity in these techniques in the order named.

Yakushi Nyorai Plate 167
Carved wood, lacquered
H. 12′ 1⅛″
Kondō of Tōshōdai-ji, Nara

This great image, attributed to a Chinese monk who came in Ganjin's train, is said to be made of lacquered and gilded cloths over a more or less detailed wood core. The oval nimbus surmounted by a circular halo is largely stripped of its dried lacquer ornament, but even as it was originally enriched, its plainer and flatter look would have seemed more appropriate for Senju Kwannon (Plate 155) in the same hall. The possibility of a mistaken exchange of halos has already been noted. A rubbing of the one which is believed to be the correct halo for this image is illustrated in Plate 203 b. The left hand of the Yakushi Nyorai and the lotus petals are not original.

The image has suffered from at least two restorations, the first of which may have served to destroy much of its character. During the second, my friend the late Mr. Sugawara of the Nippon Bijutsu-in found to his surprise that the shape of the gown which stops a little above the feet in apron-like folds did not in the least correspond to the carved wood core beneath. Either the whole thing had been stripped and wrongly restored (which close examination does not suggest) or else the sculptor had changed his mind about the garment between carving the wood and applying the lacquer cloths. Folds which in the wood core run in horizontal loops were quite filled up with dried lacquer paste and made into either plain surfaces or ridges and hollows running up and down.

The pattern and cross section of the drapery

resembles so closely those of the other two colossal images in the Kondō (Plates 136, 155) that the three would seem to have been made in the same workshop.

Shō Kwannon Plate 168
Carved wood, lacquered
H. 4′ 11½″
Dairyū-ji, Kobe, Hyōgo

This figure has formerly been attributed to the early years of the Tempyo period, because of the flat arch of the eyebrows and the formal oval of the face as well as the height of the figure in proportion to its head.

All things considered, however, and in spite of the face which reminds one of mid-century hollow dried lacquer rendered in wood, I see no valid reason for a date earlier than the last quarter of the eighth century to which a number of the wooden figures in Tōshōdai-ji are usually assigned (for example, Plates 161, 162, 177, 178, 180, 181).

Though considerable repairs have been made, some of the details of the lacquered surface cloths, for instance, on the bare midriff and the scarf across the chest, remain. By rare good chance, the scarves that hang from the elbows, separate pieces of wood, remain.

Head of Buddha Plate 169 a Plate 169
Head of a Bodhisattva Plate 169 b
Carved wood, lacquered
H. 1′ 11¼″ and 2′ 5″
Kōdō of Tōshōdai-ji, Nara

These two large heads and two others at the Hokke-ji (Plate 170) must have been made during the last quarter of the eighth century when the difficult and expensive process of hollow dried lacquer image-making had been abandoned in favor of wood cores more or less detailed. From their scale, they are believed to have belonged to a group of images measuring, if erect, sixteen feet, the canonical *joroku* proportions. They were designed by the woodcarver and finished up to the point of adding a close-fitting skin of lacquered cloth

nicely tailored to the carved surface, and above that, further details such as hair and jewelry in lacquer paste. Only patches of the lacquer skin remain, with the result that we have an unparalleled opportunity to examine four examples from the earliest years of a technique that, with differences, has lasted to the present day. From the latest of the empty shells of lacquered cloth supported on branching armatures, to the days of these solid wood carvings finished in cloth and lacquer, was a span of about half a century.

Two Heads Plate 170
 Head of Taishaku-ten Plate 170 a
 Head of Bon-ten Plate 170 b
Carved wood, lacquered
H. 2′ and 2′ 1″
Hokke-ji, Nara

These two heads, of the same scale as the two in the Tōshōdai-ji Kōdō just described (Plate 169 a, b) are of like technique and were undoubtedly from figures attendant upon a *joroku* Buddha. They date likewise from the last quarter of the eighth century.

Yakushi Nyorai Plate 171
Carved wood, lacquered
H. 4″
Jingō-ji, Kyoto

After 770 with the death of Empress Shōtoku who had aided in the unsuccessful plot to place her minister Dōkyō on the throne, her successor Emperor Kōnin carried out the order of the oracle at Usa, Kyushu, that a temple be built to protect the Imperial line. This temple was first called Jingan-ji ("temple built by God's command") but in 825 its name was changed to Jingō Kokusai ("Divine protection of the country") and finally contracted into Jingō-ji.

The temple owns an important image of Yakushi — formerly identified as Shaka — one of the later and most highly developed wood carvings to be covered with lacquer cloths. Possibly made after 794 when the capi-

tal moved to Kyoto, this figure retains much of the modeler's soft curves prevalent when surfaces were the result of modeling in plastic material rather than of chiseling wood. It is interesting to find that cloths are actually very thin over the surface and that the woodworker has been unconsciously influenced by his forerunners who were modelers rather than carvers. The webs noticeable between the fingers are characteristic of earlier sculpture.

Despite the missing curls and repairs to the left arm and lower portions of the robe, the image is a fine example of the transitional work made between the flourishing of dry lacquer and wooden sculpture, and bridging the Tempyo and Jogan periods.

Four Buddhas　　　　　　　Plates 172, 173
　　Hōshō Nyorai　Plate 172 a
　　Amida Nyorai　Plate 172 b
　　Shaka Nyorai　Plate 173 a
　　Ashuku Nyorai　Plate 173 b
Carved wood, lacquered
H. *circa* 2′ 5″ each
Saidai-ji, Nara

It is likely that the four seated Buddhas of Saidai-ji, the earliest such set extant, were made for a now lost pagoda, each facing a point of the compass. They have been on view for a number of years at the museum in the Deer Park.

All are made on wooden cores carved definitely enough to influence strongly the modeling of the lacquered cloths which form the drapery surface. In fact, technique and style combine to make it seem possible that they were made as much as a decade after the Tempyo period came to an end in 794. At any rate, the formula to which the carvers obviously conformed, their canons of proportions, the shaped edges of drapery folds, the curved eyebrows, the form of nose and eyes, all are those of the end of the eighth century.

The original gold leaf on the bodies and the blue *gunjo* pigment on the hair remain to an extent unusual for sculptures of that time.

Yakushi Nyorai　　　　　　　Plate 174
Carved wood, lacquered
H. *circa* 2′ 5″
Kōzan-ji, Kyoto

Though not usually associated with the four seated Buddhas of the Saidai-ji in Nara, the Yakushi Nyorai of the Kōzan-ji in Kyoto bears remarkable likeness to them in size, technique, and style. Like them it may be placed at the very end of Tempyo or even a decade later. Its possible association with surviving images of Nikkō and Gakkō of somewhat different technique is discussed in connection with Plates 152–153.

Bon-ten　Plate 175　　　Plates 175, 176
Taishaku-ten　Plate 176
Carved wood, lacquered
H. 6′ 2¼″ and 6′ 3″
Kondō of Tōshōdai-ji, Nara

The block-like proportions of this pair, combined with the peculiar cross section of the drapery folds, place them in the closing years of the Nara period or the decades immediately after. According to one temple tradition, they were made by Gumpo-riki, one of Abbot Ganjin's Chinese craftsmen who is said to have carved the Shi-tennō (Plates 197–199) on the same altar.

That they were conceived to be essentially wooden sculpture is obvious. They are included here as illustrating the last stage in the transition from the hollow lacquer technique to that of the wooden figure carved in all its detail.

The two figures, though over life size, are dwarfed by the three great deities with whom they are now grouped, flanking Roshana in the center. Some of the thousand Buddhas in the latter's nimbus show behind Bon-ten in the upper left of Plate 175. In the same relative position behind Taishaku-ten in Plate 176 are seen many of Senju Kwannon's thousand hands.

129

WOOD (TEMPYO AND POST-TEMPYO)

Four Bodhisattvas Plates 177–181
 Shishiku Bosatsu Plate 177
 Shūhō-ō Bosatsu Plates 178, 179
 Daijizai Bosatsu Plate 180
 Ju-ichi-men Kwannon Plate 181
Wood
H. 5′ 7⅛″ to 6′ 3⅛″
Tōshōdai-ji, Nara

The wooden sculpture of Ganjin's Tōshō-dai-ji taken as a whole presents one of the most clearly defined styles or "schools" of sculpture which appeared during the Tempyo period.

That it differs markedly from that of Tōdai-ji is due in part to the fact that when he arrived the latter was already well-established and furnished with proper images, in part to the fact that the majority of its surviving figures are of wood, and in part to the fact that most of them are later by a few decades.

It was in his new temple that Ganjin settled the group of Chinese image-makers and craftsmen, and there it was that they brought fresh influence direct from the soil of China to the soil of Japan. Beyond a doubt, the school they founded was infused with the spirit of high T'ang — and it appears to have flourished and to have drawn again on China during later T'ang when most of the Tōshō-dai-ji woods were carved.

This school, or guild of Chinese image-makers, their sons and apprentices, undoubt-edly thrived for decades, forming, in truth, a living organism transplanted.

In view of this fact our loss seems all the greater if it is indeed true that no wooden sculpture remains in China of that time. But under the grosser forms of a later age and beneath the gesso and crude colors of certain Chinese woods one sometimes receives a flash, a suggestion, of the prototypes of the Tōshō-dai-ji school.

The four figures on Plates 177–181 demonstrate the character of the late Nara trend and the height reached. Each is definitely conceived in the log-carver's technique with heads, feet, and pedestals as one. The fact that thin lacquered cloths may have been, in some cases, spread over parts of the surface, that over others there was a mere paint film, and that hair and jewelry of lacquer paste were frequently added, does not alter their essential woodenness.

From the preceding seventh century there remain not only records of wooden sculpture preserved in the temple lists but actual examples. After that, though the lists record them, none remains that can be dated with any certainty during the half century before Ganjin founded Tōshōdai-ji in 756. If the dates could be traced, some of the dramatic masks, earlier than those made in 752 for the consecration ceremonies of the Daibutsu, would perhaps be found to have been carved during that fifty years and would throw light on the prevailing

style of heads and faces at least. Wood carving in relief does indeed exist among halos and pedestals for lacquer figures, and their wooden arms and hands are of course in the round. Thus it can hardly be that those historians are entirely correct who write that wood sculpture went quite out of fashion for fifty years only to be resumed after the middle of the century. Fires in the temples have been distressingly common in the last thirteen hundred years and the wonder is — even though she was spared the bursts of iconoclasm that flared up in T'ang — that Japan did not lose its entire population of wooden sculpture as did China.

One has but to compare the imposing figure of Shishiku (Plate 177) with the earlier Bodhisattva of lacquered wood core (Plate 162) in the same temple or the better preserved Ju-ichi-men Kwannon of Shōrin-ji (Plate 163) to see that here is newly developed abstraction and no decadence. The near-fleshly beauty of such earlier Tempyo Bodhisattvas is succeeded by a less human and more godly form. One would be tempted to emphasize the calligraphic draperies rendered under influence of painting, were the looming wood bulk not so strong.

Shūhō-ō Bosatsu (Plates 178, 179) is likewise typical of the group. The rear view is shown to give an idea of the tree-trunk simplicity which is the essence of Tempyo and Jogan figure making, as it was in Suiko. Seen from the front, even the loss of the forearms, which had been mitered to the columnar body, makes it more instructive. One can see here how deceptively shallow the long sweeping knife strokes in reality were, and that the deep crosscuts were only those at the square shoulders, down to the neck on either side, and under the elbows and between the hem of the robe and the top of the pedestal on which the feet, still one with the base, jut out. It is particularly interesting to note that the front scarves bridging the gap from knee to knee were undercut but have broken away.

The Ju-ichi-men of this group (Plate 181)

suffers from restoration of the extended right arm, the side draperies, and the flat, fussy crown. But the original carving of cloth folds and the manner in which they enhance the formal torso give us wood sculpture at its best.

Daijizai Bosatsu (Plate 180), the most battered of the group, by its very condition aids us in appreciation of the massive dignity inherent in all four.

The original designations for the figures in Plates 177 and 178, called here Shishiku and Shūhō-ō, are uncertain and are sometimes interchanged.

Taishaku-ten Plate 182 Plates 182, 183 a
Bon-ten Plate 183 a
Wood
H. 5′ 2½″, 5′ 1¾″, respectively
Tōshōdai-ji, Nara

Scholars have pointed out that the Bon-ten and Taishaku-ten shown on Plates 183 a and 182 respectively were definitely a pair, not only because they usually stand together attendant on Kwannon, but also because among all the extant wooden images of this particular subdivision of the Tempyo style, this pair alone is assembled each from three vertical slabs trunneled together with wooden pegs before carving. To hide the joints there were lacquered cloths over portions of the bodies. The iron staples to be seen in the Taishaku-ten are later repairs.

The device of assembly of multiple parts to form a single image is unusual before the late Heian, or Fujiwara, period and in Kamakura it became commonplace. Our present examples are noteworthy prototypes for images so made.

Unidentified Bodhisattva, fragmentary
Plate 183 b
Wood
H. *circa* 3′
Tōshōdai-ji, Nara

WOOD

The unidentified erect Bodhisattva, also preserved at Tōshōdai-ji, is headless, footless, and badly wrecked, but enough remains to assure us that it is of the same school as the other wood sculptures in the temple. It was probably not, however, so noble a figure as those of the four great Bodhisattvas (Plates 177–181), although made at approximately the same time. Like most of the others it was presumably covered with china clay and then colored.

Ju-ichi-men Kwannon Plate 184
Wood
H. 6′ 3″
Yakushi-ji, Nara

Opinions differ as to the dating of this particular image, some placing it as the earliest, others as the latest of the late wooden Bodhisattvas including the following Daian-ji group (Plates 185–190) and the Tōshōdai-ji group just discussed with which it is always associated. Yet of all the wooden figures that are roughly classified as being in the Tempyo style, this eleven-faced Kwannon seems to me to be the earliest that falls within the actual dates of the period.

Before the face was disfigured and before the addition of the unfortunate right forearm, the new feet, and the pedestal, this figure must have resembled the four erect Bodhisattvas at Tōshōdai-ji (Plates 177–181) as well as the five Daian-ji woods (Plates 185–190). It cannot with assurance, however, be considered as belonging to either school.

The *amrita* flask in the left hand is original.

Five Kwannon Plates 185–190
Wood
 Fukū-kenjaku Kwannon Plate 185
 Shō Kwannon Plate 186
 Ju-ichi-men Kwannon Plate 187
 Batō Kwannon Plate 188
 Yōryū Kwannon Plates 189–190
H. 6′ 2″; 5′ 6″; 5′ 6″; 5′ 8″; 5′ 7½″, respectively
Daian-ji, Nara

A mile down the road from Ganjin's new Tōshōdai-ji was the ancient establishment of Daian-ji rebuilt by the Abbot Doji thirty years before under its present name. (Its former names were Kumagori, Kudara-daiji, Takaichi-daiji, and Daikan-daiji.)

Dōji was a native of Nara who had studied for the priesthood at a famous T'ang temple in Ch'ang-an said to have been built in the Indian style. Bringing back the plans, Doji rebuilt Daian-ji on similar lines. Although we have no record that, like Ganjin, he brought Chinese builders and sculptors with him, it is believed that he did. The *Daian-ji-shizai-cho* of 747 records no wooden images, but mentions specifically eleven of bronze, two bronze shrines, some sixteen images of dried lacquer, and twelve images presumably of clay. In addition are mentioned masks, jewels, relics, sutras, screens, robes, and temple furniture now dissipated and presumably lost. The dates of these objects, where they are given, are 736 and 742. Unfortunately there are no dates for the unique group of five wooden Kwannon here shown.

These five different aspects of that deity are from the same workshop, if not, perhaps, of quite the same time, and a score of details in common mark them as a unit within their general style. They are further connected with each other by the fact that they compose an iconographic series, or part of one, devoted to the esoteric practices for the worship of the several aspects of the single divinity. This development of the Kwannon cult is well known and the names of the various aspects are recorded. But the actual practices and the lore connected with their worship have been largely forgotten. Three of them seem to be exceptional among erect Bodhisattvas in that they stand on conventionalized rocks rather than on lotus pedestals.

Nearly seven heads tall, these figures, like those at Tōshōdai-ji, are fashioned, head, trunk, feet and base, from single logs to which the branching arms were mitered and the looser parts of the drapery (now largely lost

or at best restored) were attached. The head of one, the hands of all, and most of their arms are new.

As with the Bodhisattvas at Tōshōdai-ji (Plates 177–180) color seems to have been added over a thin wash of china clay and glue with certain details probably eked out in lacquer.

The eight arms, hands, nose, and lips and the outer part of the pedestal of Fukū-kenjaku (Plate 185) are restorations. The hair below the fillet is direct woodcarving, but above it the details of hair were modeled in lacquer paste over a roughly shaped wood core. This image and that of Batō seem to have exchanged the delicacies of the other three for the boldness of the end of the century.

The left arm of Shō Kwannon (Plate 186) with its lotus, part of the right hand, and the erect chignon are restorations. The flat blocks, of one piece with the feet, are all that is left of the ancient rock-shaped pedestal on which the figure originally stood.

The entire head of Ju-ichi-men Kwannon (Plate 187) with its eleven faces, and both forearms and their drapery are restorations. The necklace, like those of Shō Kwannon and Yōryū, is of great delicacy, a refinement which, repeated in the detail, much eroded, shows on the lotus pedestal.

Batō Kwannon originally had three faces and a horse's head on the crown. It was sometimes represented with eight arms, sometimes as here (Plate 188), with six. Its attributes are the ax, bow, arrow, *vajra*, and praying hands. Its countenance is terrible to dismay evildoers but its nature is pitiful, as is the nature of every Kwannon. Originally it seems to have been associated with the Sivaic horse prevalent in Lamaism today. By the esoteric sects, little understood in the eighth century, it was sometimes know as Dairiki-ji Myō-ō and, perhaps mistakenly, as Shishi-mui Kwannon ("Fearful not even of lions") and was reckoned as one of the six related forms of Kwannon of which five remain at Daian-ji. During the sixteenth to eighteenth centuries it became the special protector of horses. If the restored arms and high chignon and side scarves are ignored the main form of the figure will appear as a splendid ample wood carving typical of the late Tempyo period and the Tōshōdai-ji school.

Yōryū Kwannon (Plates 189, 190), unique among the known images of this deity, is represented with the wrathful visage and open mouth properly associated with Batō Kwannon. It therefore seems probable that at some time in the past its name was changed. The right forearm and hand and the left hand are restorations, yet altogether this image has preserved more of its original appearance than the rest of the Daian-ji group. The face, viewed again and again, never seems to lose its awesome power.

It was once considered that this group and the Tōshōdai-ji group were contemporary and that the differences in style were to be explained by varying practices in different workshops. Yet both temples were within the capital city-limits. It now seems more logical to account for the differences by a gap in time, the Daian-ji group (or at least the three in Plates 186, 187, and 189) being the earlier by a few decades.

Nikkō Bosatsu Plate 191 a Plate 191
Gakkō Bosatsu Plate 191 b
Wood
H. 6′ 3″ each
Akishino-dera, Nara

As the principal deity of Akishino-dera long ago disappeared, we are rather at a loss how to attribute this pair from an iconographic point of view. If that deity was Yakushi, these indeed may represent the attendants Nikkō and Gakkō.

Pigment over whitewash, and certain areas covered by a thin lacquer coat, prove that the woodcarver depended on his own edges and curves for sculptural effect, and did not muffle them with folded cloths and lacquer. This fact suggests that the pair were made in the last

quarter of the eighth century, or toward the close of the Tempyo period. These same two and a half decades are also suggested by the proportions of the figures and their shallow drapery ridges with broad flat spaces between, which were originally broken up by the painted designs that represent brocade. The curiously conglomerate costume of Nikkō with cuirass, scarves, and drapery across knees and thighs affords points of comparison with guardian, Bodhisattva and Buddha types. All these suggest the end of the eighth century.

Yakushi Nyorai Plate 192
Wood
H. 5′ 11½″
Yakushi-dō, Takatori-mura, Shiga

This temple, of which only one rebuilt hall, the Yakushi-dō, remains, was according to tradition founded by Gyōgi at the command of Shōmu Tennō in 729 as Hokke-ji.

Under Kammu Tennō, Dengyō Daishi went there to worship on his return from China in 802. It is recorded that his visit was during the Enrayku era which came to an end in 806, so the date is fixed within the space of three years. On this occasion the buildings were enlarged and redecorated and, judging from their style, the main Yakushi Nyorai and the Jūni-jinshō which attend it, were made. Three of the twelve attendants (Plate 157 a, b, c) have survived.

The splendid proportions of this erect figure of Yakushi and its well-preserved condition should make it famous among its fellows. But, even in Japan, it has received little notice and is visited by few. It has all the main characteristics of the best full-blown Tempyo style at the close of the eighth century — and at the same time bears close resemblance to its contemporary bronzes in Korea. This brings up again the question whether, after all, the tide of influence may have been sent back from Japan toward Korea after the first half of the eighth century. For then Japanese artists were

firmly on their feet and seem to have produced more and greater masterpieces than the Koreans did.

A number of small Korean Buddhist bronzes and one tall one in the Keijo Museum might well have been the very models for this wood or the other way around. Indeed, in those years Japan could have provided the type by way of the little Kingdom of Mimana at the butt end of the Korean peninsula. However, a Chinese prototype was behind both, although no woods and no large bronzes in quite this style have survived in China proper. The characteristics are recognizable enough: a thick waist not yet, to our eyes, so clumsy as it was soon to become, great unwrinkled ovals of heavy clothing tight over the thighs, rounded eyebrows, and particularly plump feet, all add to the solid dignity of figures made toward the end of the eighth century in both Japan and Korea. It remains the log on end, scored in graceful rather shallow falls of drapery which, one imagines, inherit something of the curves from the modeler when he worked, a generation before, with lacquered cloths above a wooden core that lacked detail.

The great seated wooden Yakushi in the Kondō of Shinyakushi-ji — not illustrated separately but seen in the midst of the circle of its twelve guardians — seems to be of the same period and style. We are here very close to that indistinguishable borderline that separates, or fails to separate, the end of Tempyo from the beginning of Jogan. Inevitably, since there was no collapse nor decadence, Tempyo comes to a merging, not an ending.

Two Buddhas, standing Plates 193–195
 Yakushi Nyorai Plate 193
 Unidentified torso Plates 194, 195
Wood
H. 6′ 9¾″ and 5′ 10⅜″
Tōshōdai-ji, Nara

The fact that I have published one of these figures elsewhere as the prime example and

JAPANESE SCULPTURE OF THE TEMPYO PERIOD

type of the Jogan period which follows Tempyo, does not prevent my including them both here to illustrate the beauties possible in the new style toward which the eighth century was tending. Typical of the new style, they are splendid examples of sculptural proportion.

They should be studied for the cross section of the woodcarver's long drapery grooves that are, in these examples, even shallower and more regularly grouped than those of the Tempyo period proper. The obvious characteristic of this fresh style is the different pitch to the wall of the groove which, with its lengthwise taper and its curve, emphasizes the sheath-like garment around a pear-shaped body, and achieves a formal beauty quite independent of any resemblance to folds of cloth.

Two Buddhas, seated Plate 196
 Shaka Nyorai Plate 196 a
 Tahō Nyorai, fragmentary Plate 196 b
Wood
H. 2′ 6″ and 2′ 1″
Kōdō of Tōshōdai-ji, Nara

These two wooden figures were possibly the foundations for complete surfaces of lacquered cloth and for superficial details such as curls of lacquer paste. But, if so, all of these are now lost. Both illustrate the solid wood construction carved out of a single vertical block against which the crossed legs to make a flat lap were tenoned into the mortise holes that can be seen in the photograph (Plate 196 b). The grain of the lap ran horizontal and that of the trunk vertical, and thus corresponded roughly with the direction of the folds of the flat drapery. The right arm of each was mortised to the body, but the left was supported on the lap, if not indeed an integral part of the slab of which the leg was shaped. The cross section of the drapery folds betrays the style developed around the turn of the century when Tempyo merged with Jogan.

Iconographically this pair, Shaka and Tahō, in Sanskrit Sakyamuni, and Prabhutaratna, is of peculiar interest. Popular in China during the sixth century but rare in Tempyo, the two together recall a scriptural incident whereby the truth of Shaka's words was such as to cause the extinct Tahō suddenly to reappear.

Four Heavenly Kings (Shi-tennō)
 Plates 197–199
 Zōchō-ten Plate 197 a, 199 a
 Jikoku-ten Plate 197 b
 Kōmoku-ten Plate 198 a, 199 b
 Tamon-ten Plate 198 b
Wood
H. 6′ 2⅝″, 6′ 1″, 6′ 2⅜″, 6′ 2″, respectively
Kondō of Tōshōdai-ji, Nara

Although much restored on the sleeves, helmets, and weapons, there remains plenty of evidence, including gesso and painting directly on the wood, to prove that these four guardians were not mere supports for a cloth and lacquer skin. Additions to the solid tree trunk from which they were made were long and thin as in the knotted sleeves and the tails of the gowns which hang below the leather armor and give them a look which, in Europe, we associate with the Baroque style.

This group of four are usually classed with the sculpture of Tempyo but it is possible that they were made during the decade after the close of that period when the court was moving to Kyoto. Figures in these proportions and, like these, not calculated for cloth-and-lacquer surfaces were more common after 794 than before. Together with Bon-ten and Taishaku-ten (Plates 175–176) of the same scale and technique, who form part of the same group, they are traditionally ascribed to the hand of a Chinese carver named Gumporiki.

The setting of head well down on shoulders, and several features of armor and drapery call to mind the three attendants of Yakushi in the Yakushi-dō in Shiga (Plate 157). It is also

136

interesting to compare the splendidly carved faces of these guardians (Plate 199 a, b) with the less vivid faces of the smaller figures at Daian-ji (Plates 201, 202) and of the pair in the Kōdō of Tōshōdai-ji (Plate 200). For this, the Tōshōdai-ji Kondō series, has kept the formula of triangular eyes and expressive mouths so successfully developed some half-century before in the Tōdai-ji workshops. It is not without significance that something very close to this type of eye is already found some two centuries previous in the guardian lions of Wei China.

Two of the Four Heavenly Kings (Shi-tennō)
Plate 200
Zōchō-ten Plate 200 a
Jikoku-ten Plate 200 b
Wood
H. 4′ 3½″ and 4′ 4⅜″
Kōdō Tōshōdai-ji, Nara

Only two kings, known, correctly or not, as Zōchō-ten and Jikoku-ten, remain from the original set of four guardians attendant on the main image in the Kōdō of Tōshōdai-ji, now a Kamakura image of Miroku. In spite of restored hands and right sleeves of each, as well as the demons on which they stand, they remain the most completely and elaborately carved wooden images left from the Tempyo period. Such detail under lacquer would have lost its crispness; evidently pigment with water and glue was applied direct to the wood over thin whitewash. The artist depended on true carving rather than lacquer paste for his relief effects. His color was gold leaf on the armor and brocade patterns painted on the sleeves and skirt. For all his skill in details, however, the faces and gestures cannot compare in spirit with those of the series in the Kondō of this temple (Plates 197–199) which must have been very nearly contemporary. If so much as a decade separated the two groups, these two figures are the later, and it is just possible that they are provincial productions that have

long enjoyed sanctuary in the great temple where they are now found.

Four Heavenly Kings (Shi-tennō)
Plates 201, 202
Tamon-ten Plate 201 a
Jikoku-ten Plate 201 b
Kōmoku-ten Plate 200 a
Zōchō-ten Plate 202 b
Wood
H. 4′ 7⅝″; 4′ 11½″; 4′ 6½″; 4′ 8″, respectively
Daian-ji, Nara

Style alone cannot determine whether these four guardians should be included within the limits of the Tempyo period. They were certainly made in its closing years if not in the Jogan period that followed. They are definitely inferior to the similar set at Tōshōdai-ji (Plates 197–199) particularly in their solid stance and in the failure of the artist to portray the terrific facial expressions achieved within the same traditional formula by the Tōshōdai-ji carver. Certainly the general effect conforms with that of the first thirty years after the end of the Tempyo period. Like the others they were colored over a thin whitewash of glue and china clay, and were set into their pedestals on thick blocks of one piece with the feet. Their wooden stiffness and the inexplicably repeated posture of three of them, despite their sacred purpose, call to mind the traditional American cigar-store Indian.

Nimbus and Halo Plate 203
Nimbus with Halo Plate 203 a
Yakushi-ji, Nara
Halo Plate 203 b
Kondō of Tōshōdai-ji, Nara

The huge wooden halo from Yakushi-ji (Plate 203 a) would have been adequate for the central seated bronze Yakushi in the Kondō (Plates 3–4) if indeed that great image was never furnished with a proper bronze one.

One can imagine this flat wood carved in low relief with flame and tendril and open lotus centered on sun disc, all spread with gold leaf and set up behind the seated Yakushi. Others in similar style of appropriate proportion would have been provided for the erect attendants. From blank spaces in the upper outer portion it is possible to infer the presence originally of seven small Dhyani Buddhas.

The ink rubbing on the right (Plate 203 b) is taken from the central disc, lacking the flames and flower motives on the rim, of the wooden halo now behind the Senju Kwannon of Tōshōdai-ji, as may be seen in Plate 155. It has already been noted that this halo may originally have been made for the standing wood-core lacquer image of Yakushi in the same hall. The heritage of this beautiful halo is easily traced, in stone carving, to the halos of the great T'ang Buddhas cut in the mother rock of Lung-mên and Pin-yang, China, and in the halos of earlier Indian Gupta Buddhas at Mathura and Sarnath. The calligraphic quality of its decorative detail bears direct relationship to painted halos at Tun-huang and ceiling roundels at Ajanta.

GIGAKU MASKS

PLATES 204–217

Four Gigaku Masks Plate 204
- a. Wood, colored
 eighth century
 11″ × 8¾″
- b. Wood, colored. Crown of thin bronze, gilt.
 seventh–eighth century
 11¼″ × 8¼″
- c. Camphor wood, colored
 eighth century
 1′ × 9″
- d. Wood, colored
 eighth century
 11⅝″ × 9″

Tokyo National Museum; formerly in Hōryū-ji, Nara

So much of Tempyo sculpture is concerned with the formal images of deities quite beyond our realm in apparel, posture, and expression that it may be suitable to conclude with something lighter. Our illustrations end therefore with masks of the Gigaku drama in which comedy and religion met. Despite our meager knowledge of individual designation and use of the masks in that semi-sacred drama, as a group they show us how tellingly the Tempyo artists applied their skills of carving, modeling, and painting to the portrayal of the human face.

Some decades ago the thirty-two masks on Plates 204–211 were donated by the Hōryū-ji authorities to the Imperial Household Museum, now the Tokyo National Museum.

Mask "b" on this plate may represent Kongō Rikishi. Its face and crown show similarities to the earlier Shi-tennō in the Kondō of Hōryū-ji. It is one of eight or more masks that have been generously released for various exhibitions abroad — and was shown in five American museums during 1953: in Washington, New York, Chicago, Seattle, and Boston.
Mask "c" was shown in Boston in 1936.

Four Gigaku Masks Plate 205
- a. Paulownia wood, colored. Crown of thin bronze, gilt
 eighth century
 1′ 4″ × 8⅝″
- b. Paulownia wood, colored, with metal crown
 eighth century
 1′ 3¼″ × 9″
- c. Camphor wood, colored
 seventh–eighth century
 1′ × 9″
- d. Wood, colored
 seventh–eighth century
 11¼″ × 10″

Tokyo National Museum; formerly in Hōryū-ji, Nara

The many holes seen in three of these were for the insertion of imitation hair, usually hemp fibers. A dozen or more of the masks illustrated in this volume are bearded. The chignon seen is Masks "a" and "b" and in 211 d is probably,

as in India, a symbol of royalty. Mask "b" traveled in 1957 to a special exhibition of Japanese art in Honolulu.

Although certainly later, the face and ears of Mask "c" recall similar features in Wei sculptures in the Yün-kang grottoes in China. An inscription on Mask "d" gives the name "Koji-no-chichi," father of an orphan, and "Ikaruga-dera," an old name for Hōryū-ji (compare Plate 212 b).

Four Gigaku Masks Plate 206
 a. Camphor wood, colored
 seventh–eighth century
 10¾″ × 7½″
 b. Paulownia wood, colored
 eighth century
 9″ × 6⅞″
 c., d. Wood, colored
 seventh–eighth century
 10¾″ × circa 7¼″ each
Tokyo National Museum; formerly in Hōryū-ji, Nara

Subtleties of facial expression are best studied when several similar examples, like the four here, are brought together. All probably represent boys and Masks "c" and "d" are probably a pair. On the last, the painting to indicate hair — perhaps the tonsure — shows clearly. Over thirty of the masks shown in these plates have the long ears which may indicate a follower of Buddha in whom they were — in their empty jewel-less earlobes — a symbol of renunciation. Such is not the case with royal masks as for example 204 b and 207 b which would properly have been fitted with earrings.

Four Gigaku Masks Plate 207
 a. Camphor wood, colored
 seventh–eighth century
 1′ ¾″ × 7⅞″
 b. Paulownia wood, colored
 eighth century
 1′ 4¾″ × 10″

 c. Paulownia wood, colored
 eighth century
 1′ ⅜″ × 6⅞″
 d. Camphor wood, colored
 seventh–eighth century
 1′ × 8⅝″
Tokyo National Museum; formerly in Hōryū-ji, Nara

The wide range of characterization is seen in the contrast between the human and the super-human types on this plate. Mask "a" was shown in Boston in 1936, and in San Francisco in 1951. The exceptionally large Mask "b" probably represents Suiko-ō, an intoxicated Iranian king.

Masks "c" and "d" with beak, comb, and wattles of a cock probably represent Vishnu's mount, Garuda. He appears amongst the twelve protectors of Yakushi (Plate 98). Simpler planes and more direct cutting in "d" suggest an earlier date than for its companion.

Four Gigaku Masks Plate 208
 a. Paulownia wood, colored and lacquered
 eighth century
 1′ 1″ × 8″
 b. Camphor wood, colored
 eighth century
 1′ 3″ × 8″
 c., d. Wood
 eighth century
 circa 1′ × 8¾″
Tokyo National Museum; formerly in Hōryū-ji, Nara

Masks "a" and "b", an older and a younger woman, are important to us since the female in Tempyo sculpture is rare. Nor has anything of the kind — female faces larger than life — survived from T'ang sculpture. Obvious parallels on lesser scale are found in the Hōryū-ji pagoda clays (Plates 54 b, c, 55c) and in Chinese grave figurines.

One beautiful brush stroke of an eyebrow on the younger reminds us that pigment plays

a real part in the finished mask, and that parallels are to be found in the paintings of T'ang. Comparison of this mask with contemporaneous screen paintings in the Shōsō-in and the later Noh drama masks will increase our respect for the character inherent in the feminine eyebrow.

Masks "c" and "d" emphasize, in contrast to the preceding two, the rugged, bony face of the male. Thanks to their unfinished state, we see the work of the mask-maker part way between the solid block and the final painted product. All four masks in this plate show worm holes.

Four Gigaku Masks Plate 209
 a. Paulownia wood, colored
 eighth century
 10¼″ × 8¼″
 b. Camphor wood, colored
 eighth century
 1′ 3″ × 10½″
 c. Paulownia wood, colored
 eighth century
 9⅛″ × 8″
 d. Lacquer
 eighth century
Tokyo National Museum; formerly in Hōryū-ji, Nara

Alike in rugged brow and jowl and jaw these four combine animal and human features. Note the tusks of "a" and "b", the floppy ear of "d", and the broad snouts of all.

In Mask "b" is an uncertain inscription that appears to include a date equivalent to 751.

Four Gigaku Masks Plate 210
 a., b., c. Paulownia wood, colored
 d. Camphor wood, colored
 eighth century
 a. 1′ ⅜″ × 8⅞″ b. 1′ × 8″
 c. 10¾″ × 8⅞″ d. 1′ ½″ × 8⅞″
Tokyo National Museum; formerly in Hōryū-ji, Nara

The face of the tragic, wrinkled old man in Mask "a" is linked to the others on this plate by an excessively long nose said to symbolize conceit. Their mouths are as different as their noses are alike.

Mask "d" came to America with the traveling exhibition of 1953.

Four Gigaku Masks Plate 211
 a., b. Dry lacquer, colored
 eighth century
 b. 10½″ × 7⅞″
 c., d. Paulownia wood, colored
 eighth century
 d. 9″ × 8⅝″
Tokyo National Museum; formerly in Hōryū-ji, Nara

There seems to be no limit to the variety of feature possible to the Gigaku mask carver. Note how the forty odd wrinkles of Mask "a" set it apart from "b".

Mask "d" was shown in September 1951 in San Francisco.

Two Gigaku Masks Plate 212
 a. Clay mixed with hemp fibers, lacquered
 and colored.
 eighth century (752)
 11¾″ × 9″
Tōdai-ji, Nara
 b. Paulownia wood, colored
 eighth century
 circa 1′ 2″ × 9″
Hōryū-ji, Nara

Fragments of an original clay mold still remain within Mask "a" as well as an inscription. This reads, "Tōdai-ji. Made by Sori Gyōsei, 9th day, 4th moon, 4th year of Tempyō Shōhō" (May 26, 752, according to the solar calendar of the West) the day of the consecration of the Daibutsu at Tōdai-ji. Thus in a single mask we have the whole story of its making, the name of its maker, the place and

date of its use. As with most others, however, we lack its name and that of the drama in which it was worn.

Mask "b", like that seen in Plate 205, is inscribed, "Ikaruga-dera," an old name for Hōryū-ji. Smiling down the centuries, it remains now the sole Gigaku mask in that temple.

Four Gigaku Masks Plate 213
 a., b. Paulownia wood, colored
 eighth century
 a. 11⅜″ × 6¼″ b. 10⅝″ × 6″
 c., d. Paulownia wood, colored. Traces of
 white paint in wrinkles.
 eighth century
 c. 12″ × 9″ d. 12″ × 8⅜″
Tōdai-ji, Nara

Both Mask "a" and "b" are inscribed on the back by the name of their maker, "Shamokushi." They appear to be two young monks, or perhaps two slightly different versions of a single character.

The wrinkled visages of Masks "c" and "d" present a striking contrast to the sleek young pair above. Mask "c" is dated in accordance with 751 and was repaired in 1793. The better preserved example at the right may well be of the same date and hand.

Four Gigaku Masks Plate 214
 a., b., c., d. Paulownia wood, colored. Eyebrows and beards of palm fiber.
 eighth century
 a. 11″ × 7⅜″ b. 11⅜″ × 8¾″
 c. 12¼″ × 8″ d. 12⅛″ × 8¼″
Tōdai-ji, Nara

Mask "a" is painted in white, others in red. Inscriptions show that all four were made in 751 and repaired in 1793. Compare Plate 213 c.

The effect of the hirsute details must be remembered in looking at many of the other masks which were originally similarly equipped.

Four Gigaku Masks Plate 215
 a., c., d. Wood, painted black
 eighth century
 a. 1′ 3″ × 9⅜″ c. 1′ 1¾″ × 10⅜″
 d. 1′ × 10″
 b. Paulownia wood, traces of green paint
 eighth century
 1′ 3″ × 7⅝″
Tōdai-ji, Nara

For the three broad masks, "a", "c", and "d", the swelling crania, bulging eyes, short fat snouts, bared tusks, and beastly ears proclaim a single diabolical concept.

An effect very different from these is attained in the narrow example, "b", with its pointed skull, eyes, nose, and chin. The tip of the nose is repaired.

In September 1951, Mask "d" was shown in San Francisco.

Four Gigaku Masks Plate 216
 a. Paulownia wood, painted brown
 eighth century
 11″ × 8⅜″
 b. Paulownia wood, colored
 eighth century
 11¼″ × 7½″
 c. Wood painted green
 eighth century
 10″ × 8⅜″
 d. Paulownia wood, painted red on a lacquered ground
 eighth century
 10¾″ × 8¼″
Tōdai-ji, Nara

With so much surface color lost in Mask "b", it can be seen that the nose, as usual, was carved in one piece with the face. An inscription on the back tells that it was "carved by Kiyeishi," in the year equivalent to 752. Thus the names of three carvers of Gigaku masks are known. The weathering of this specimen reveals the grain of the wood and accentuates the cadaverous character of the face.

By the same hand as the preceding, Mask "c" also bears the inscription "carved by Kiyeishi," with the indication of the same year, 752. In addition it bears the temple name "Tōdai-ji." Comparison of these two similar works by a single craftsman reveals the refinement that comes with the addition of the final veneer to the raw wood.

Four Gigaku Masks Plate 217
 a. Paulownia wood, colored
 eighth century
 1′ ½″ × 8½″
 b. Paulownia wood, traces of brown and
 green paint
 eighth century
 1′ ¼″ × 9″
 c. Paulownia wood, traces of red paint
 eighth century
 1′ 1″ × 7¾″
 d. Paulownia wood, painted black
 twelfth century
 11⅜″ × 7″
Tōdai-ji, Nara

The face of Mask "a" though a combination of cock and monkey, manages to convey a peculiarly human expression. A similar type survives to modern times in the minor persecuting demons known as *tengu*.

Mask "b" is dated in accordance with the year 751. It seems reasonable enough that high hat and too long nose should go together.

Mask "c" is dated in accordance with the year 751 and was repaired in 1793. For others of the same year see preceding masks (Plates 209 b, 213 c, and 214 a–d).

The last mask in our series, "d" on this plate, is an important document from the Kamakura revival of Tempyo culture. It is signed by the great sculptor Kōkei, father of Unkei, and dated in accordance with 1196. Its literal and lifelike rendering — despite exaggeration of the nose — is typical of the period. One thing it lacks in sufficient measure that is found generously in all Tempyo sculpture: the quality of abstraction.

APPENDIX
BIBLIOGRAPHY
INDEX

TEMPLES and KINDS OF SCULPTURE

	Bronze	Clay	Lacquer (hollow dried)	Lacquer (hollow: lattice support)	Wood core (lac-quered)	Carved wood (lac-quered)	Wood	Masks
Akishino-dera			128–133				191	
Art University, Tokyo					153			
*Daian-ji							185–190 201–202	
Dairyū-ji, Kobe						168		
*Gakuan-ji					154			
*Hannya-ji	33							
*Hokke-ji					150–151	170		
*Hōryū-ji	12–18	50–57 64–65 74–75	127	134–135 138–139	140–149			204–212
Jindai-ji, Tokyo	20–21							
Jingō-ji, Kyoto						171		
Jizō-in, Kyoto	33							
Kakurin-ji, Hyōgo	19							
Kaniman-ji	43–47							
*Kōfuku-ji	41–42		93–104 125–126					
Kōryū-ji, Kyoto		85						
Kōzan-ji, Kyoto					152–153	174		
Kwannon-ji, Kyoto						165–166		
Oka-dera		86			159–160			
*Saidai-ji	31–32					172–173		

APPENDIX

	Bronze	Clay	Lacquer (hollow dried)	Lacquer (hollow: lattice support)	Wood core (lacquered)	Carved wood (lacquered)	Wood	Masks
*Shinyakushi-ji	A–B	76–84						
*Shōrin-ji					163–164 166			
*Taema-dera		49	88–92					
*Tōdai-ji	22–30 34–35 37–40	58–63 66–73	105–122					212–217
Tokyo National Museum					152			204–211
*Tōshōdai-ji		48	123–124	136–137	155–156 161–162	167, 169 175–176	177–183 193–200 203	
Yakushi-dō, Takatori-mura, Shiga					157		192	
*Yakushi-ji	1–11		87		158		184, 203	
Zensui-ji, Shiga	36							

Note 1

Temples are in Nara city or prefecture unless otherwise indicated. Those starred (*) will be found on Map II.

Note 2

In some instances more than one plate is devoted to a single sculpture; in others one plate illustrates two or more.

LIST OF DEITIES AND SAINTS

IN ORDER OF THEIR APPEARANCE IN THE PLATES

(Only one plate is listed for an individual sculpture appearing on several
— that of its first appearance, unless a separate plate is devoted to it.)

JAPANESE NAME	CHINESE NAME	SANSKRIT NAME	PLATE NUMBER
Yakushi Nyorai	藥師如來	Bhaisajya-guru	B, 3, 4, 33, 134, 149, 167, 171, 174, 192, 193.
Shō Kwannon (See also Kwannon Pl. 13 etc.)	聖觀音	Avalokitesvara	1, 161, 168, 186.
Nikkō and Gakkō			
Nikkō Bosatsu	日光菩薩	Surya-prabha	6, 152, 191.
Gakkō Bosatsu	月光菩薩	Candra-prabha	7, 153, 191.
Amida Nyorai	阿彌陀如來	Amitabha	13, 14, 142, 143, 145, 172.
Kwannon and Seishi			
Kwannon Bosatsu (For various other forms of Kwannon, see end of List.)	觀音菩薩	Avalokitesvara	13, 18, 19, 86, 127, 144, 146.
Seishi Bosatsu	勢至菩薩	Mahasthamaprapta	13, 127, 144, 146.
Shaka Nyorai (See also Tanjō Shaka Pls. 34 etc.)	釋迦如來	Sakyamuni	20, 43, 50, 173, 196.
Roshana Butsu	嘘舍那佛	Vairocana	22, 136.
Ashuku Nyorai	阿閦如來	Aksobhya	33(?), 173.
Tanjō Shaka	誕生釋迦	Sakyamuni	34, 36.
Hōshō Nyorai	寶生如來	Ratnasambhava	48(?), 172.
Miroku Nyorai (See also Miroku Bosatsu Pl. 140)	彌勒如來	Maitreya	49, 50, 85.

149

APPENDIX

JAPANESE NAME	CHINESE NAME	SANSKRIT NAME	PLATE NUMBER
Horyu-ji pagoda clays, selected figures			
Monju Bosatsu	文殊菩薩	Manjusri	53.
Yuima Koji	維摩居士	Vimalakirti	50, 150.
Kentatsuba (Kandaba) (One of the Hachi-bushu, Deva Kings, see Pl. 93)	乾闥婆	Gandharva	52, 96.
Riyū (Ryū)	龍	Naga	56.
Ashura (One of the Hachi-bushu, Deva Kings, see Pl. 93)	阿修羅	Asura	56, 96.
Rakan (Arhat)	羅漢	Arhat	56, 57.
Giba Daijin (?)	耆婆大臣	Jivaka	57.
Shukkongō-jin	執金剛神	Vajrapani	58.
Bon-ten and Taishaku-ten			
Taishaku-ten	帝釋天	Indra	60, 65, 106, 128, 170, 176, 182.
Bon-ten	梵天	Brahma	61, 64, 105, 128, 170, 175, 183.
Kichijō-ten and Benzai-ten			
Kichijō-ten	吉祥天	Mahasri	66.
Benzai-ten	辯財天	Sarasvati	66.
Shi-tennō: Four Heavenly Kings	四天王		
Zōchō-ten	增長天	Virudhaka	68, 74, 88, 112, 125, 197, 200, 202.
Jikoku-ten	持國天	Dhrtarastra	69, 74, 88, 112, 125, 197, 200, 201.
Kōmoku-ten	廣目天	Virupaksa	71, 75, 91, 115, 126, 198, 202.
Tamon-ten	多聞天	Vaisravana	72, 75, 91, 115, 126, 198, 201.
Juni-jinshō: Twelve	十二神將		
Guardians of Yakushi (Kubira, a modern replacement, is not illustrated)	宮毘羅	Kumbhira	

APPENDIX

JAPANESE NAME	CHINESE NAME	SANSKRIT NAME	PLATE NUMBER
Bikara	毘羯羅	Vikarala	77, 157(?).
Haira	波夷羅	Pajra	79, 157(?).
Santeira	珊底羅	Sandila	79, 157(?).
Indara	因陀羅	Indra	80.
Bajira	伐折羅	Vajra	80.
Shindara	眞達羅	Kimnara	81.
Shōtora	招杜羅	Catura	81.
Anira	頞儞羅	Anila	82.
Anteira	安底羅	Andira	82.
Magora	摩睺羅	Maharaga	83.
Mekira	迷企羅	Mikira	83.

Hachi-bushu: Kings of the Eight Classes of Devas (Kentatsuba and Ashura are among clays illustrated from Hōryū-ji pagoda, see Pl. 52, etc. and 56 etc.)	八部衆		
Kinnara	緊那羅	Kimnara	93.
Guhanda	鳩槃荼		93.
Shakatsura	沙羯羅		94.
Hibakara	畢婆迦羅		94.
Karura	迦樓羅	Garuda	98.
Gobujō	五部淨		99.

Ju-daideshi: Ten Disciples of Shaka (six extant)	十大弟子		
Subodai	須菩提	Subhuti	100.
Kasenen	迦旃延	Katyayana	100.
Ragora	羅睺羅	Rahula	102.
Furuna	富樓那	Purna	102.
Sharihotsu	舍利弗	Sariputra	104.
Mokukenren	目犍連	Maudgalyayana	104.

151

APPENDIX

JAPANESE NAME	CHINESE NAME	SANSKRIT NAME	PLATE NUMBER
Ni-ō: Two Great Kings	二王		
Misshaku Rikishi	密迹力士	Guhyapada	119.
Kongō Rikishi	金剛力士	Vajrapani	120.
Gudatsu Bosatsu	救脱菩薩		130.
Gigei-ten	伎藝天	Visvakarma (?)	131.
Miroku Bosatsu	彌勒菩薩	Maitreya	140.
Kokuzō Bosatsu	虛空藏菩薩	Akasagarbha	154.
Shishiku Bosatsu	獅子吼菩薩	Simhanadanadi	177.
Shūhō-ō Bosatsu	衆寶王菩薩		178.
Daijizai Bosatsu	大自在菩薩	Mahesvara	180.
Tahō Nyorai	多寶如來	Prabhutaratna	196.
Other Forms of Kwannon Bosatsu			
Fukū-kenjaku Kwannon	不空羂索觀音		108, 185.
Senju Kwannon	千手觀音菩薩	Sahasrabhujasahasranetra	155.
Ju-ichi-men Kwannon	十一面觀音		163.
Batō Kwannon	馬頭觀音	Hayagriva	188.
Yōryū Kwannon	楊柳觀音		189.

Note

In addition to the above names, there are a few figures identifiable in type, but now nameless; there are also various attendant beings, angelic or demonic, to which names were perhaps never attached; and finally there are three posthumous priests' portraits, not deities, but sacred sculpture: Ganjin Oshō, Pl. 123; Gyōshin Sōzu, Pl. 138; Gien Sōjō, Pl. 159.

LIST OF SUTRAS AND OTHER SCRIPTURE

JAPANESE NAME	CHINESE CHARACTERS	SANSKRIT NAME
Daihannya-kyō	大般若經	Mahaprajna-paramita sutra
Hokke-kyō	法華經	Saddharma-pundarika sutra
Issai-kyō "All the Sutras" (the then existing canon)	一切經	
Kegon-kyō	華嚴經	Avatamsaka (Buddhavatamsaka) sutra
Kon-kō-myō-kyō	金光明經	Suvarna-prabhasa sutra
Nehan-kyō	涅槃經	Mahaparinirvana sutra
Ninno (Ninno-hannya-kyō)	仁王 (仁王般若經)	Prajna-paramita sutra
Shibun-ritsu (Shibun-ritsuzō) (Canons of the Church)	四分律 (四分律藏)	
Shi-dai-zen-mon (Gate of the Doctrine of Zen)	次第禪門	
Taishō	大正	
Sanzō	三藏	Tripitaka
Yakushi-kyō	藥師經	Bhaisajyaguru-vaiduryaprabhasa-Tathagata-purvapranidhana sutra
Yuima-kyō	維摩經	Vimalakirtinirdesa sutra

PRINCIPAL PERIODS OF JAPANESE ART

SUIKO (552–645)
 Alternate: Asuka, old name for Nara

HAKUHO (645–710)
 Alternate: Early Nara

TEMPYO (710–794)
 Alternate: Late Nara

JOGAN (794–897)
 Alternates: Konin or Early Heian

FUJIWARA (897–1185)
 Alternate: Late Heian

KAMAKURA (1185–1392)
 The period is extended to include the Division of the North and South, or Namboku Cho (1336–1392)

ASHIKAGA (1392–1568)
 Alternate: Muromachi

MOMOYAMA (1568–1615)

TOKUGAWA (1615–1868)
 Alternate: Edo

153

ERA NAMES
(after Papinot)

Taikwa	645–650
Byakuchi	650–655
Sujaku	672
Hakuho	673–686
Shuchō	686–701
Taihō	701–704
Keiun	704–708
Wadō	708–715
Reiki	715–717
Yōrō	717–724
Jinki	724–729
Tempyō	729–749
Tempyō-Kampō	749
Tempyō-Shōhō	749–757
Tempyō-Hōji	757–765
Tempyō-Jingo	765–767
Jingo-Keiun	767–770
Hōki	770–781
Tennō	781–782
Enryaku	782–806
Daidō	806–810
Kōnin	810–824

EMPERORS AND EMPRESSES
(after Papinot)

Name	Accession	Abdication	Death
Suiko (Empress)	593		628
Jomei	629		641
Kōgyoku (Empress)	642	645	
Kōtoku	646		654
Saimei (Empress)	655		661
Tenchi	662		671
Kōbun	672		672
Temmu	673		686
Jitō (Empress)	687	696	703
Mommu	697		707
Gemmyō (Empress)	708	714	722
Genshō (Empress)	715	723	748
Shōmu	724	748	756
Kōken (Empress)	749	758	
Junnin	759	764	765
Shōtoku (Empress)	765		769
Kōnin	770		781
Kammu	782		805

BIBLIOGRAPHY

Anesaki, Mahasaru, Buddhist Art in its Relation to Buddhist Ideals, Cambridge, Mass., 1915

———— History of Japanese Literature, London, 1930

Art Guide of Nippon, vol. I, Nara, Mie and Wakayama Prefectures, The Society of Friends of Eastern Art, Tokyo, 1943

Bijutsu Kenkyu, the Journal of Art Studies, Institute of Art Research, Tokyo, 1932 ff.

Bukkyo Bijutsu (Buddhist Art), quarterly journal, Nara, 1924–1935

Bulletin de l'École Française d'Extrême-Orient, Hanoi, 1901 —

Bulletin of Eastern Art, no. 30, The Society of Friends of Eastern Art, Tokyo, June 1942

Coomaraswamy, A. K., The Christian and Oriental or True Philosophy of Art, Newport, R. I., 1939

Cram, Ralph Adams, Impressions of Japanese Architecture, The Japan Society of New York, 1930

Dai Nihon Kokuho Zenshu: Catalogue of the National Treasures of Japan, Tokyo, 1931

Eliot, Sir Charles, Japanese Buddhism, London, 1935

Fenollosa, Ernest, Epochs of Chinese and Japanese Art, London, 1913

Hackin, J. and others, Asiatic Mythology, Paris, 1928

Harada, Jiro, Catalogue of Treasures in the Imperial Repository Shosoin, Toyko, 1932

———— Glimpses of Japanese Ideals, Tokyo, 1937

———— History of Japanese Art (tr. of Dai Nihon Teikoku Bijutsu Ryakushi), Tokyo, 1913

Japanese Temples and Their Treasures, 3 vols., Tokyo, 1910

Judaiji Okagami: Catalogue of the Art Treasures of the Ten Great Temples of Nara (Japanese text), 25 vols., 4 supplements, Tokyo, 1932–1937

Kokka, an Illustrated Journal of the Fine and Applied Arts of Japan, Tokyo, 1889 ff.

Kuno, Takeshi and Seiroku Noma, Bijutsu Shuppan Sha, Album of Japanese Sculpture, vol. III, Hakuho; vol. IV, Tempyo, Tokyo, 1953–1955

Memoirs of the Research Department of the Tokyo Bunko, Irreg., Tokyo, 1926–1938

Minamoto, Hoshu, An Illustrated History of Japanese Art, Trans. by H. G. Henderson, Kyoto, 1935

Nakamura, Ichisaburo, Catalogue of the National Treasures of Paintings and Sculptures in Japan, Kyoto, 1915

Naito, Toichiro, The Wall-paintings of Horyuji, Trans. and ed. by W. R. B. Acker and Benjamin Rowland, Jr., Baltimore, Md., 1943

Nanto Shichidaiji Okagami: Collection of Works of Art from Seven Famous Temples (Japanese text), Tokyo, 1929

Okakura, Kakuzo, Ideals of the East, London, 1920

Ooka, M. and T. Tazawa, Zusetsu Nihon Bijutsu Shi (Illustrated Survey of Japanese Art), Tokyo, 1935

Pageant of Japanese Art, vol. 3, Sculpture, Tokyo National Museum, Tokyo, 1952

Paine, Robert T. and Alexander Soper, The Art and Architecture of Japan, Baltimore, Md., 1955

Papinot, E., Historical and Geographical Dictionary of Japan, Ann Arbor, Mich., 1948 (Reprint)

Reischauer, A. K., Studies in Japanese Buddhism, New York, 1917

BIBLIOGRAPHY

Reischauer, Edwin O., Ennin's Travels in T'ang China, New York, 1955
——— Japan Past and Present, New York, 1946
Sansom, G. B., Japan, a Short Cultural History, rev. ed., New York, 1943
Soper, Alexander, The Evolution of Buddhist Architecture in Japan, Princeton, N. J., 1942
Tajima, Shiichi, ed., Shimbi Taikan: Selected Relics of Japanese Art, 20 vols., Kyoto, 1899–1908
Toyei Shuko: an Illustrated Catalogue of Ancient Imperial Treasure Called Shosoin, English notes, rev. ed., 6 vols., Tokyo, 1910 ff.
Toyo Bijutsu (Eastern Art), Monthly, Nara, 1929–1937

Toyo Bijutsu Taikwan: Selected Masterpieces of Far Eastern Art, vol. XV, Tokyo, 1918
Tsuda, Noritake, Handbook of Japanese Art, Tokyo, 1935
De Visser, M. W., Ancient Buddhism in Japan, vols. I and II, Leyden, 1935
Warner, Langdon, The Craft of the Japanese Sculptor, New York, 1936
——— The Enduring Art of Japan, Cambridge, Mass., 1952
——— Japanese Sculpture of the Suiko Period, New Haven, Conn., 1923
With, Karl, Buddhistische Plastik in Japan, Vienna, 1922
——— Die Japanische Plastik, Berlin, 1923
Yashiro, Y. and M. Wada, Bukkyo Bijutsu Shiryo: Materials for the Study of Buddhist Art, Tokyo, 1923

INDEX

INDEX

INDEX

INDEX

INDEX

INDEX

INDEX

INDEX

INDEX

PLATES

*The following plates are reproduced from
collotype plates made by Benrido, Tokyo, Japan*

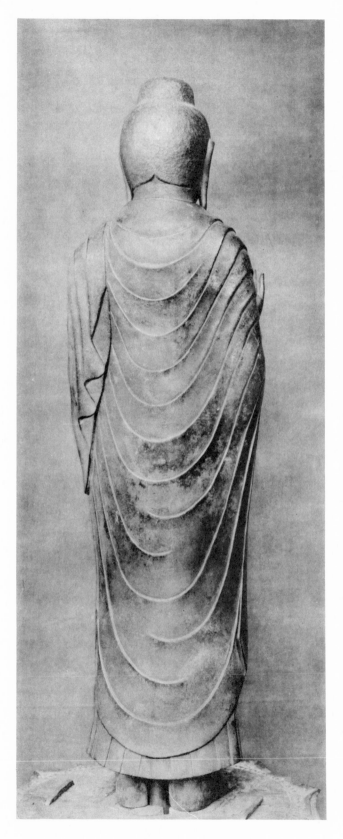
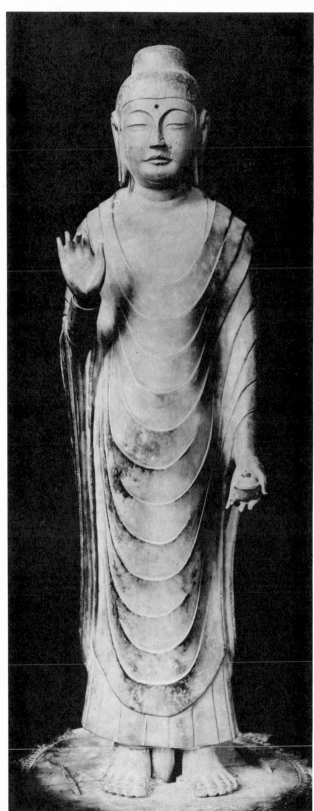

A

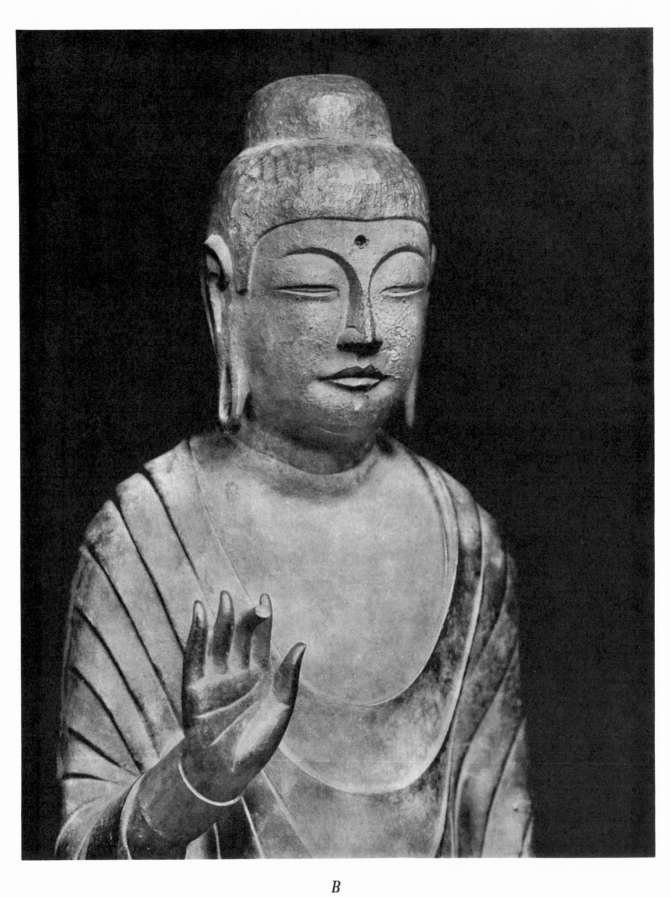

B

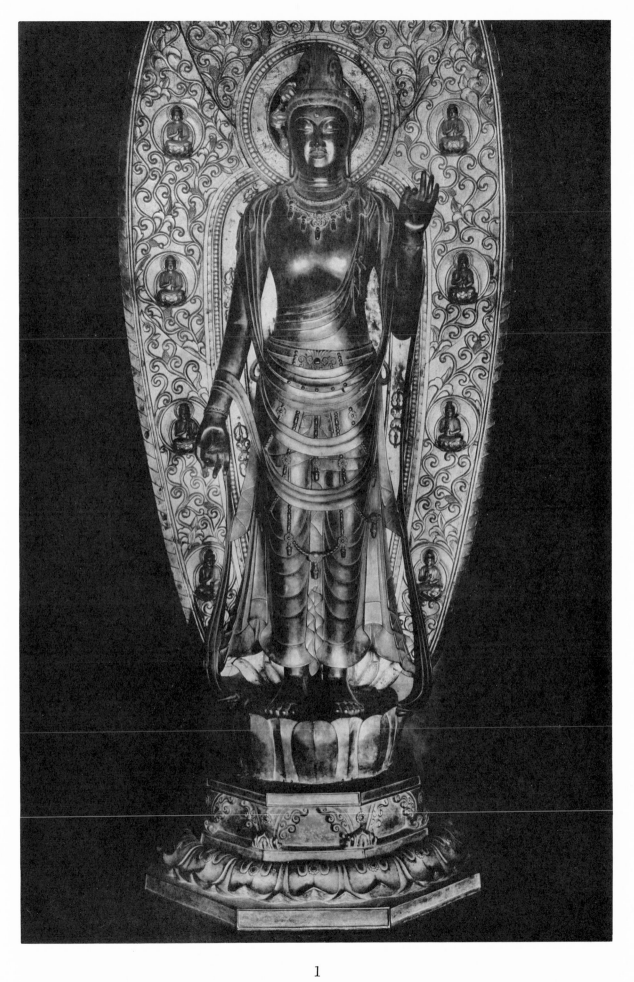

1

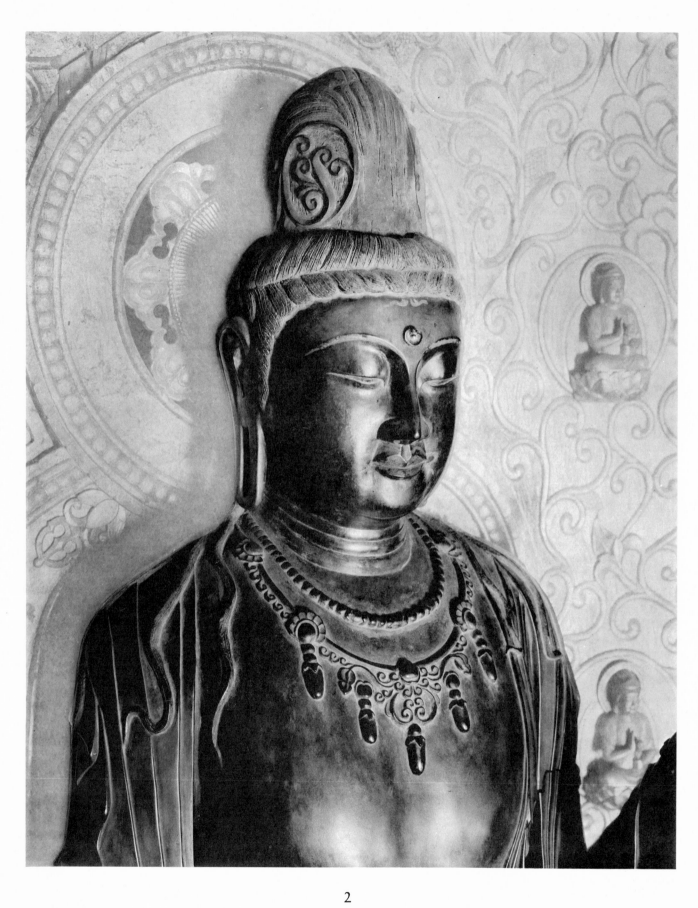

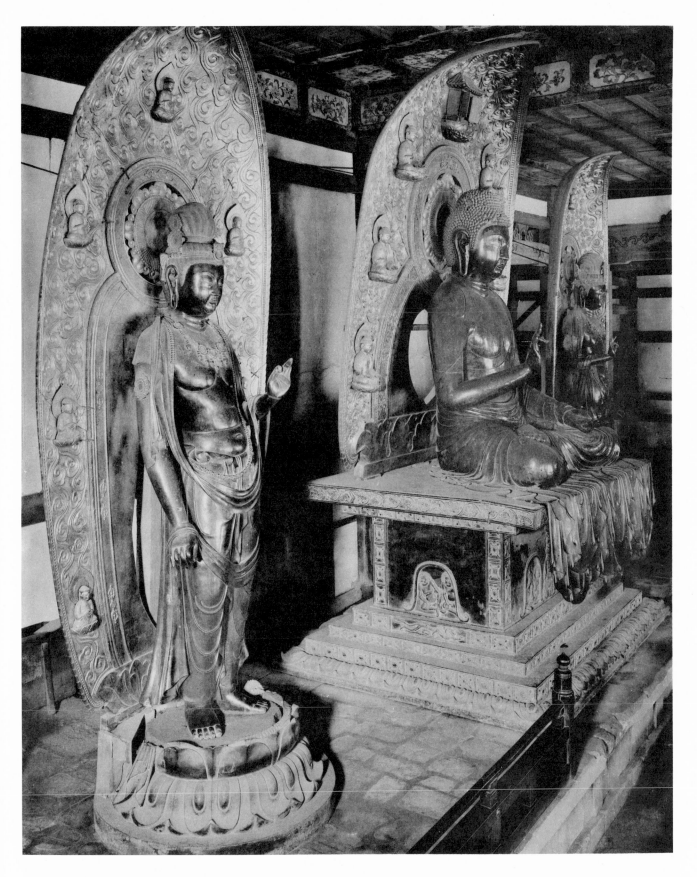

3

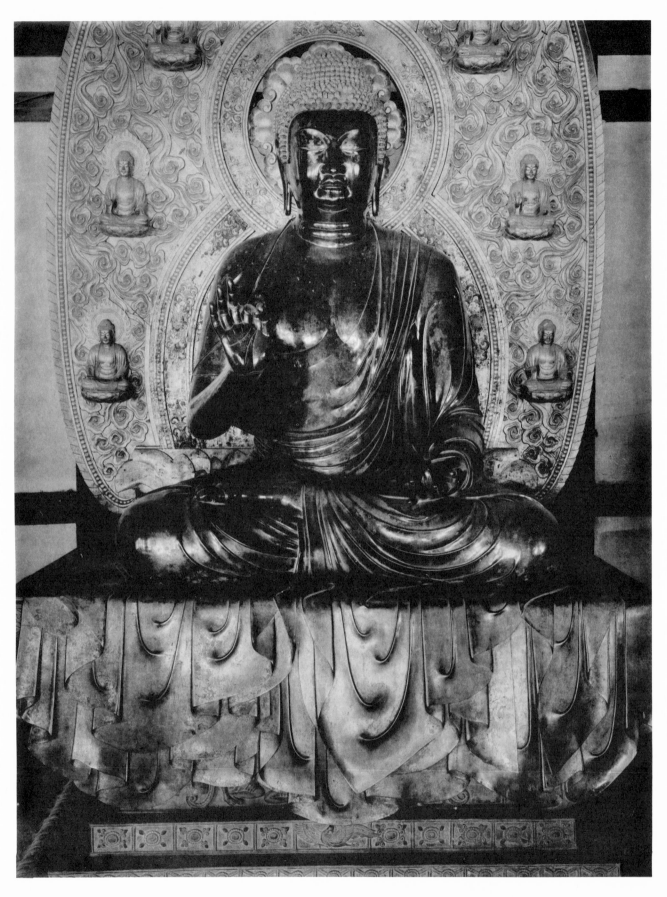

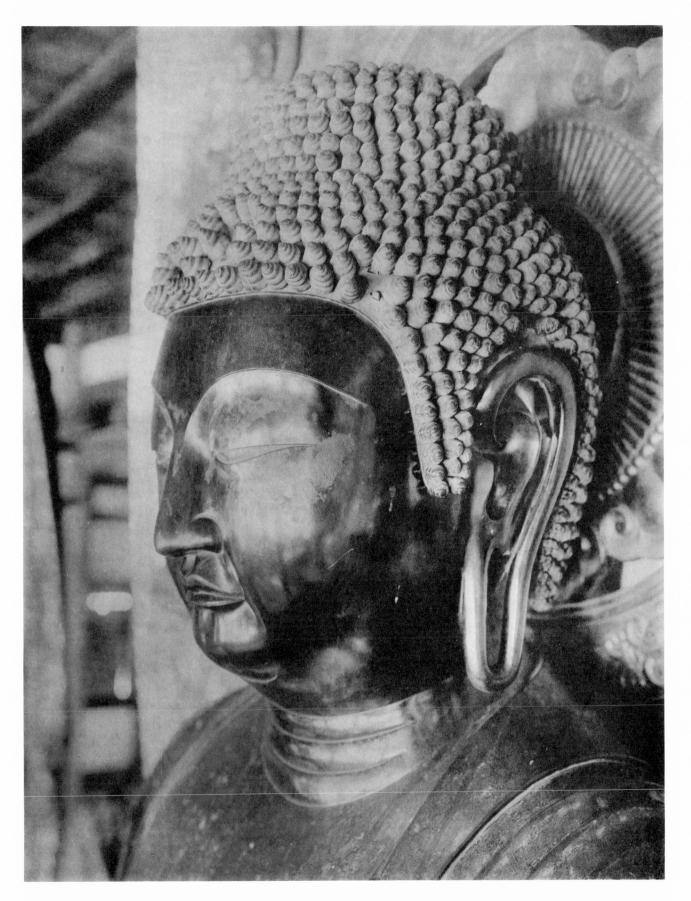

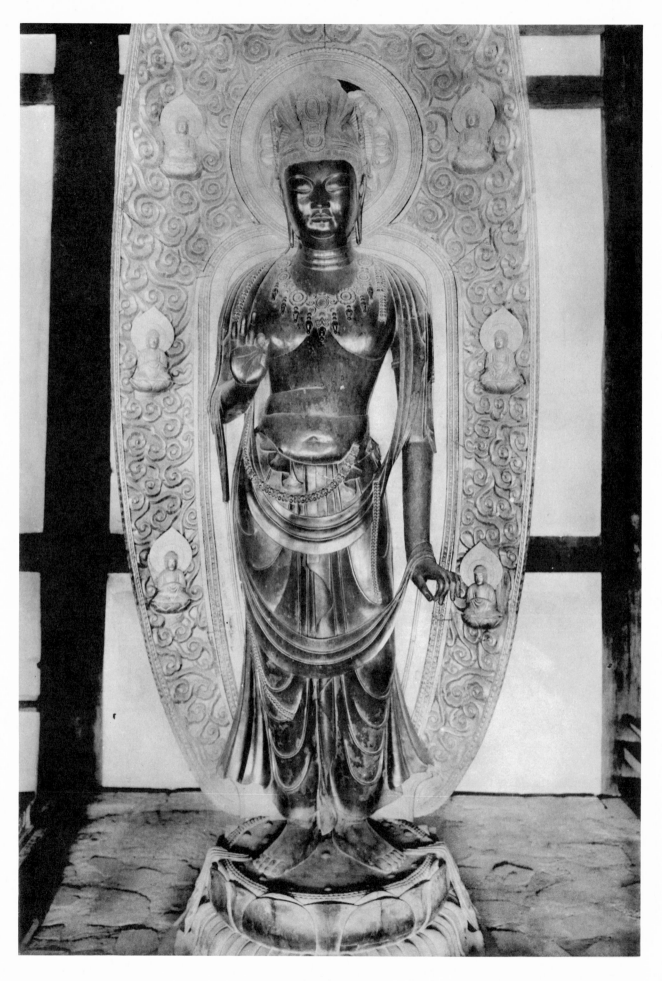

6

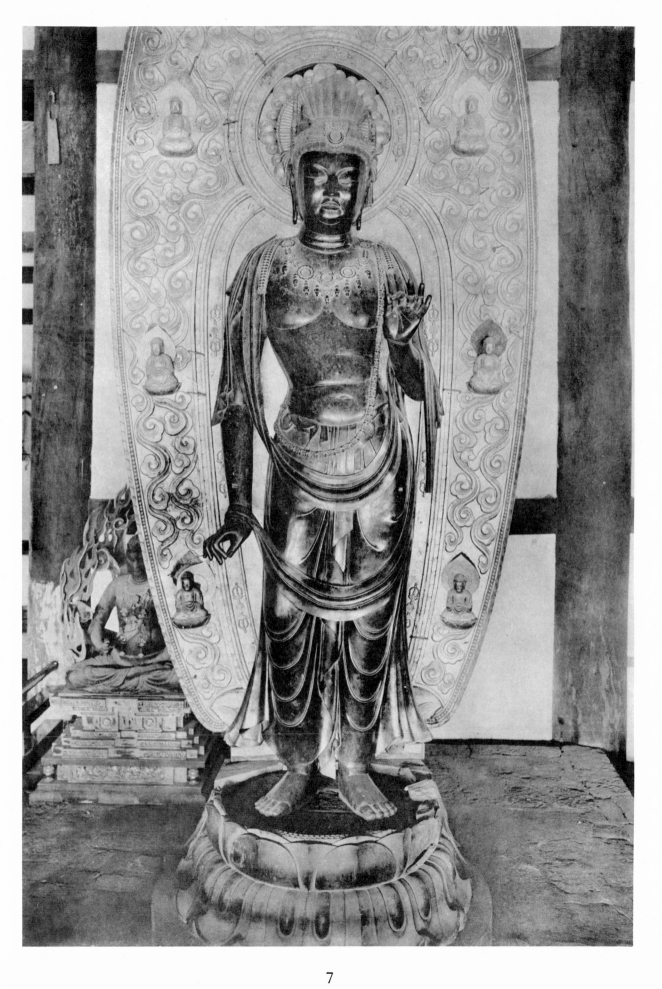

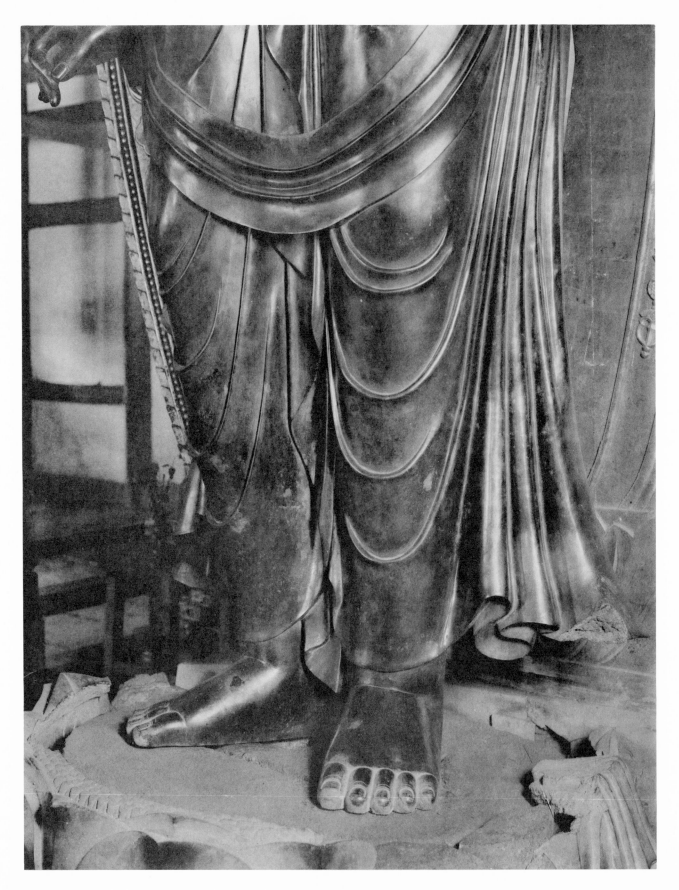

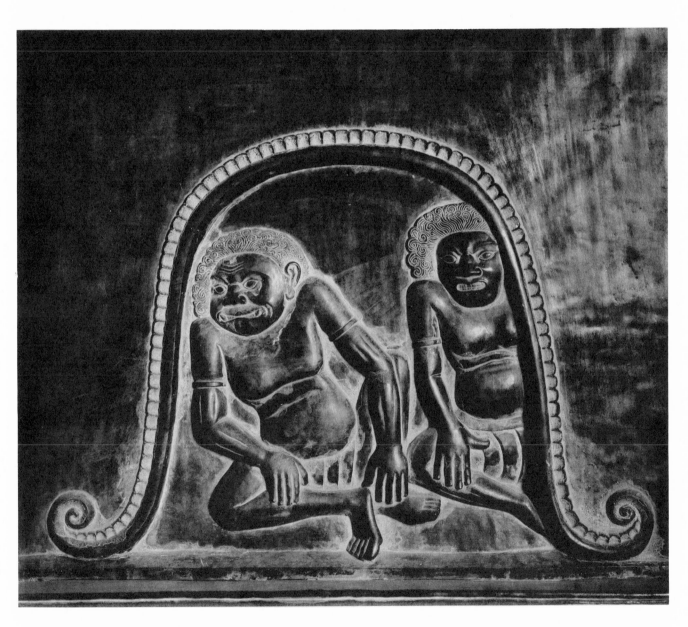

9

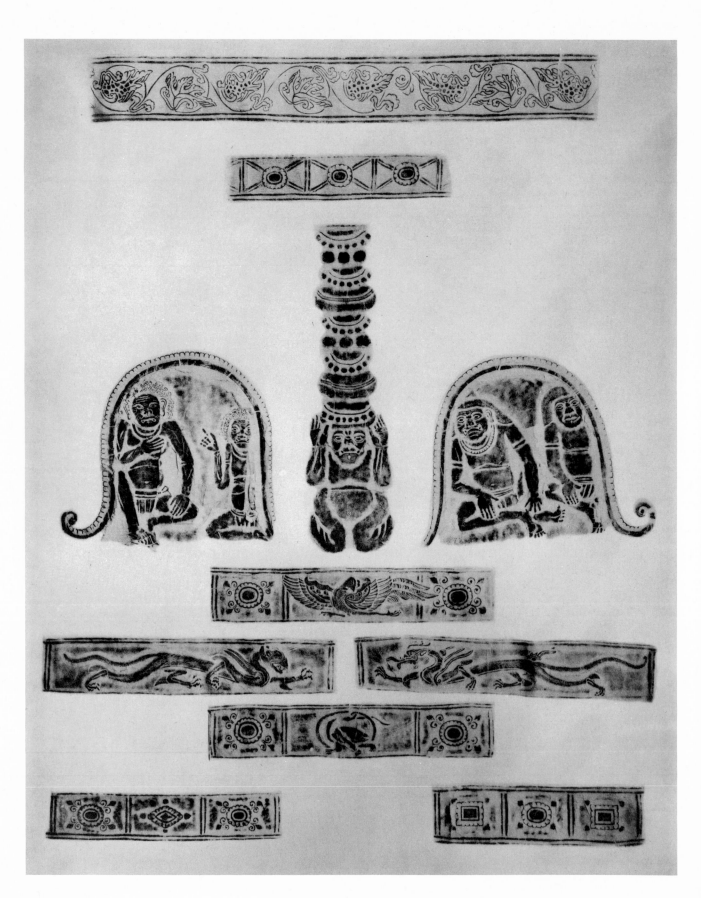

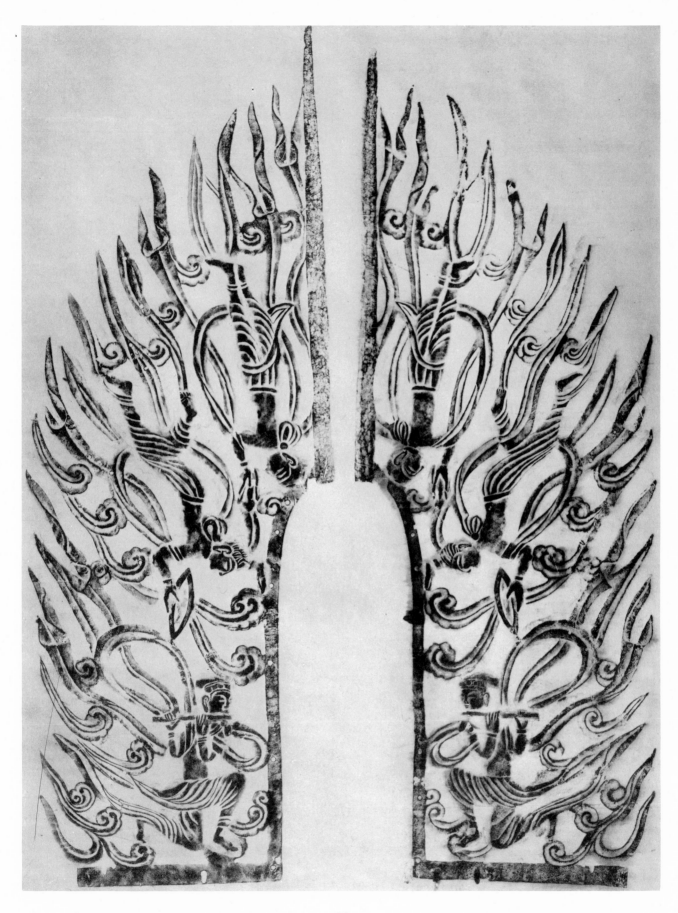

11

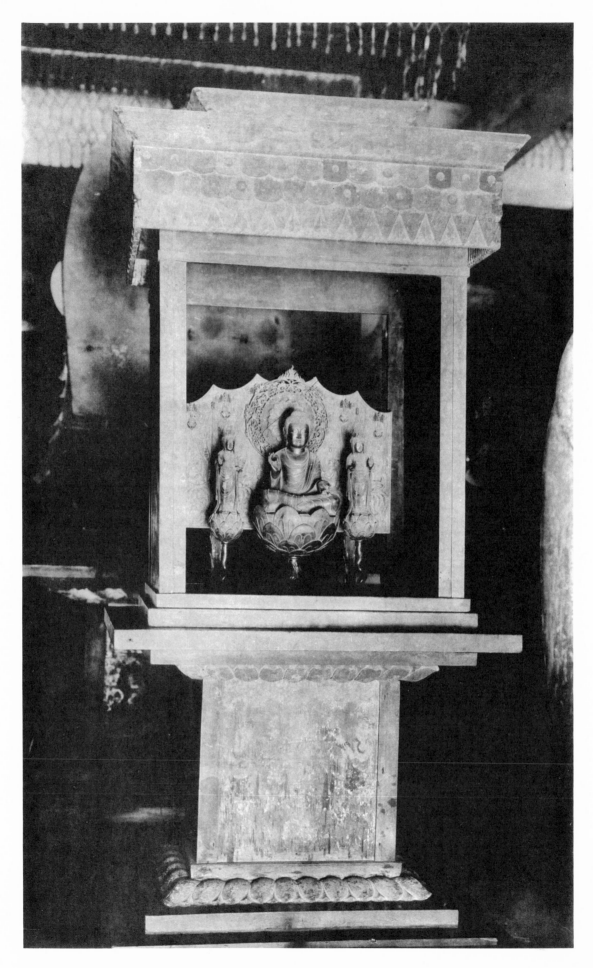

12

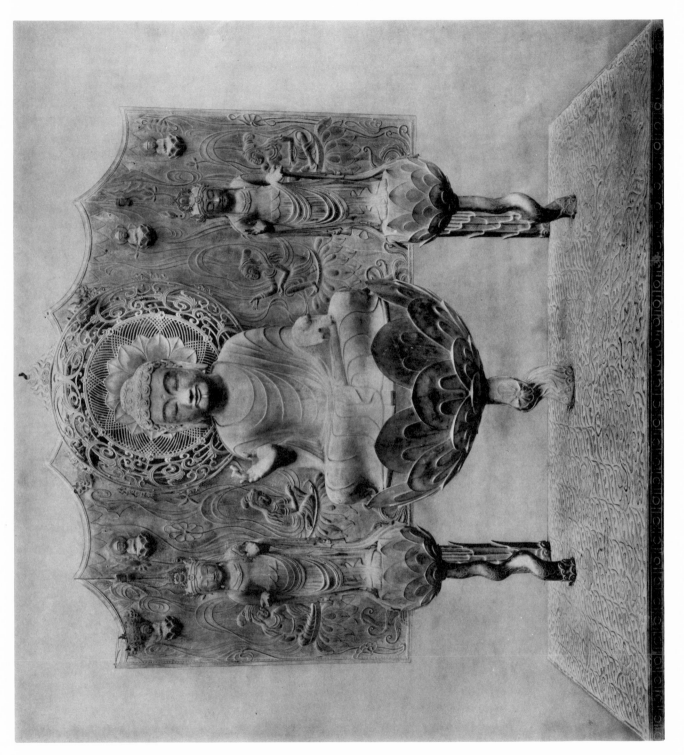

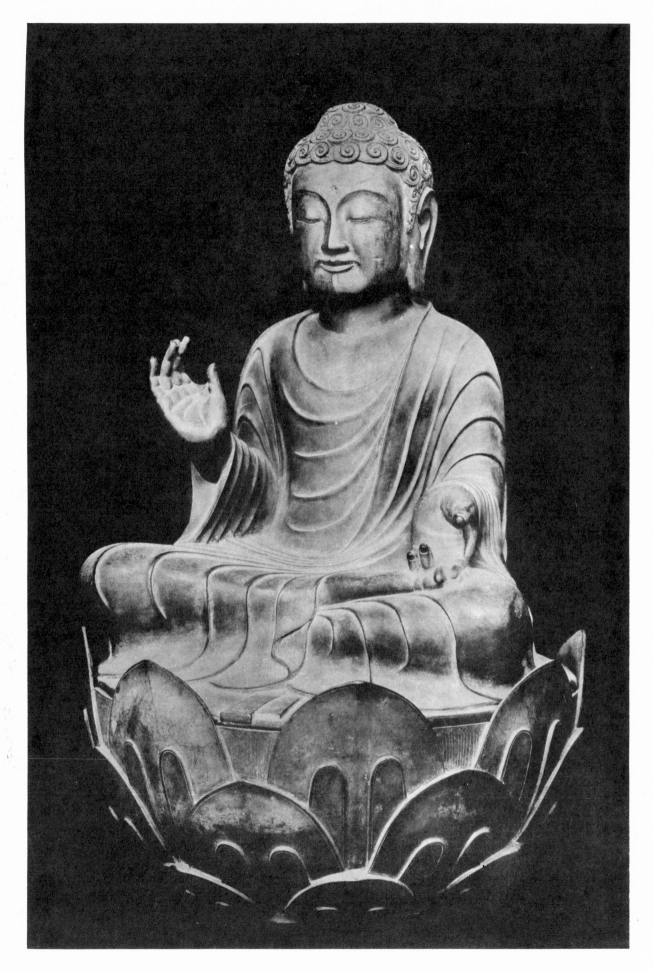

14

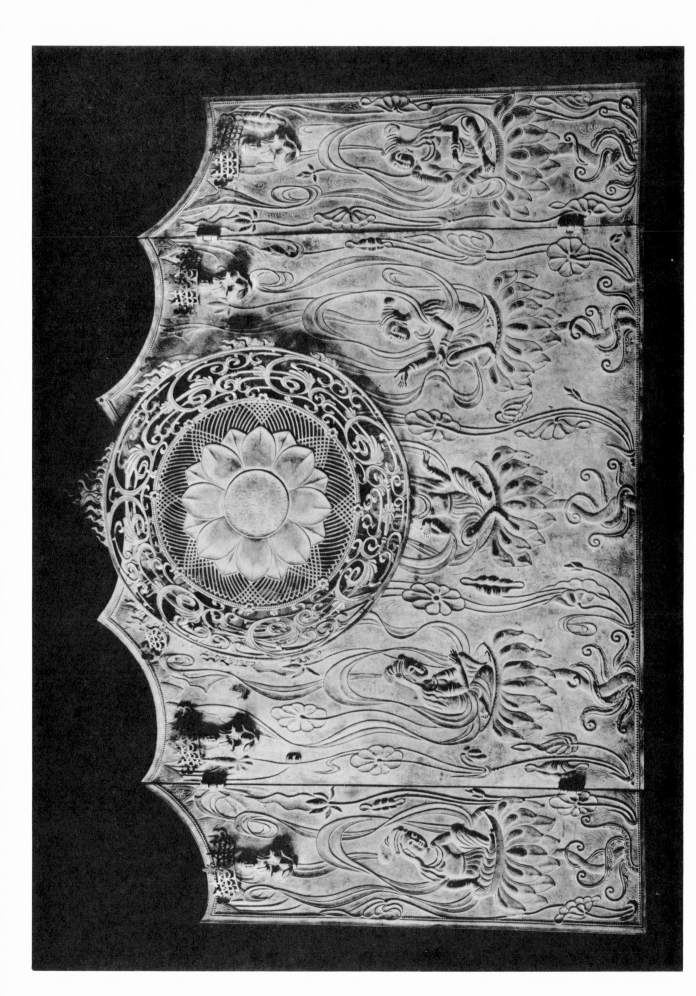

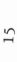

16

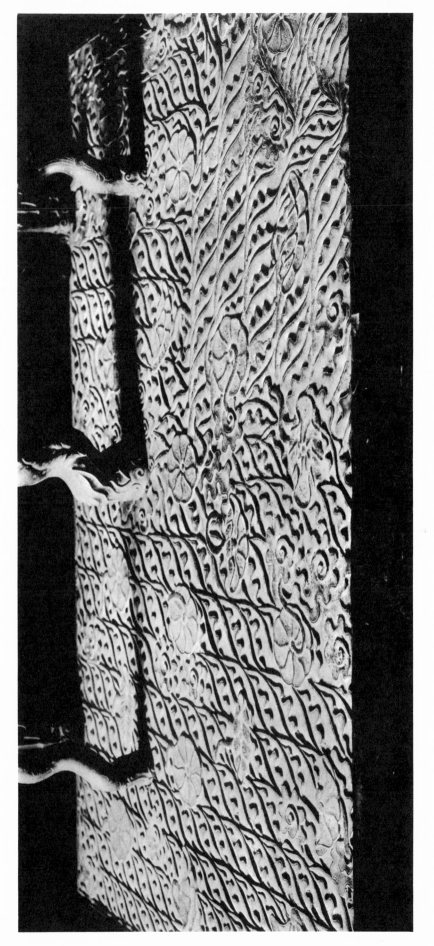

17

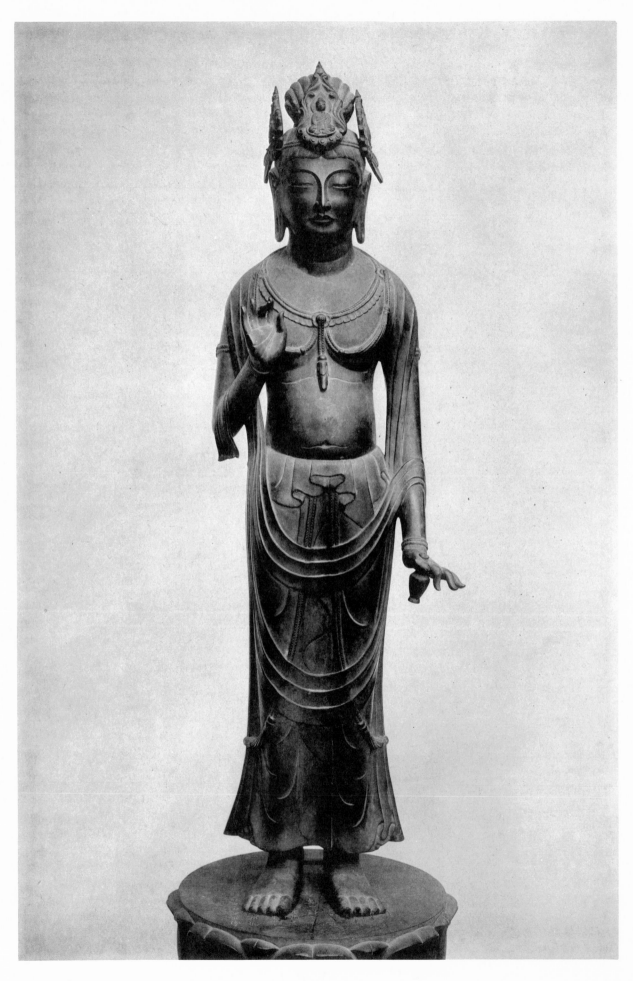

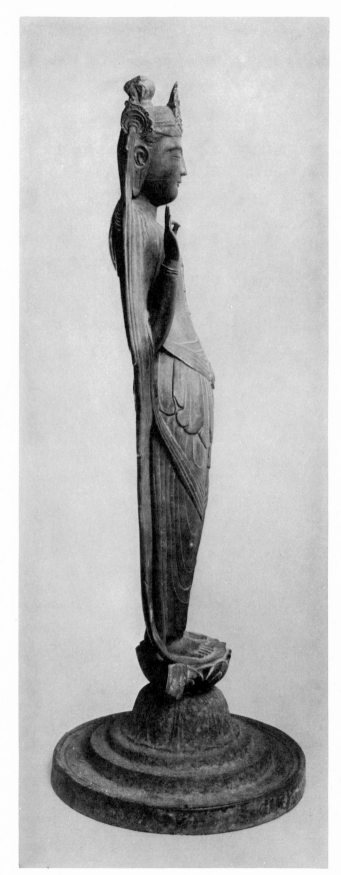

a

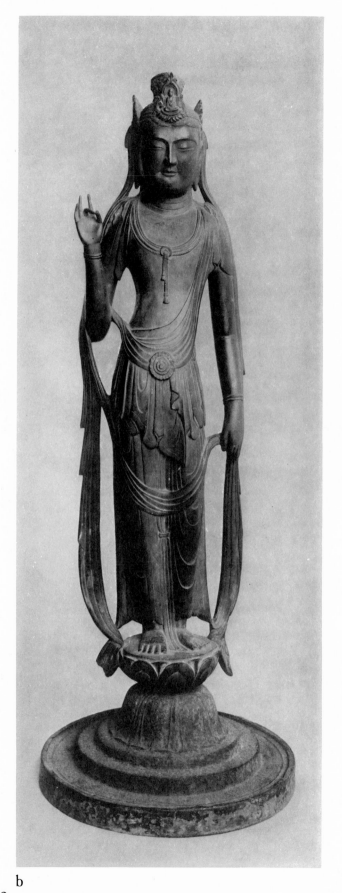

b

19

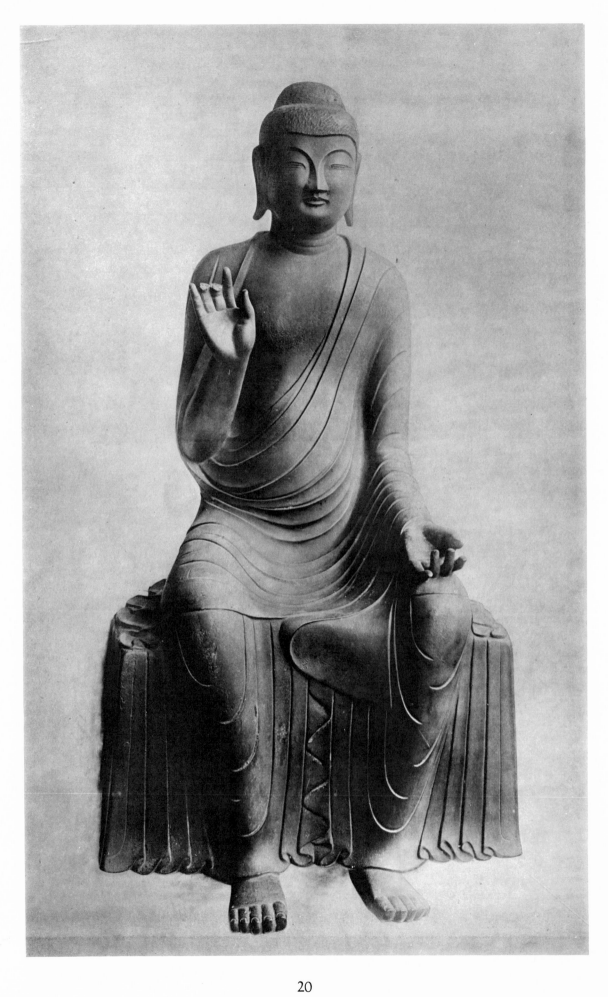

20

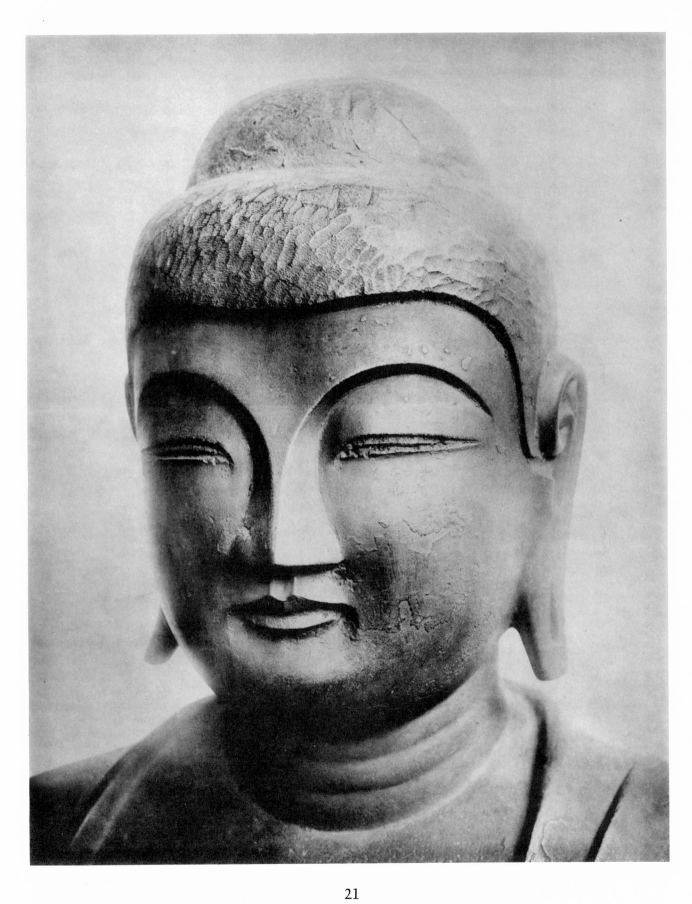

21

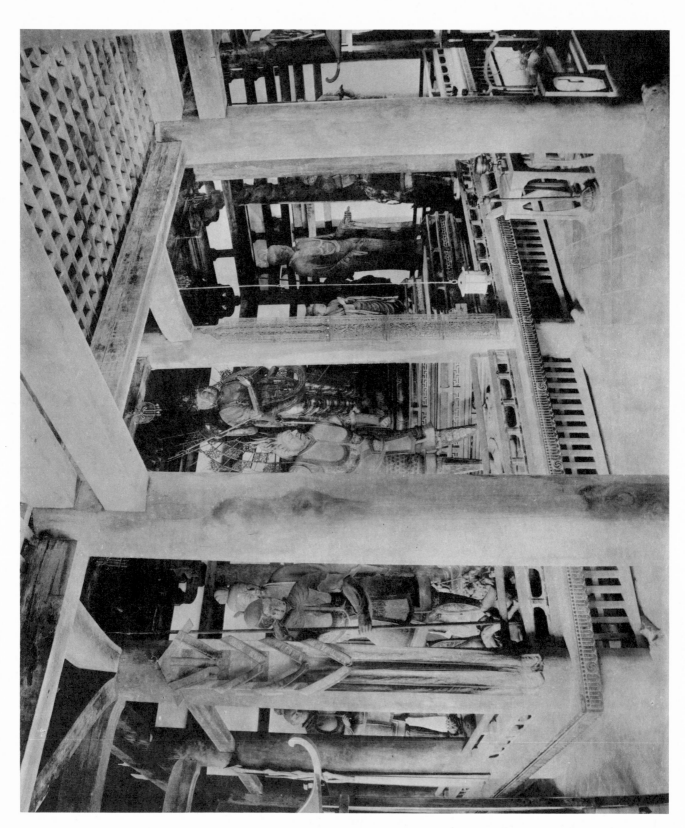

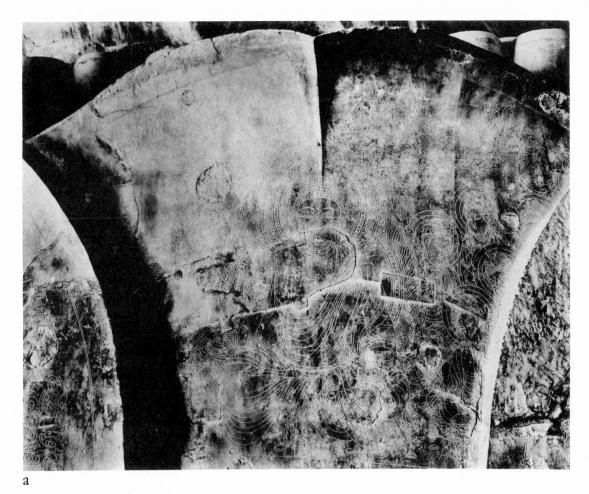

a

b

23

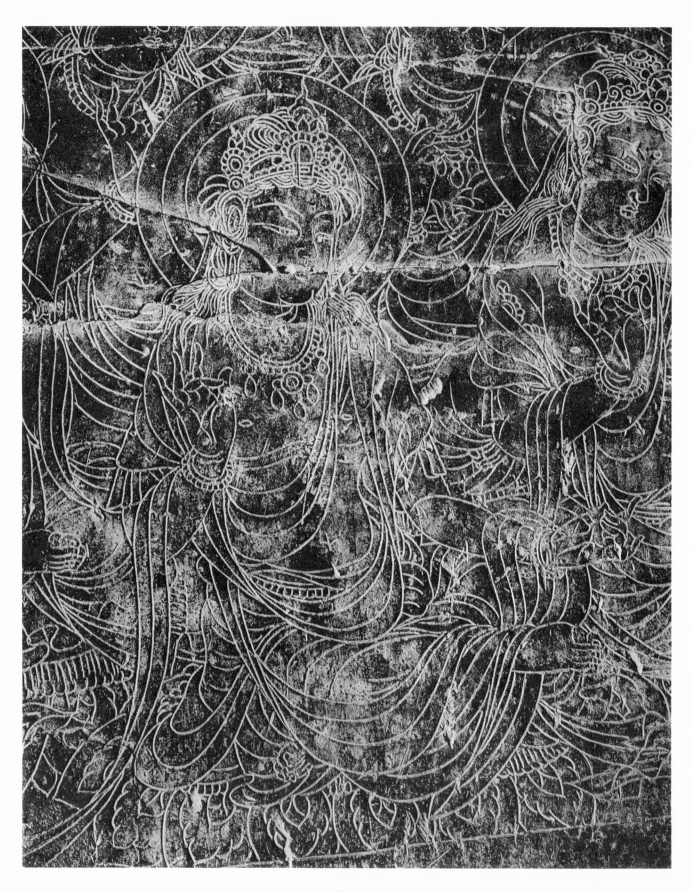

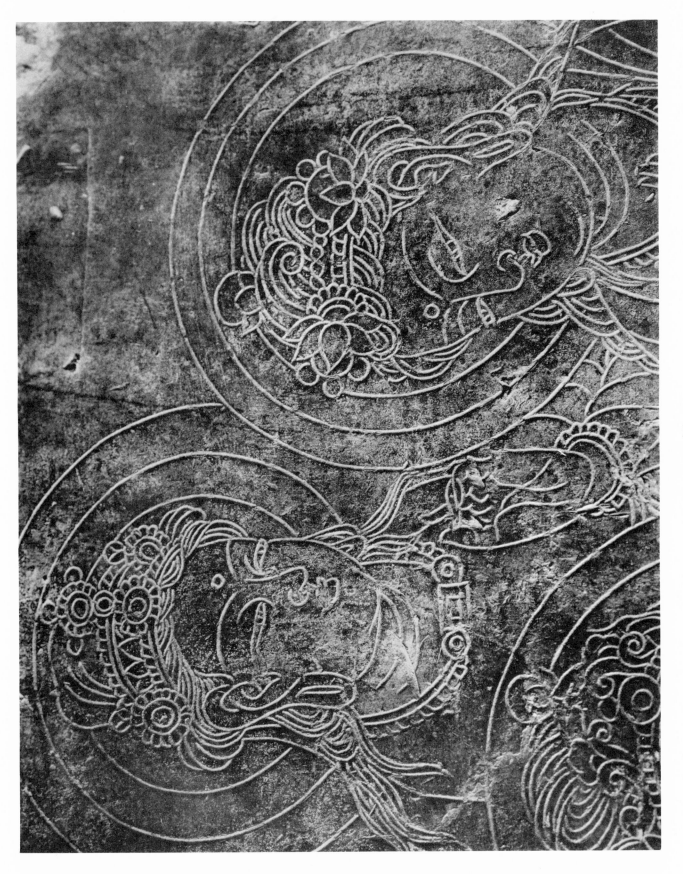

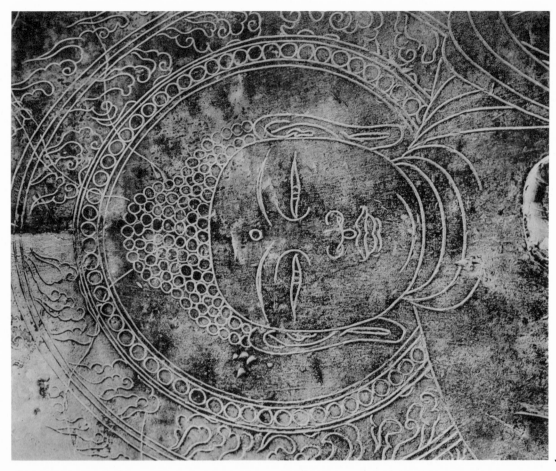

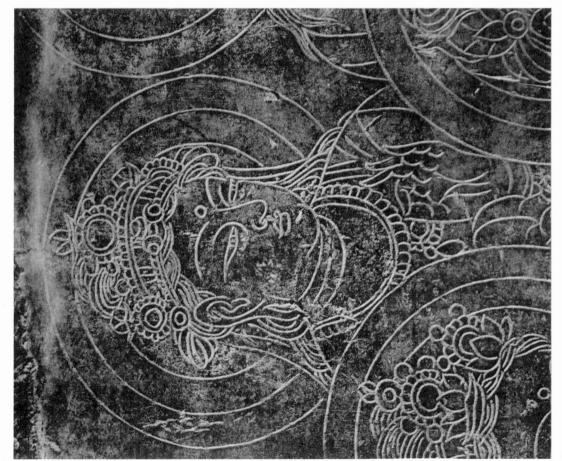

a

b

26

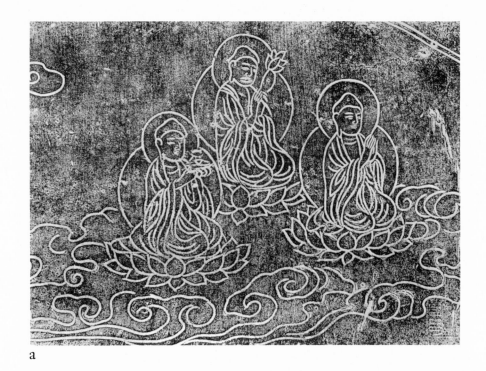

a

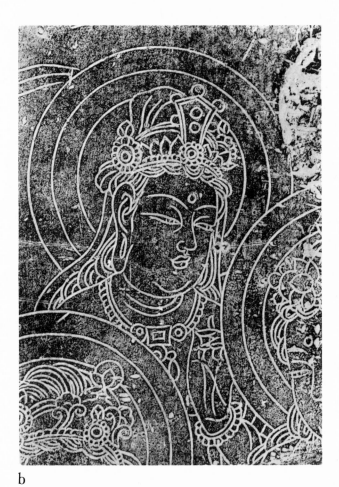

b

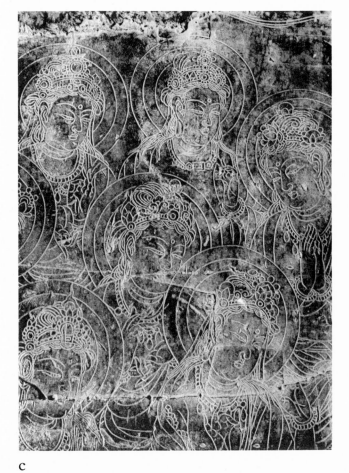

c

27

a

b

28

29

a

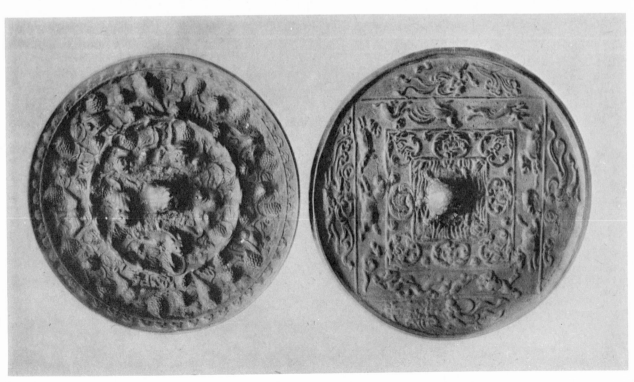

b

30

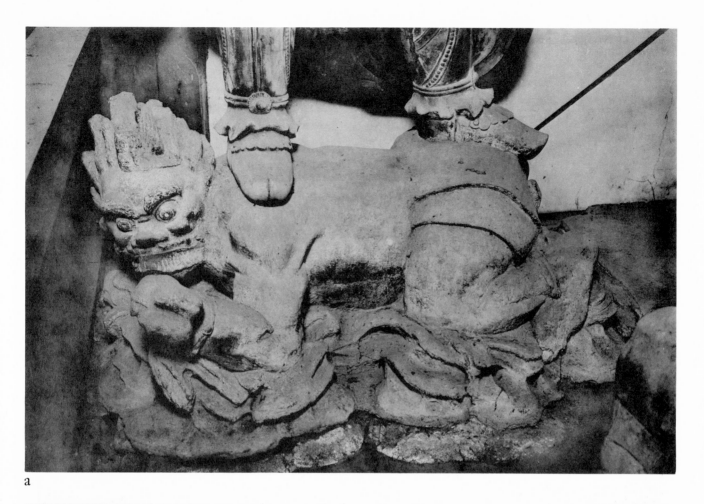

a

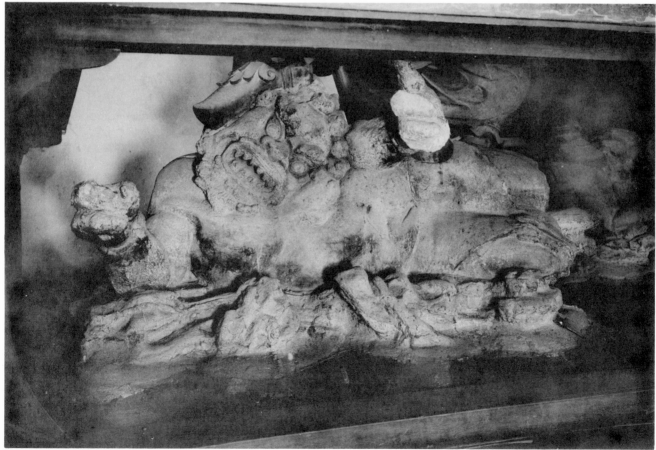

b

31

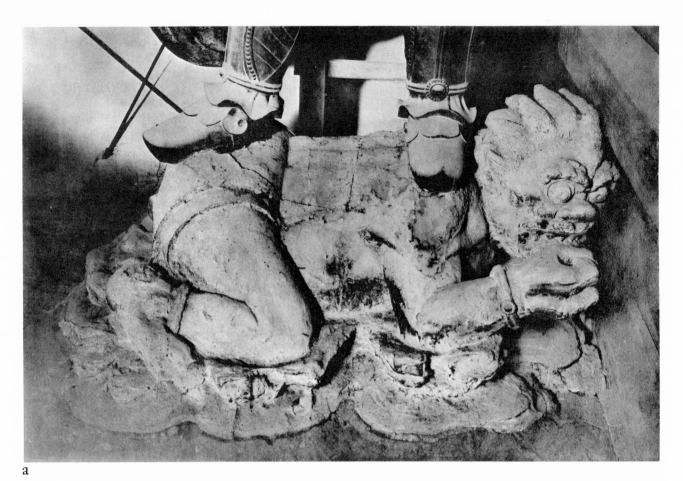

a

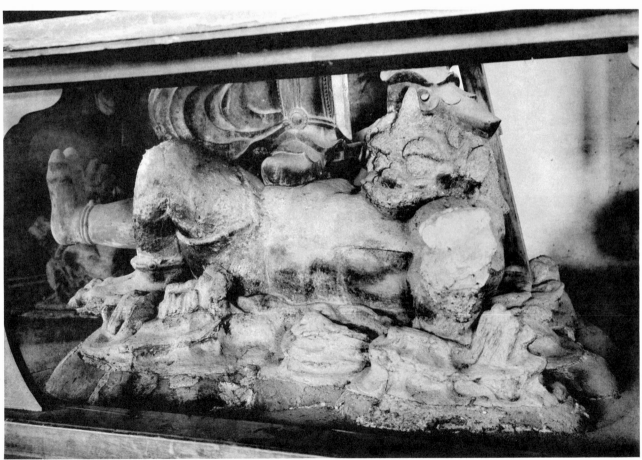

b

32

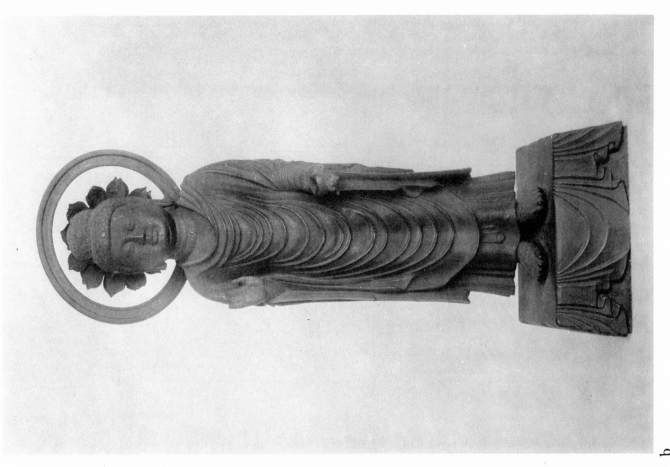

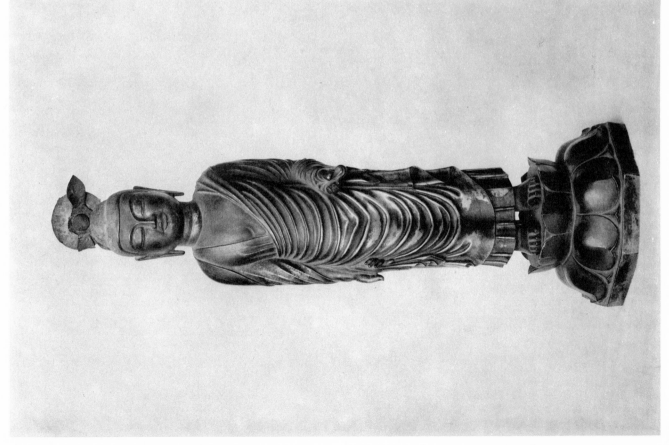

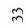

a

b

33

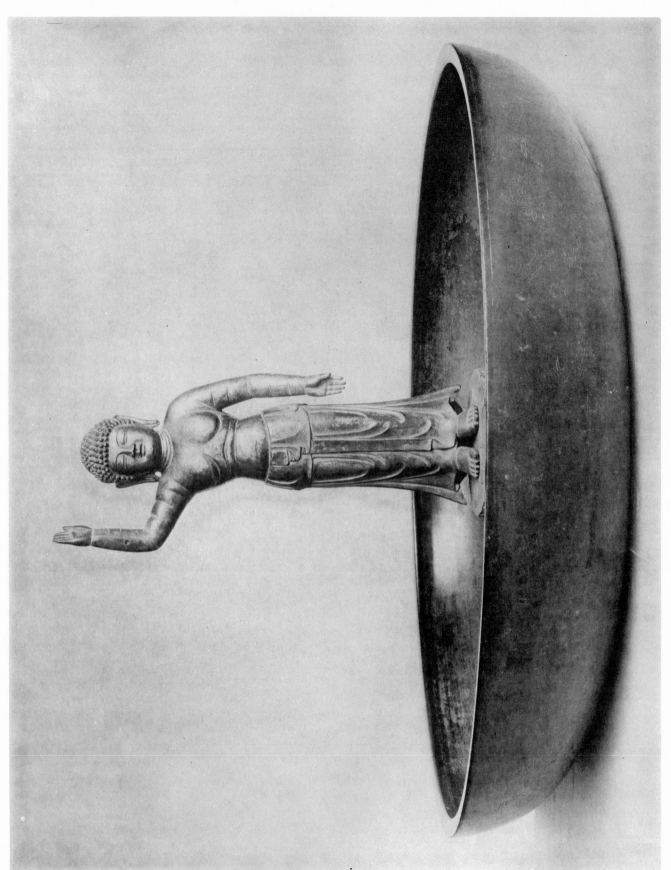

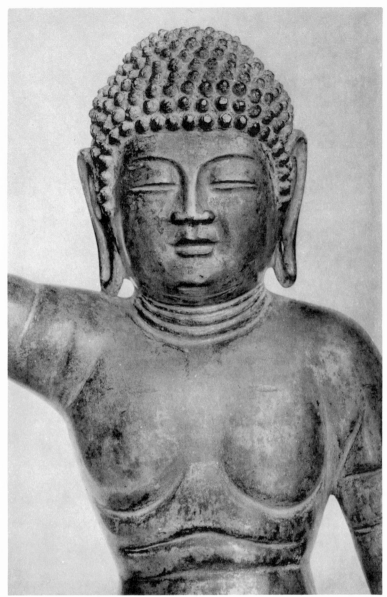

a

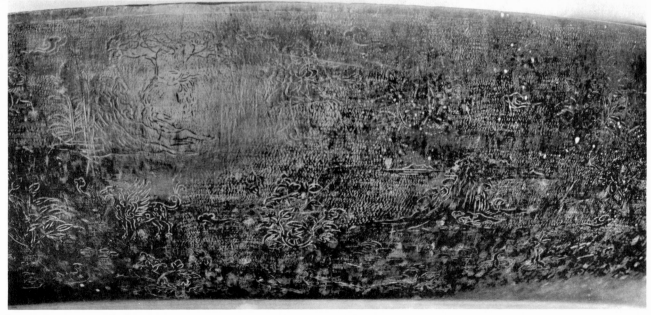

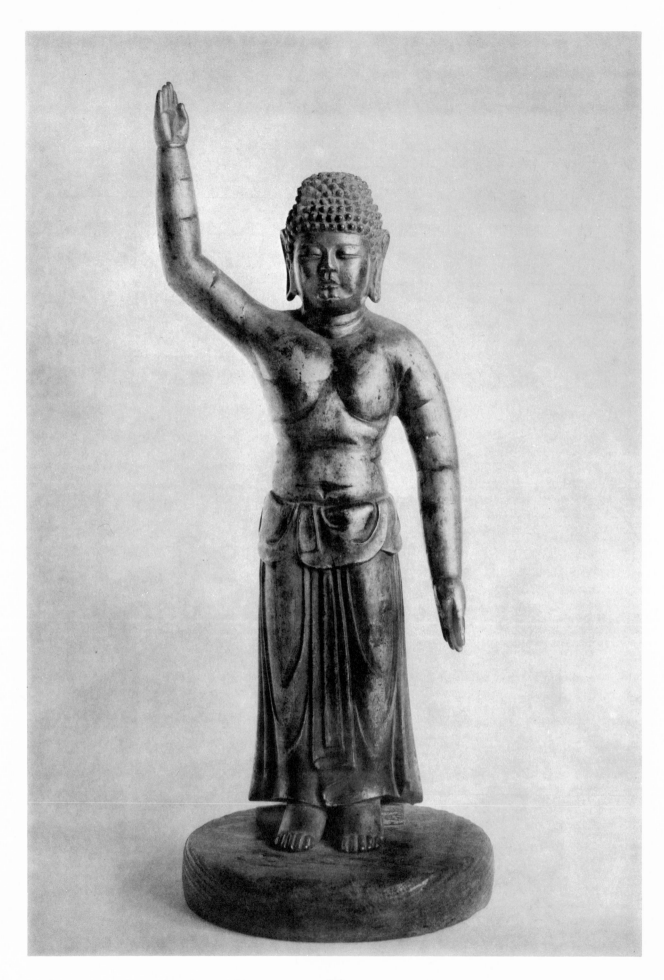

36

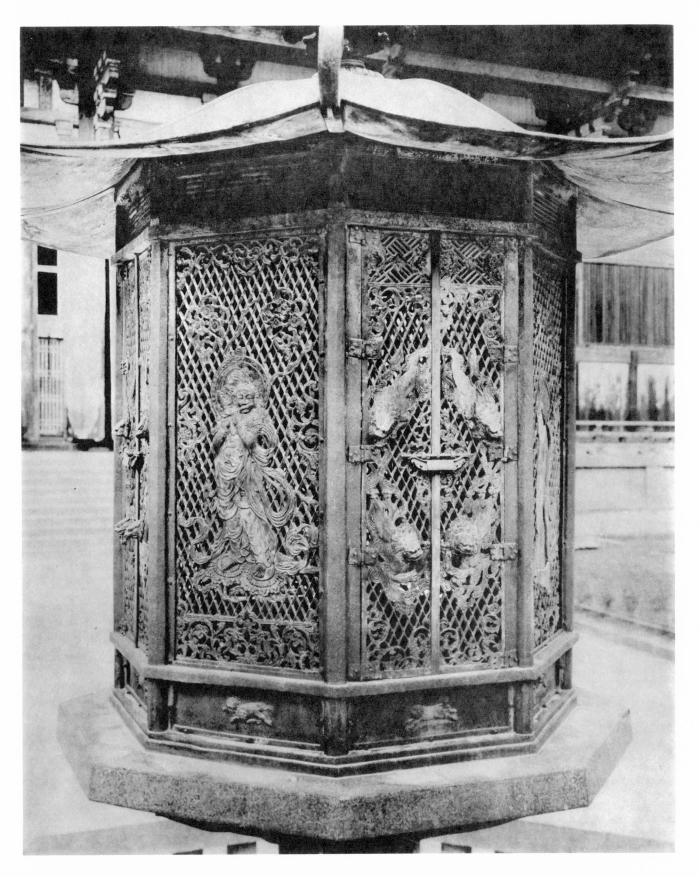

37

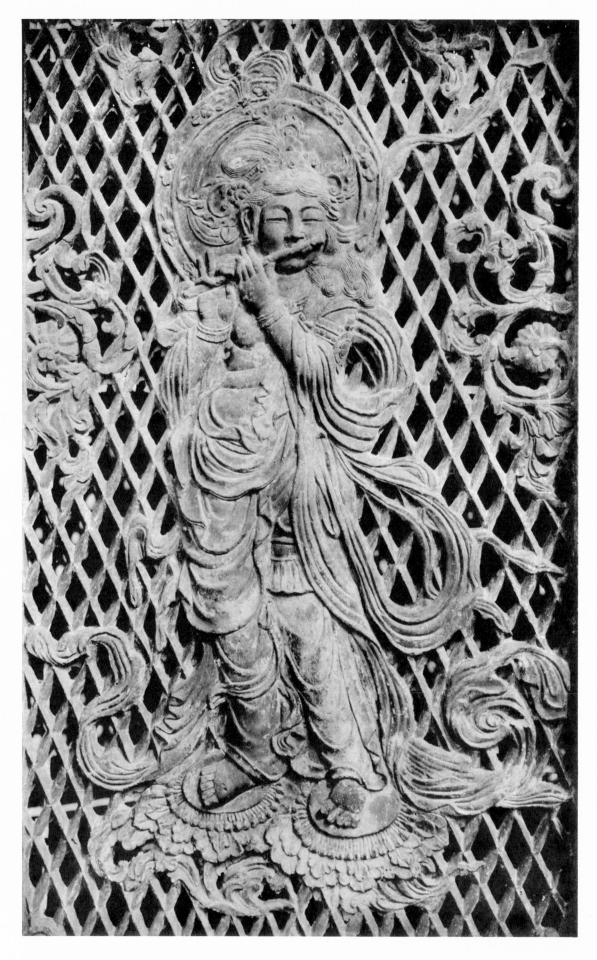

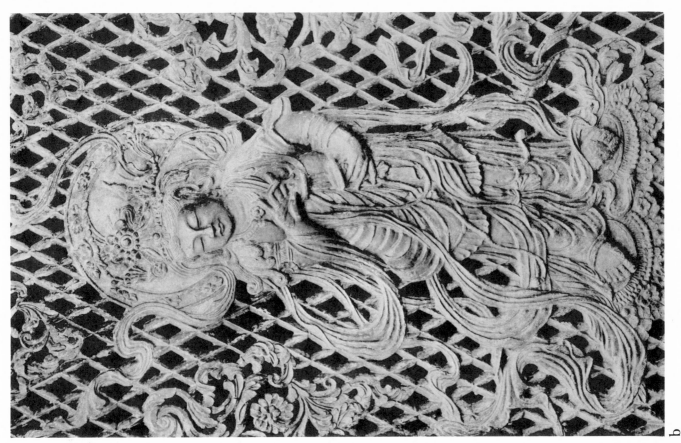

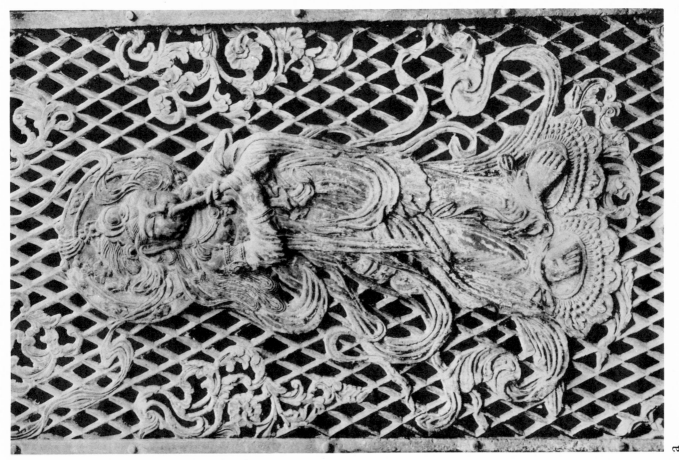

a

b

39

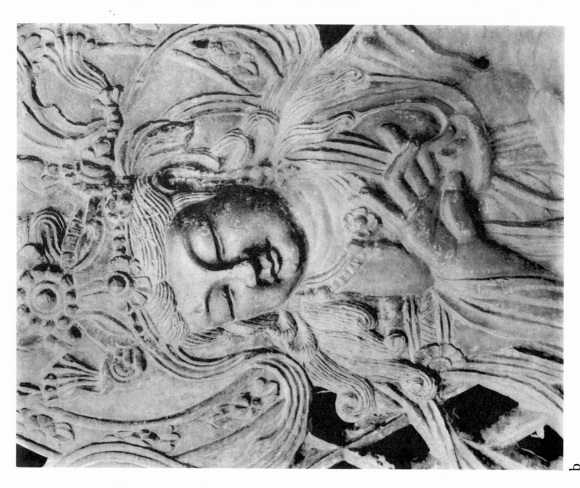

40 b

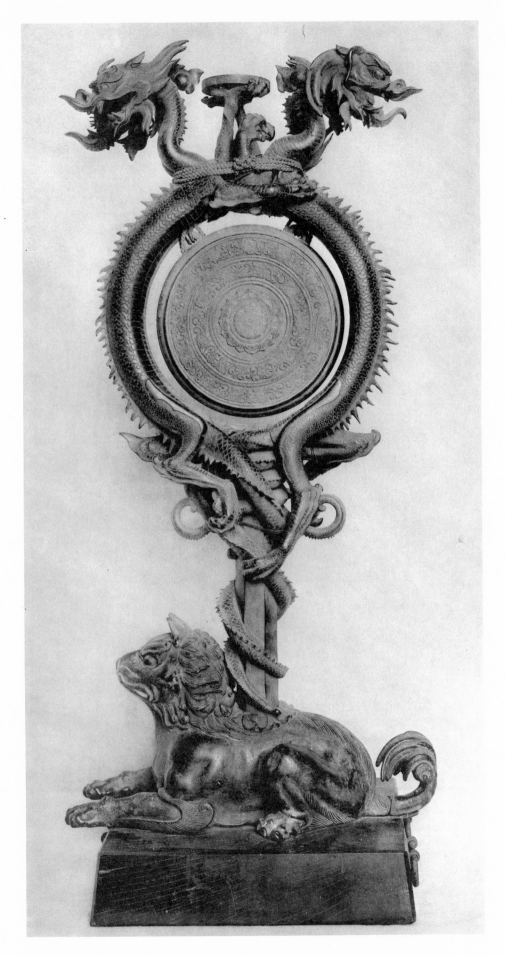

41

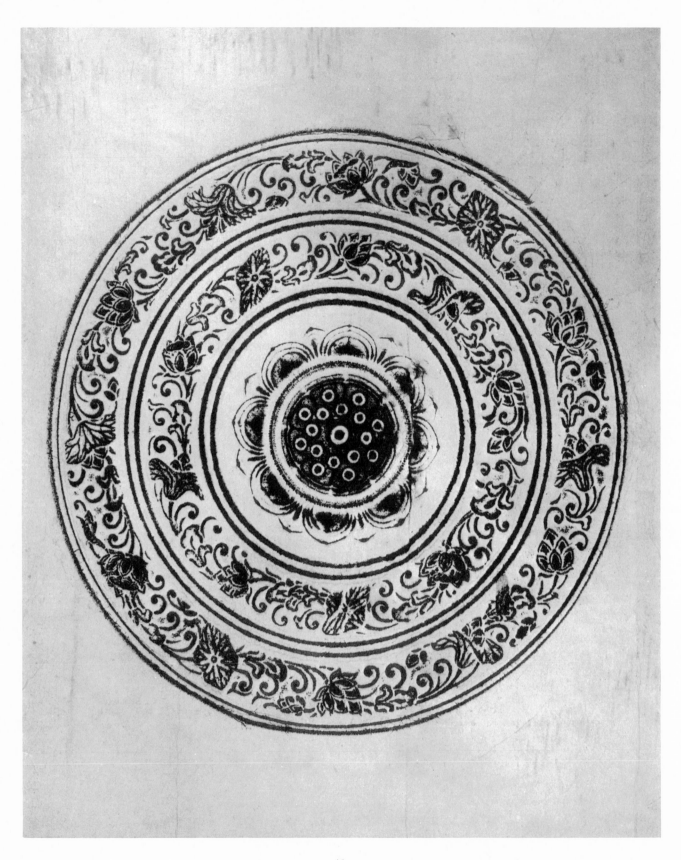

42

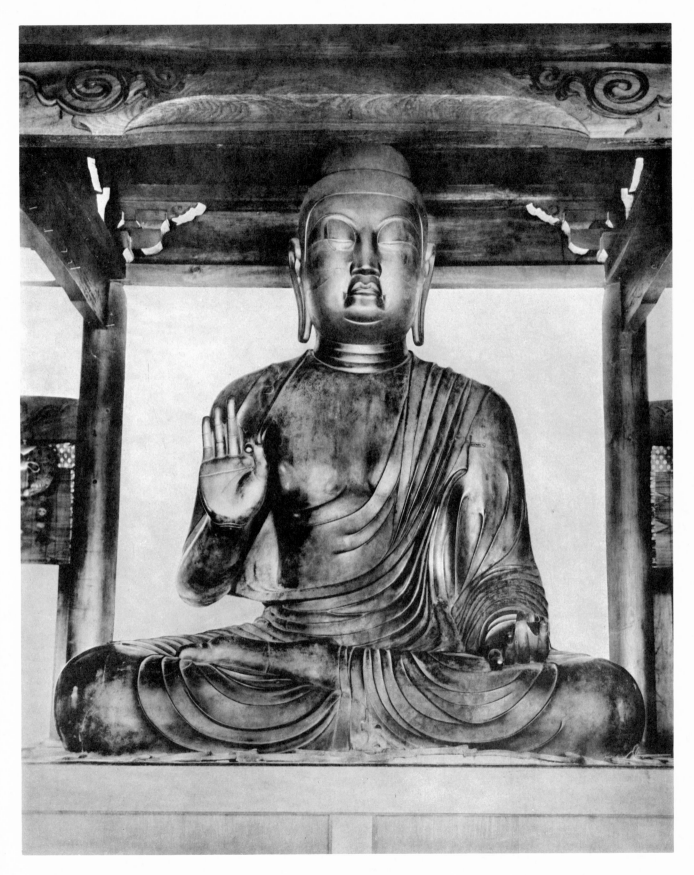

43

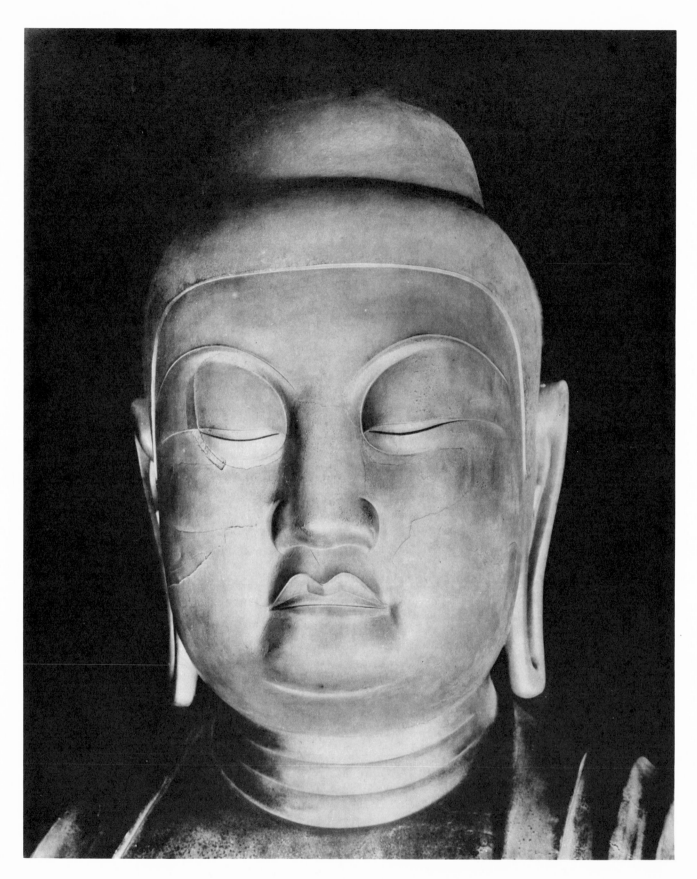

44

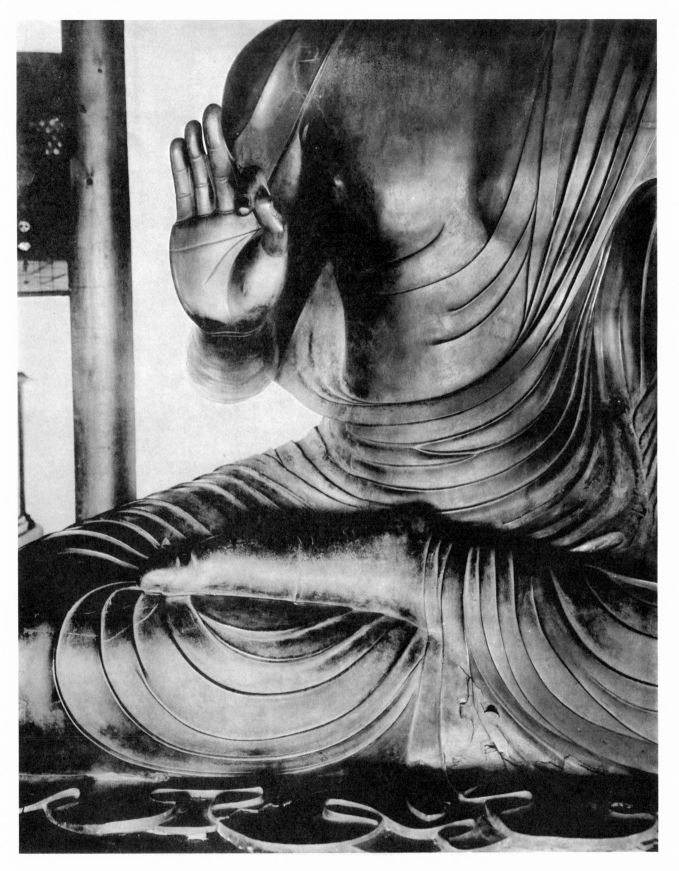

45

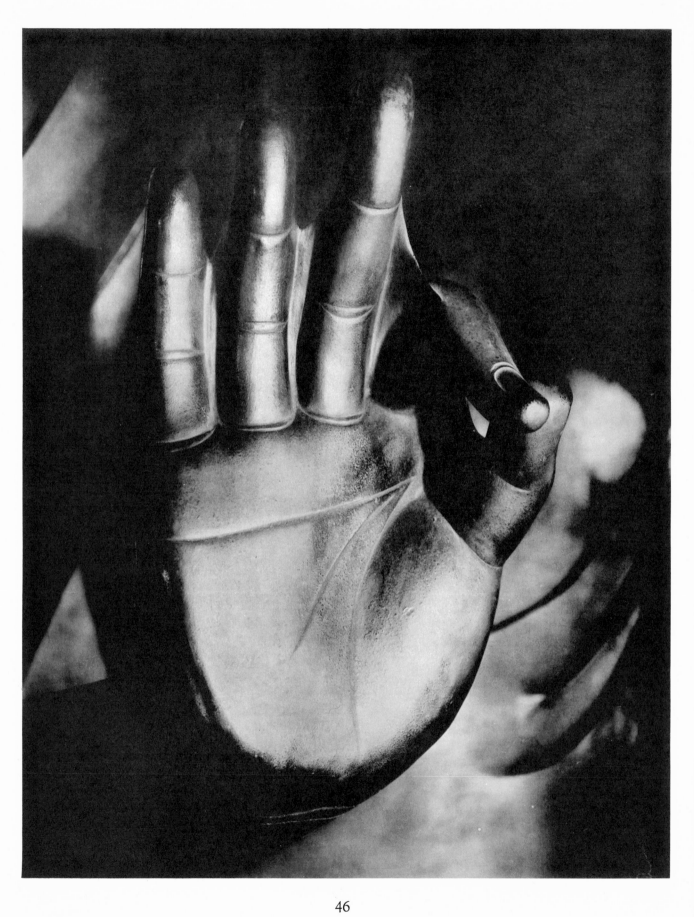

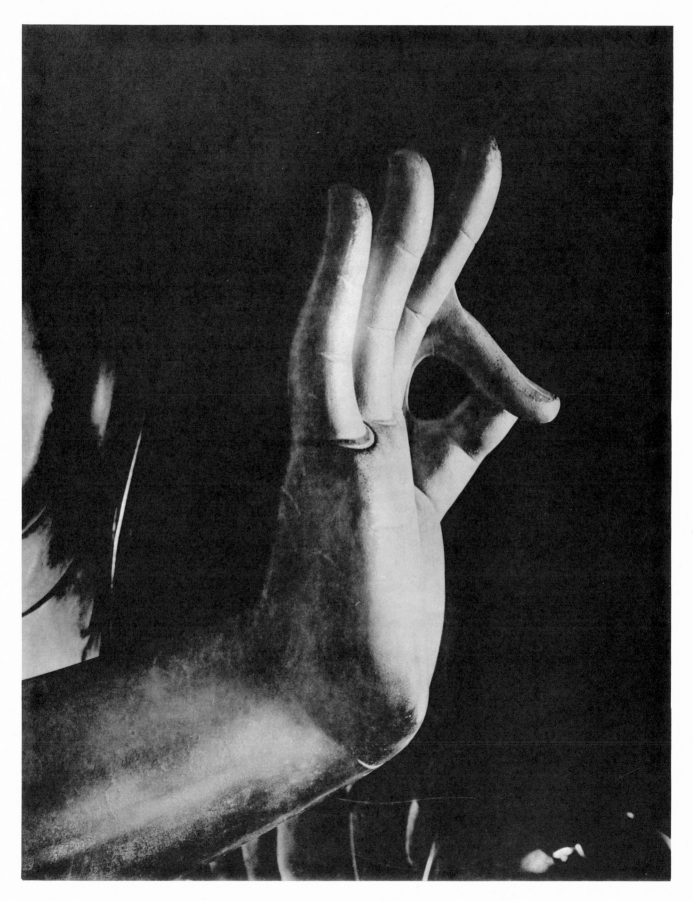

47

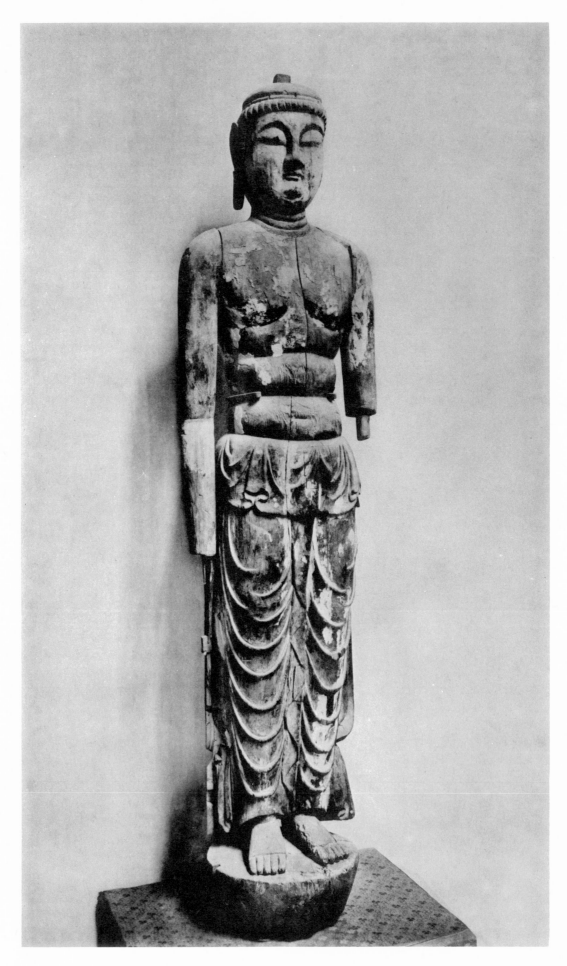

48

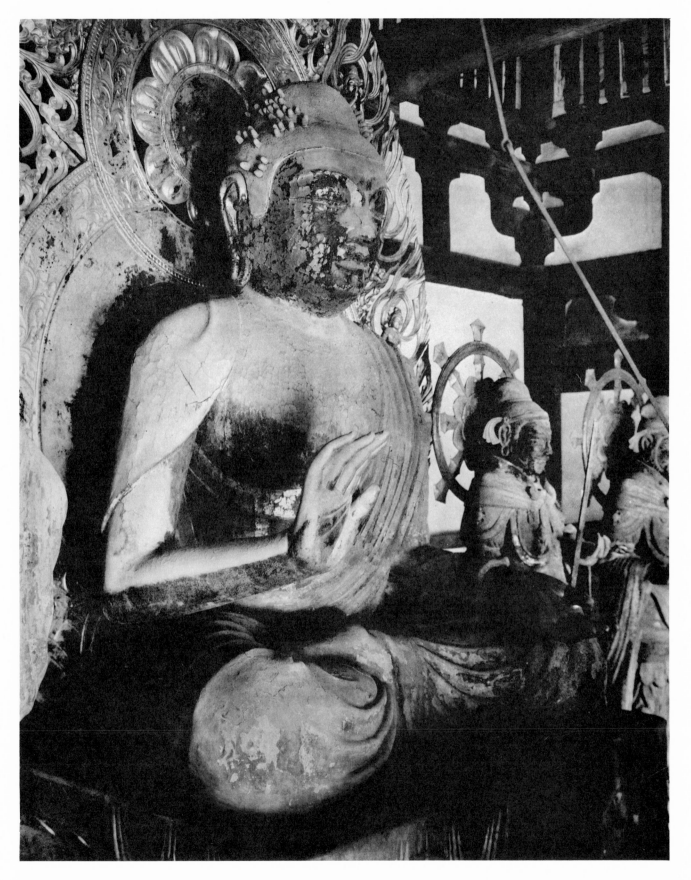

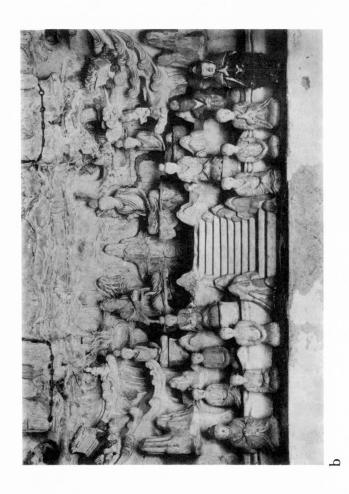

a

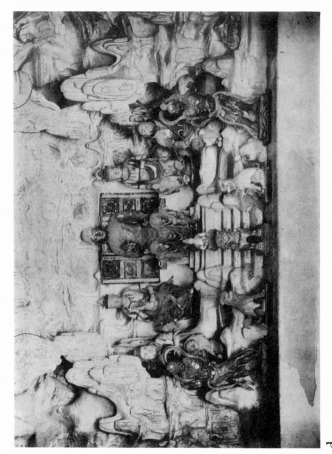

b

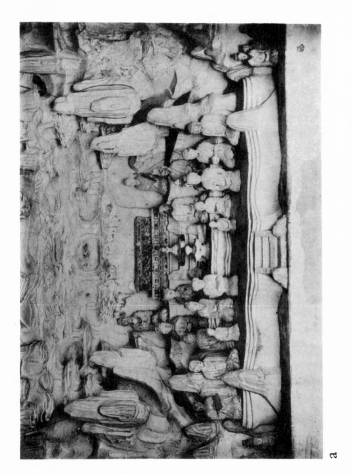

c

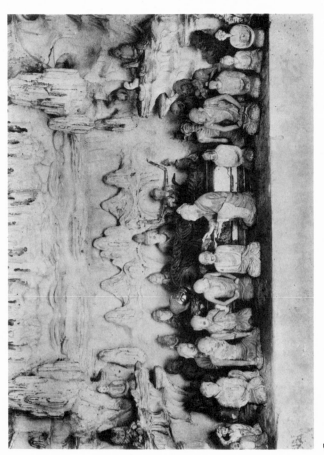

d

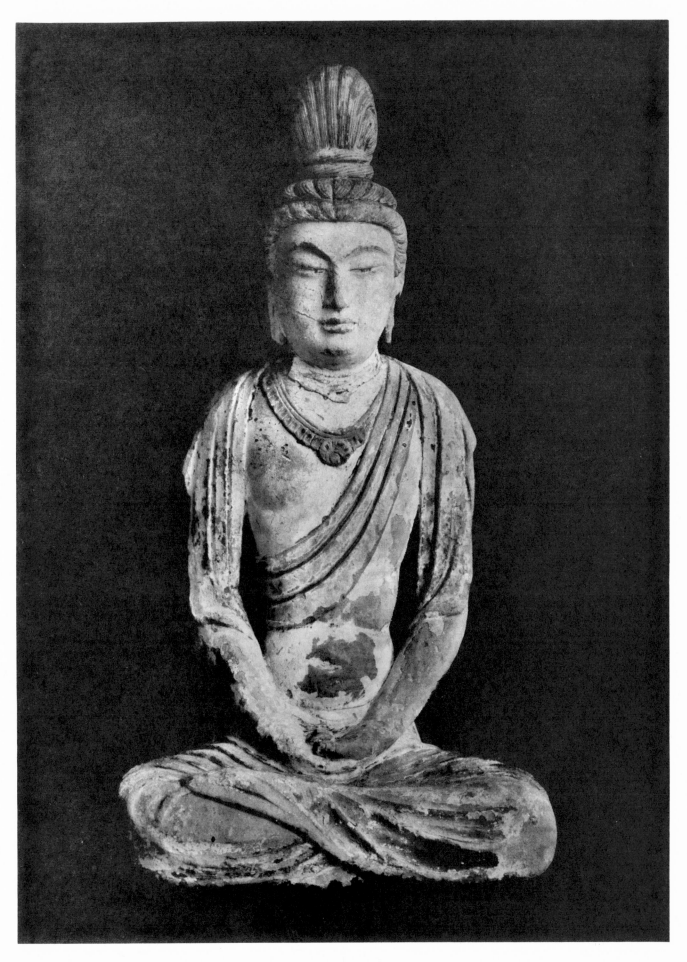

51

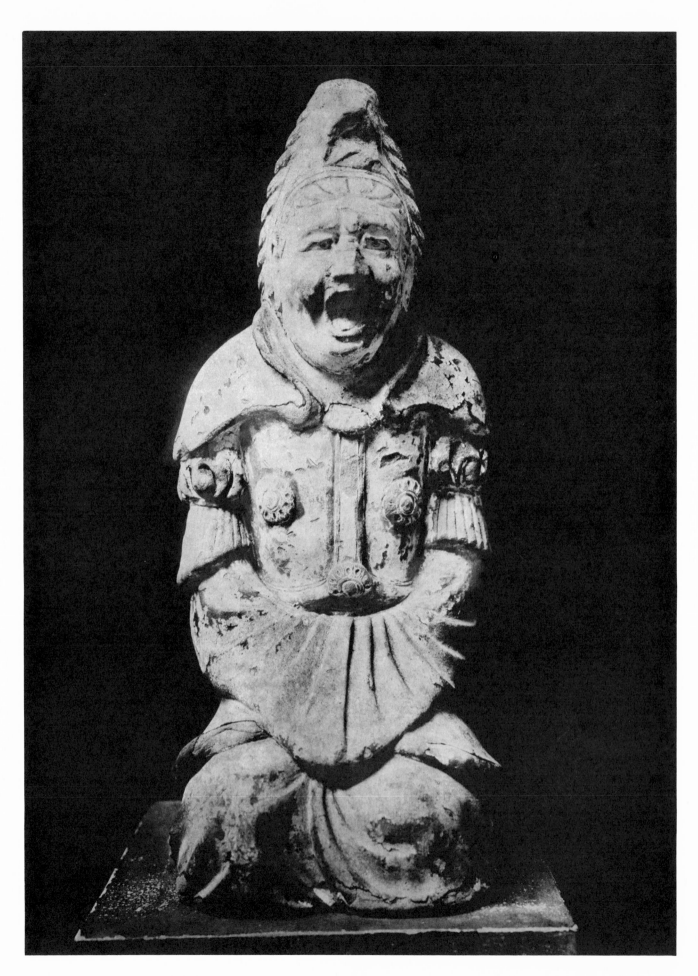

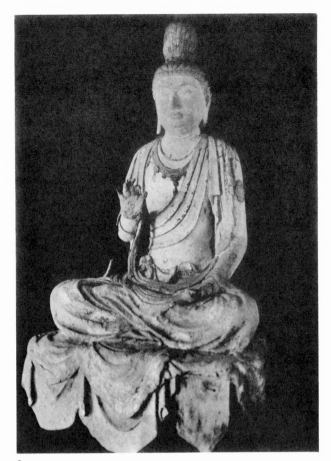

a

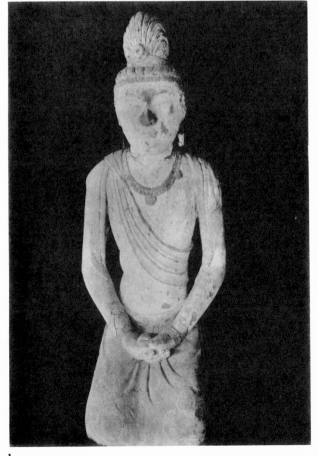

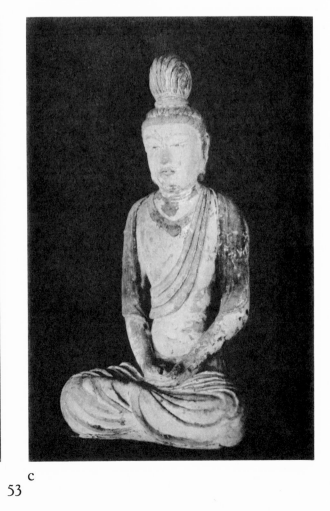

b

c

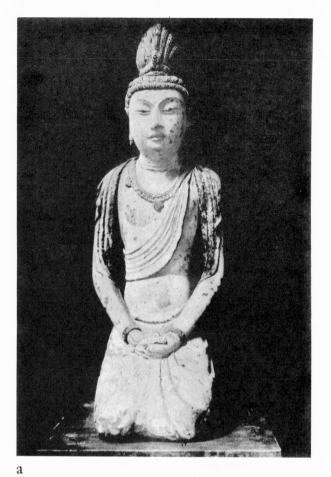

a

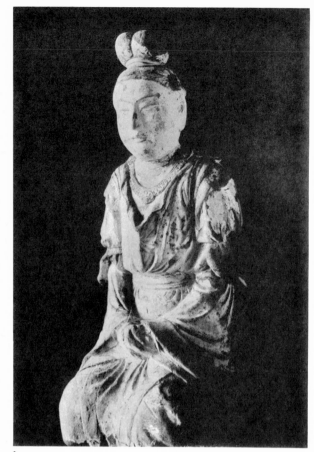

b

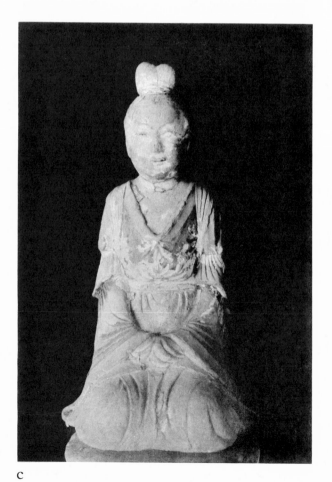

c

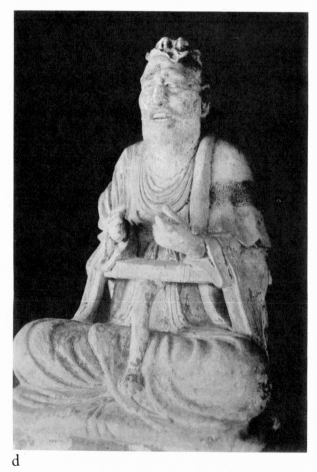

d

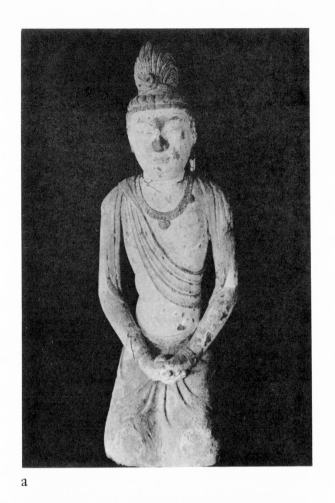

a

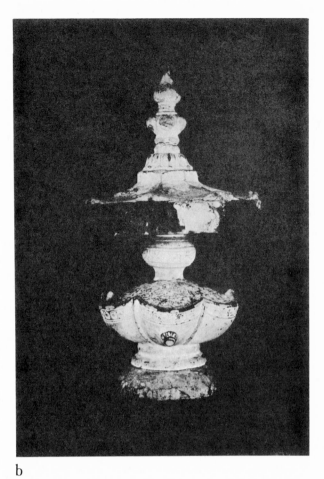

b

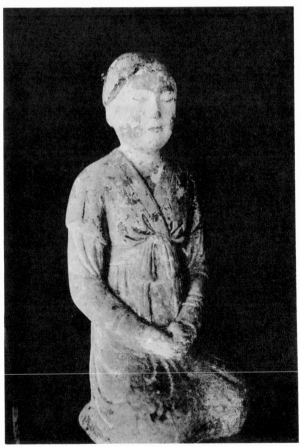

c

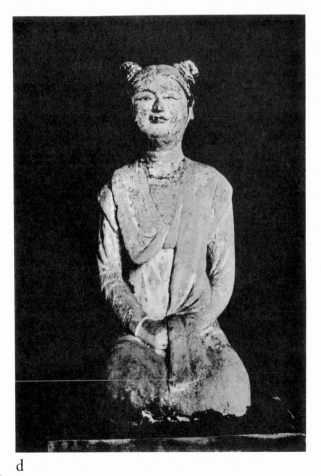

d

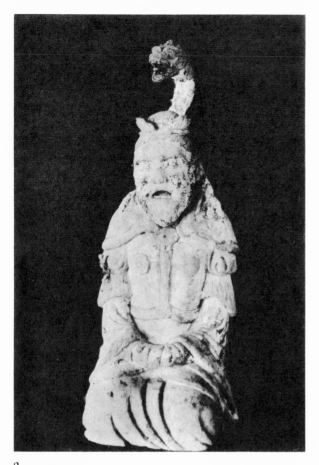

a

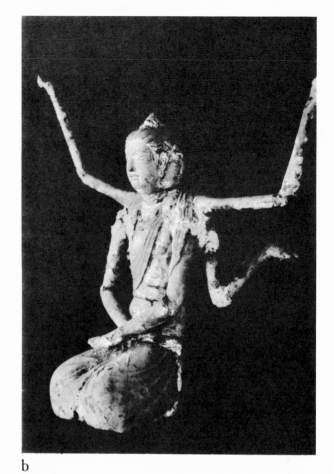

b

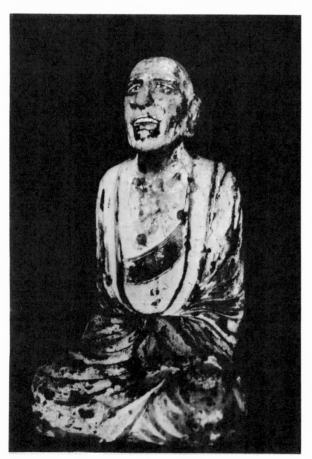

c

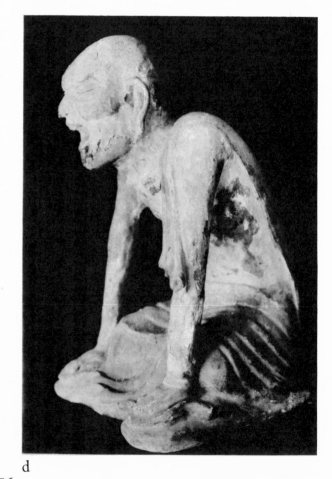

d

56

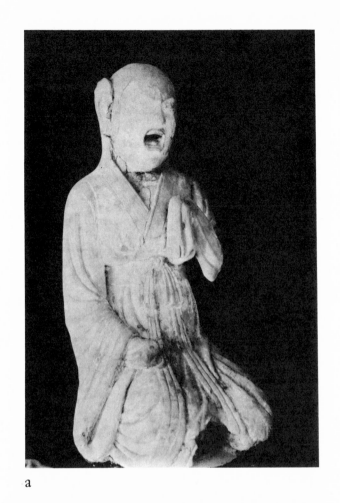

a

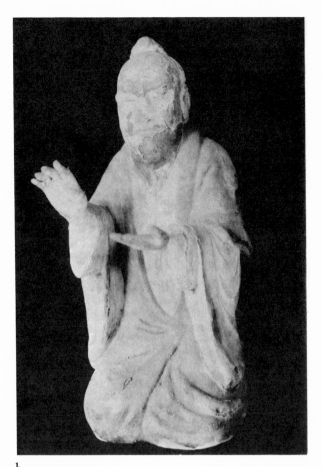

b

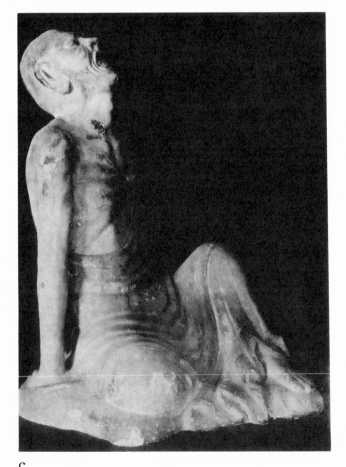

c

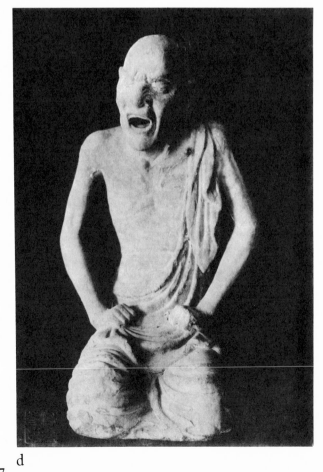

d

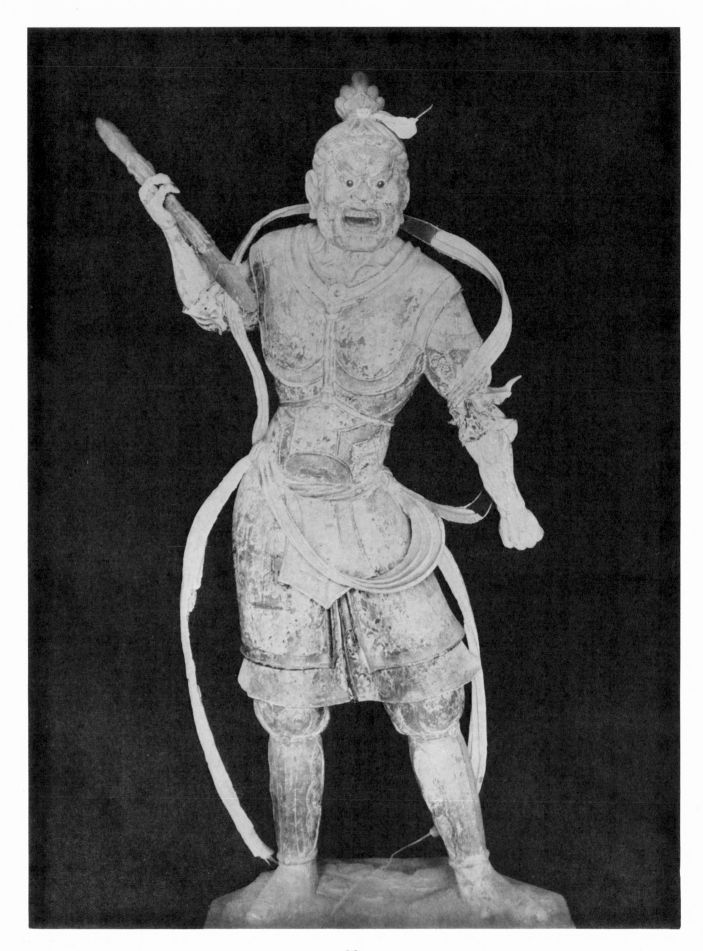

58

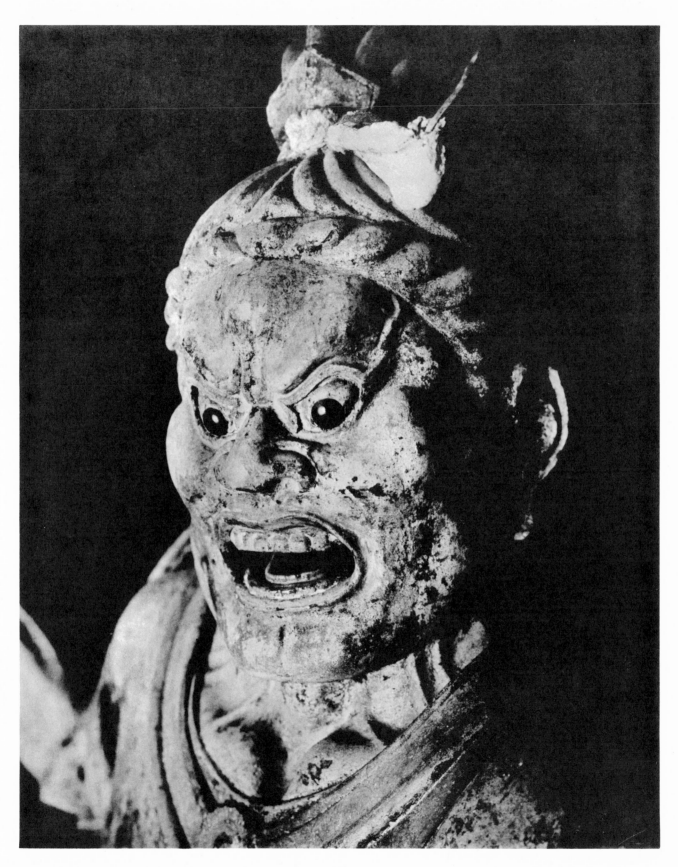

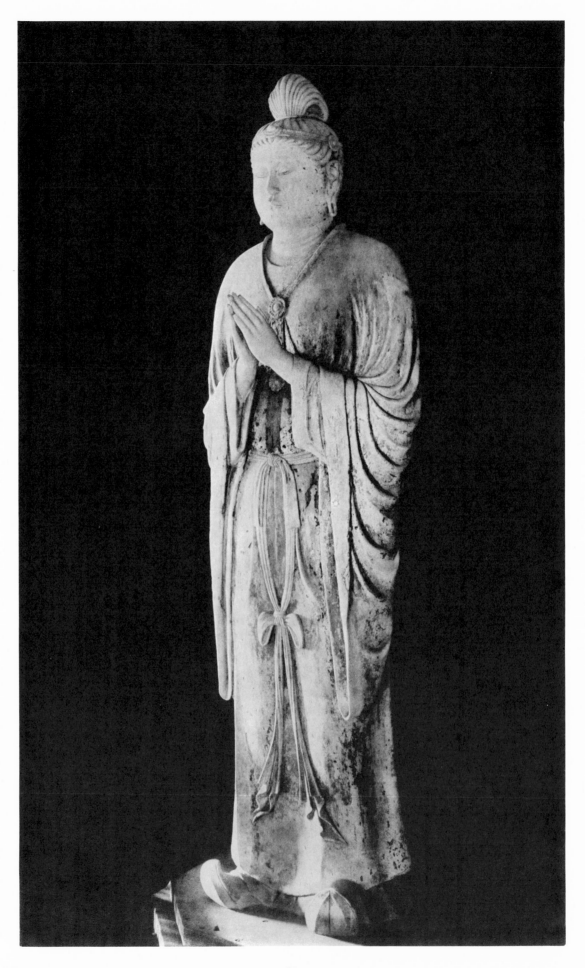

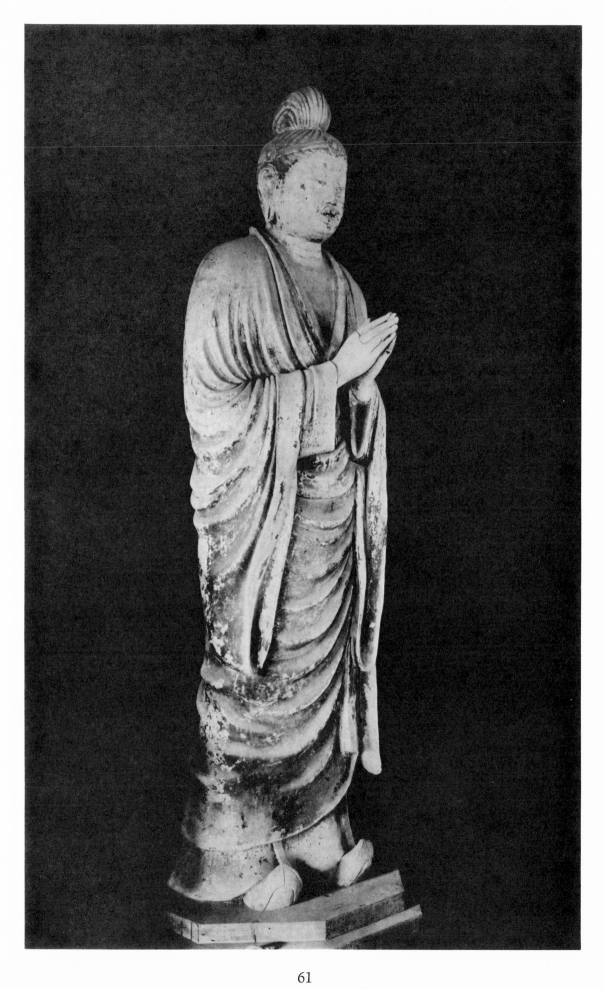

61

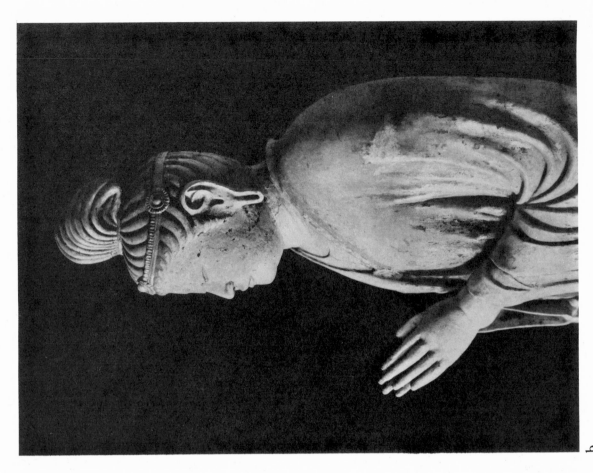

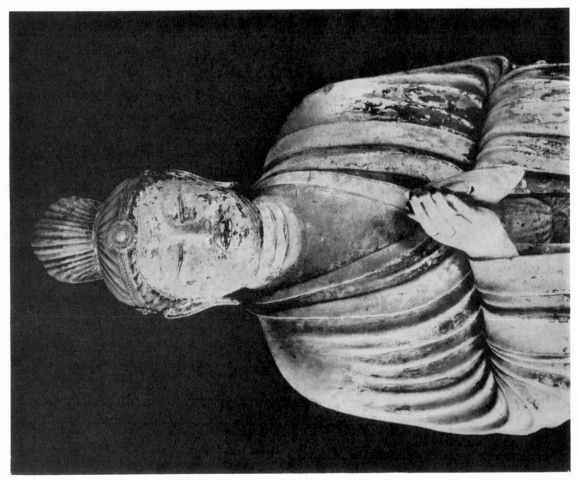

a

b

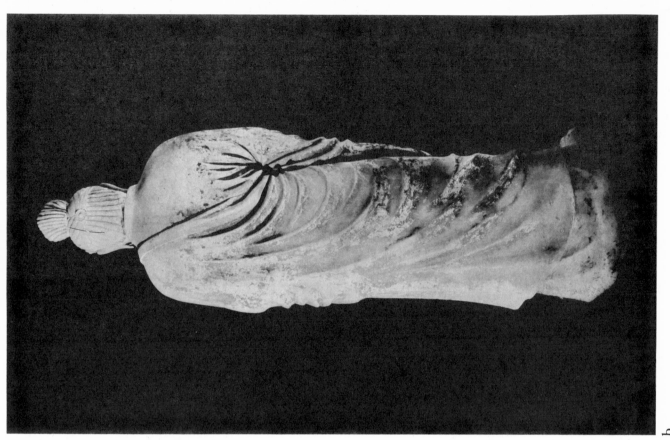

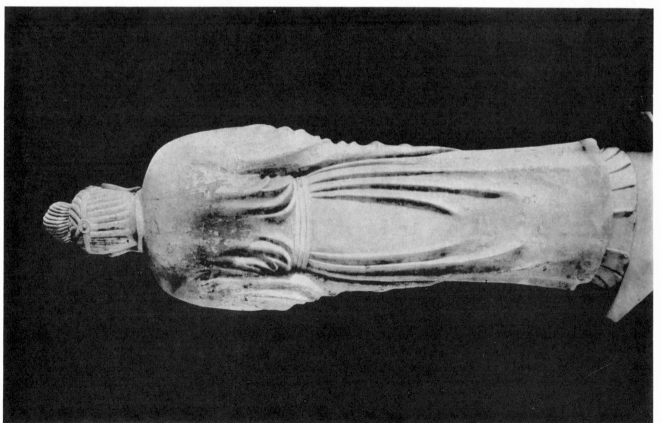

a

b

63

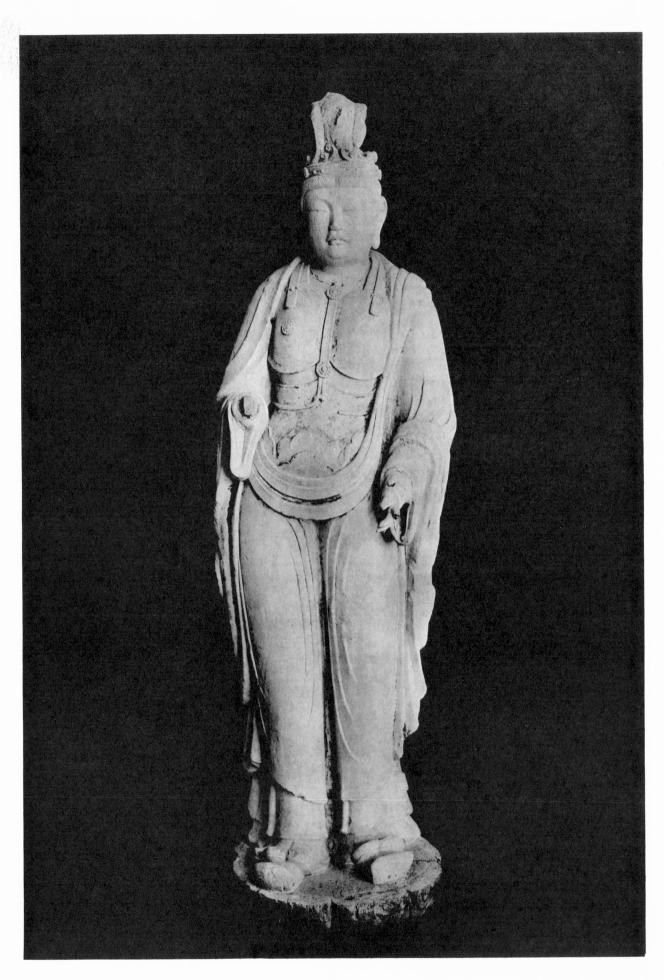

64

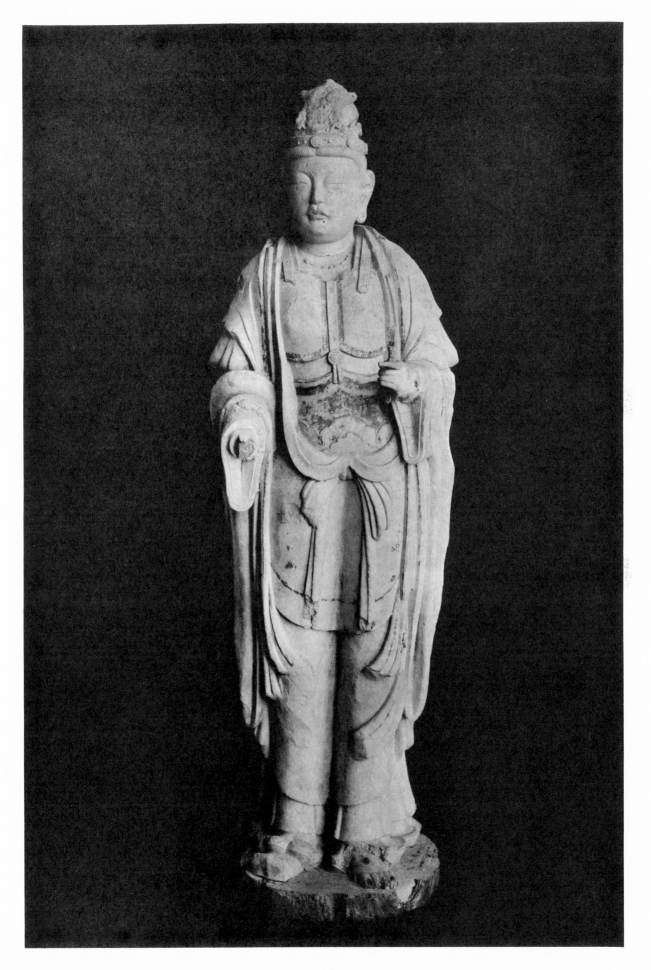

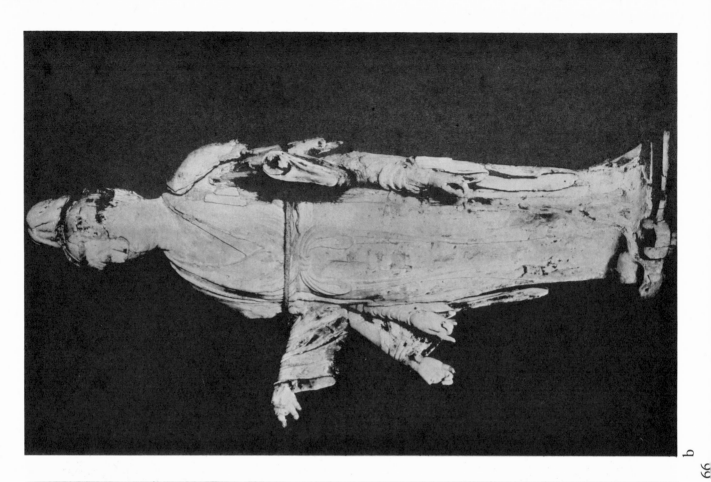

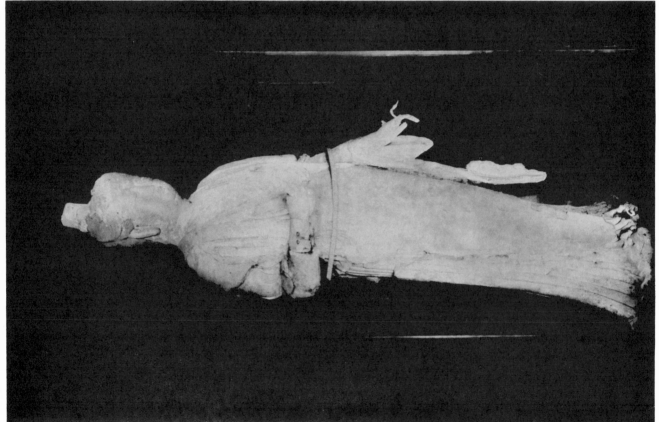

99

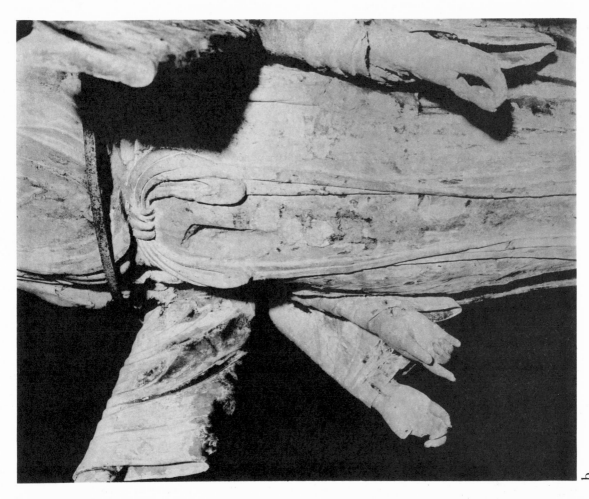

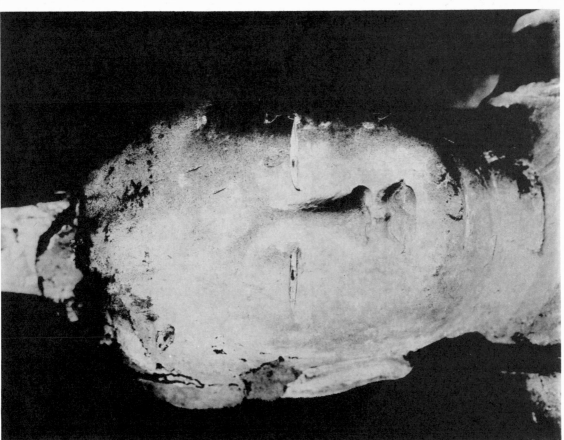

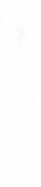

a

b

67

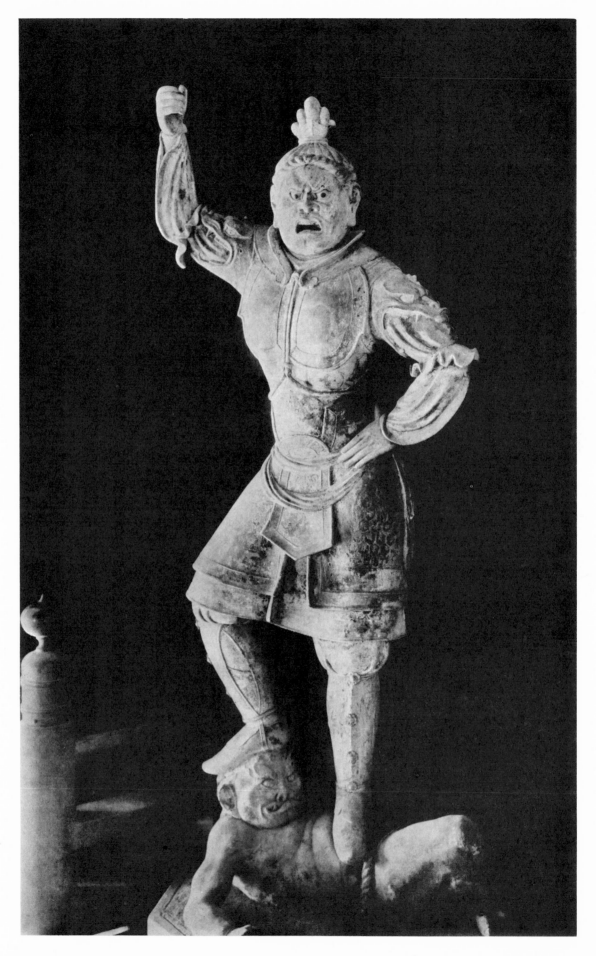

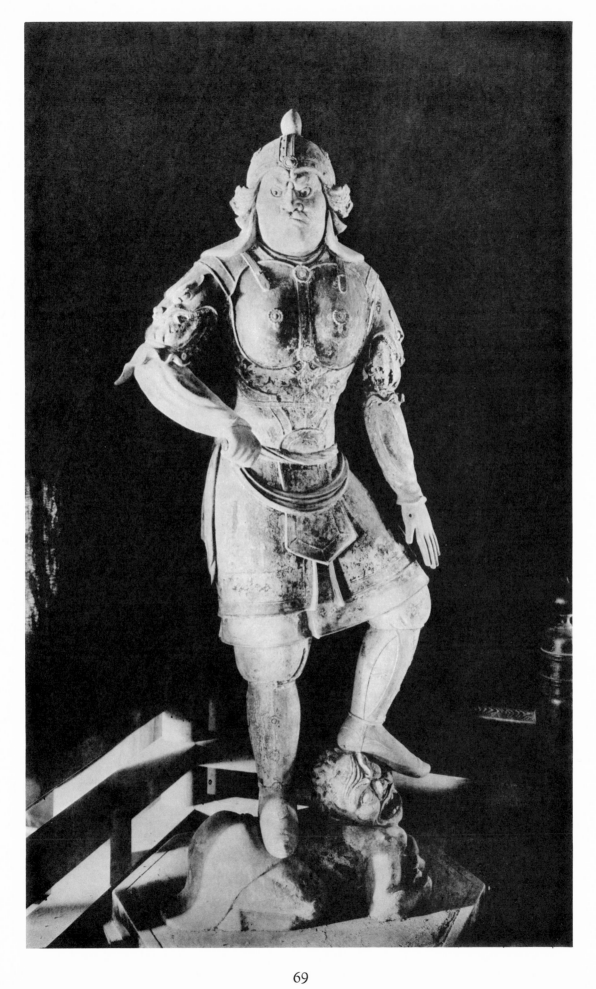

69

b

70

a

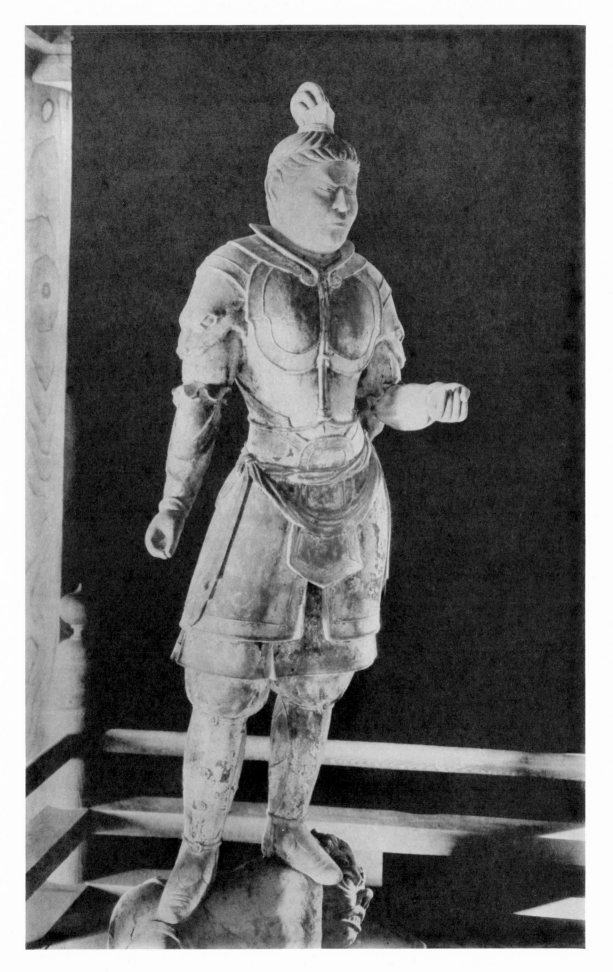

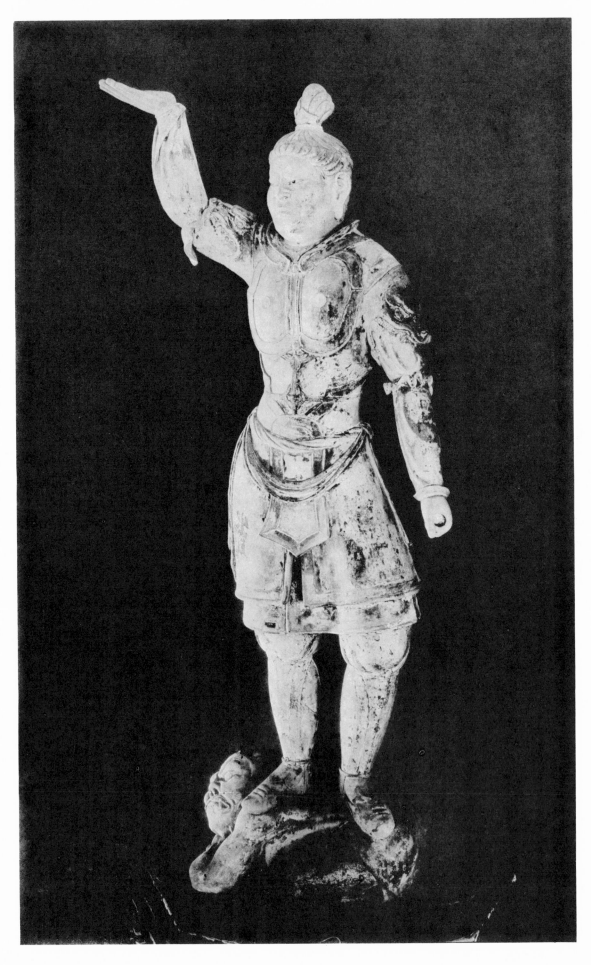

72

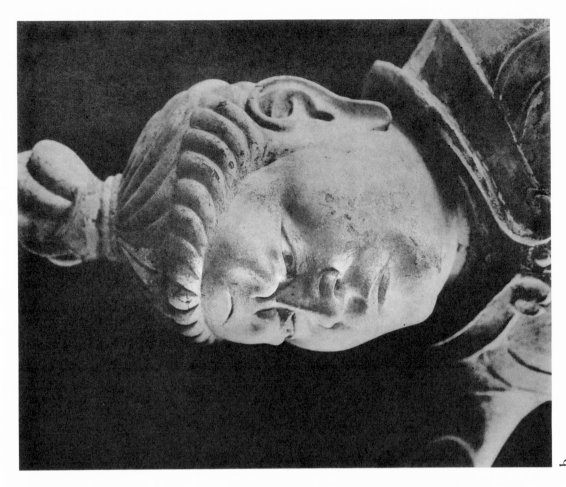

73

b

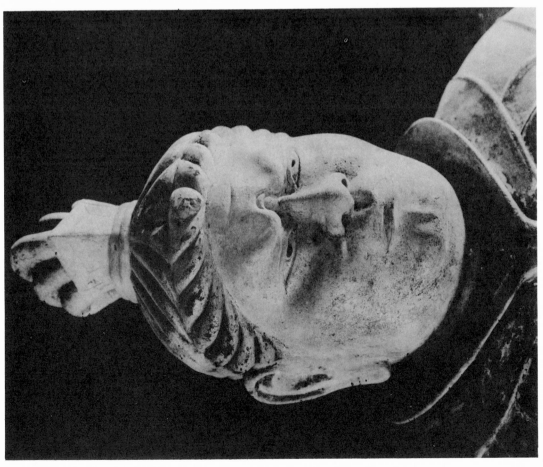

a

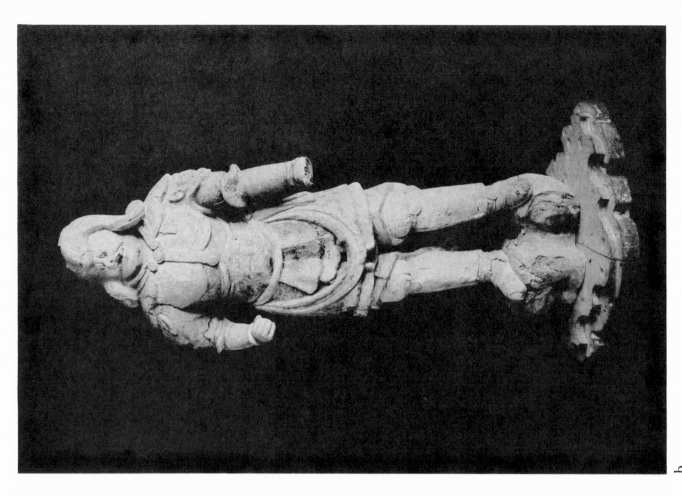

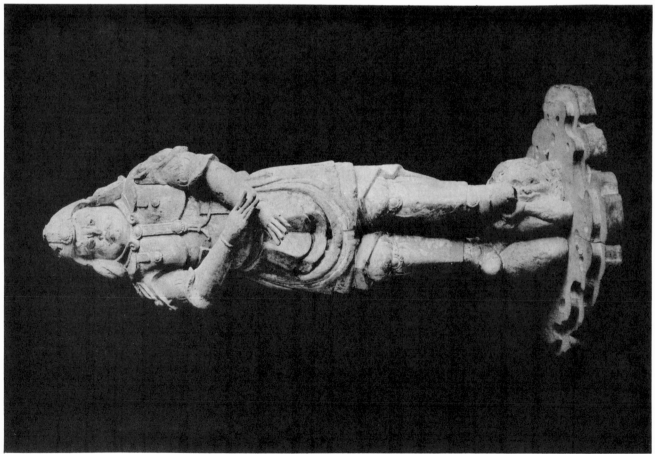

b

a

74

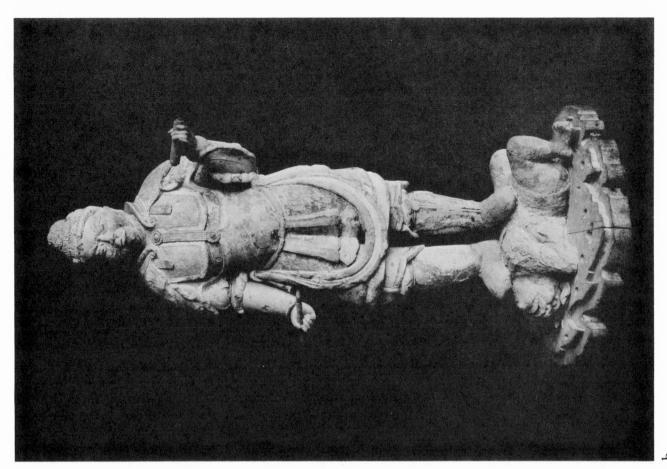

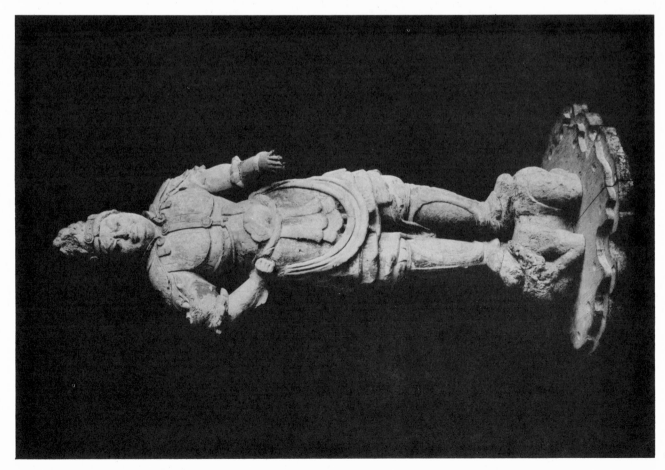

a

b

75

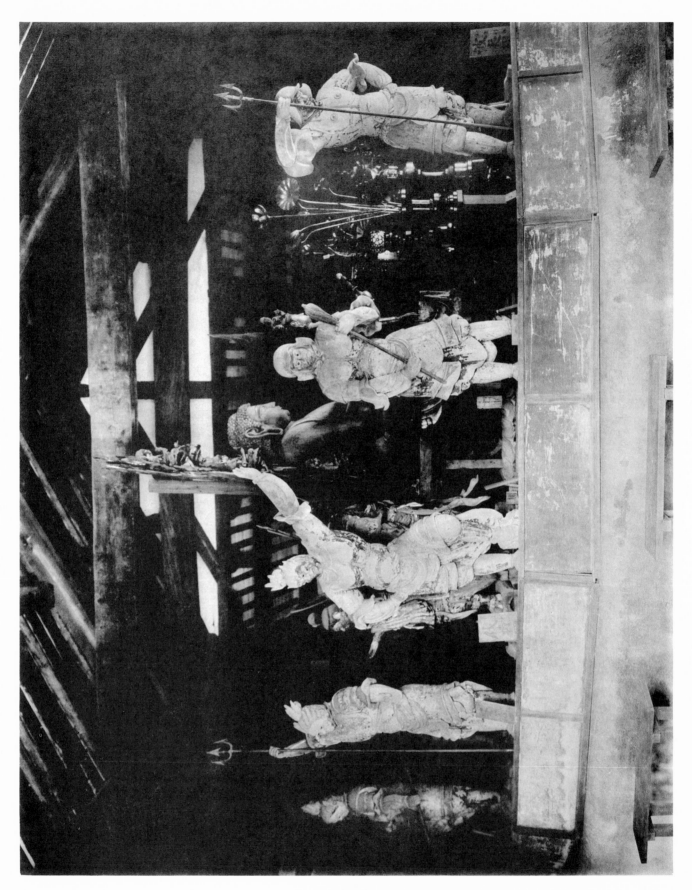

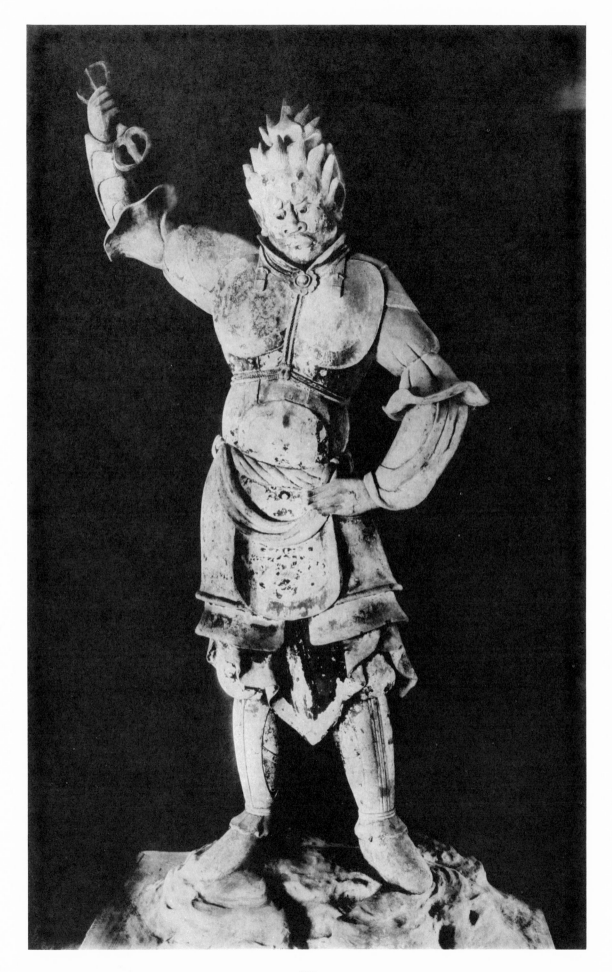

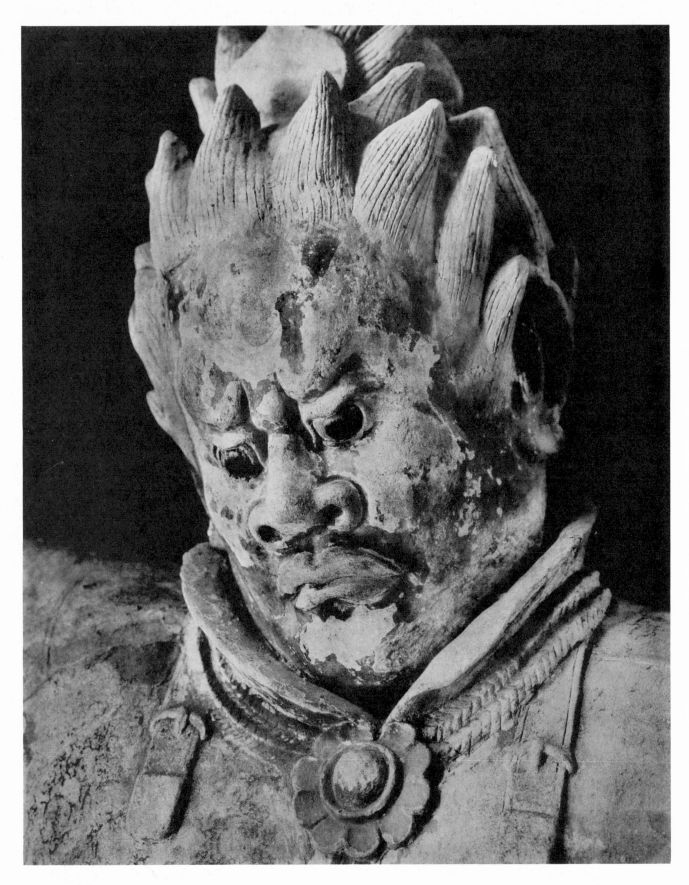

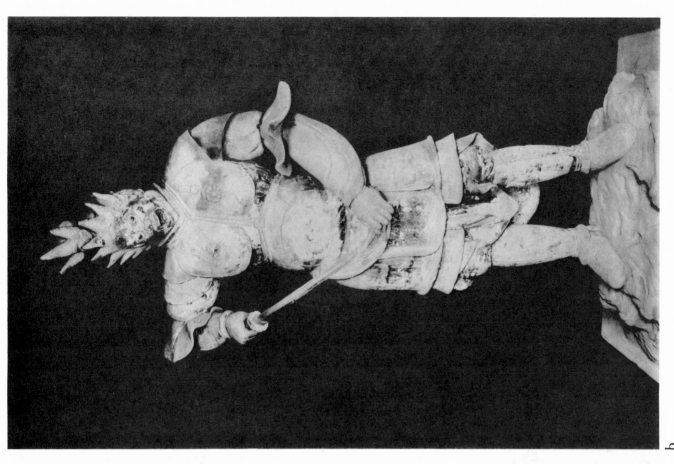

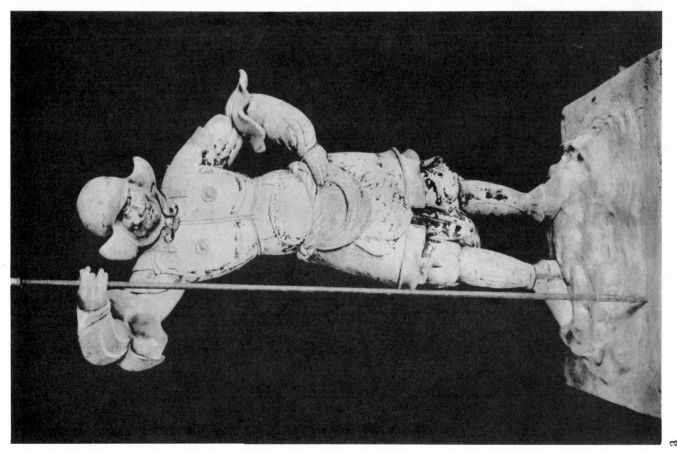

a

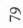

b

79

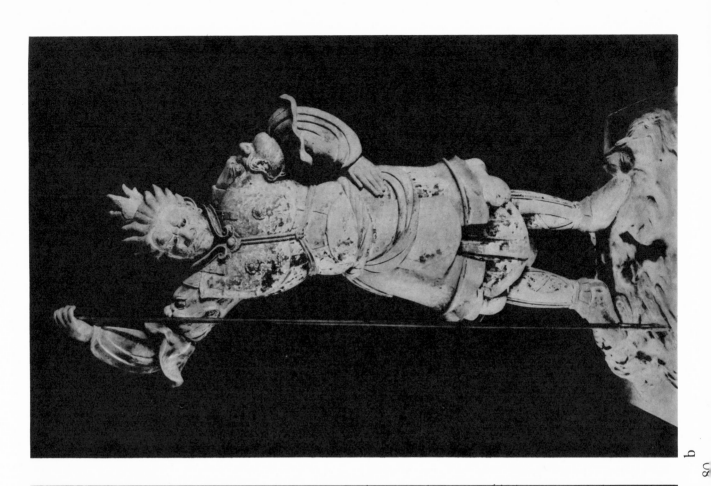

b

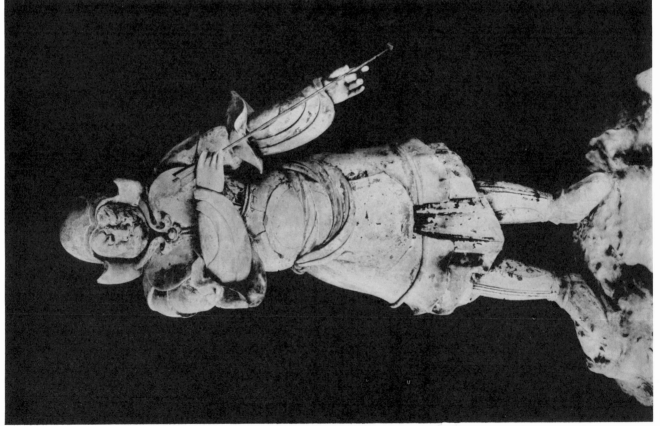

a

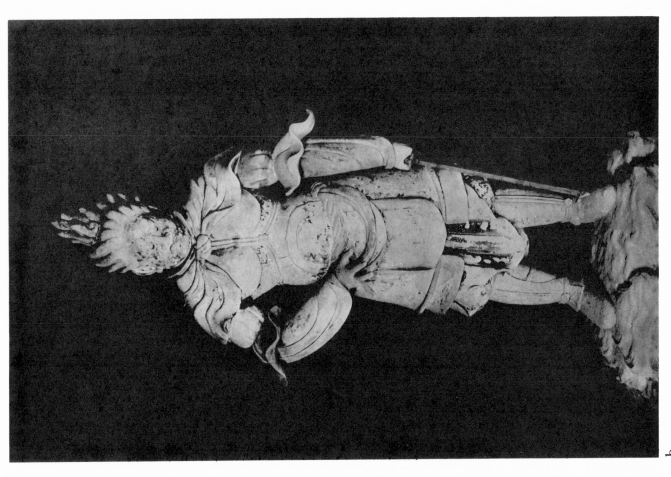

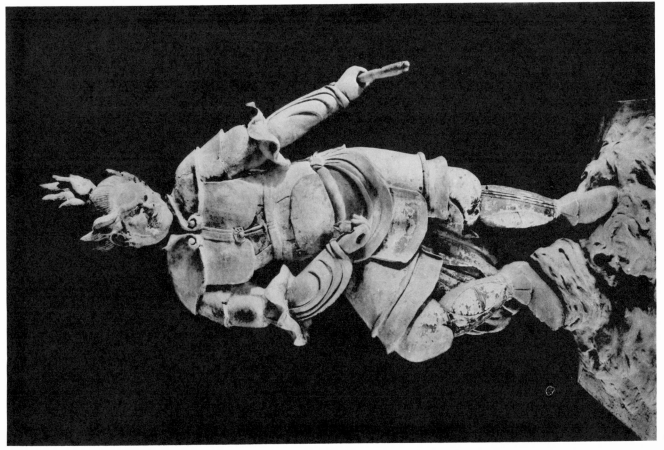

a

b

81

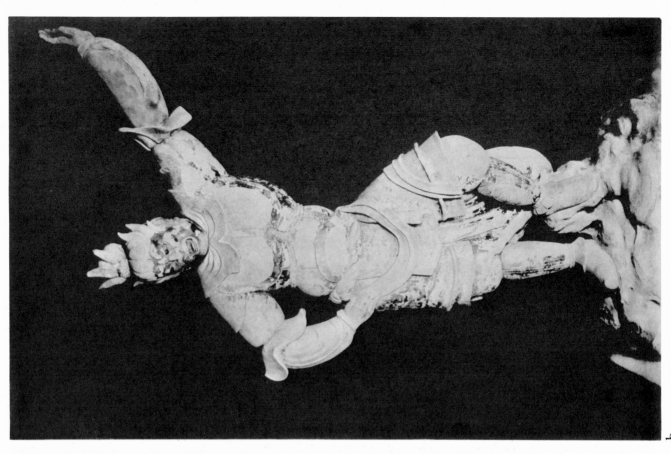

b

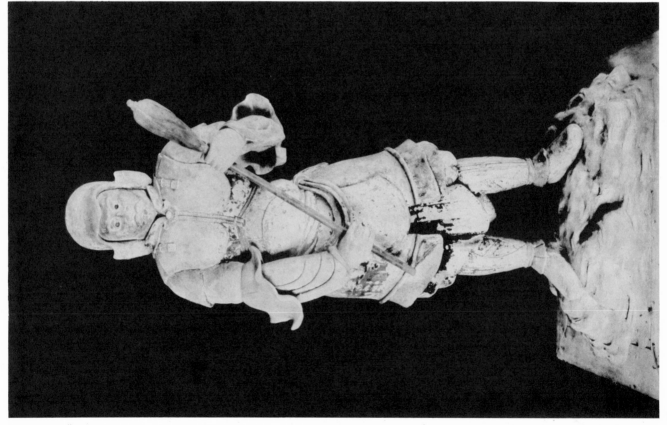

a

82

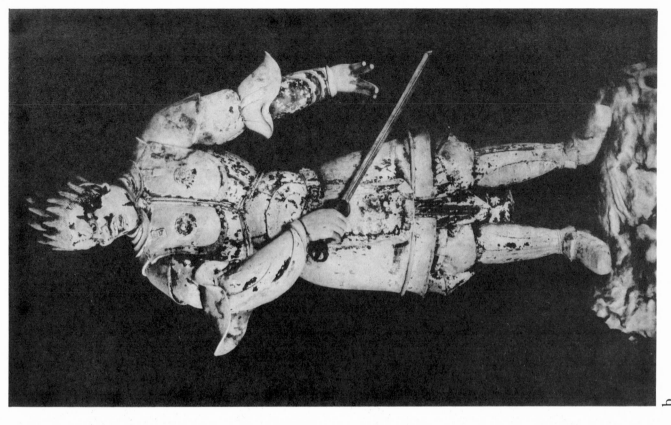

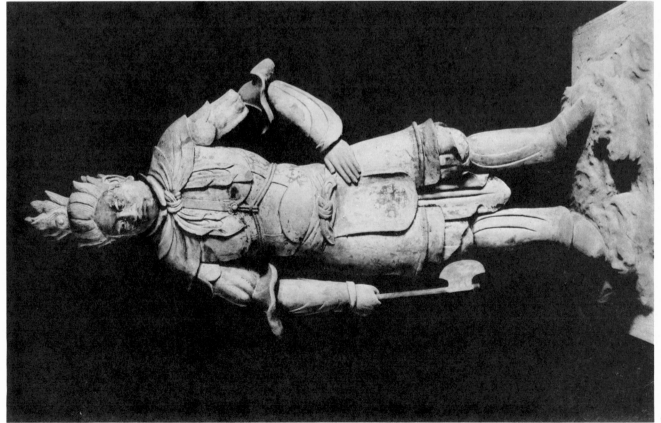

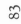

a

b

83

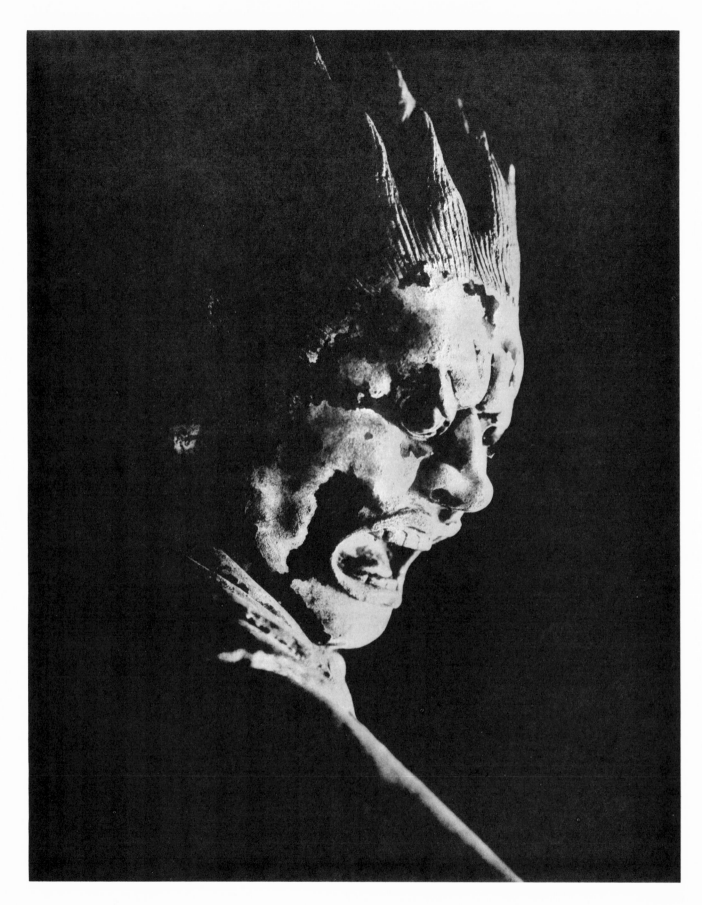

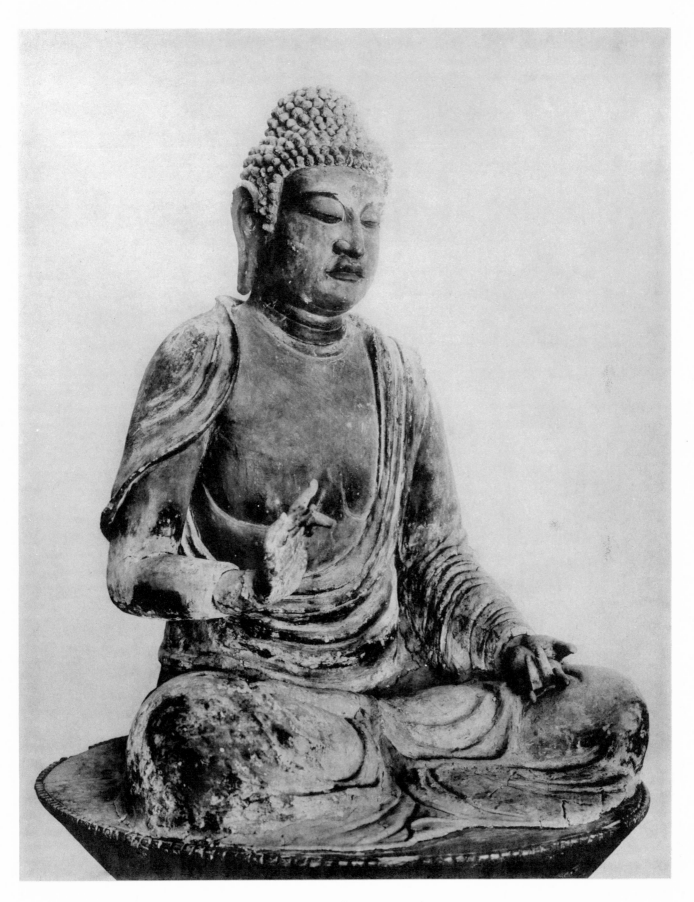

85

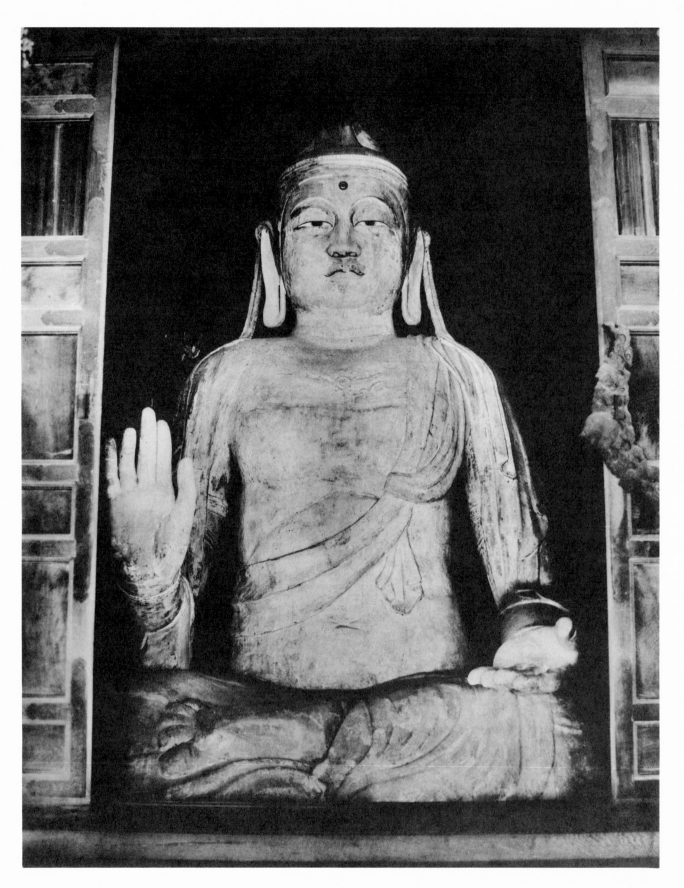

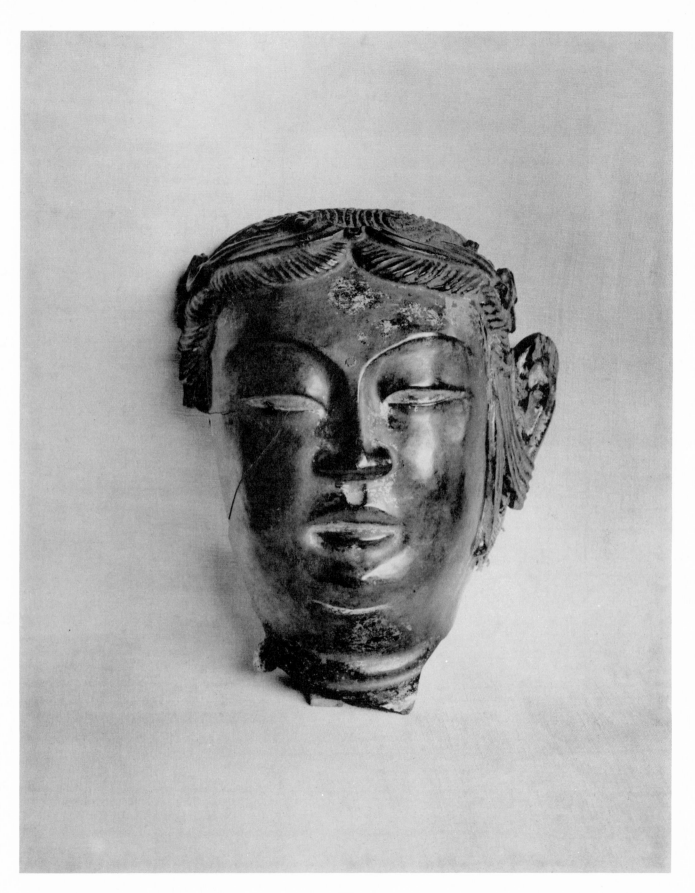

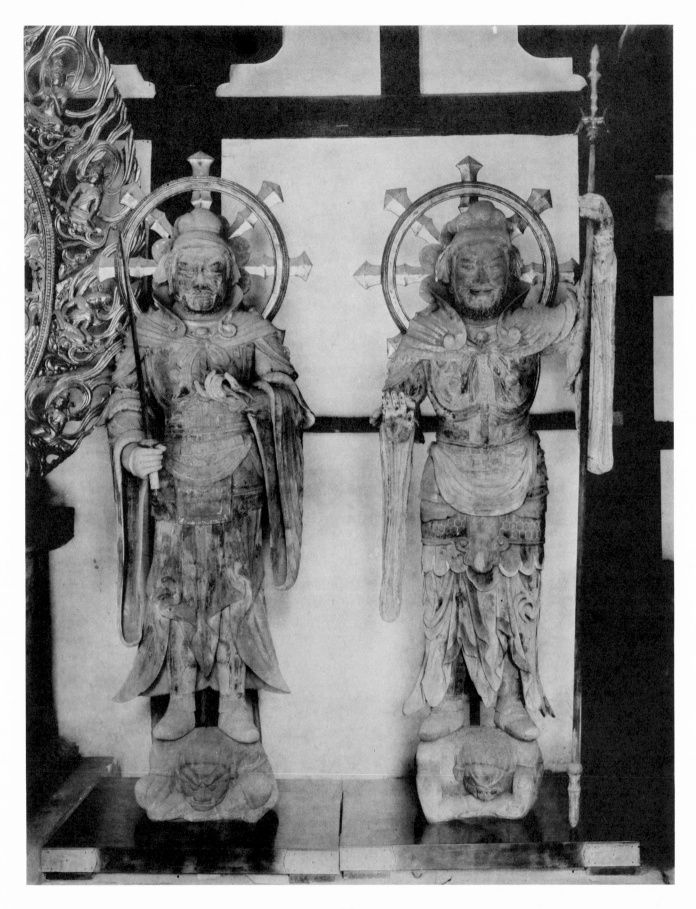

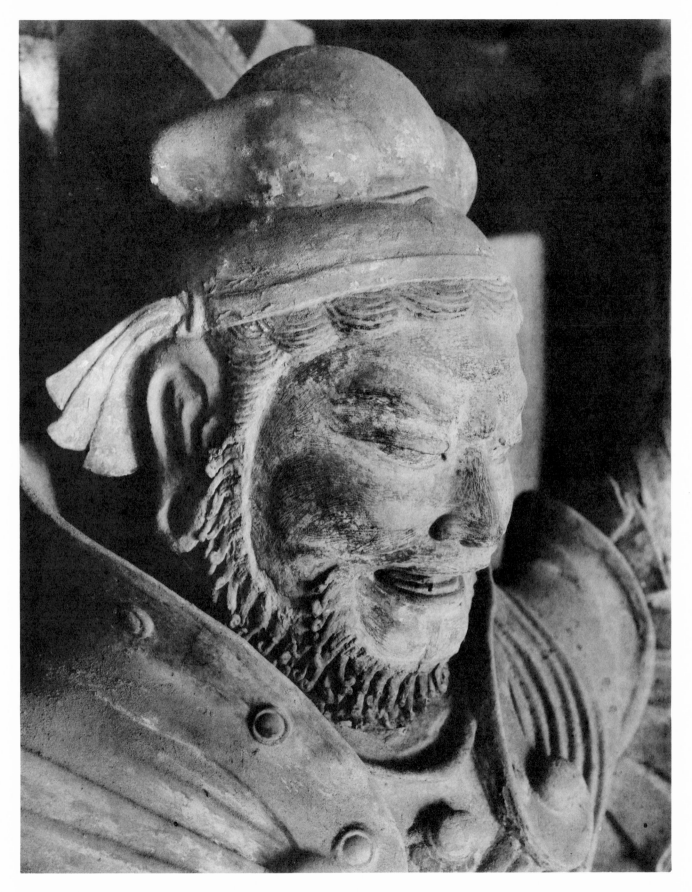

89

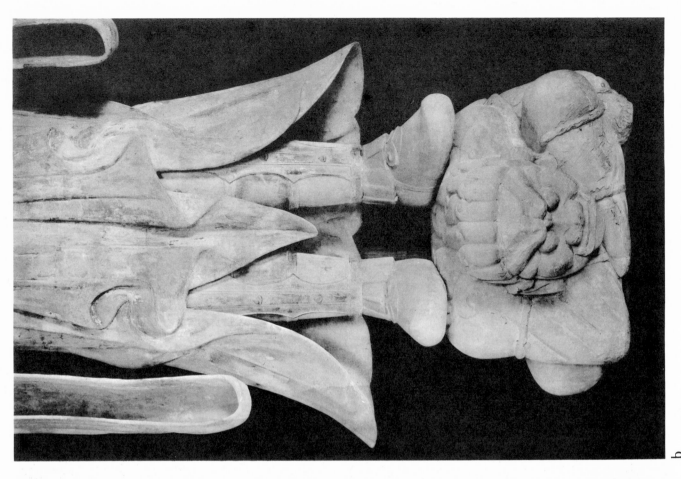

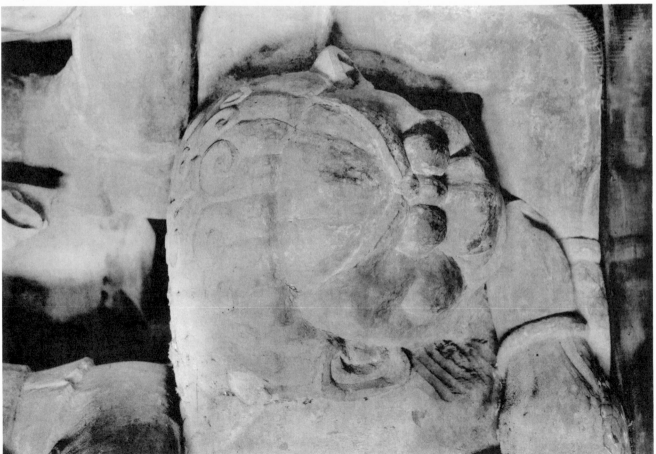

a

b

90

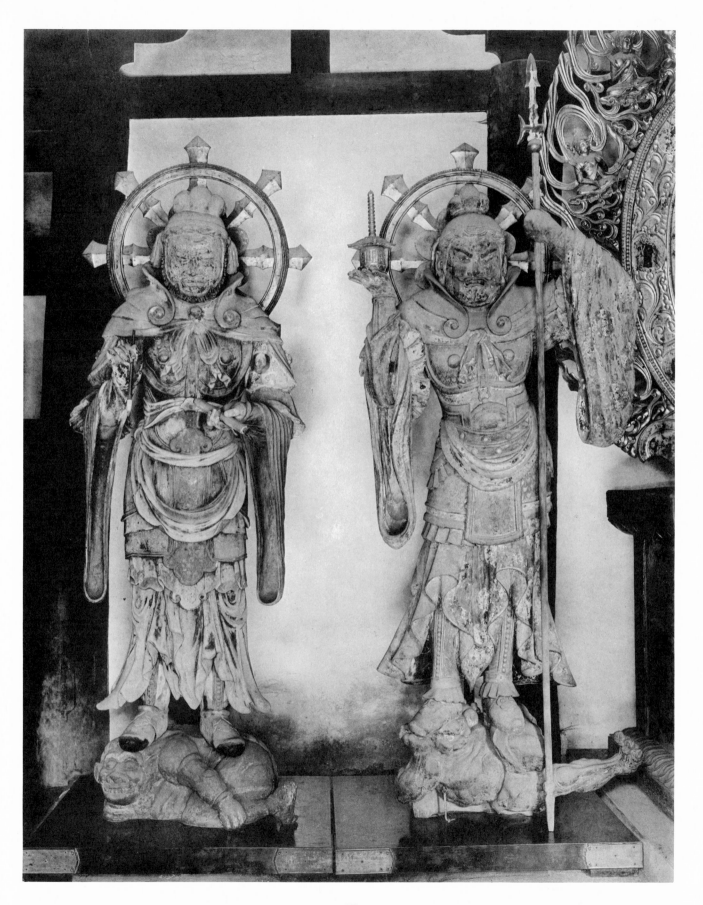

91

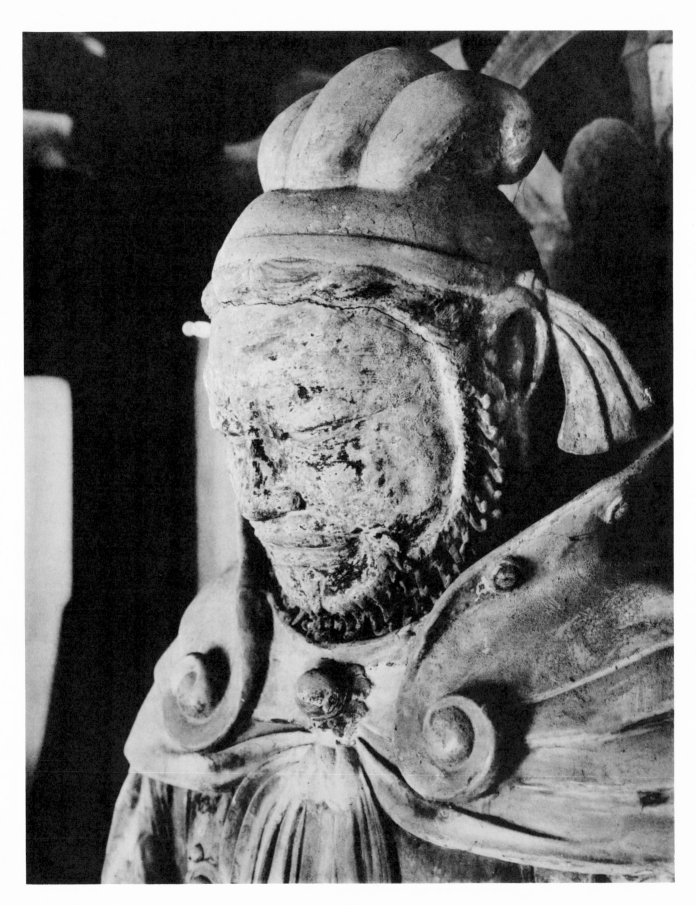

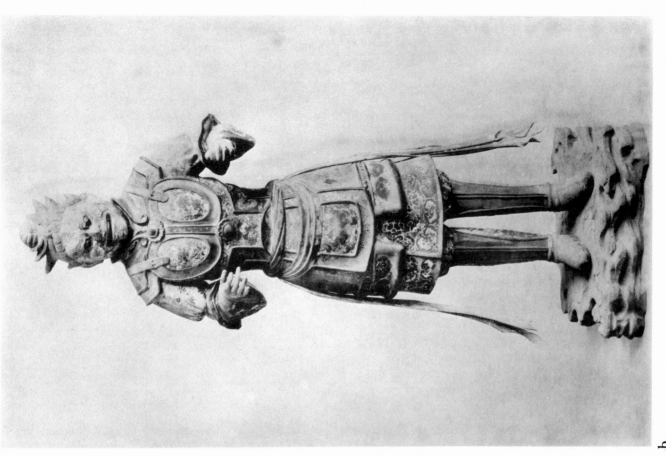

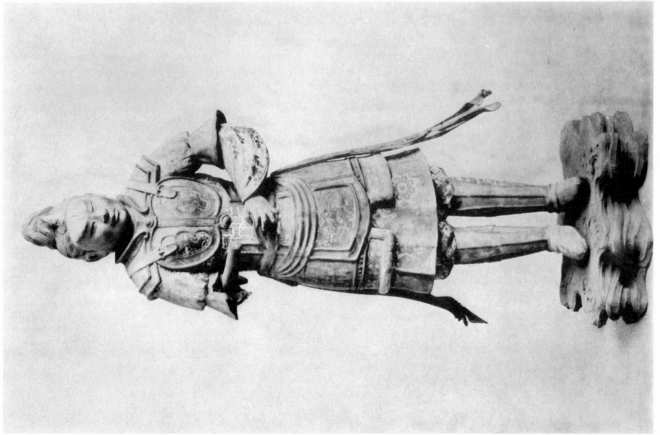

a

b

93

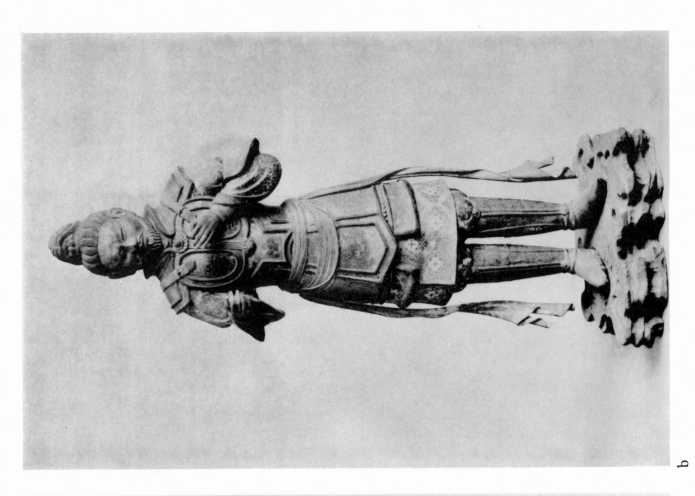

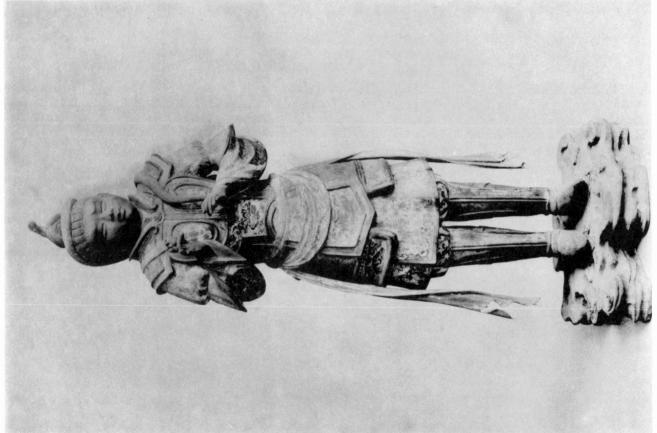

b

a

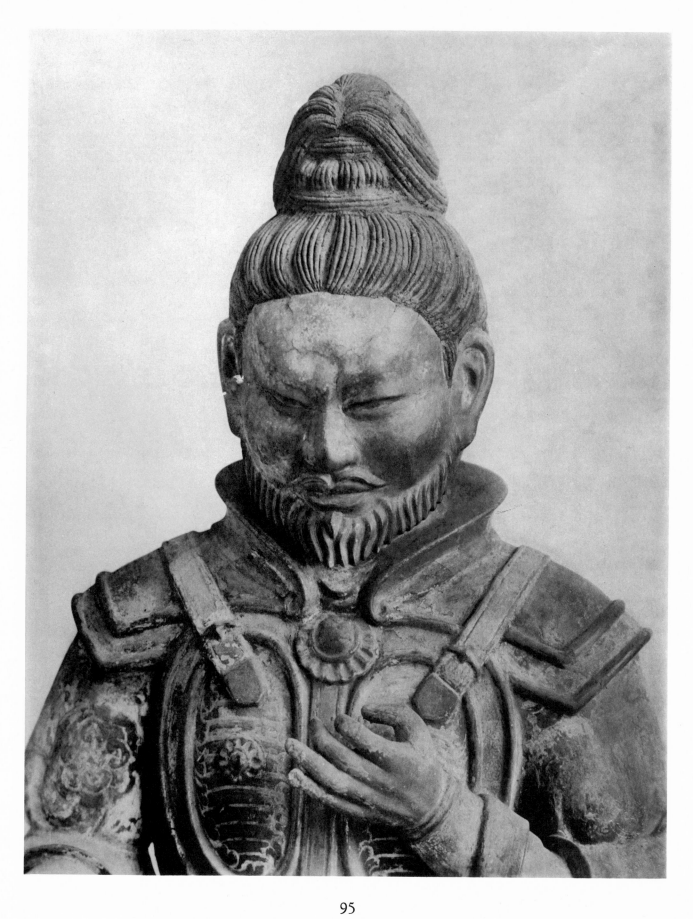

95

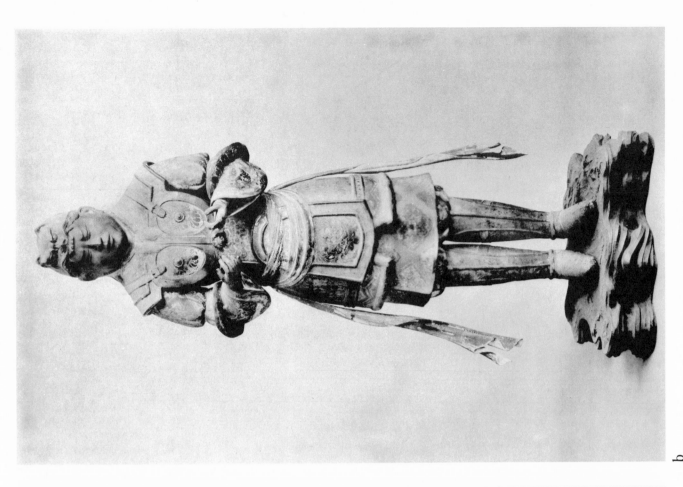

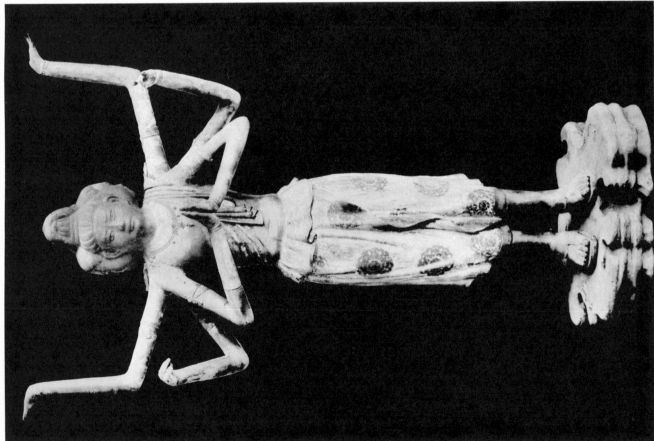

b

a

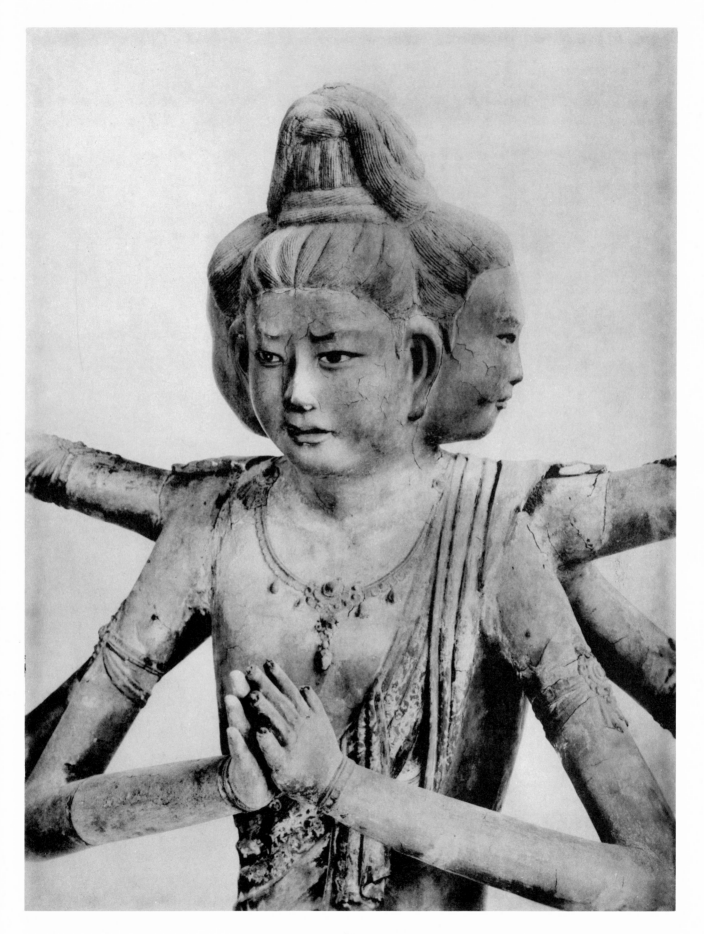

97

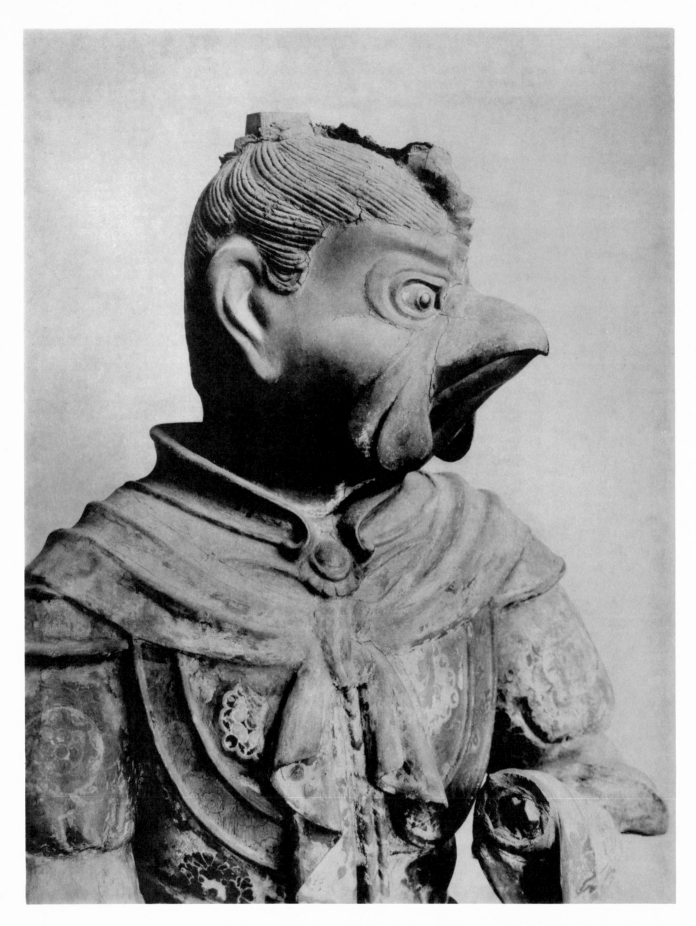

98

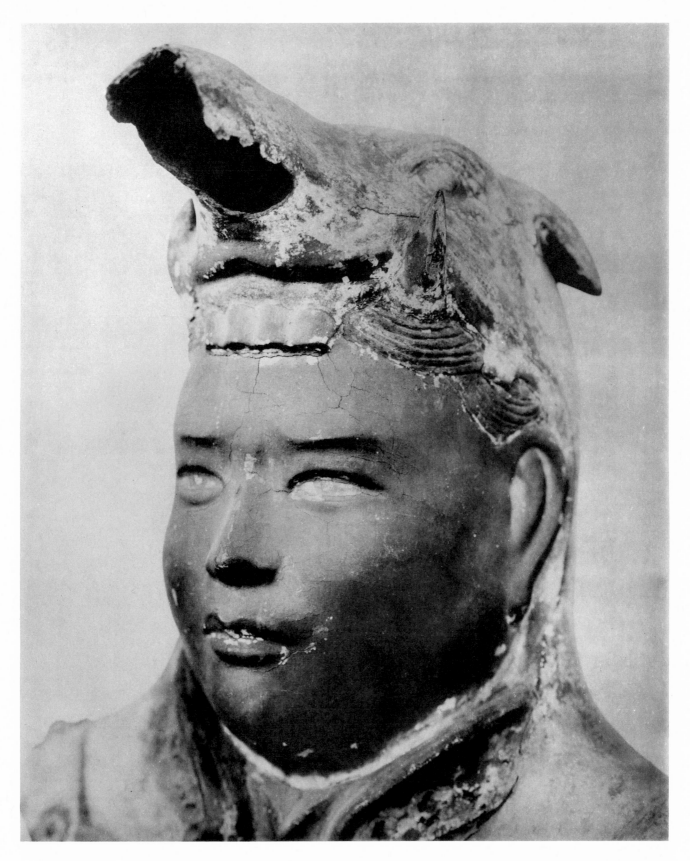

99

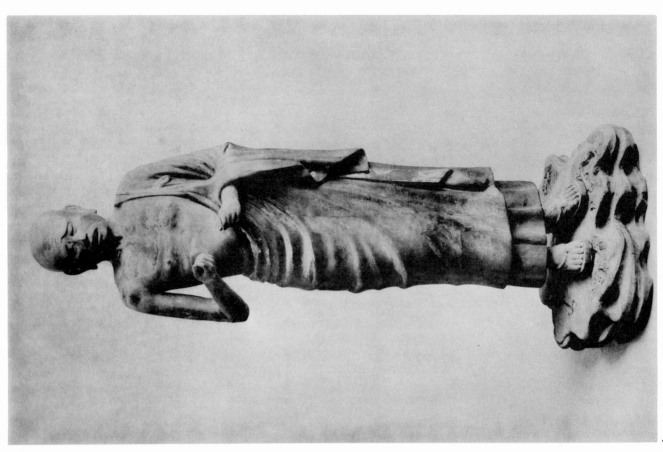

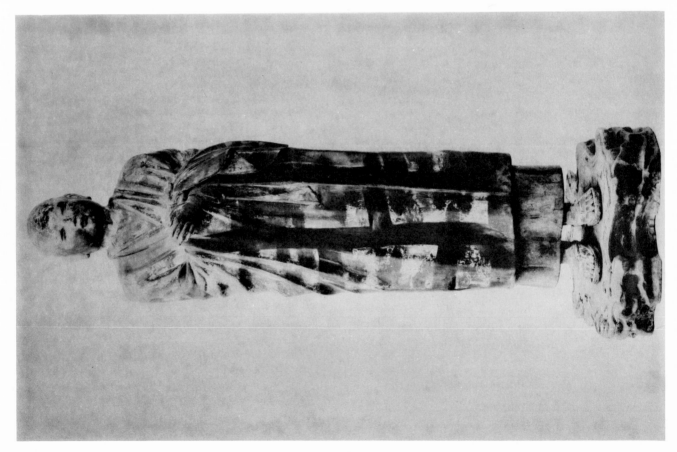

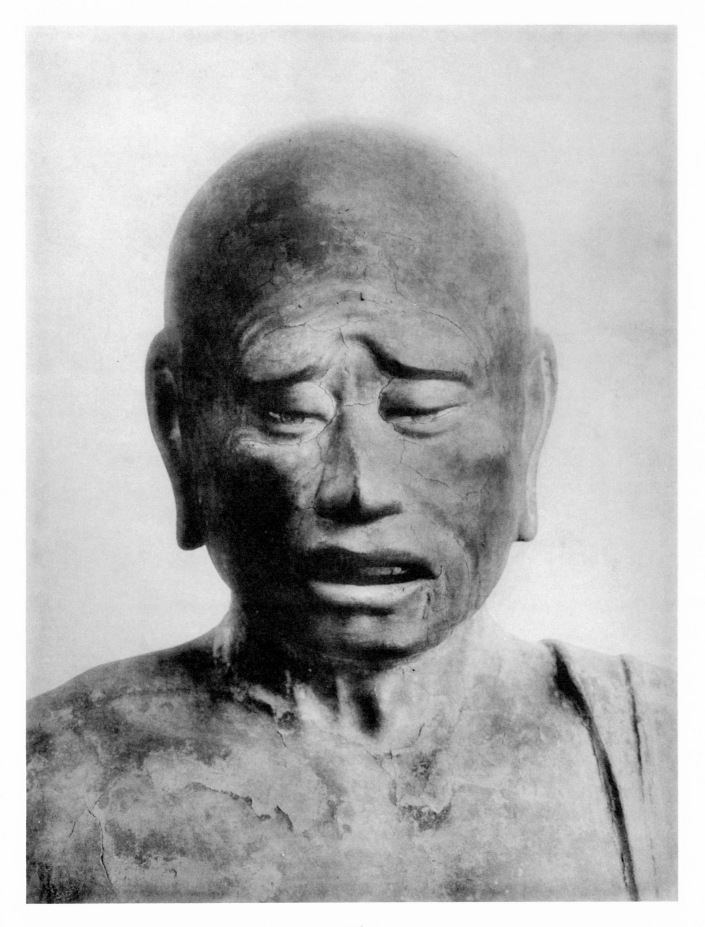

101

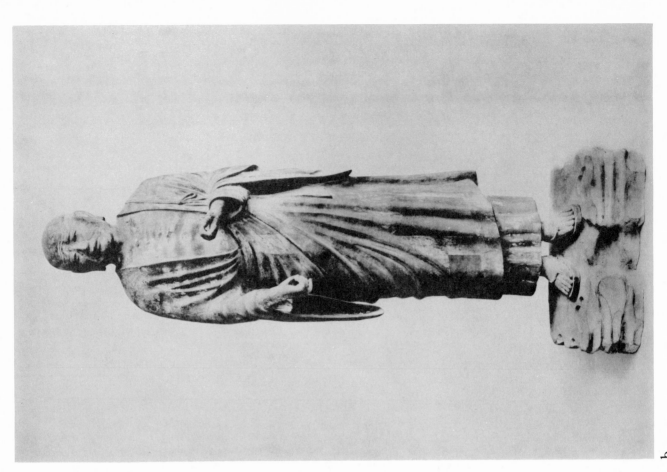

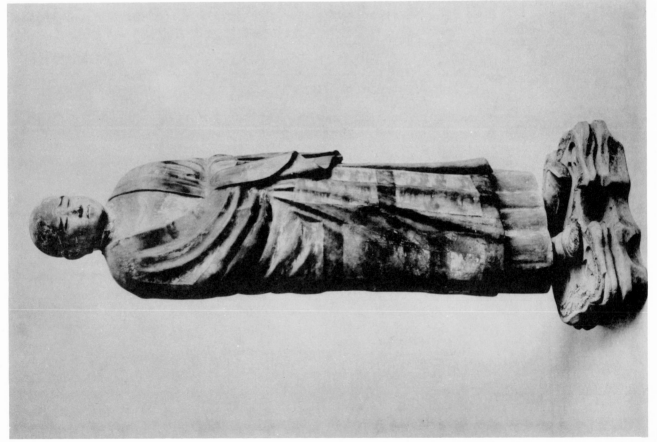

b

a

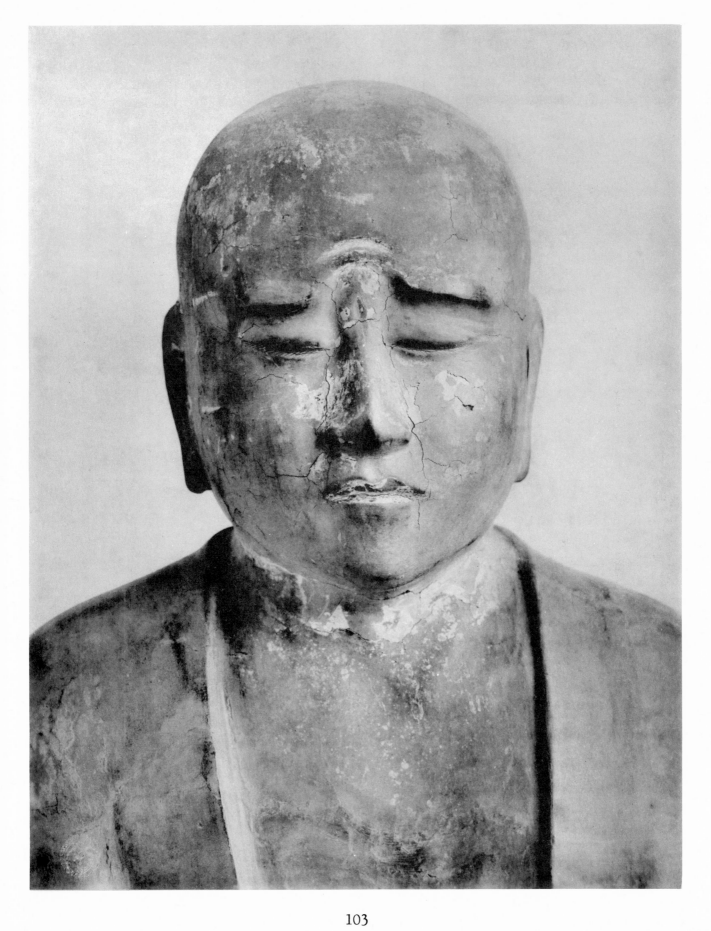

103

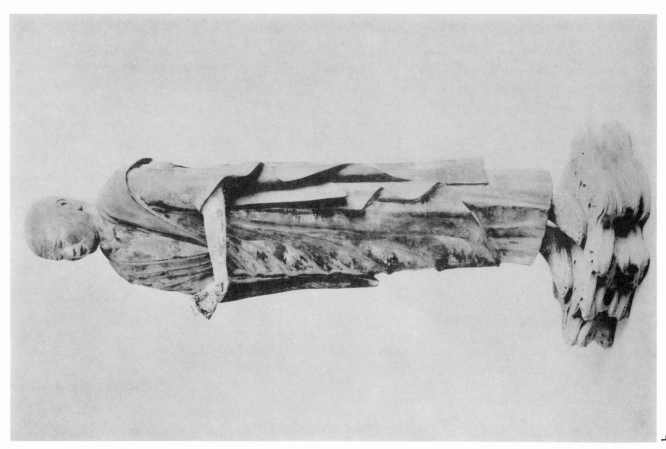

b

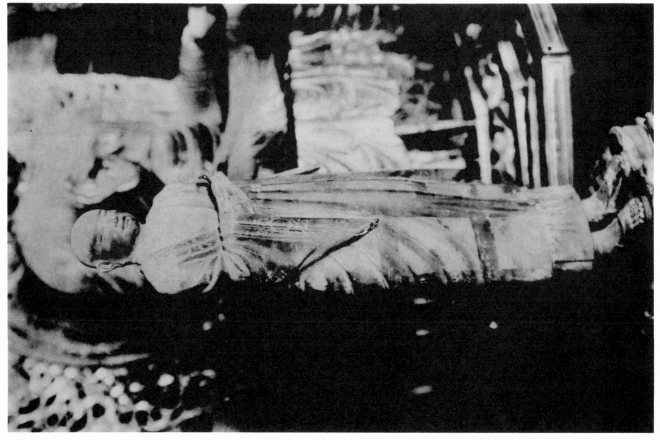

a

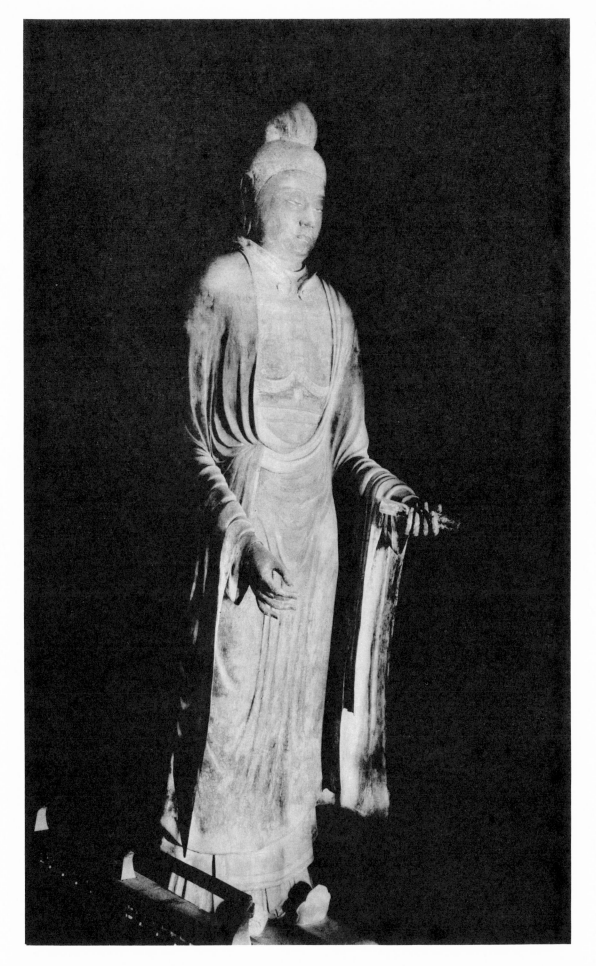

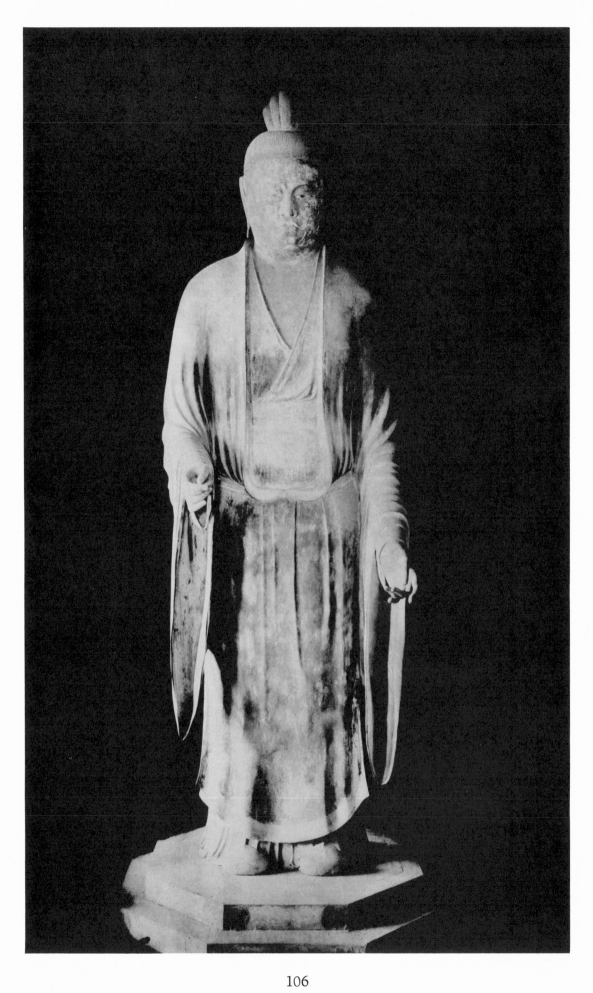

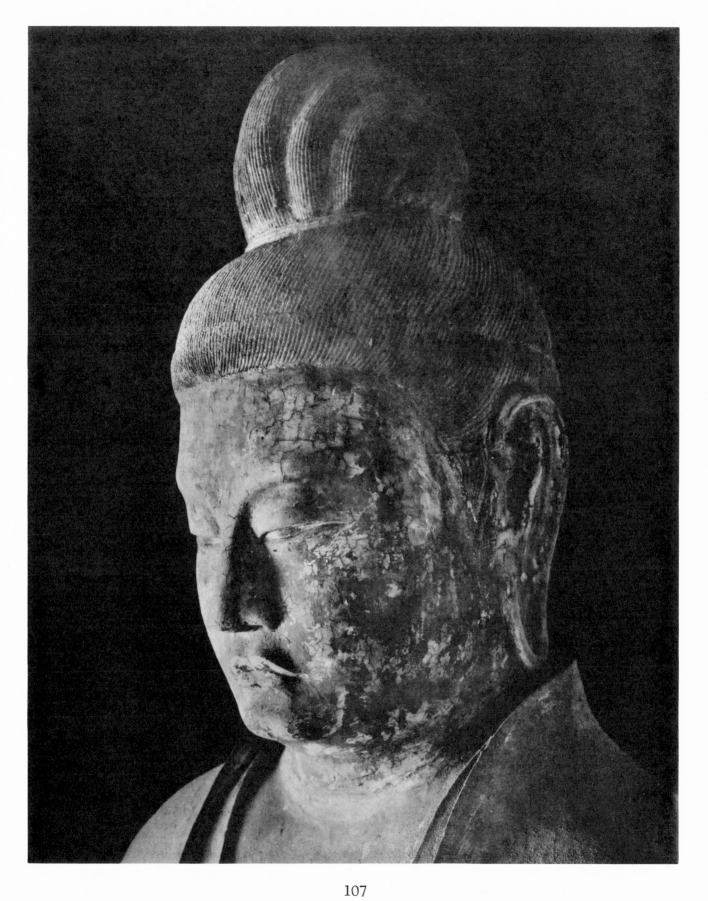

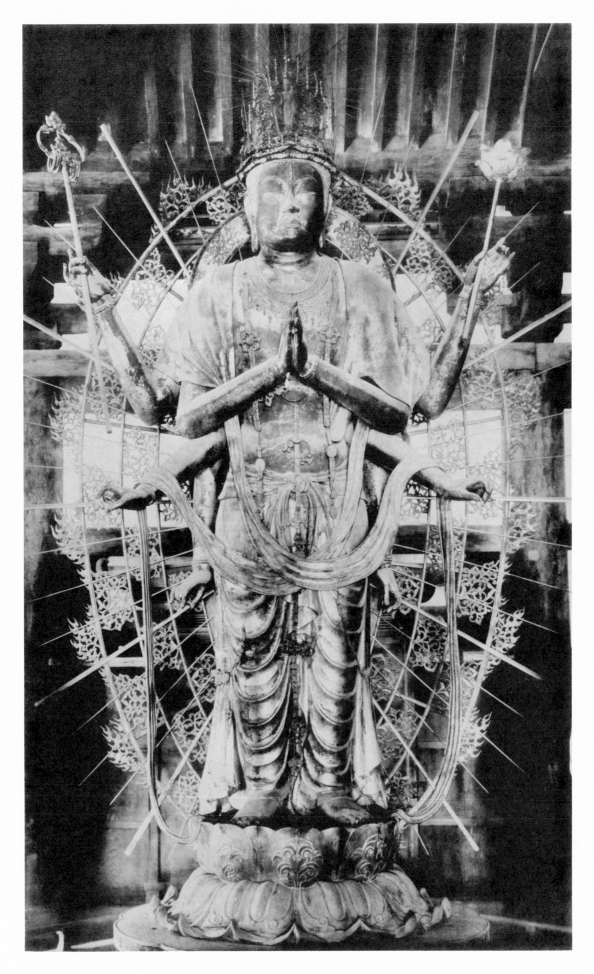

108

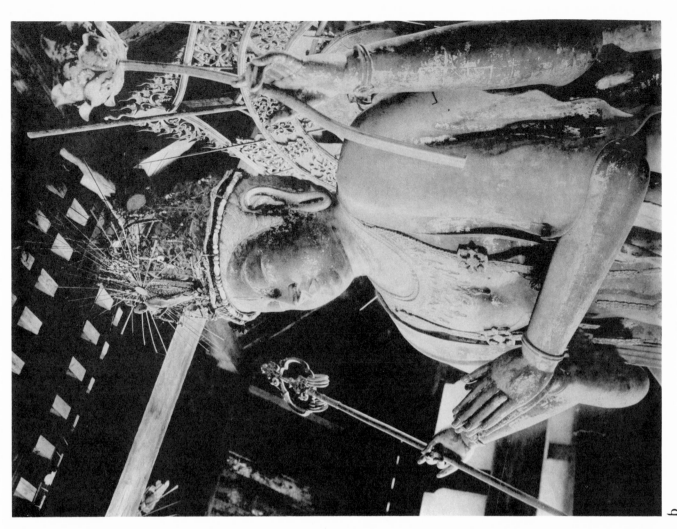

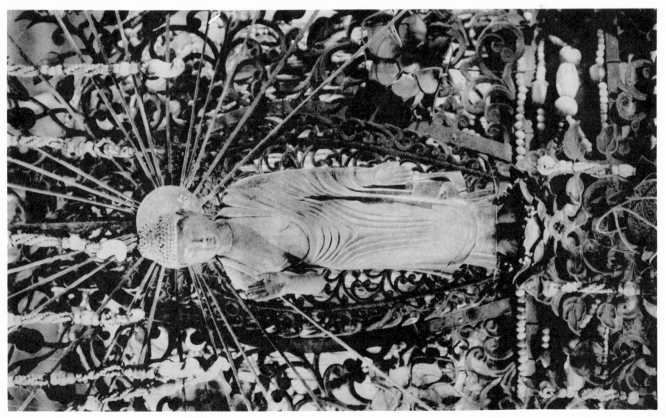

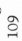

a

b

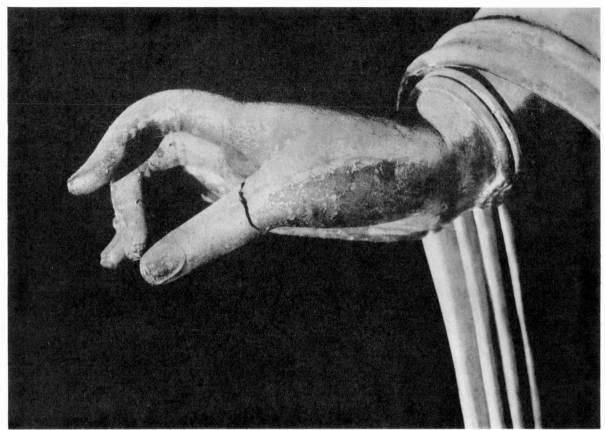

a

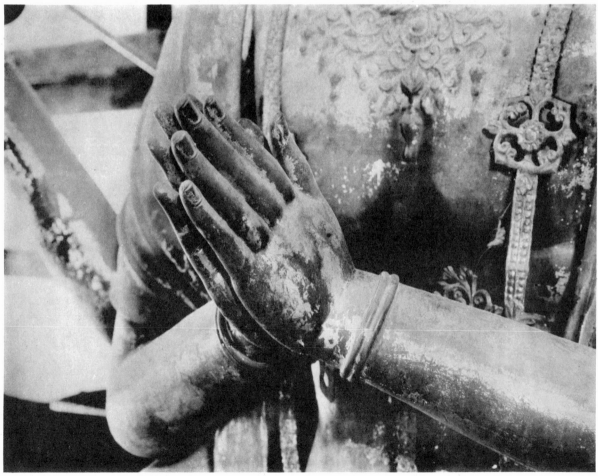

b

110

a

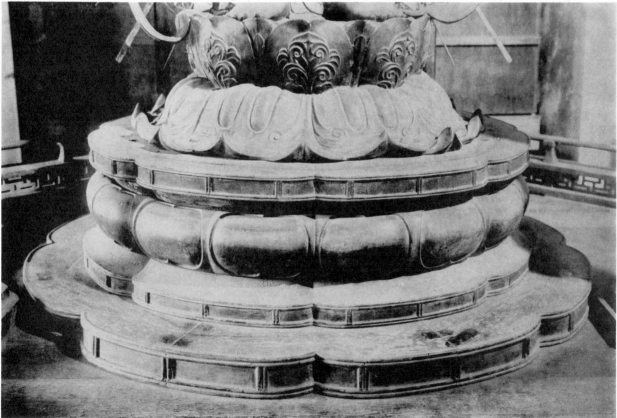

b

111

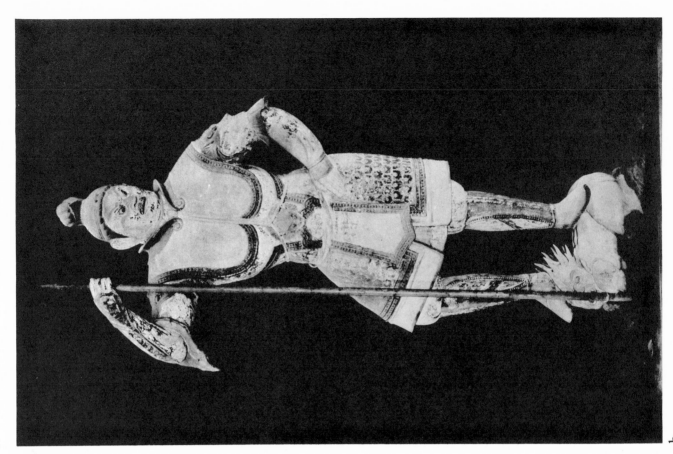

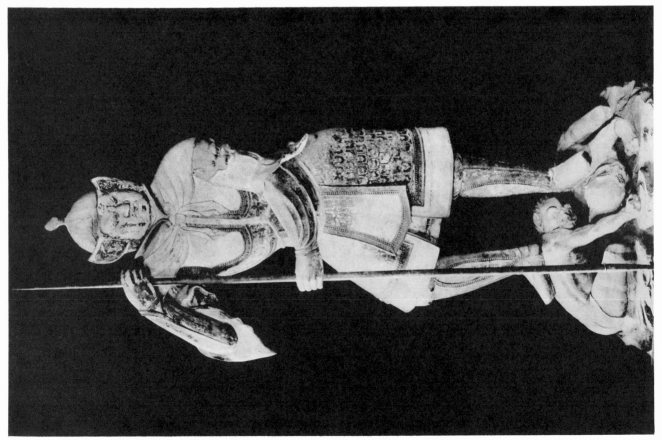

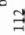

a

b

112

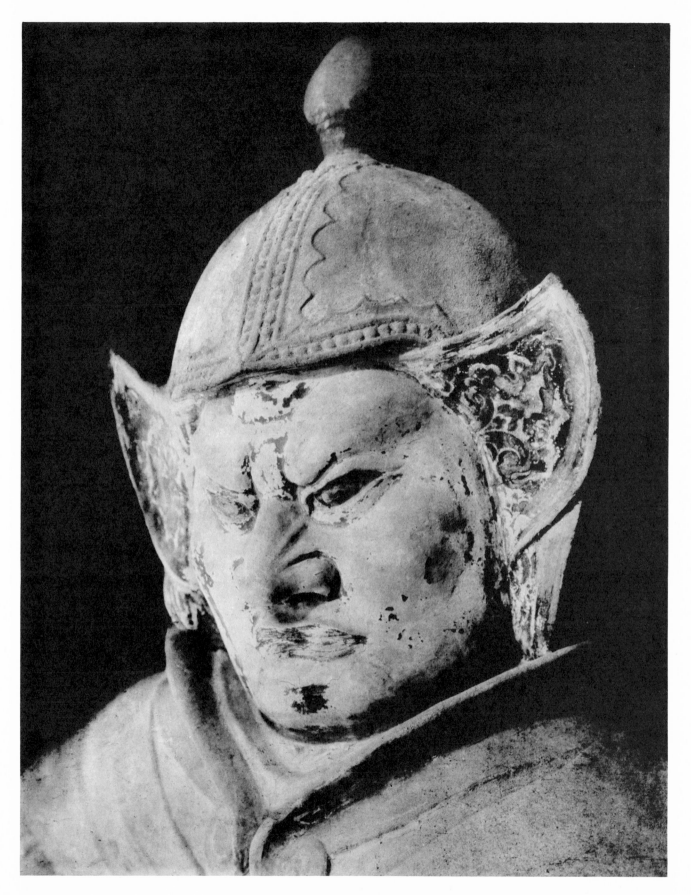

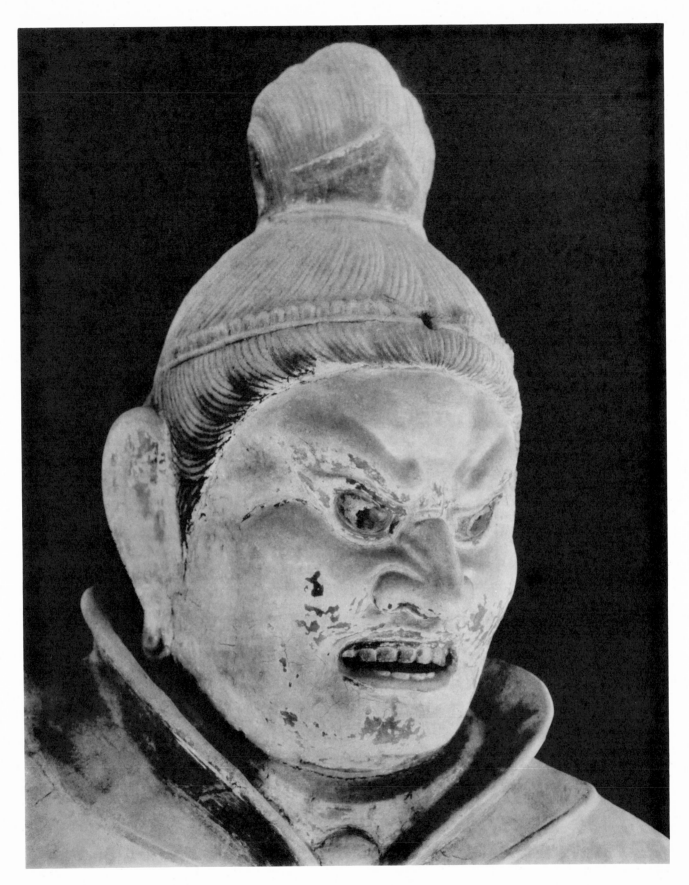

114

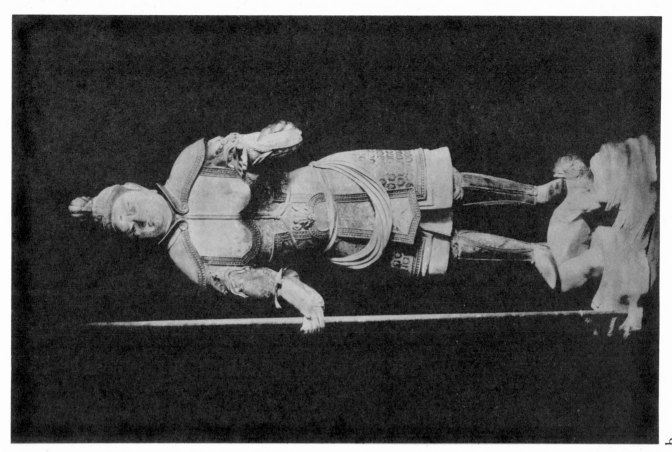

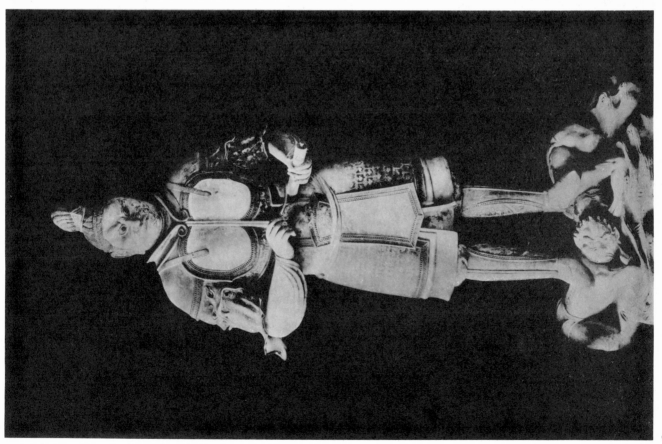

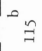

b

a

115

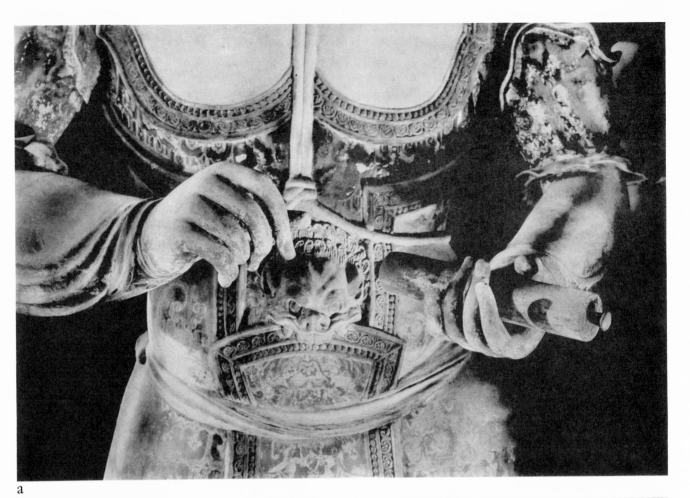

a

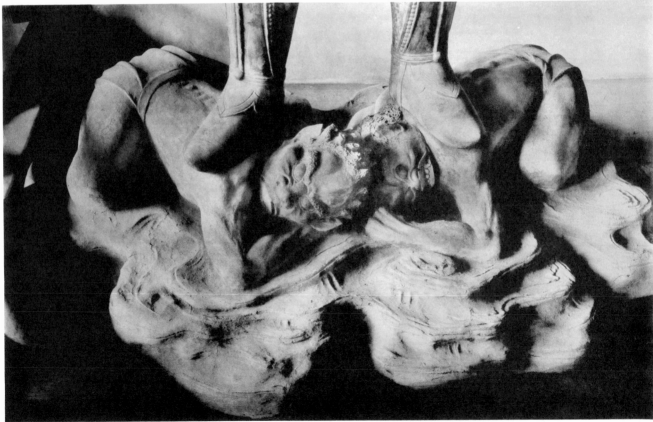

b

116

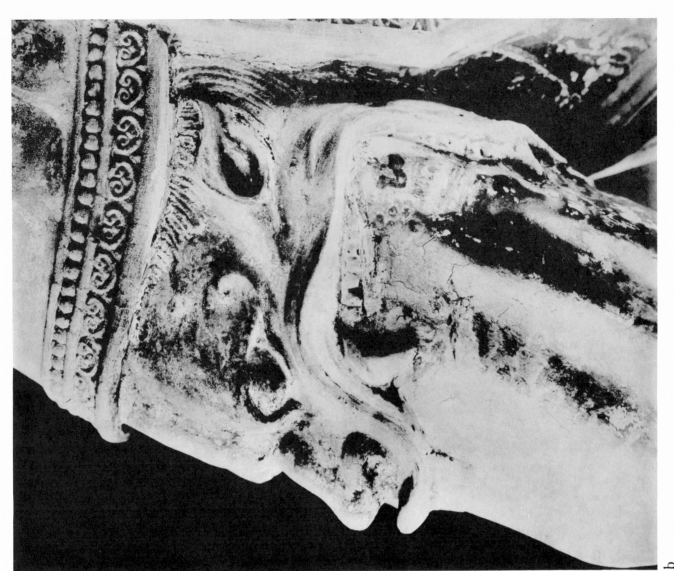

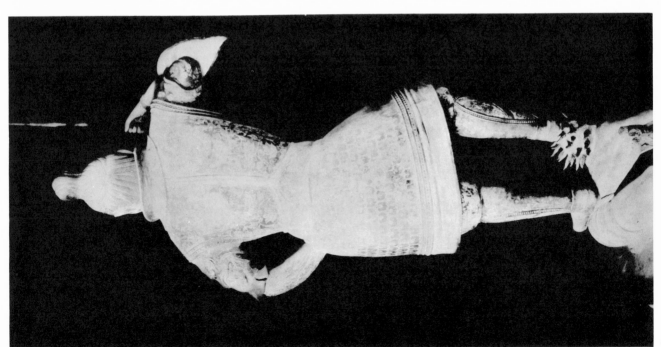

117

b

a

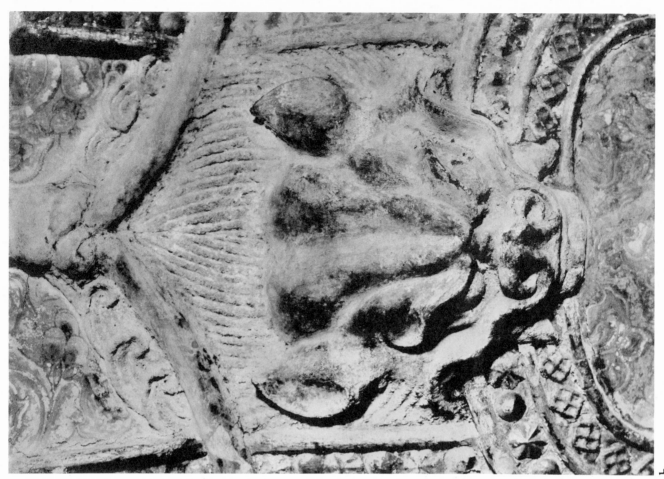

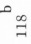

b

a

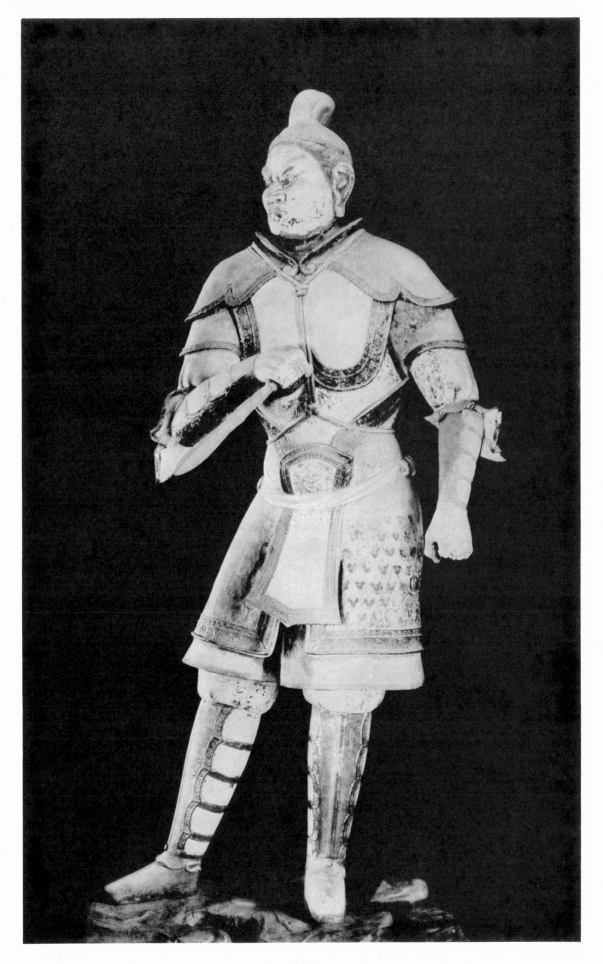

119

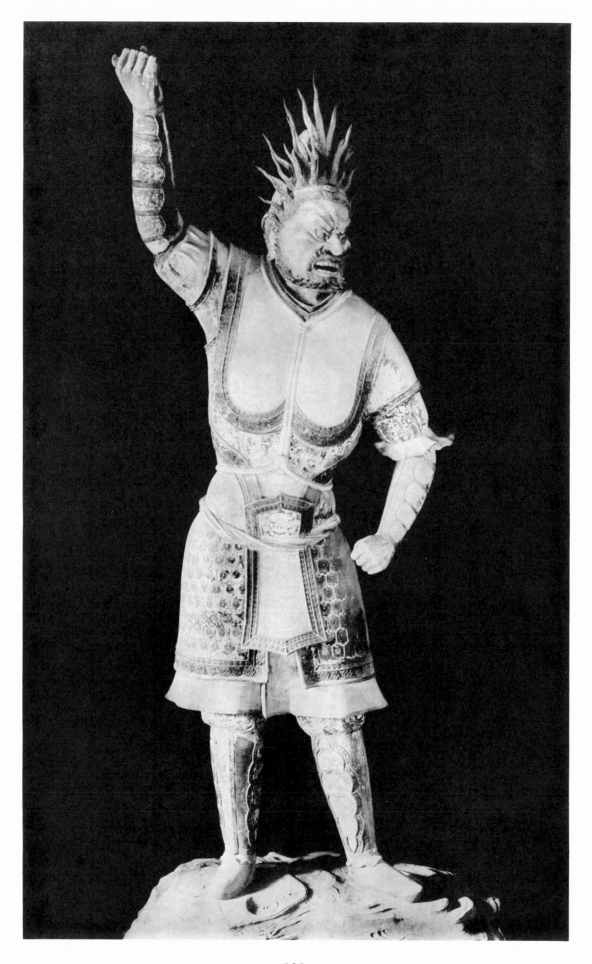

120

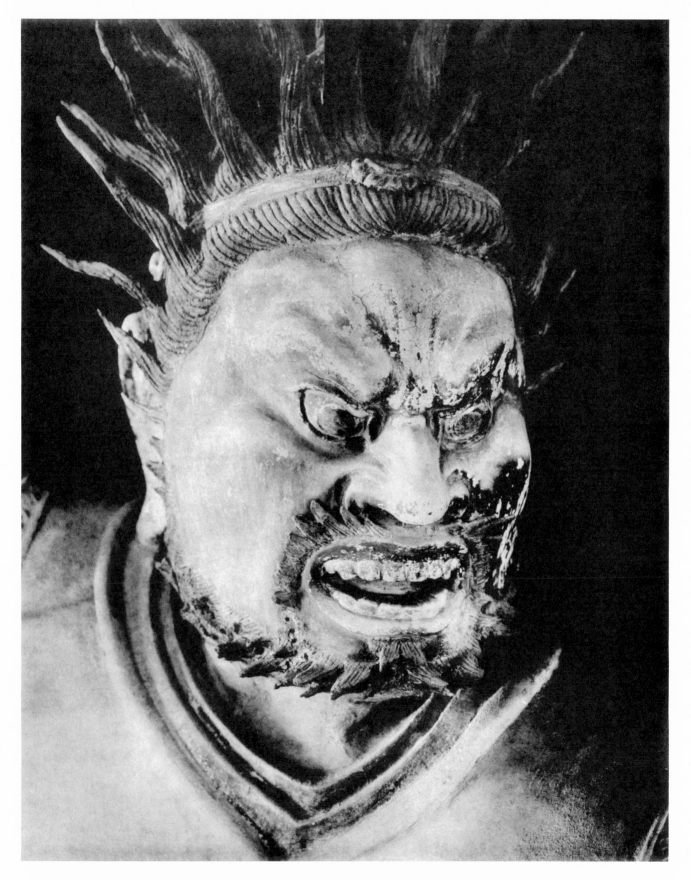

121

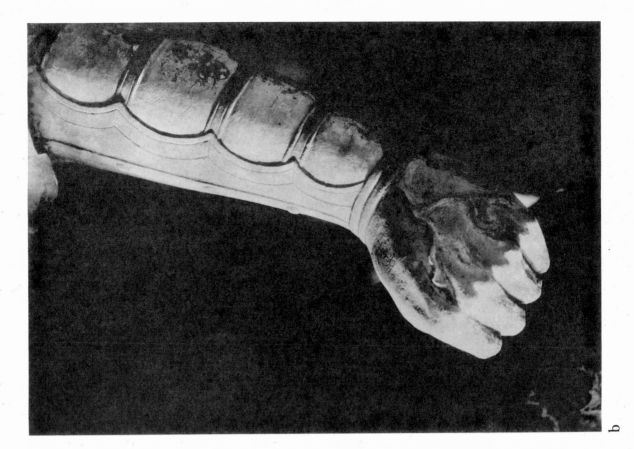

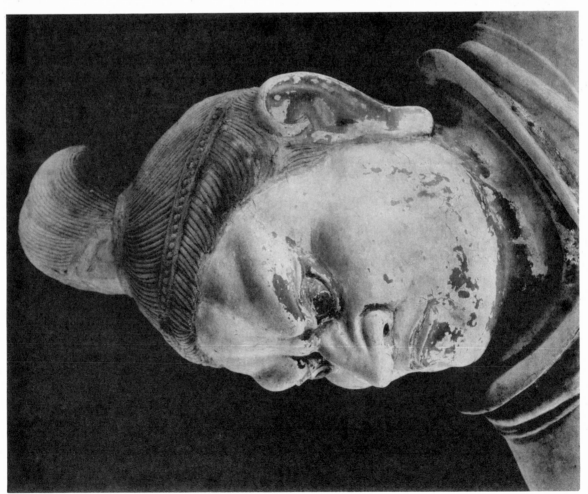

b

a

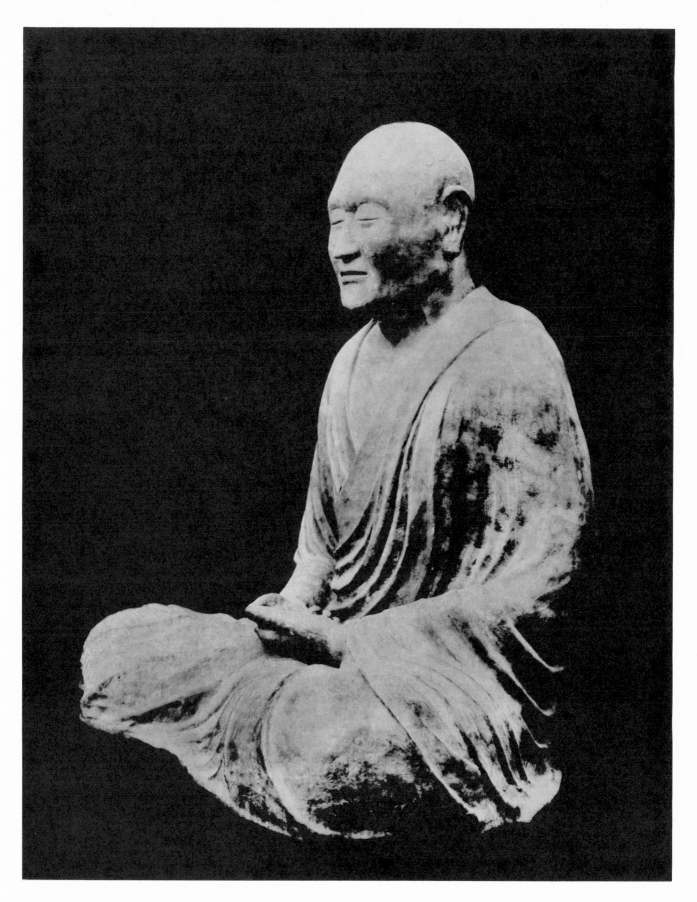

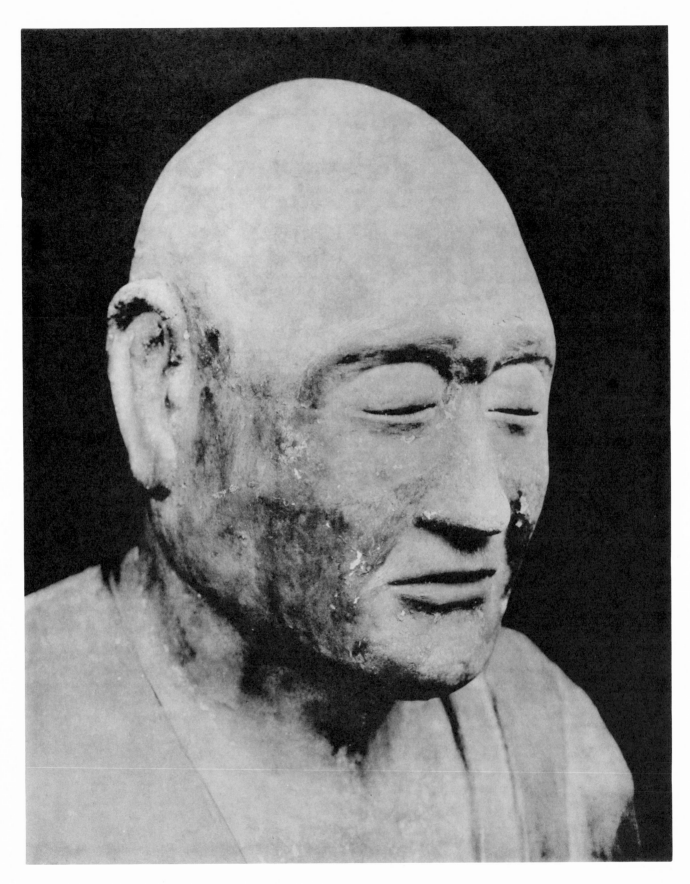

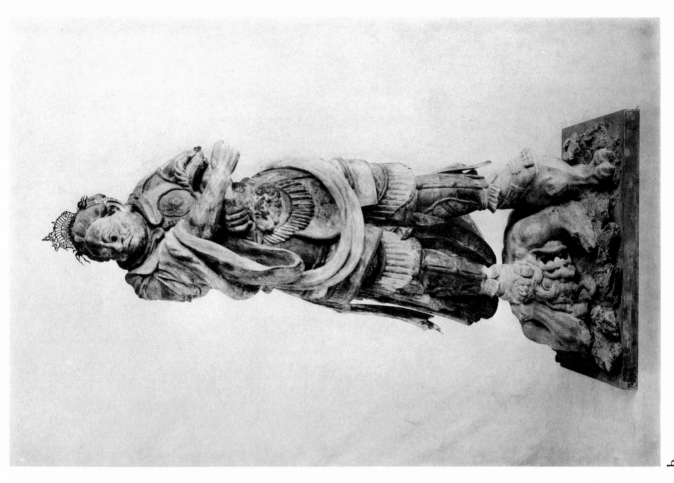

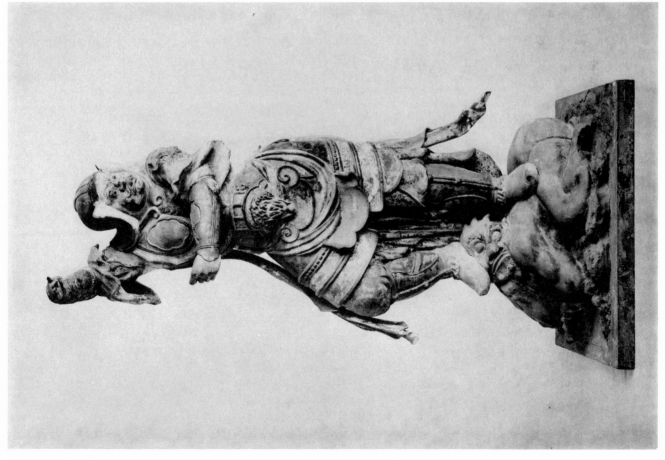

a

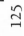

b

125

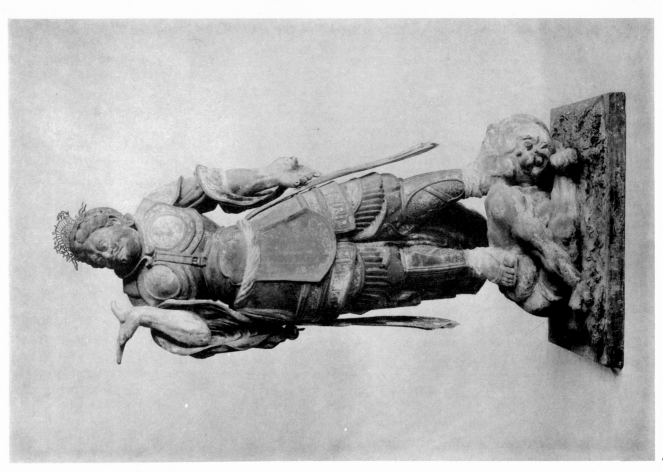

a

b

a

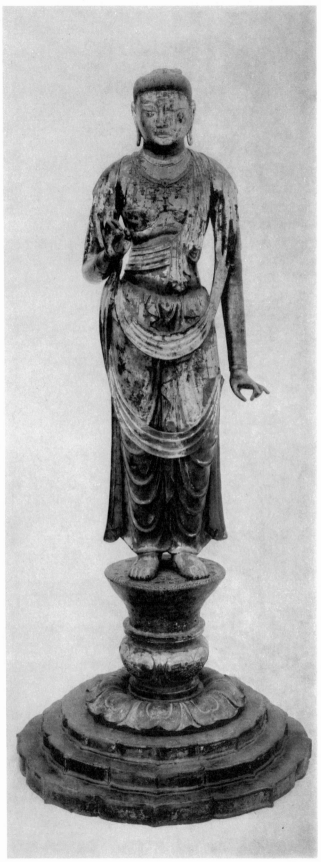

b

127

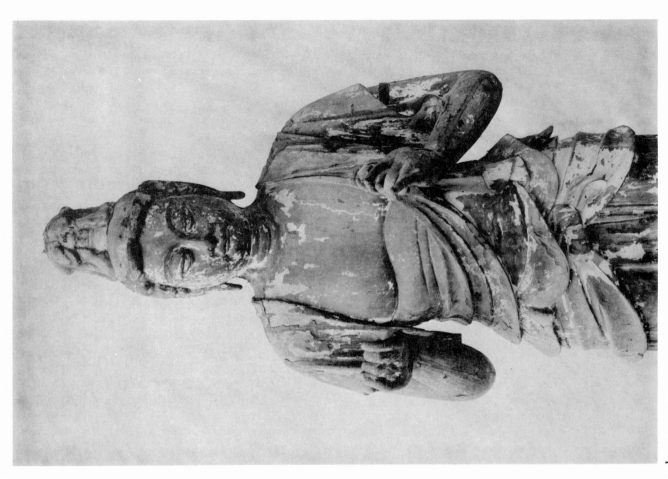

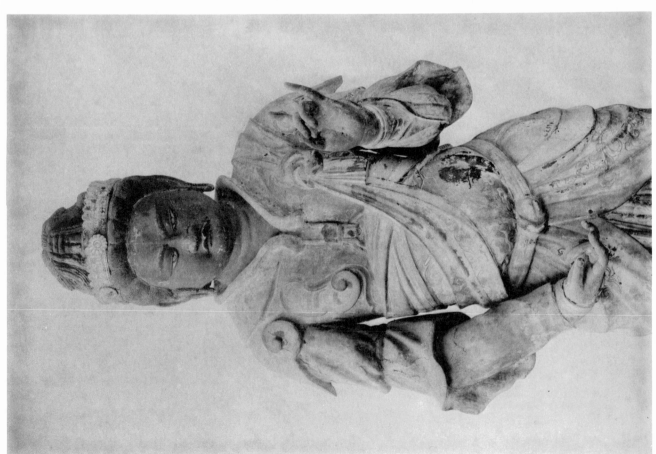

a

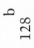

b

128

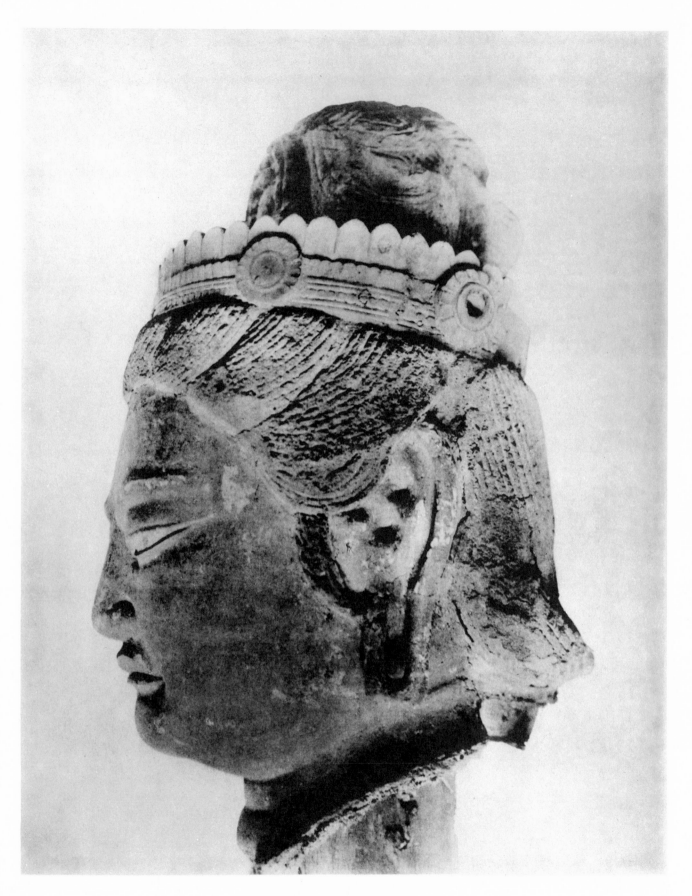

129

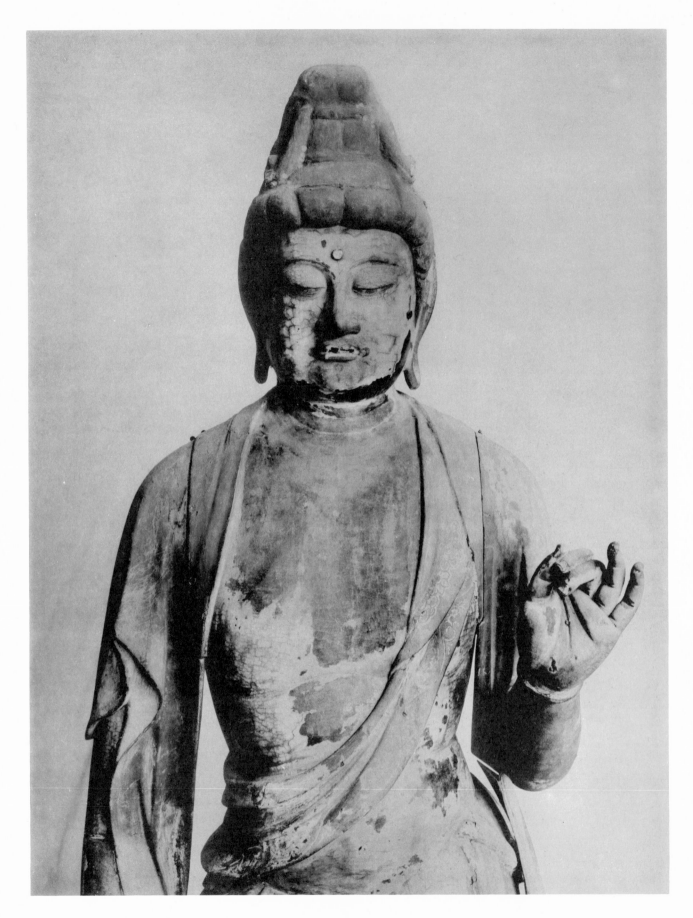

130

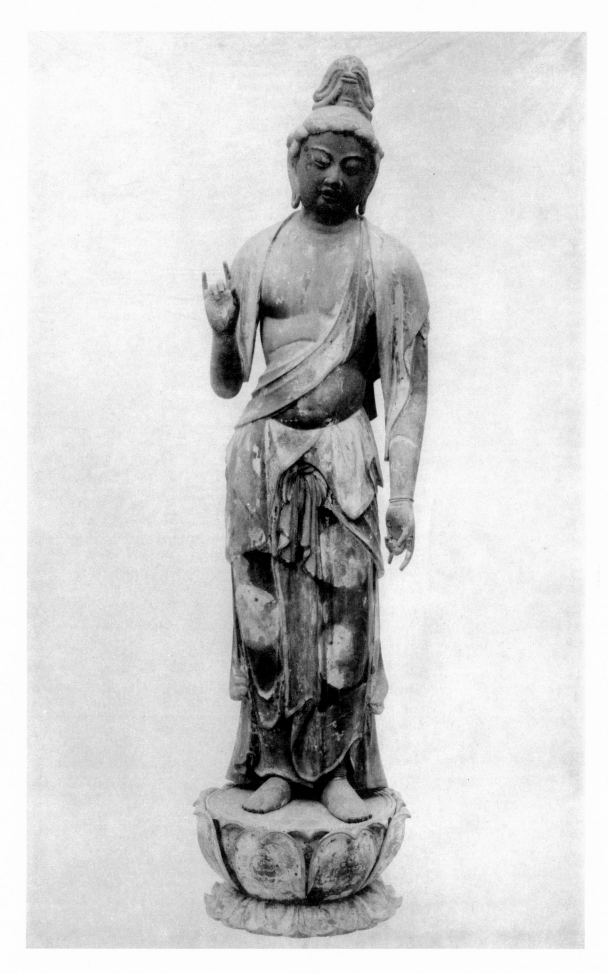

131

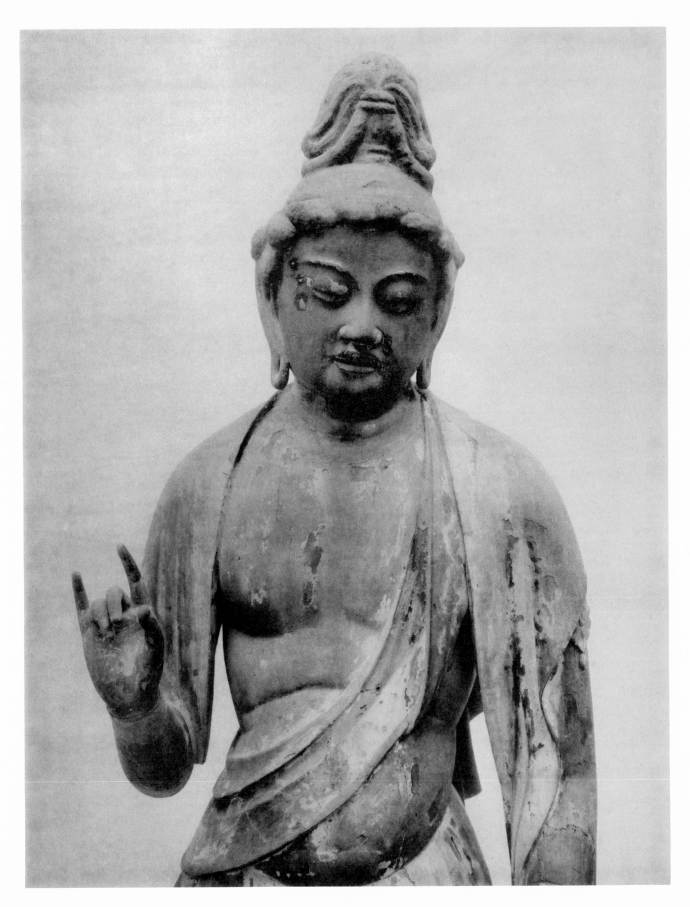

132

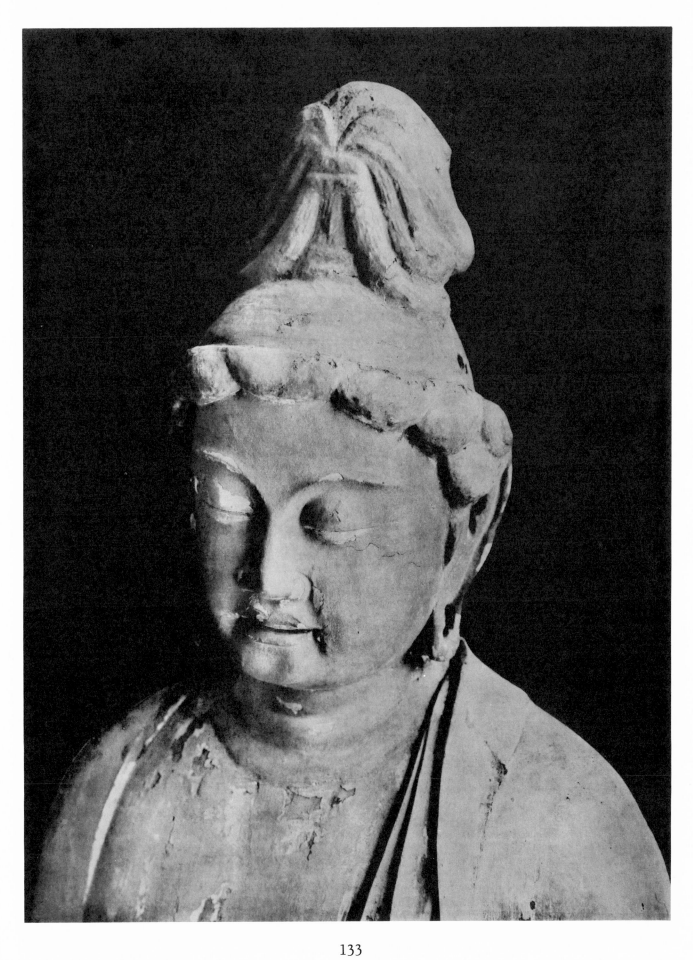

133

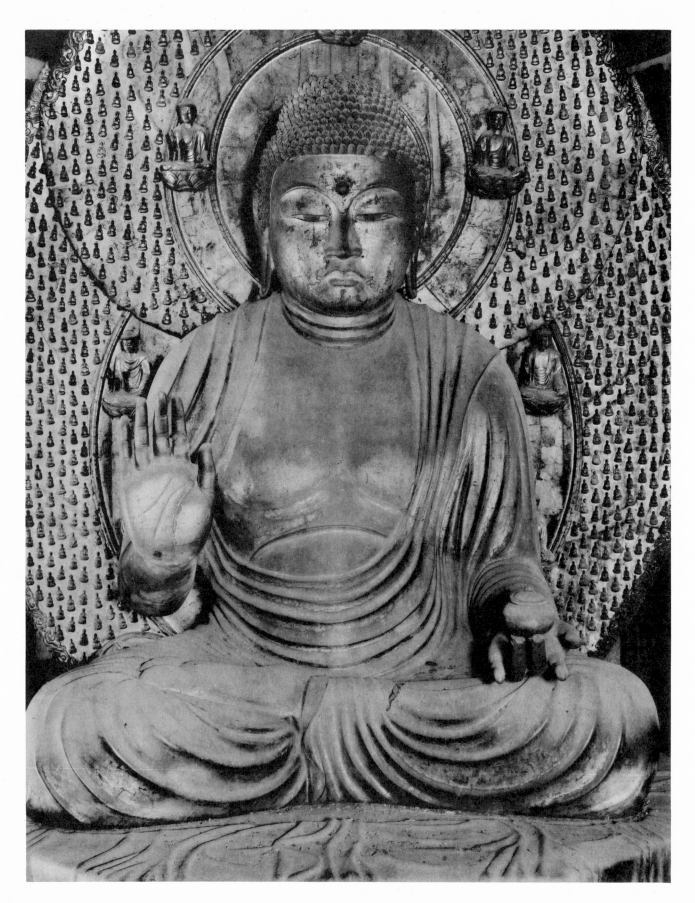

134

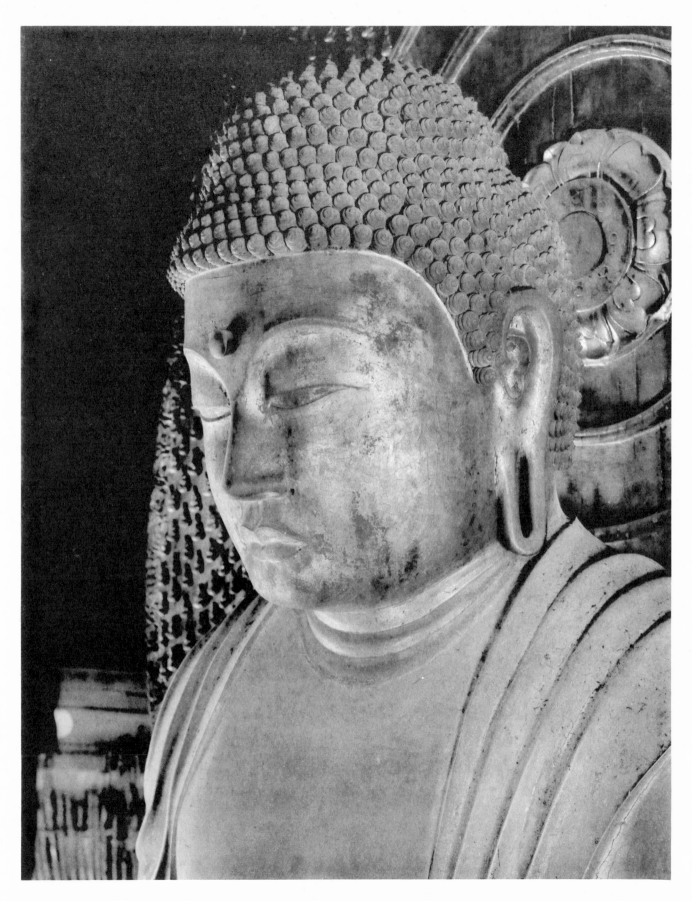

135

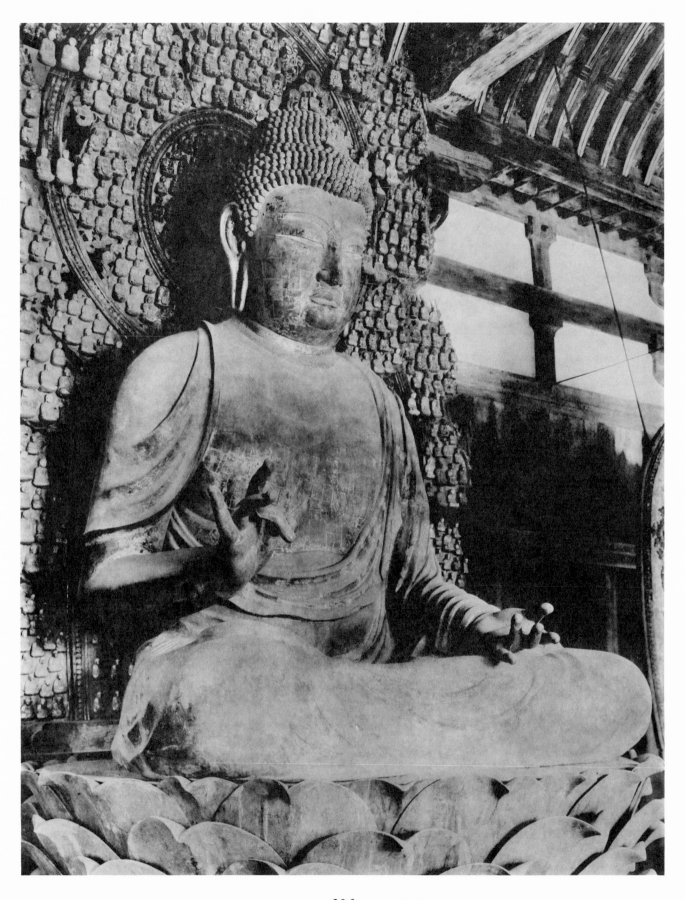

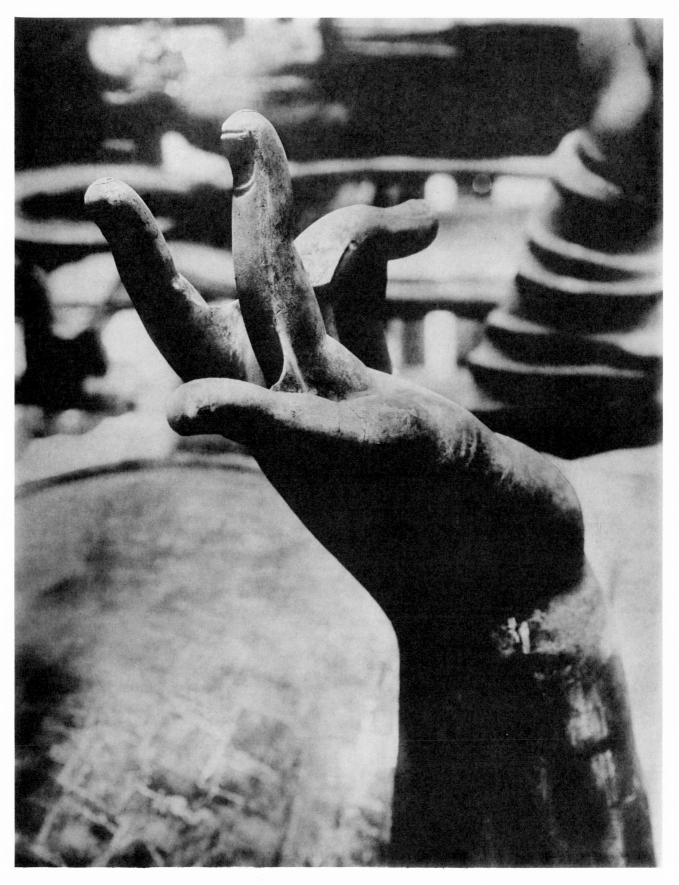

137

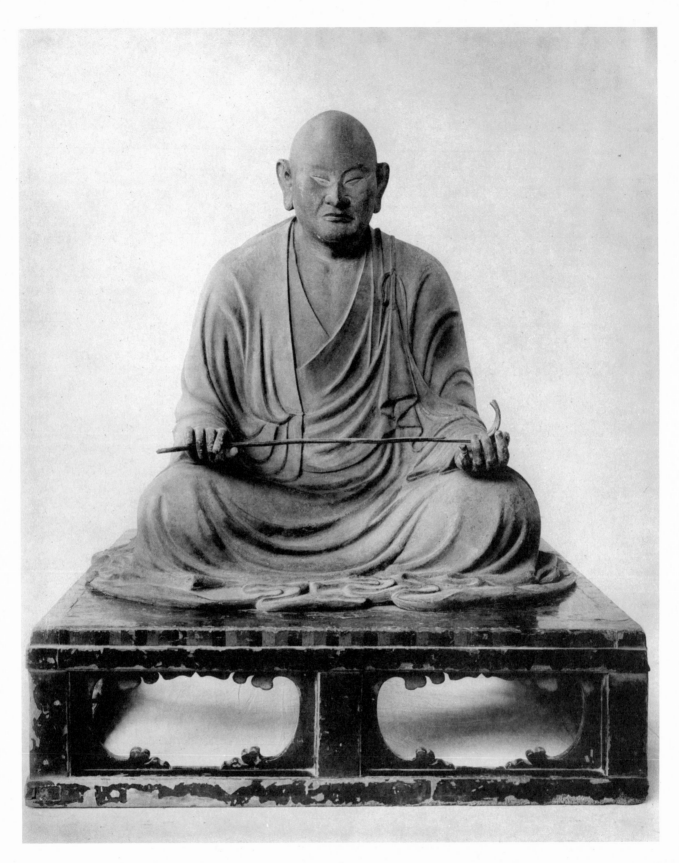

138

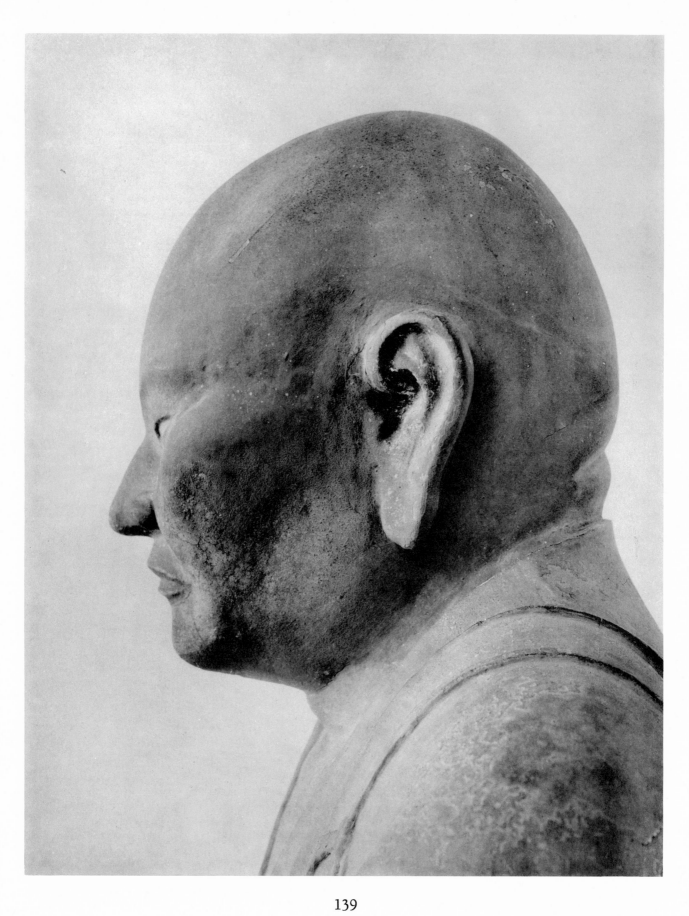

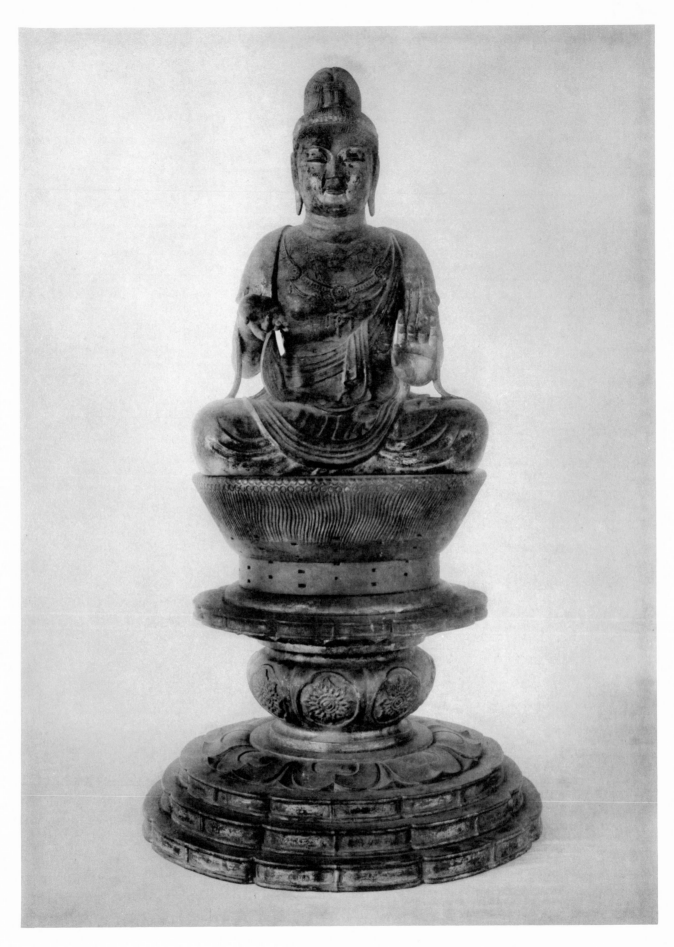

140

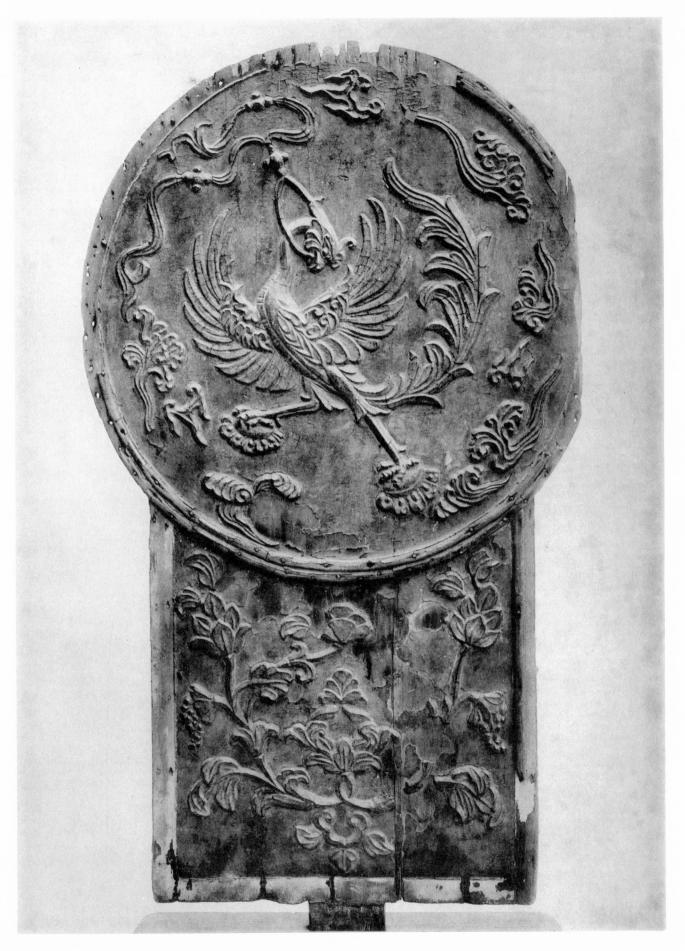

141

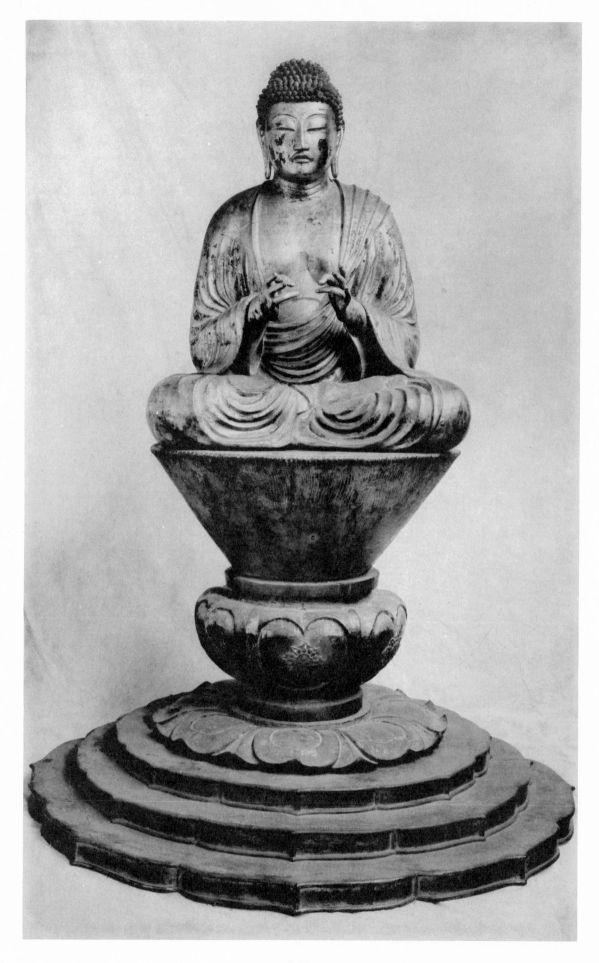

142

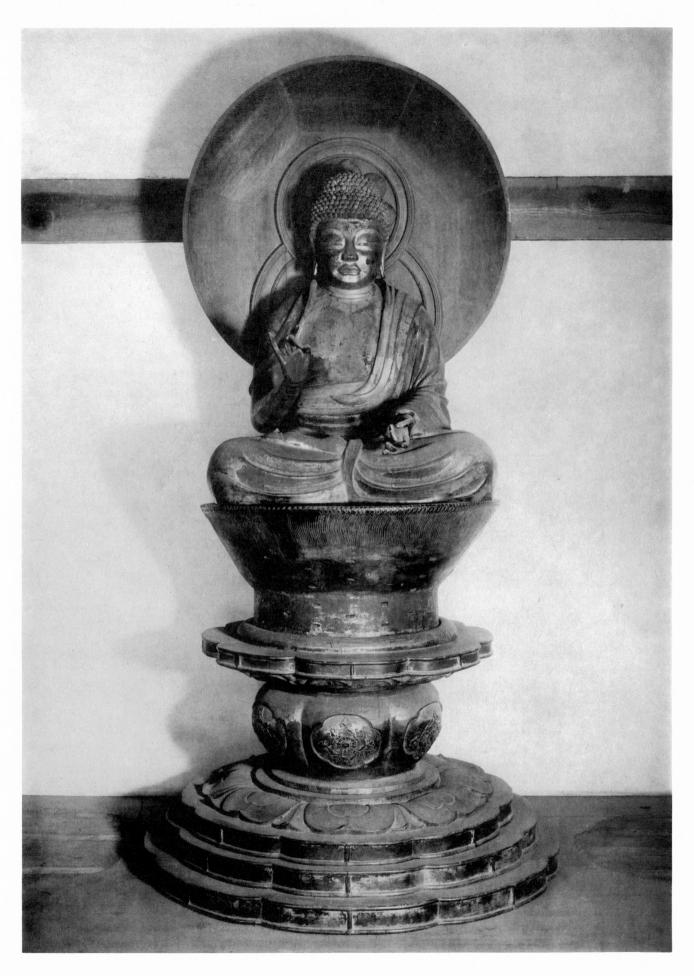

143

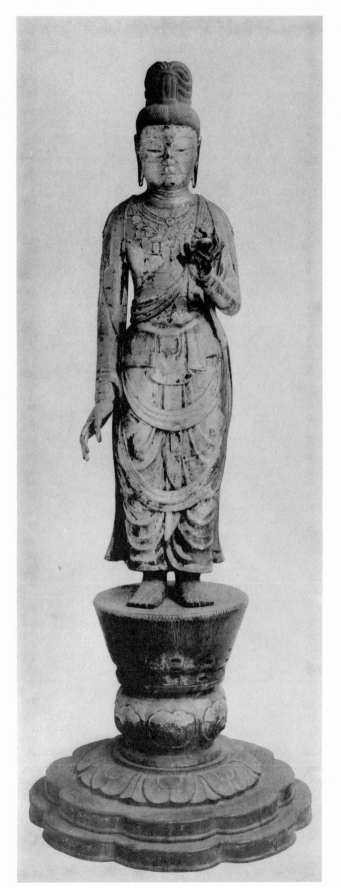

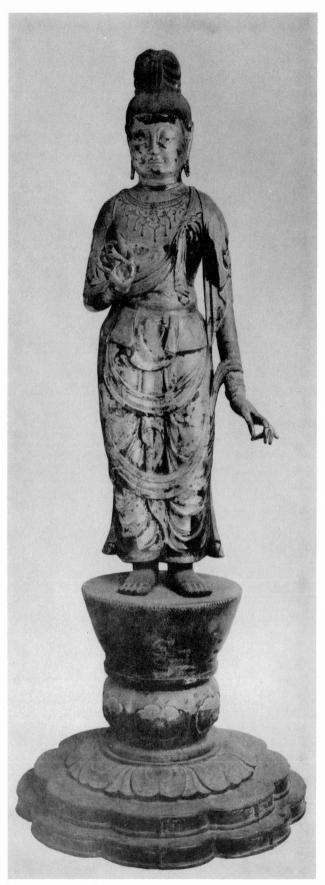

a

b

144

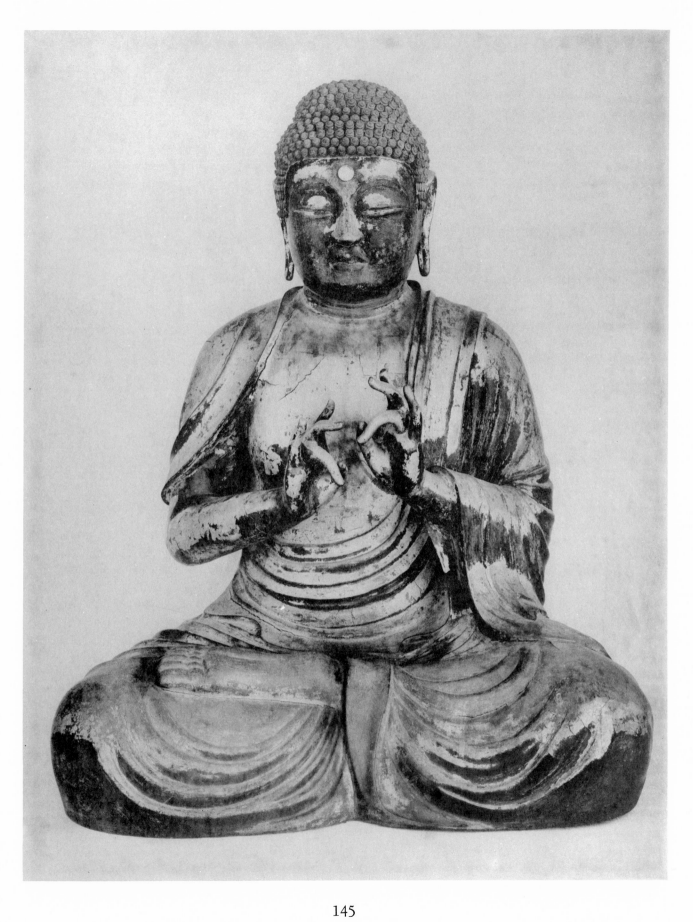

145

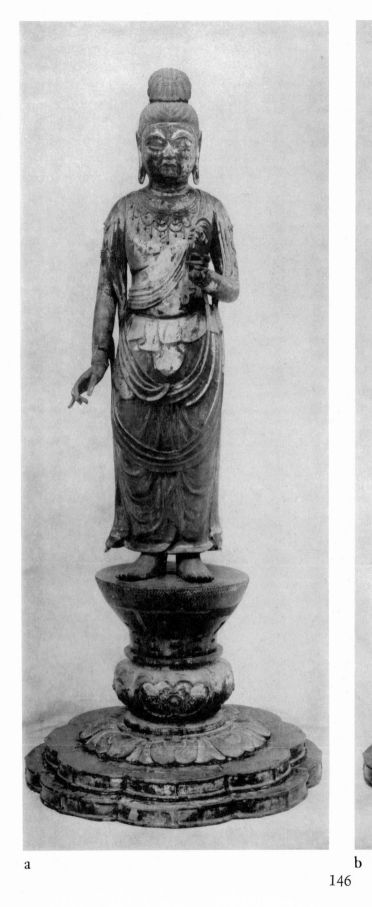

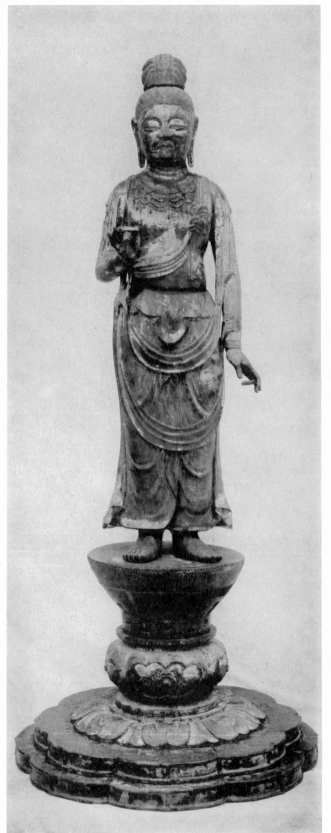

a b

146

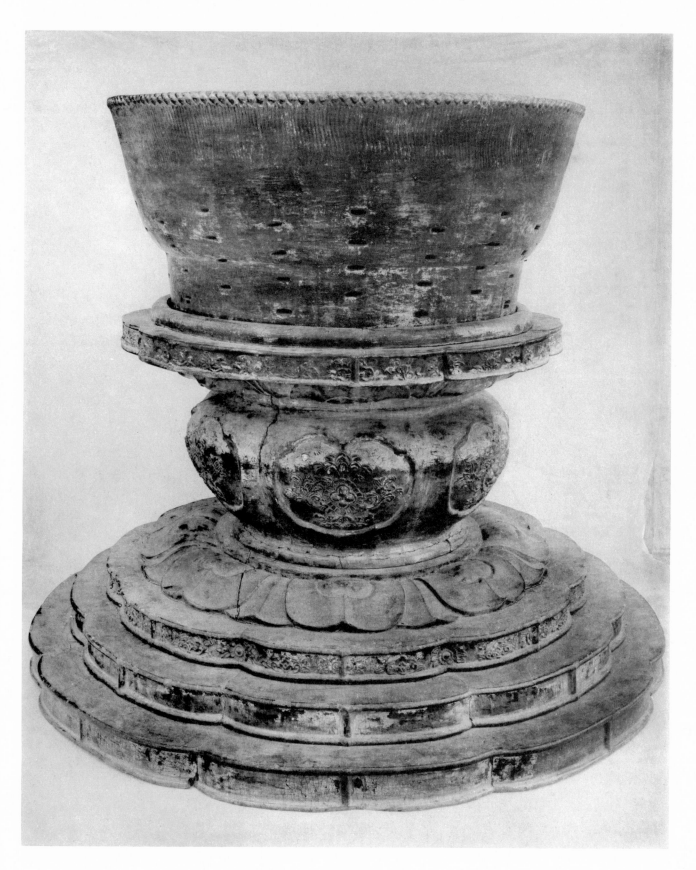

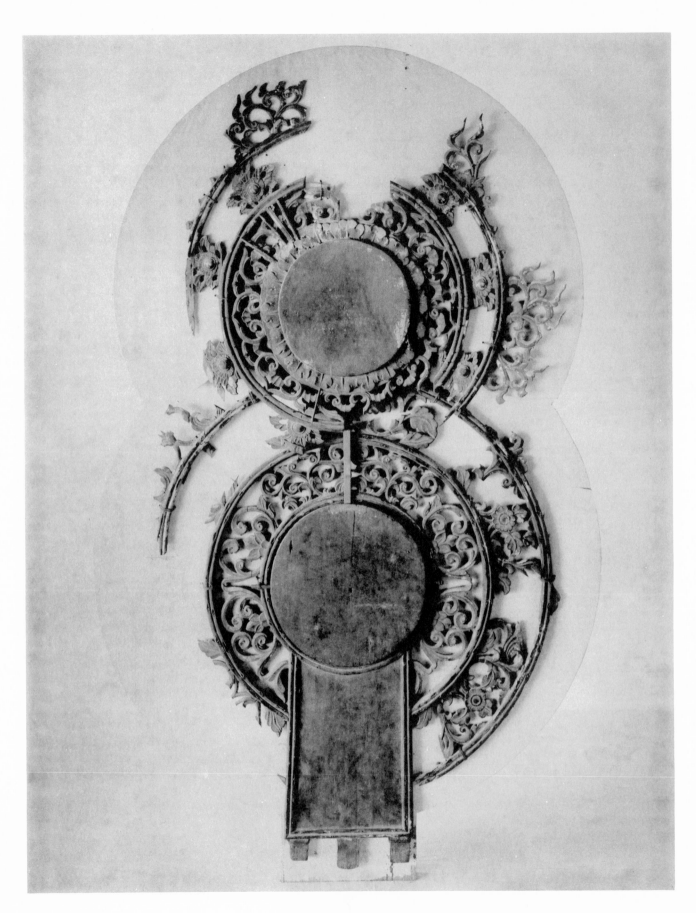

148

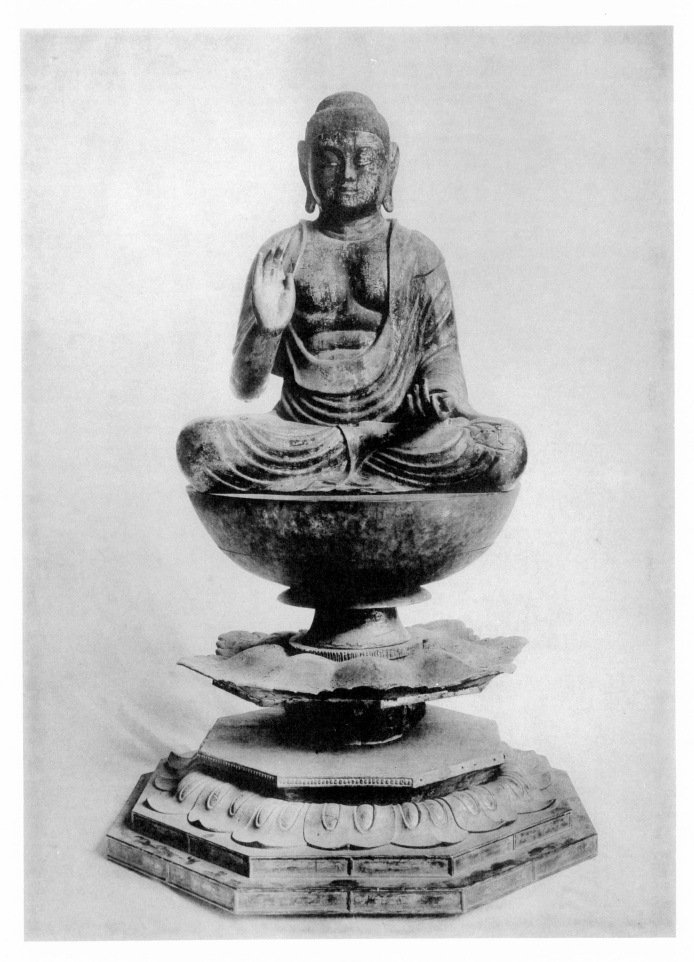

149

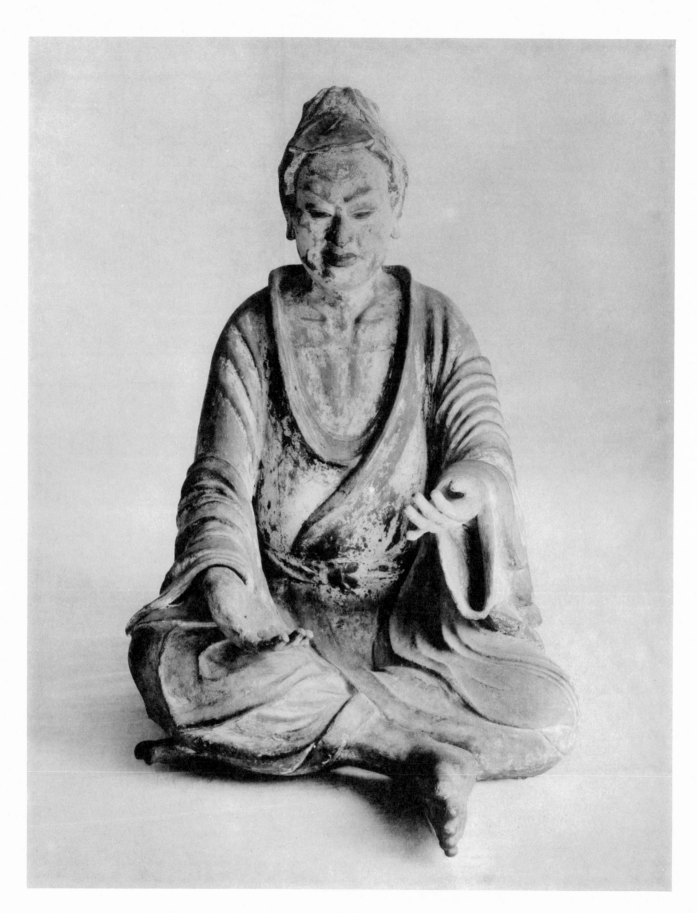

150

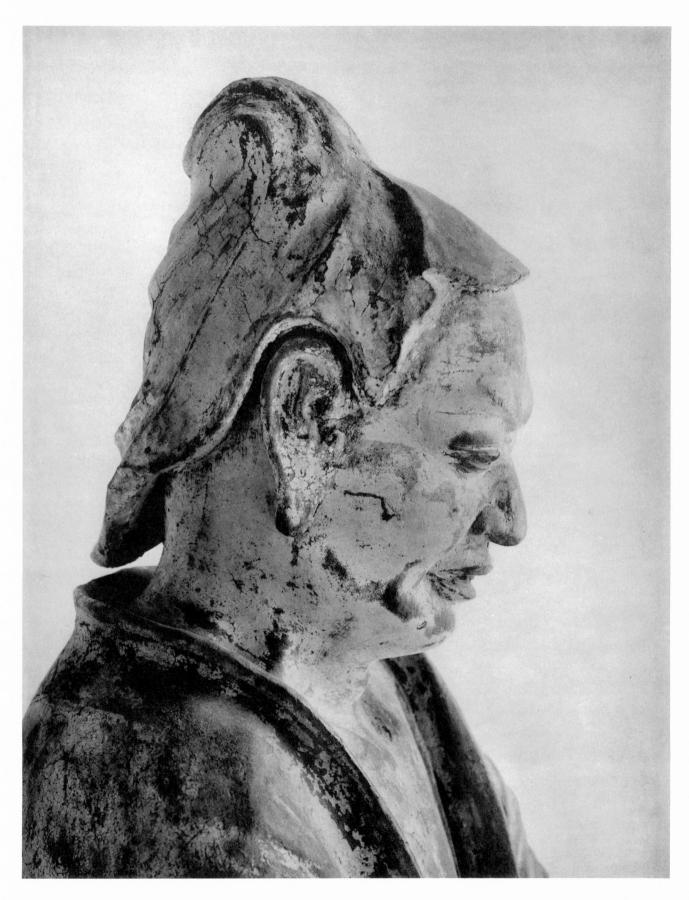

151

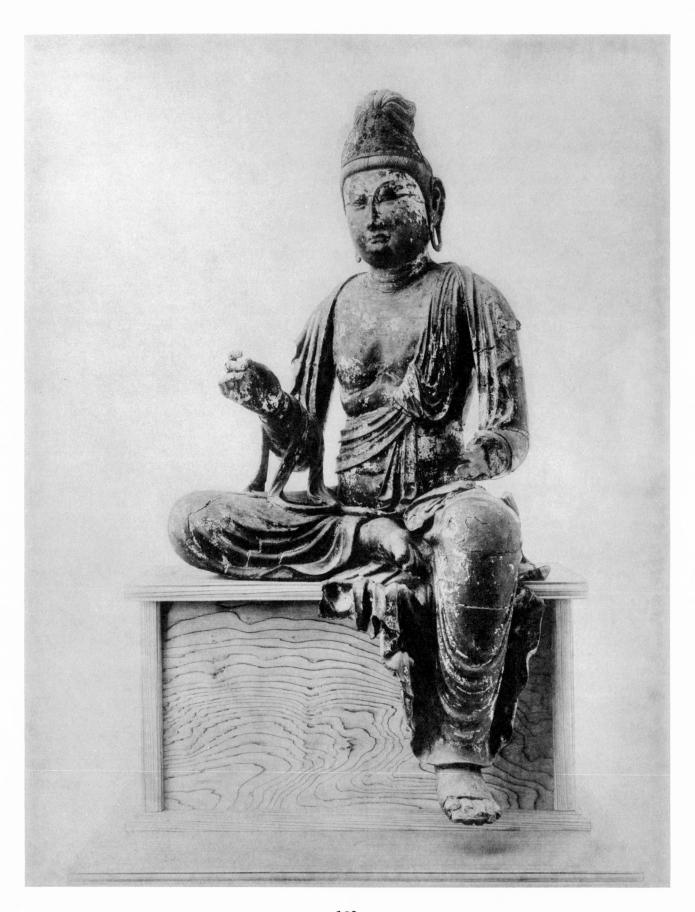

152

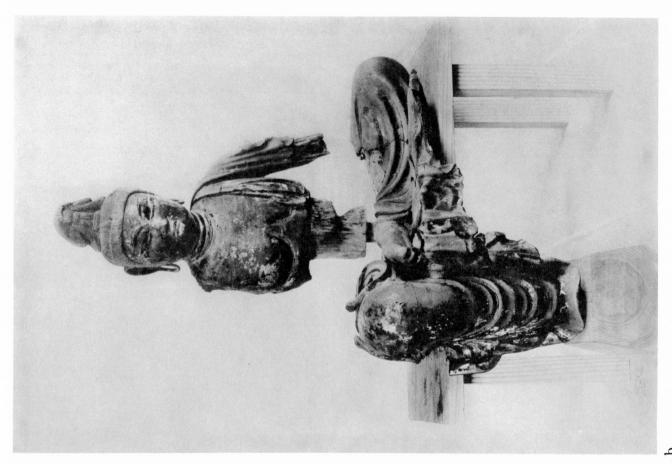

a

b

153

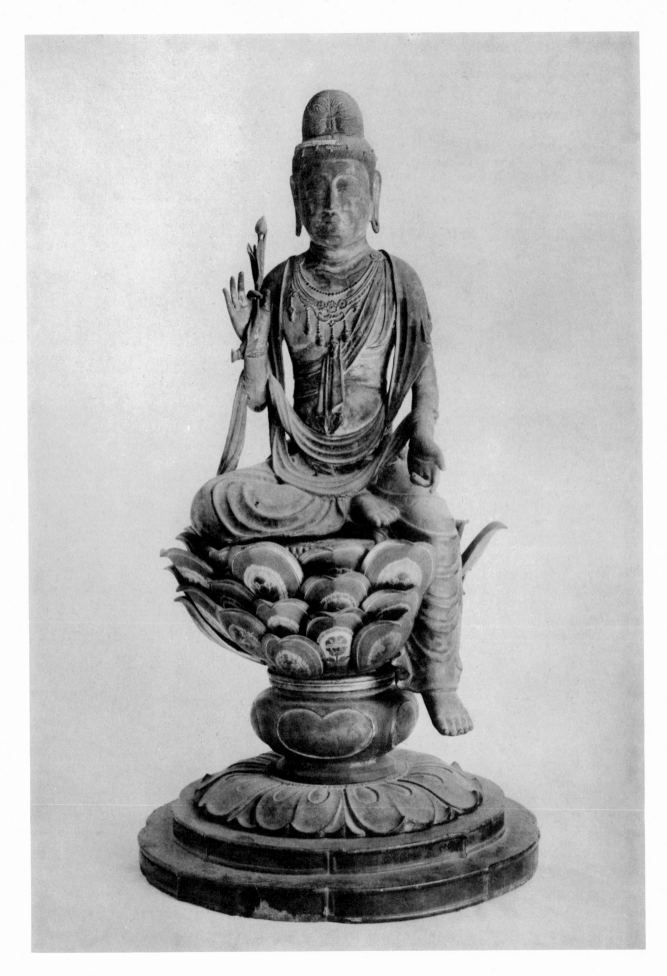

154

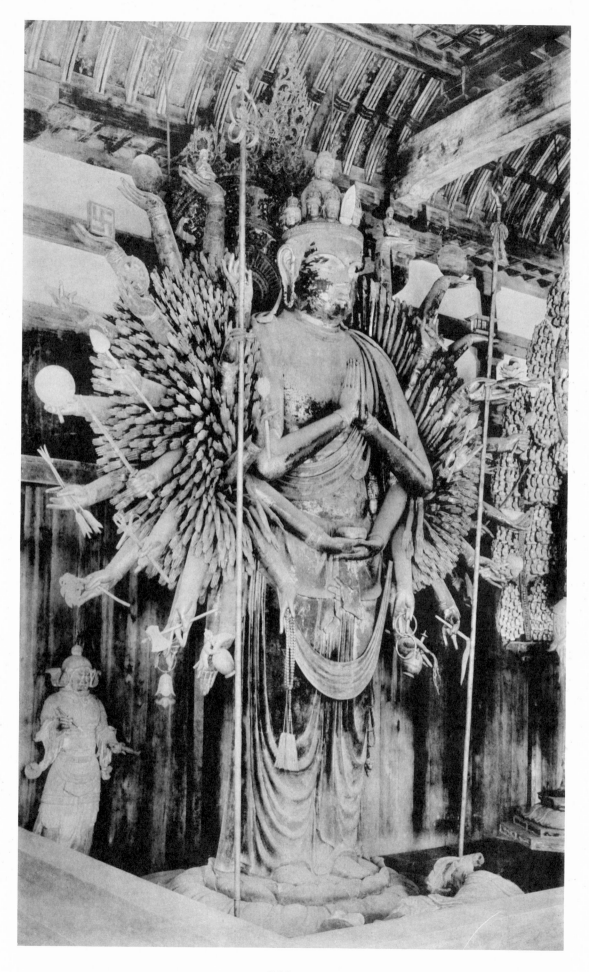

155

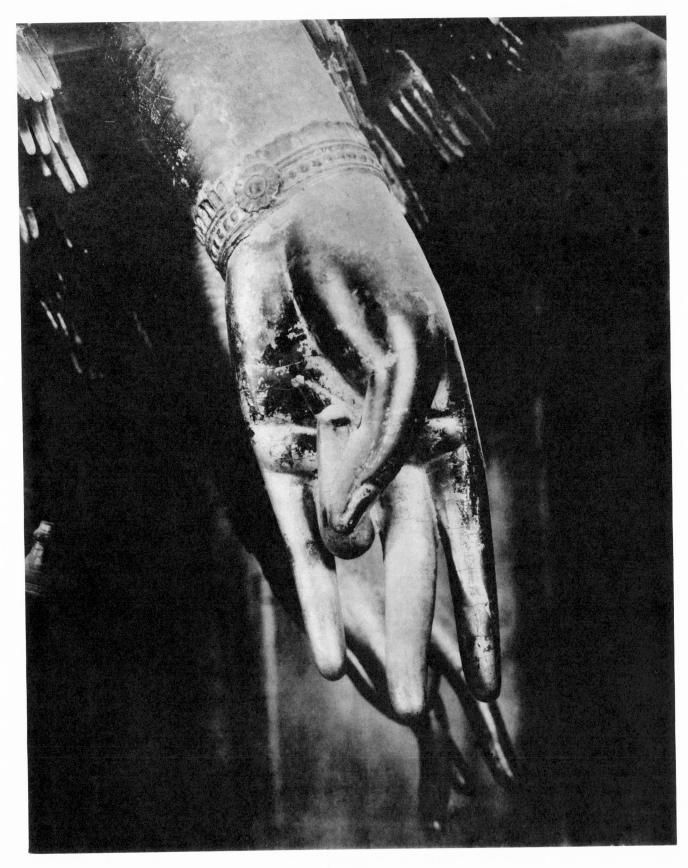

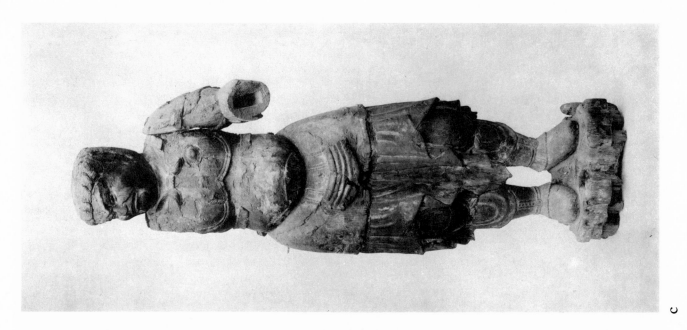

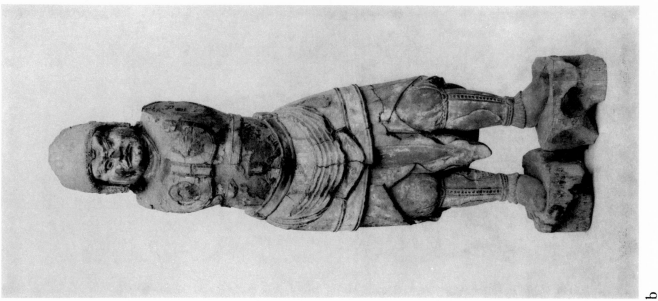
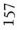

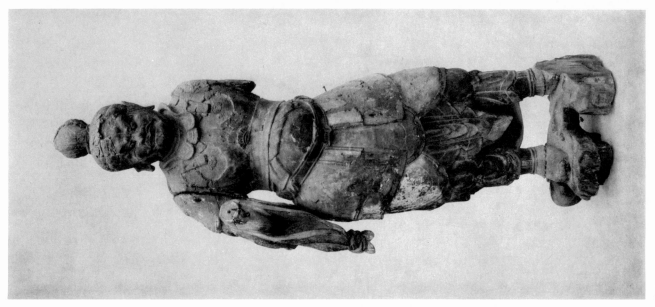

a

157

b

c

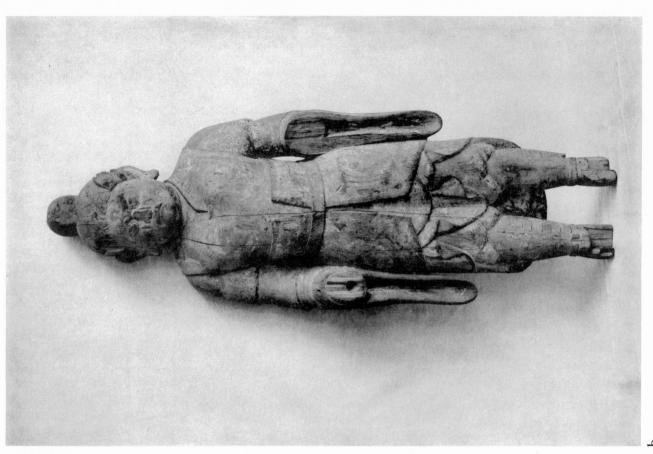

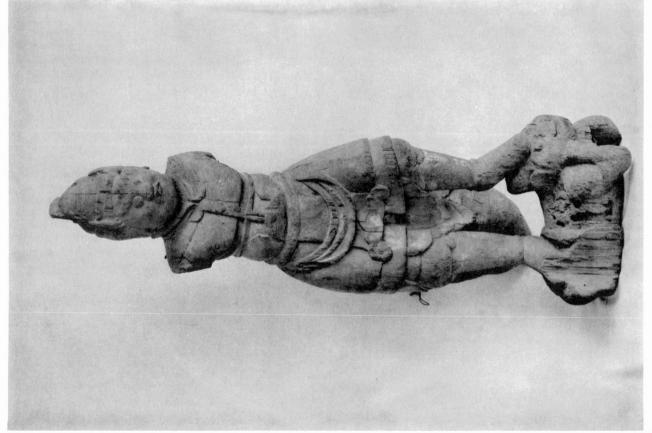

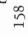

b

158

a

159

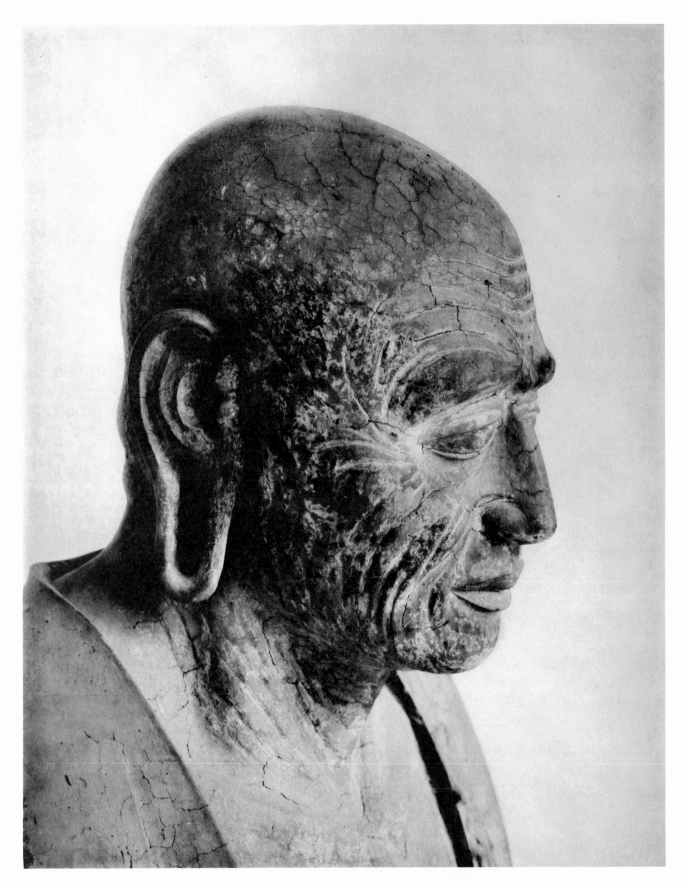

160

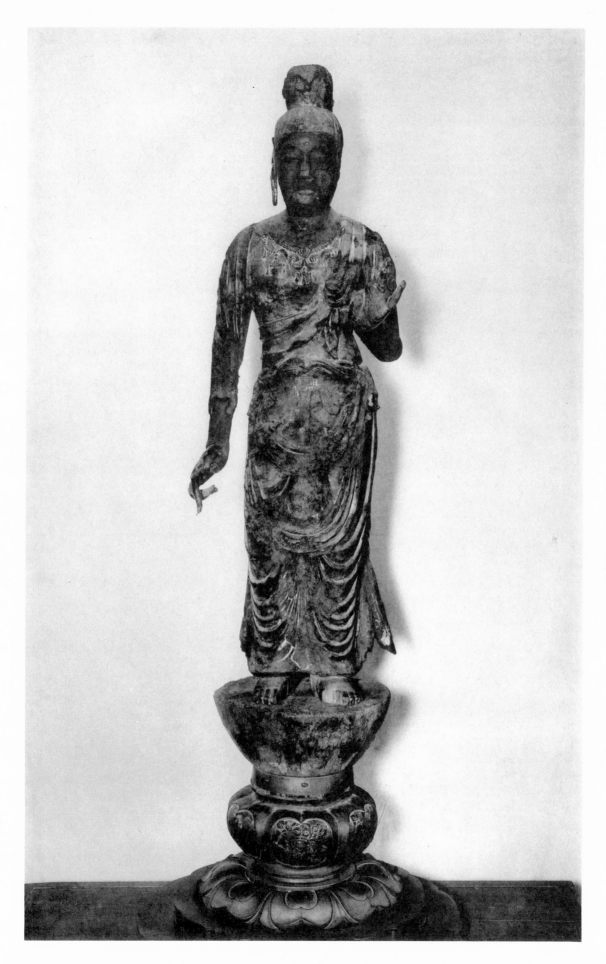

161

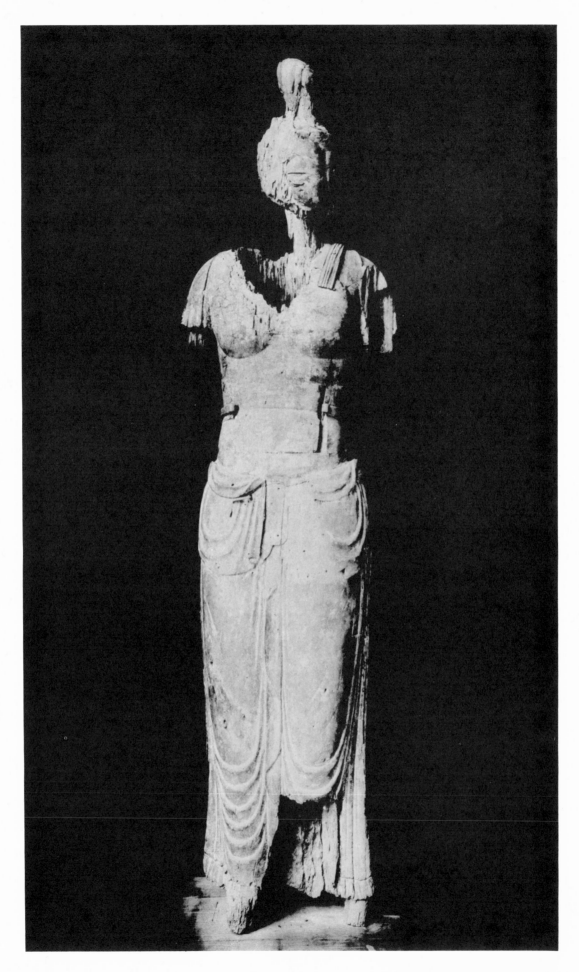

162

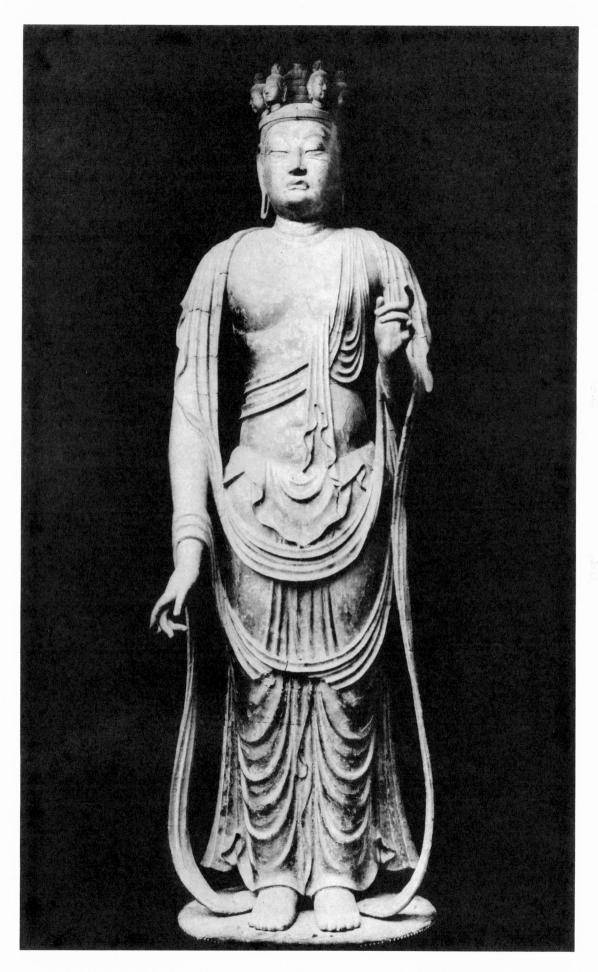

163

164

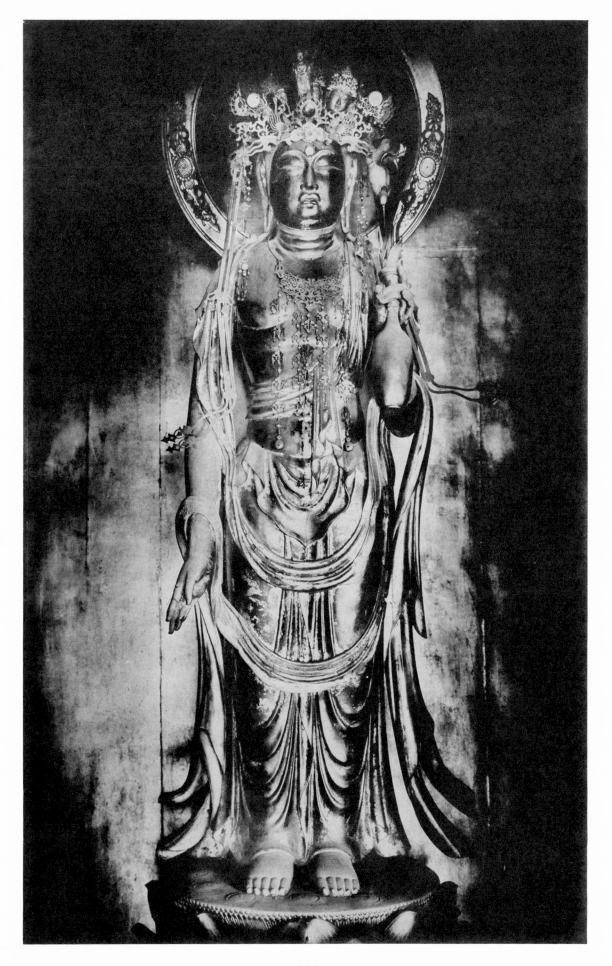

165

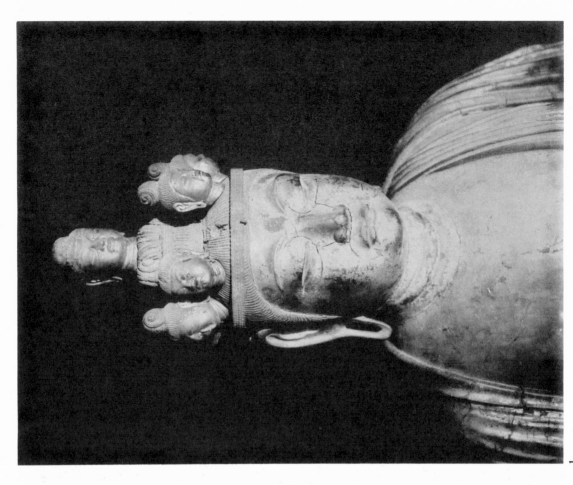

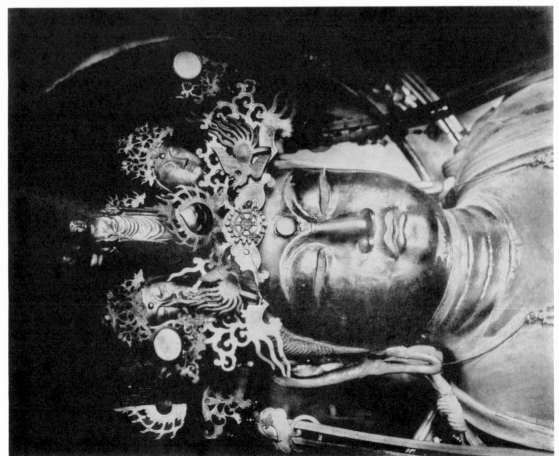

a

b

166

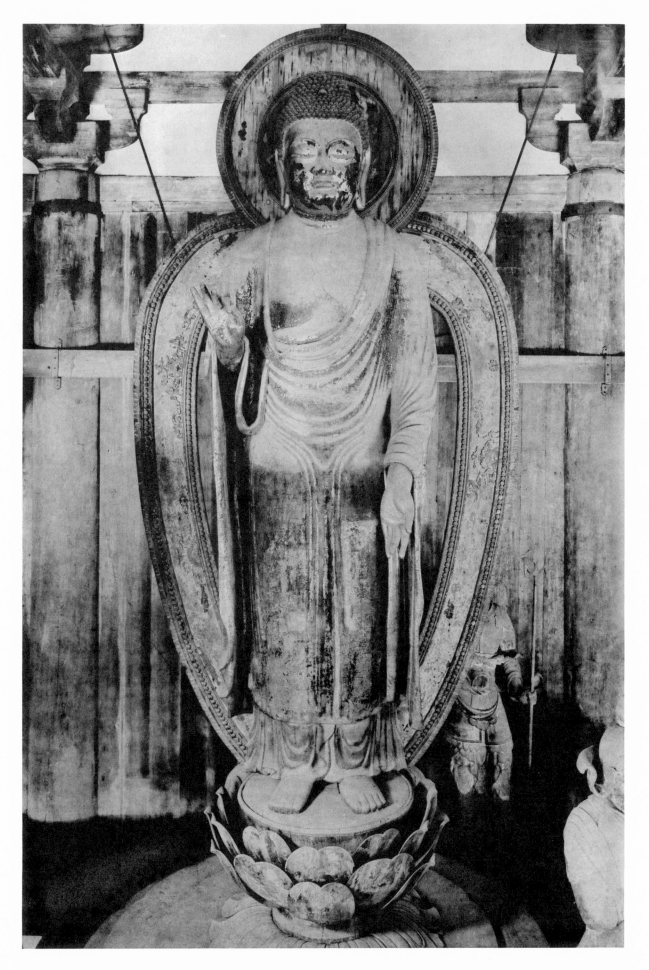

167

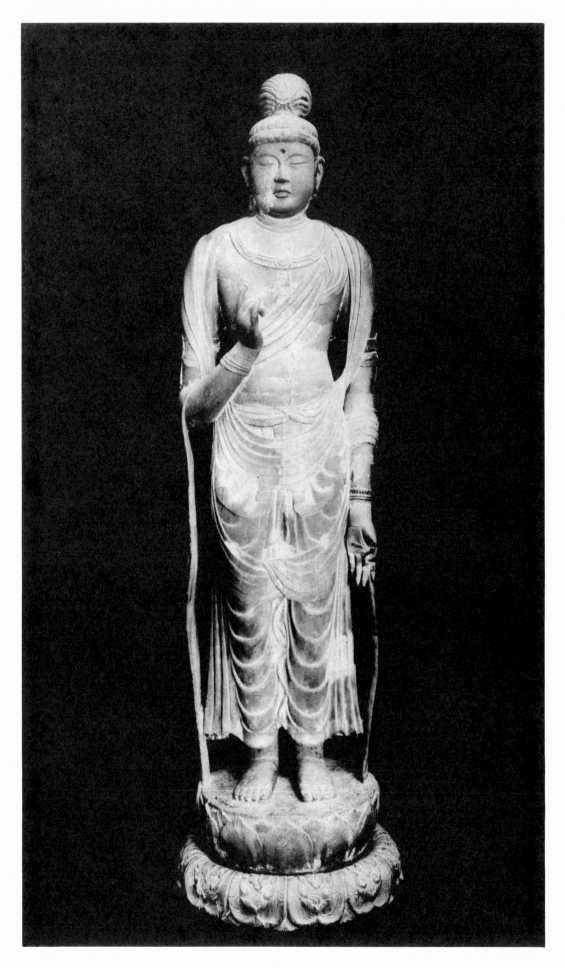

168

a

b

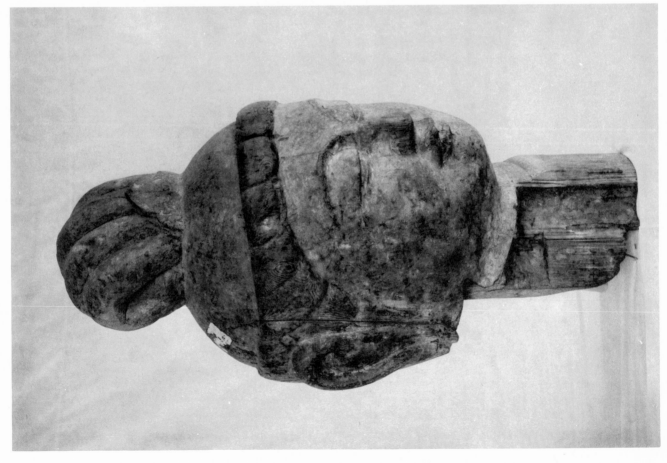

a

170

b

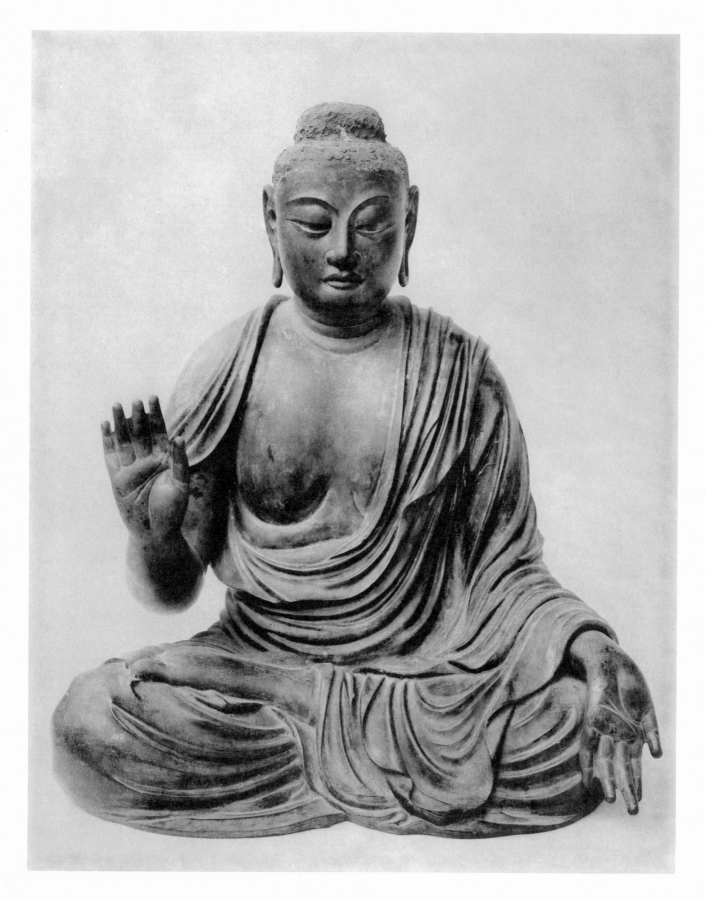

171

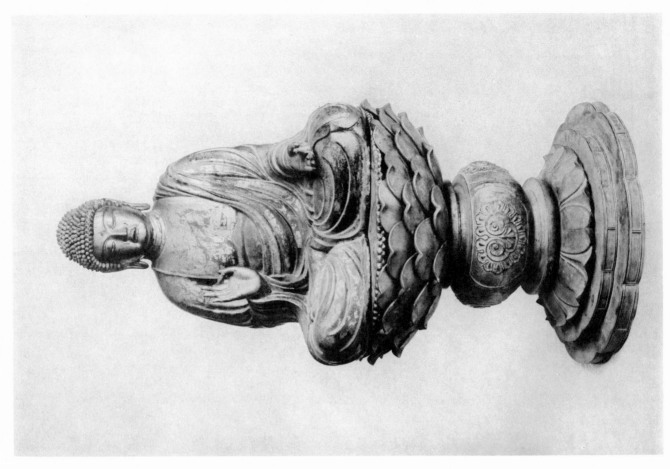

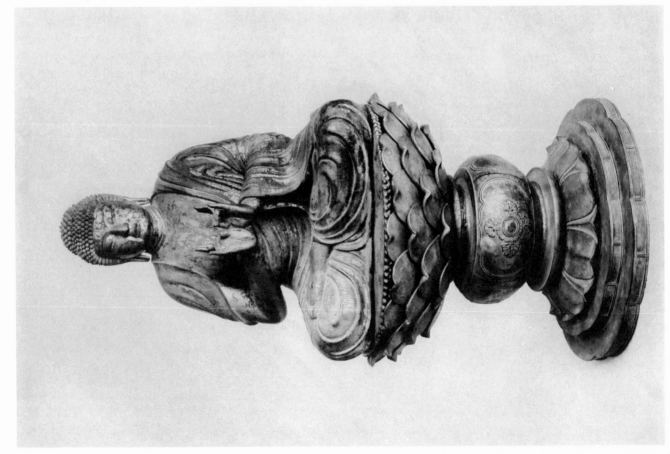

b

a

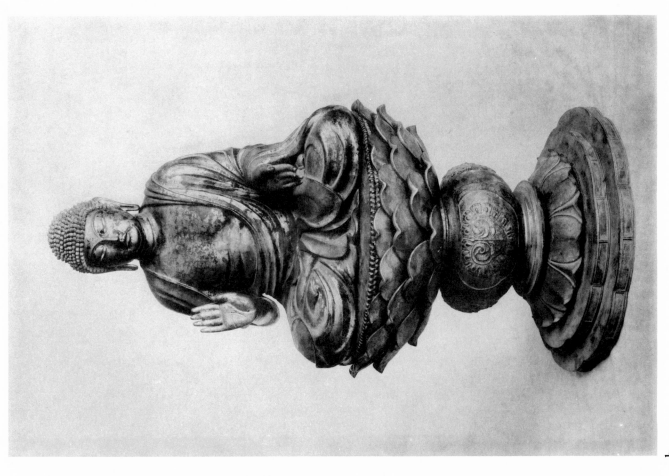

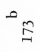

b

173

a

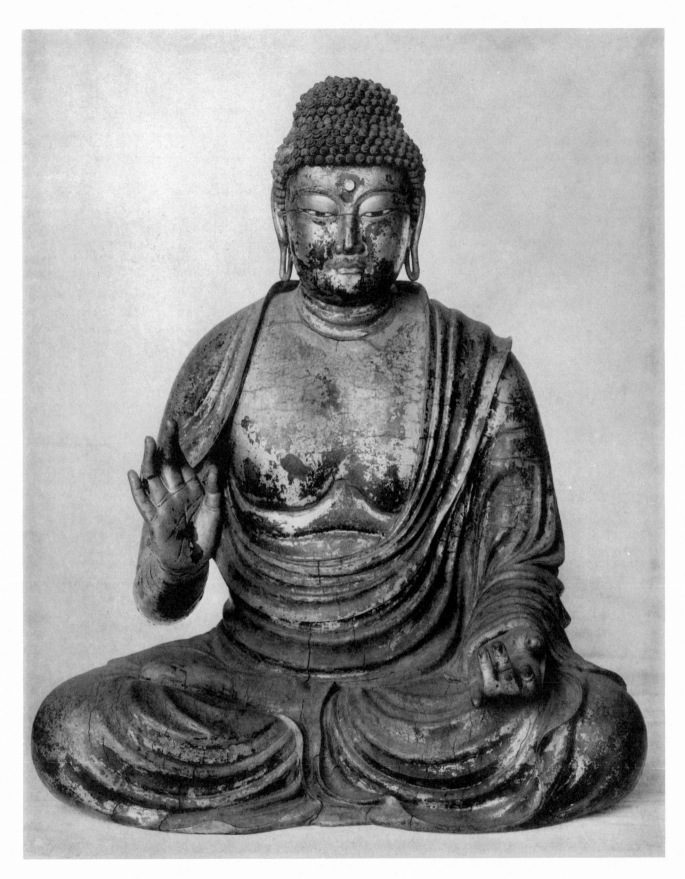

174

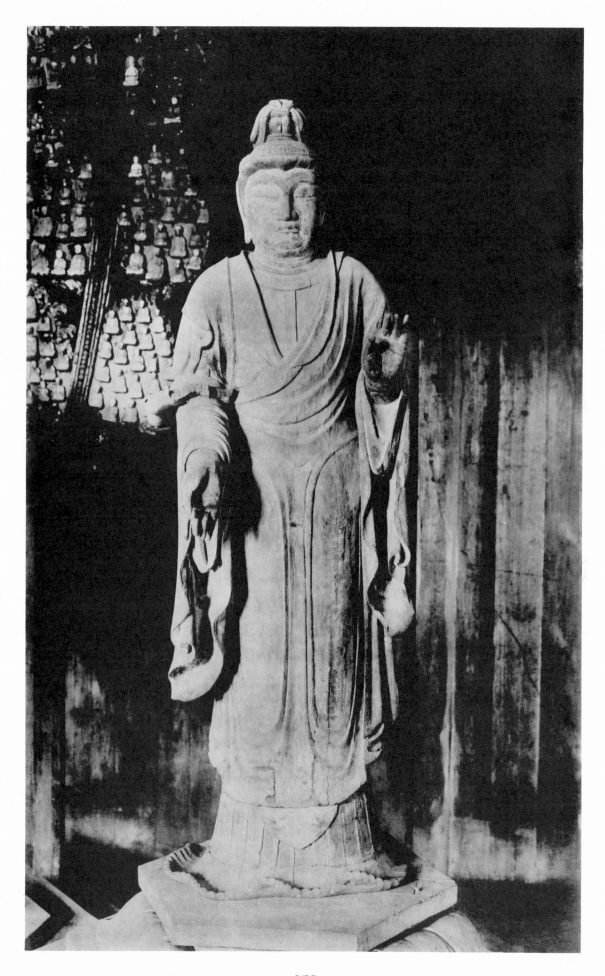

175

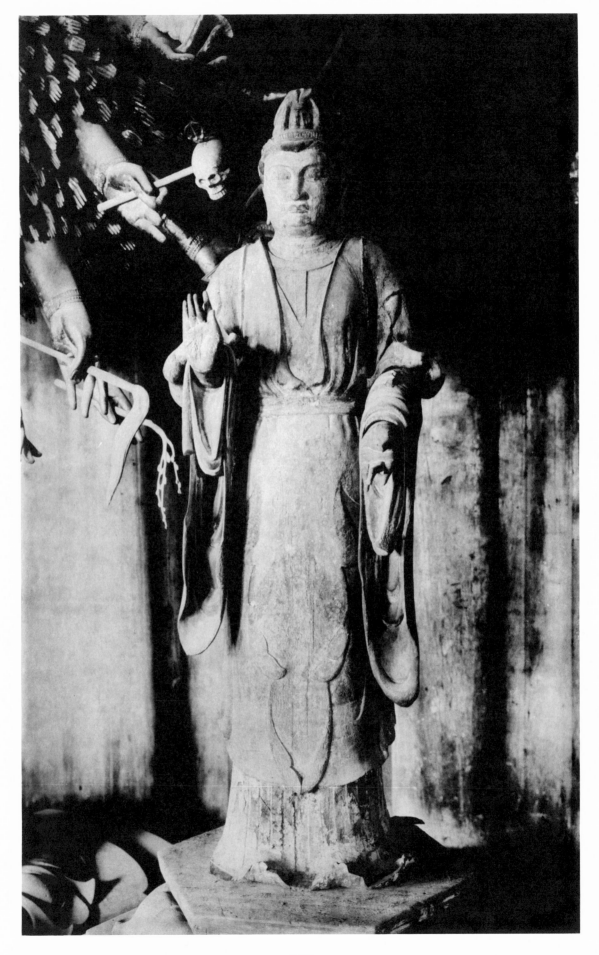

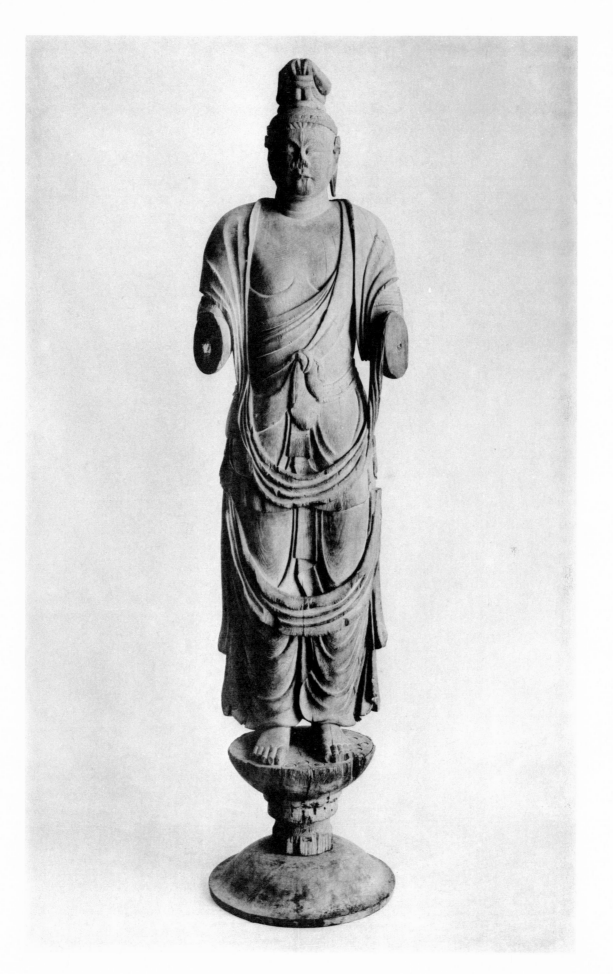

177

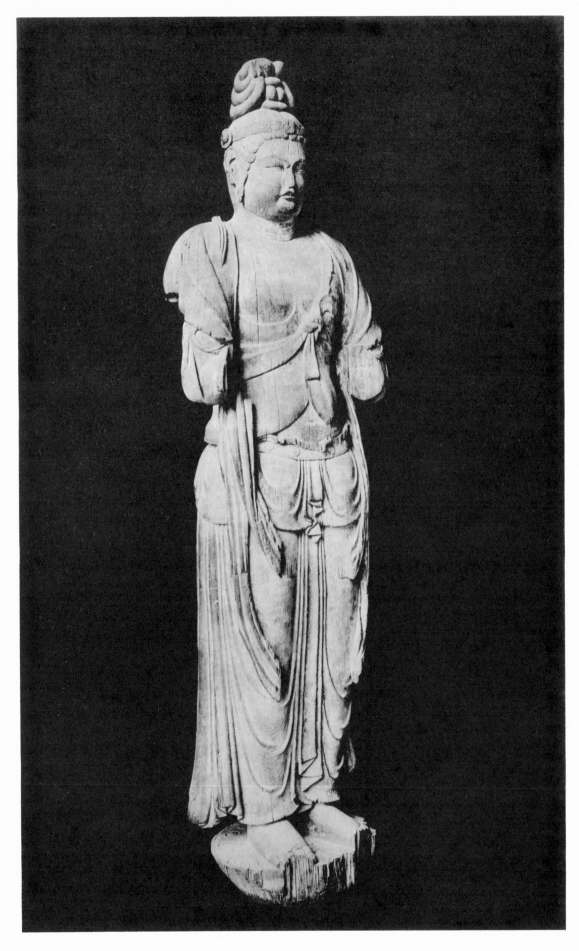

178

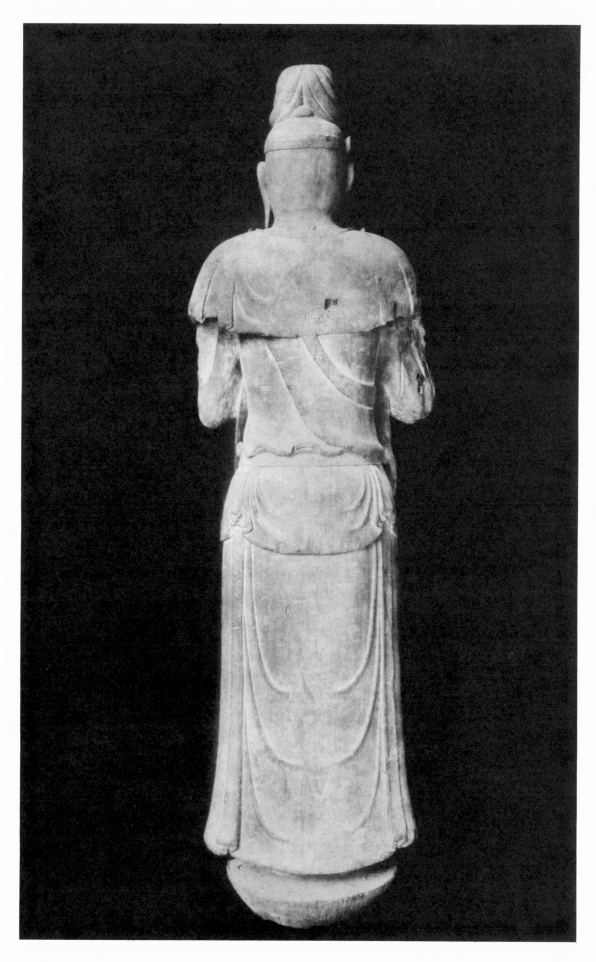

179

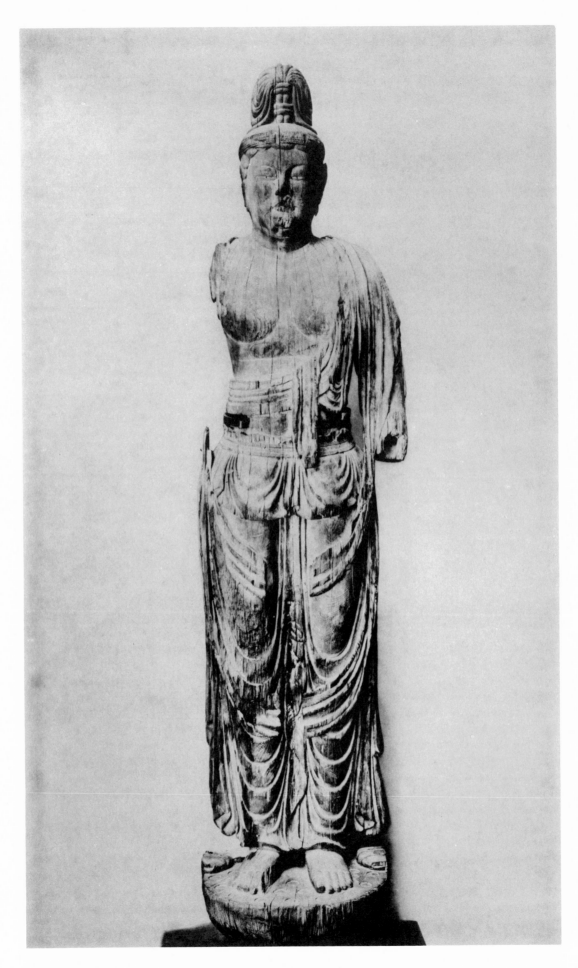

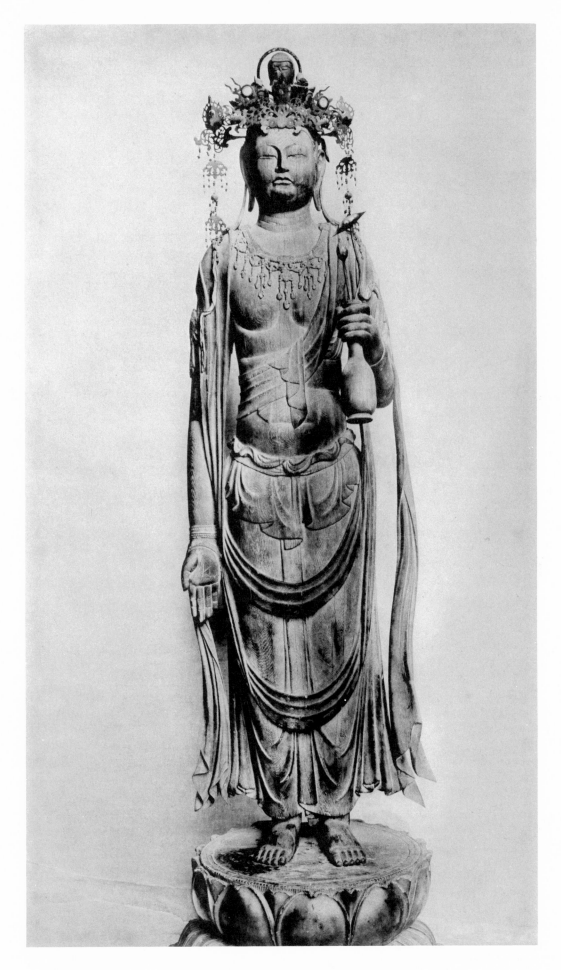

181

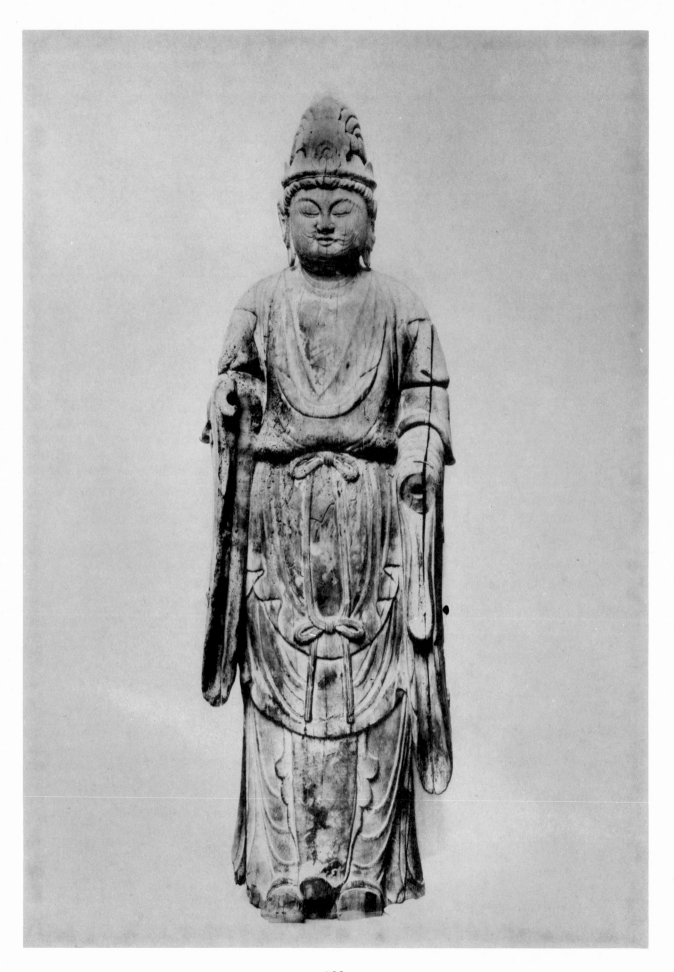

182

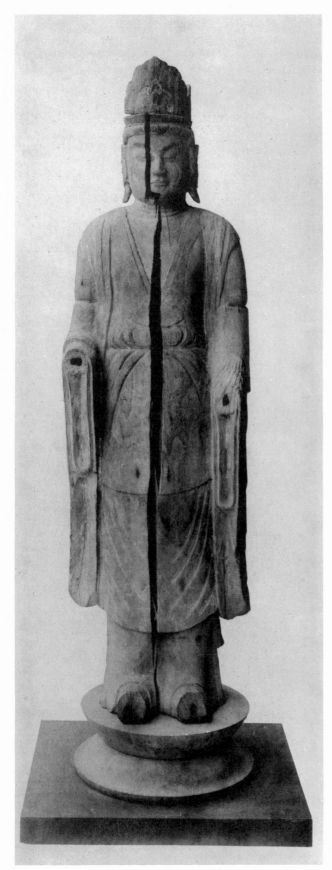

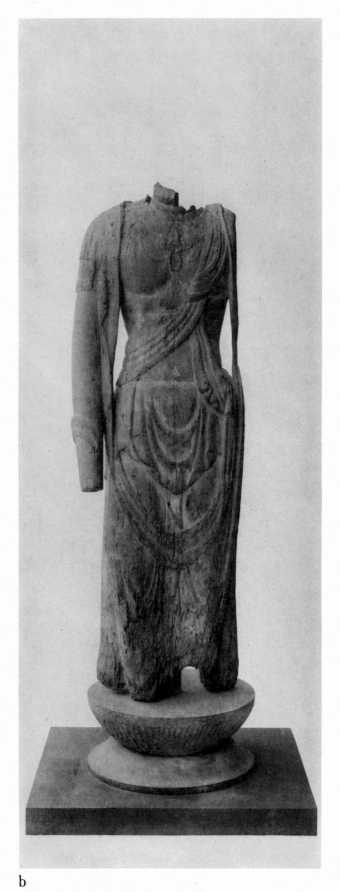

a
b

183

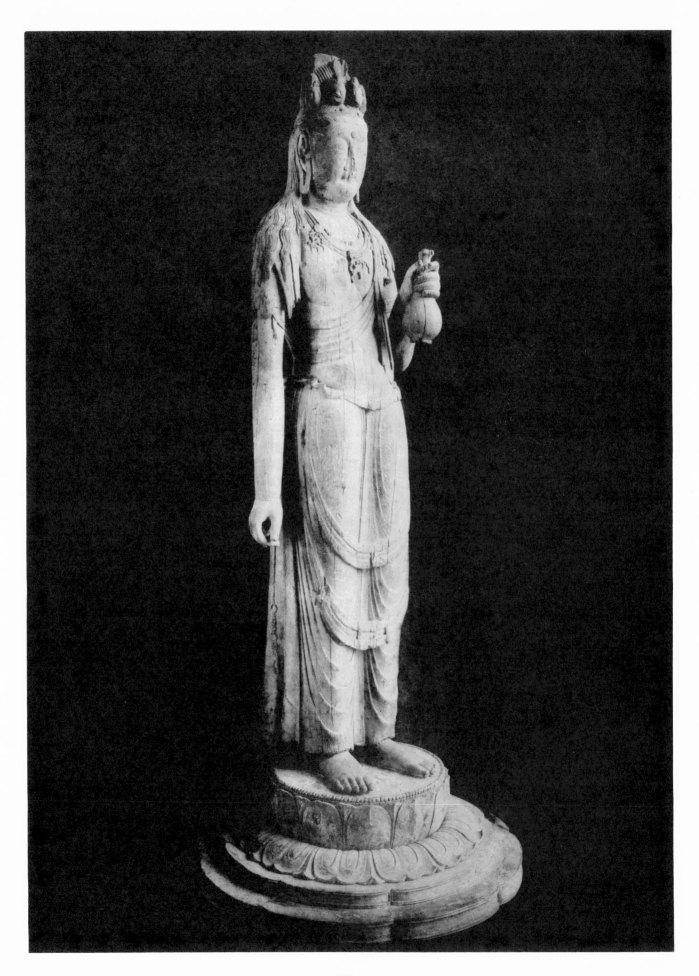

184

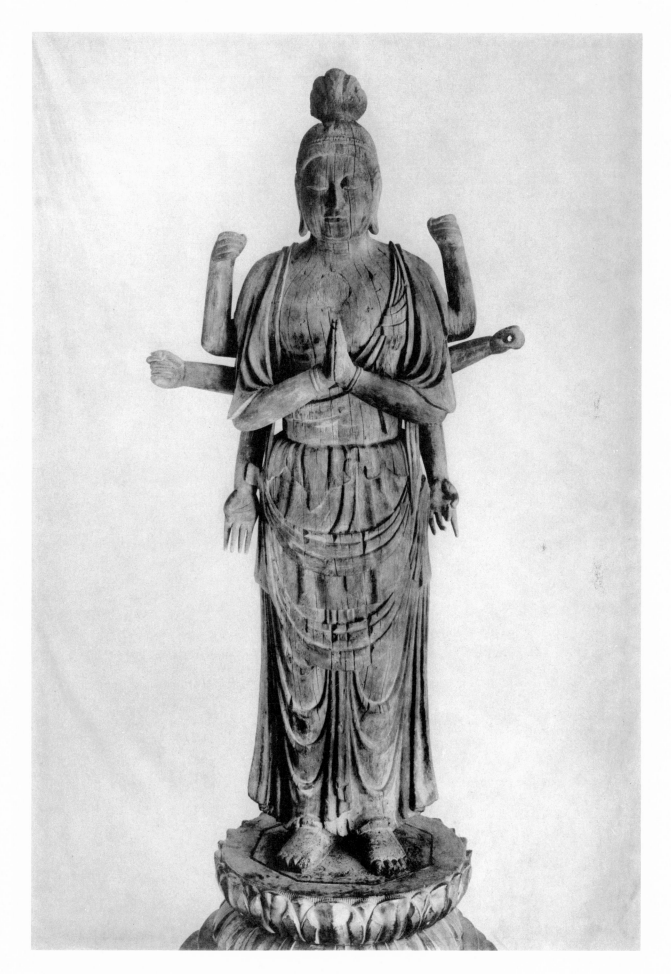

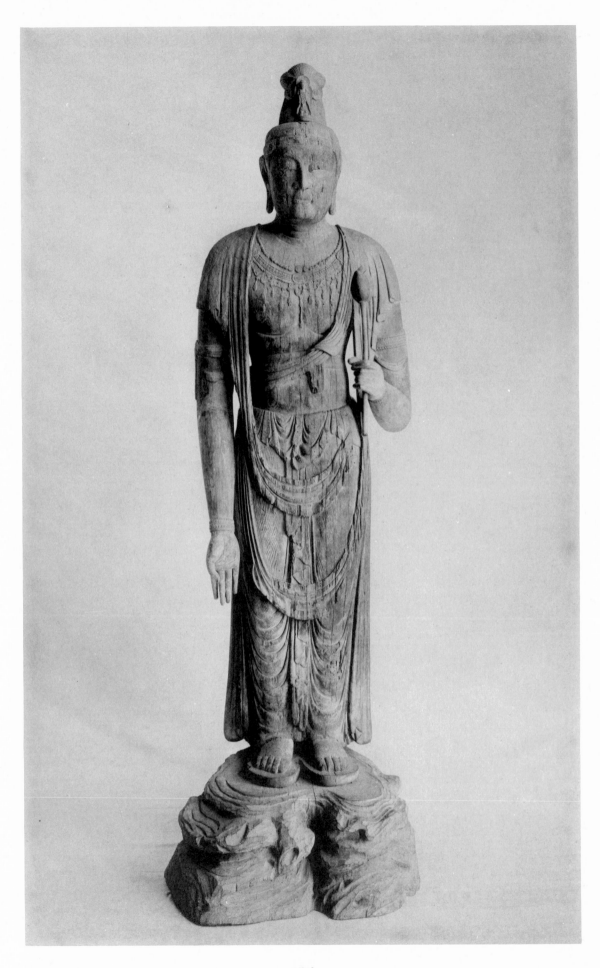

186

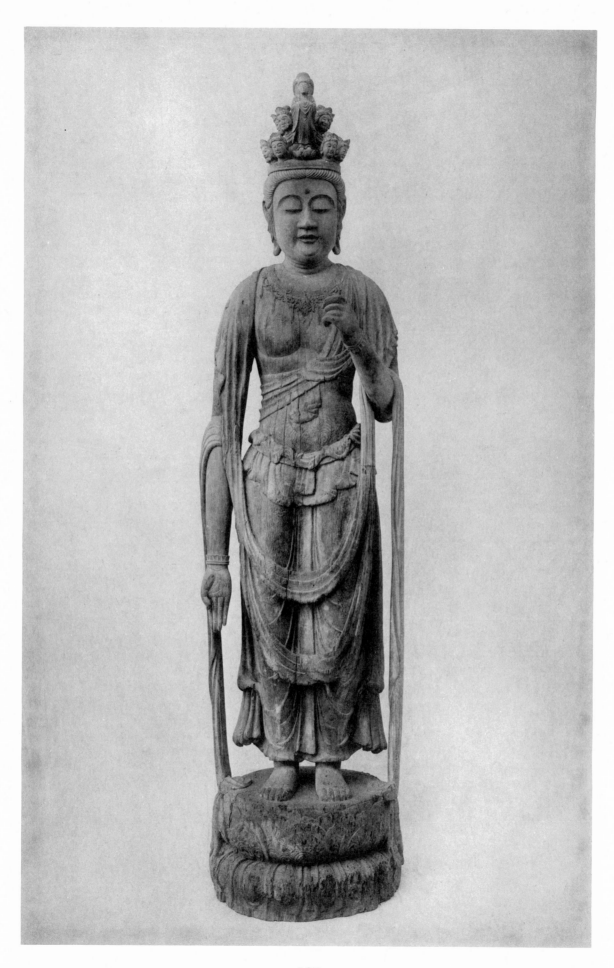

187

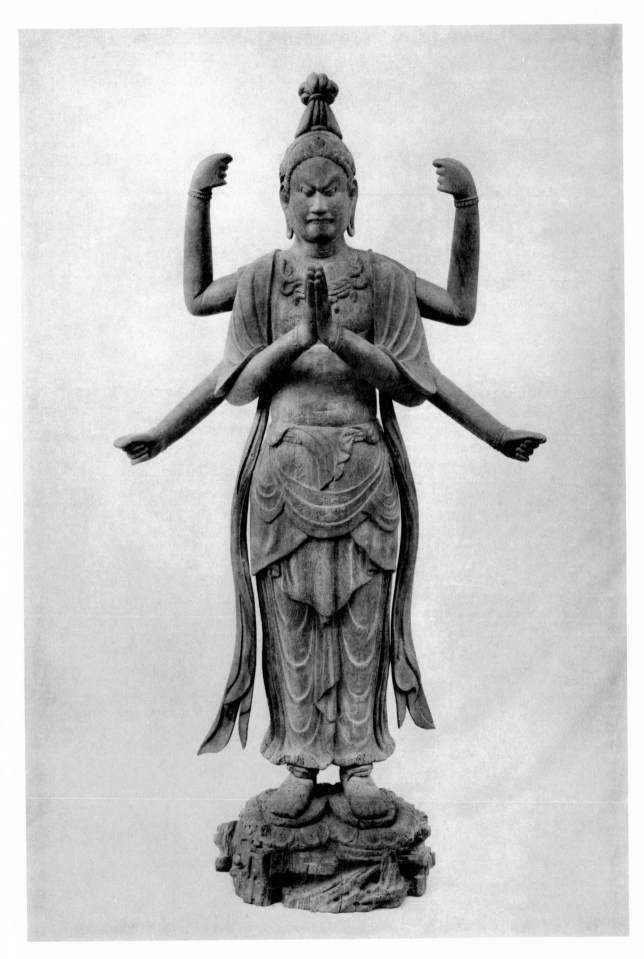

188

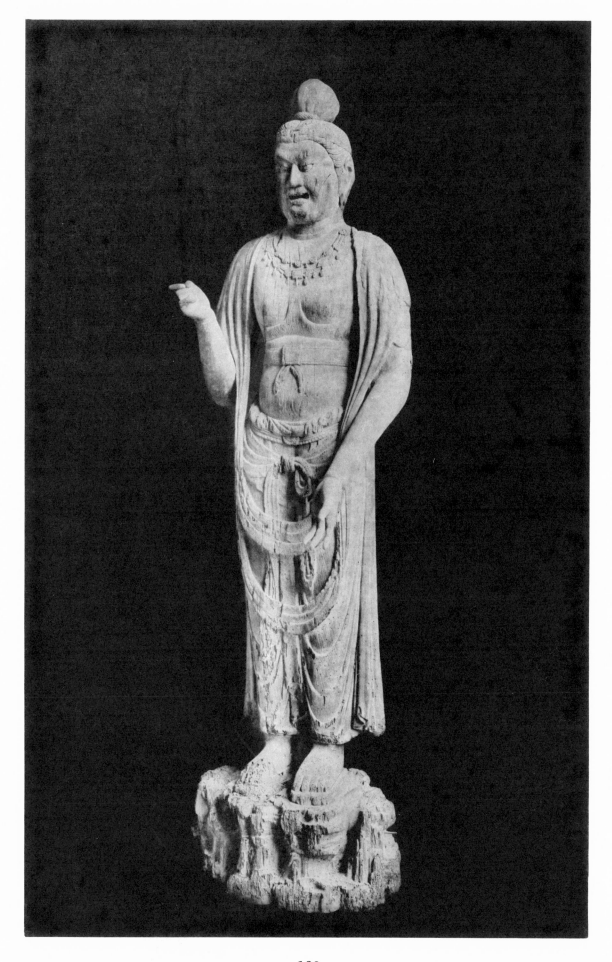

189

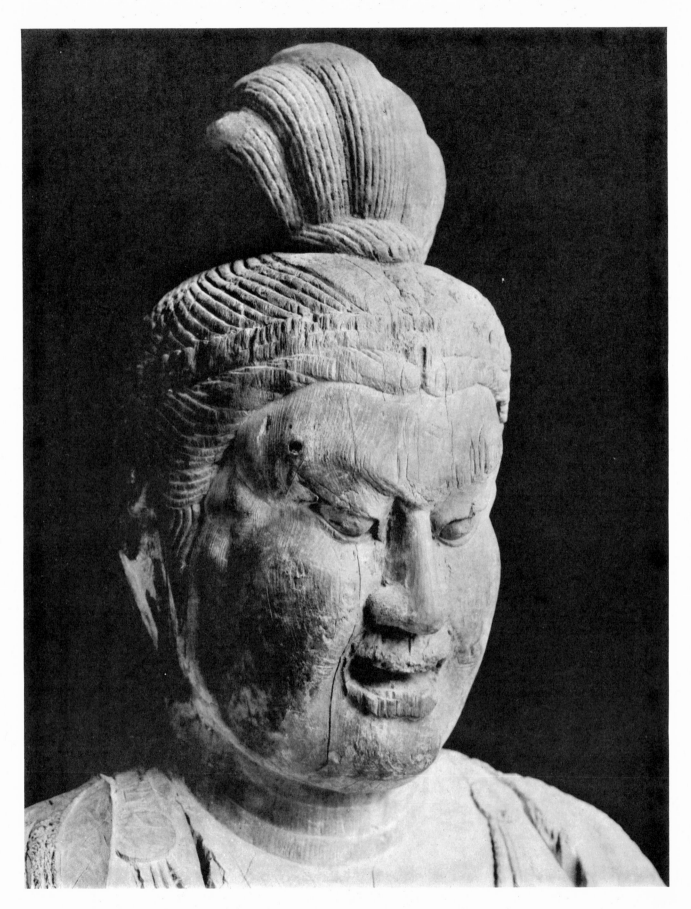

190

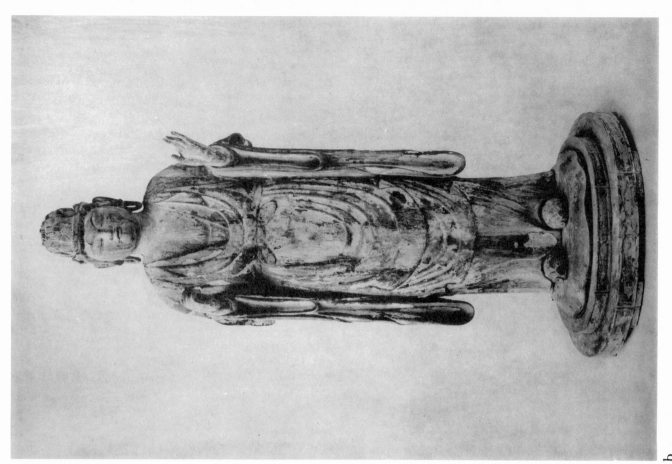

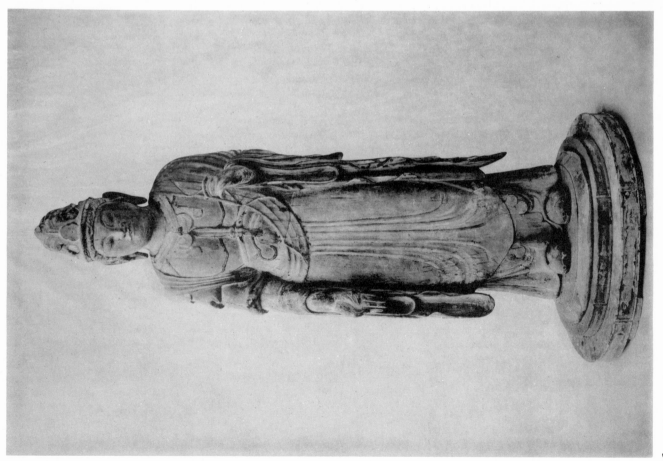

a

b

191

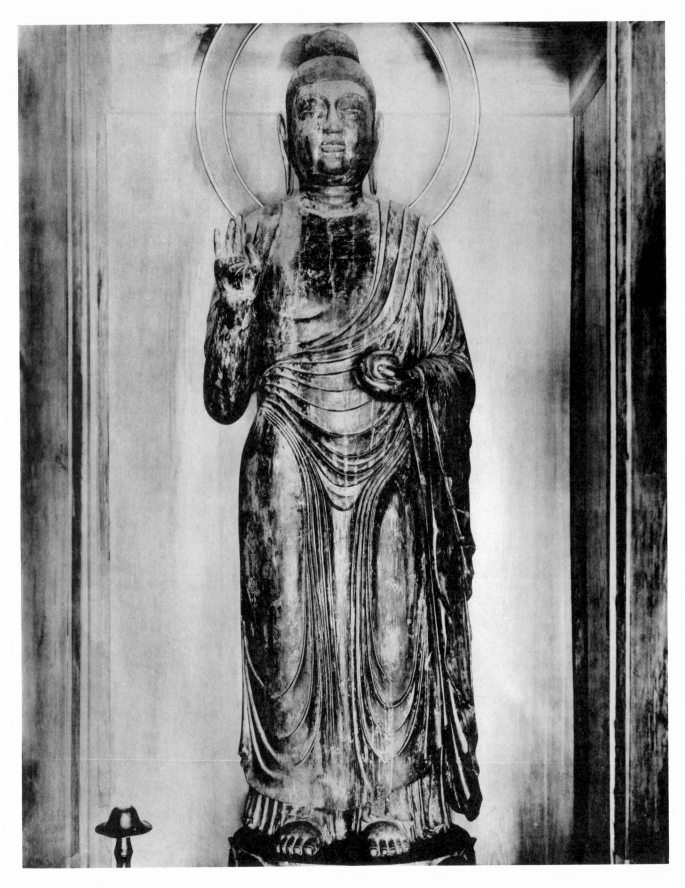

192

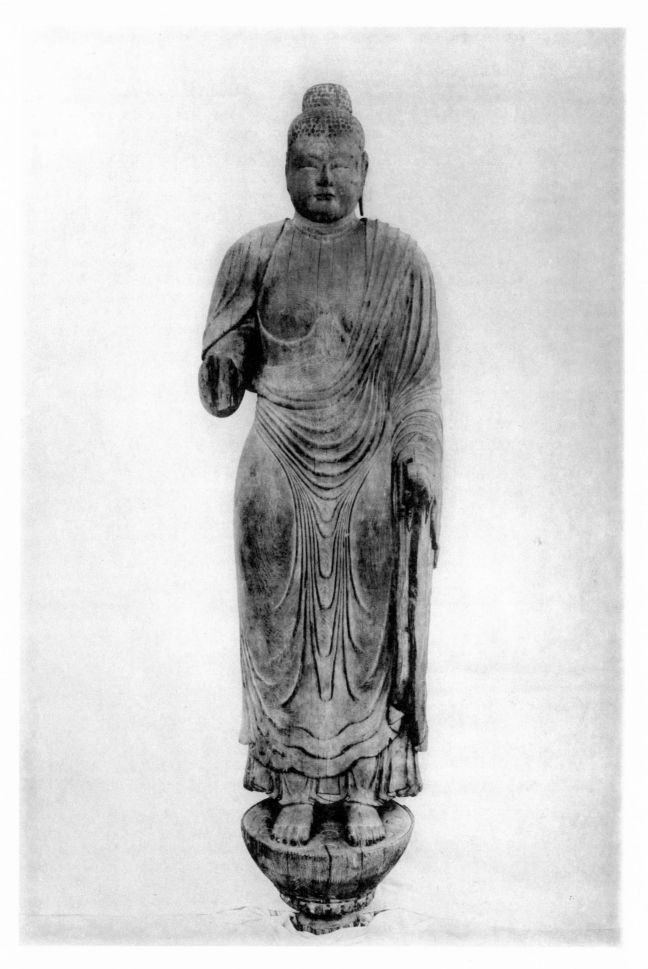

193

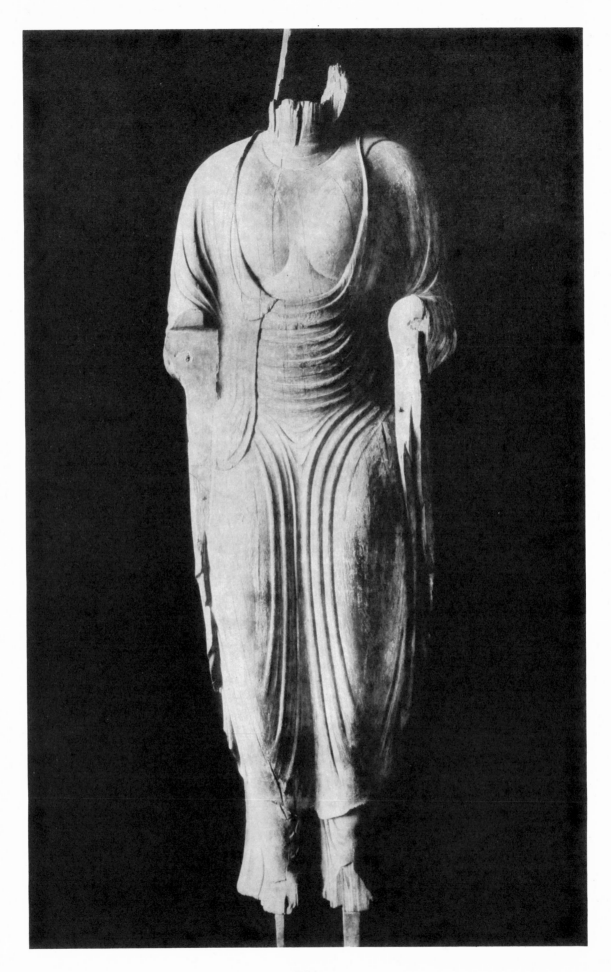

194

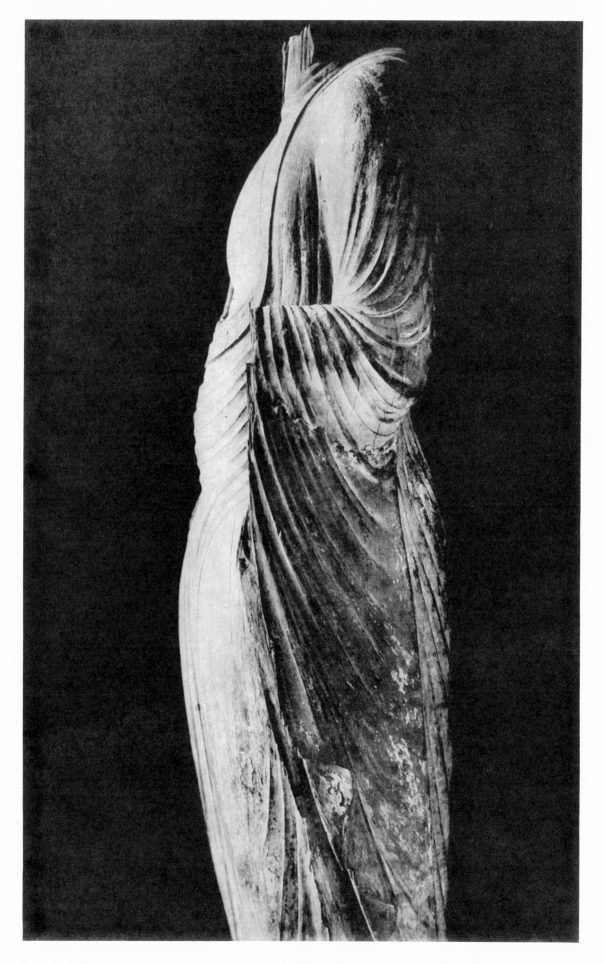

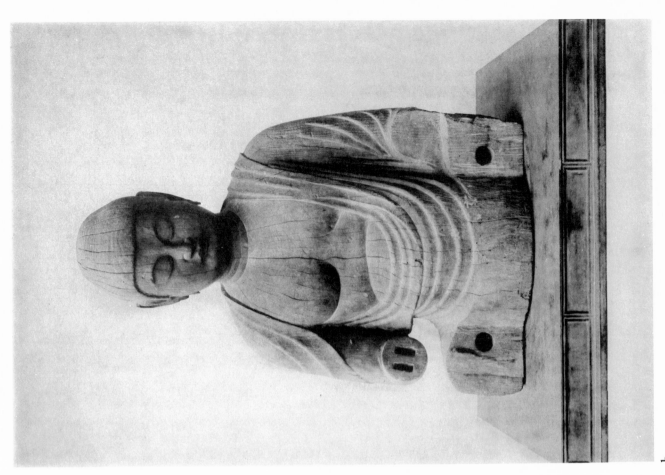

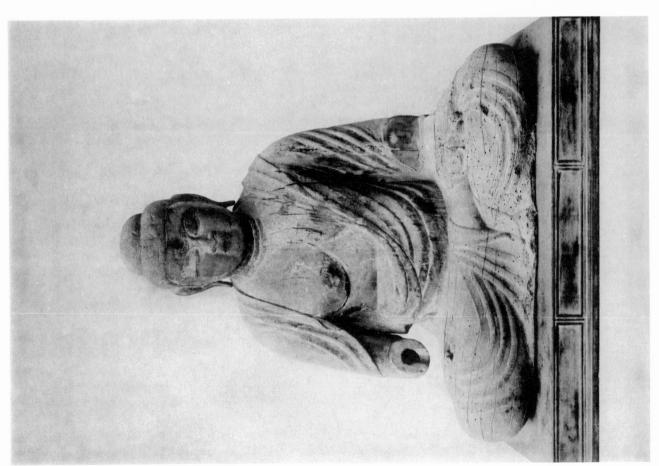

a

b

196

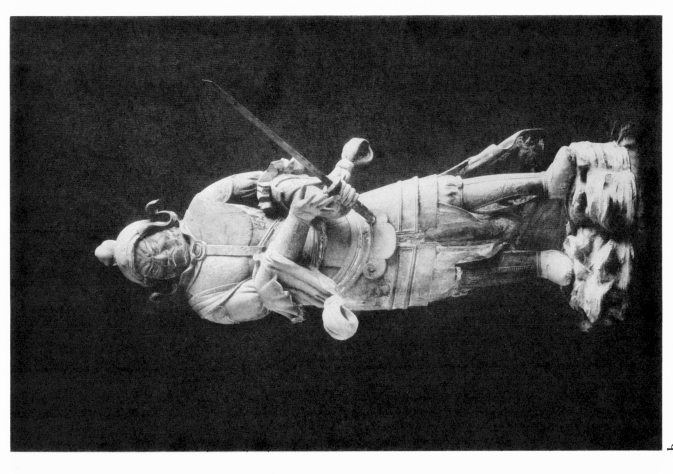

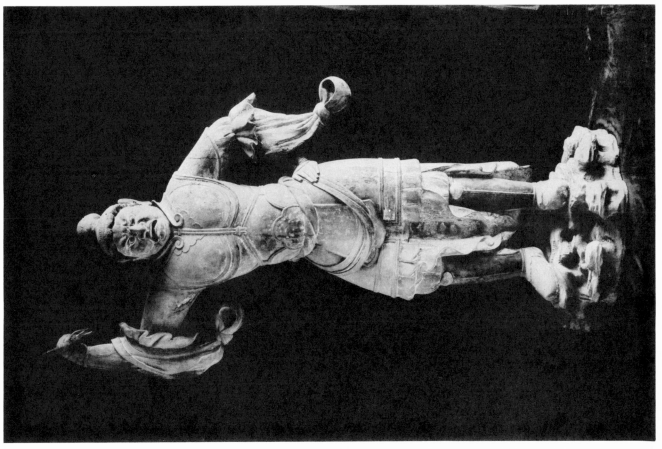

b

197

a

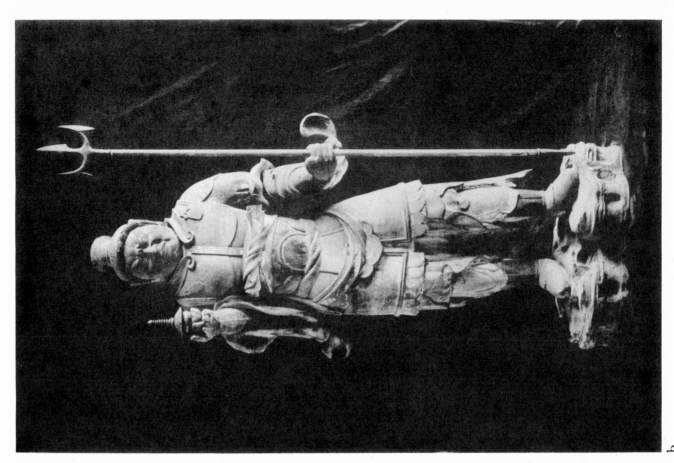

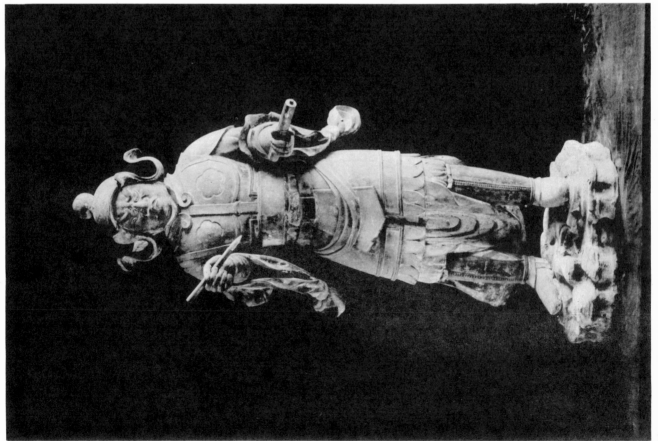

b

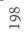

a

198

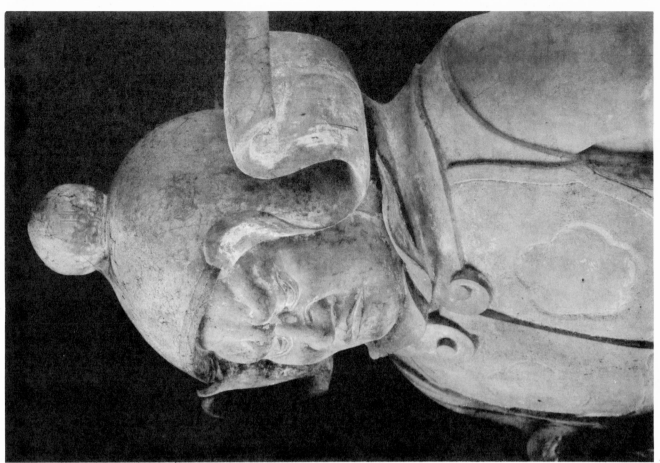

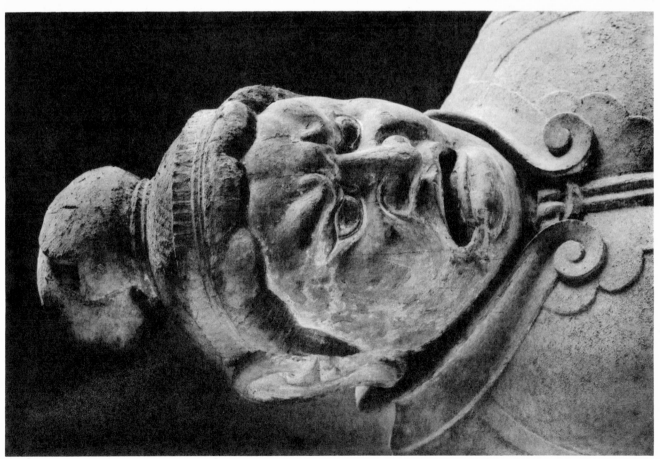

a

b

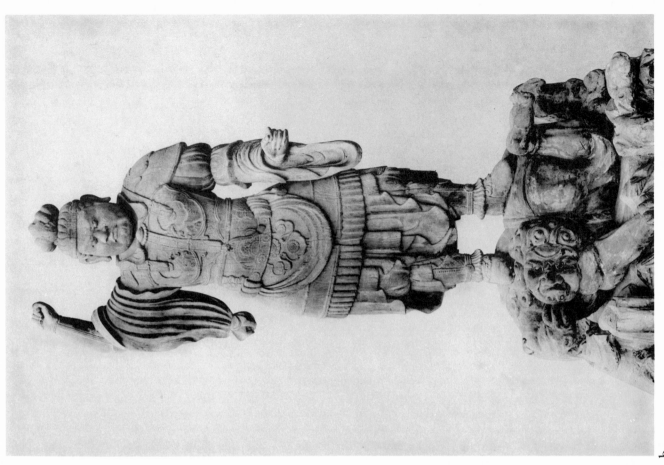

b

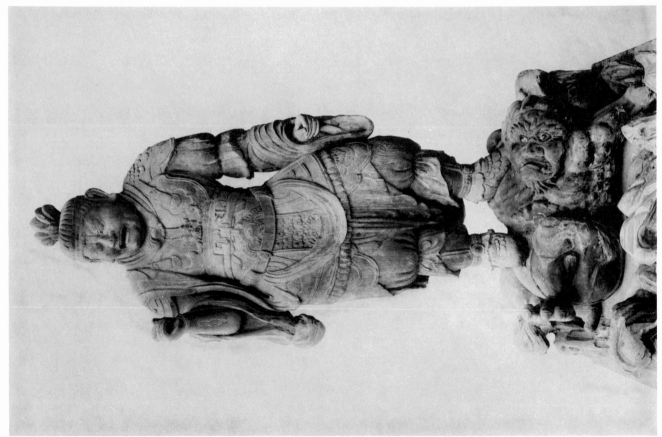

a

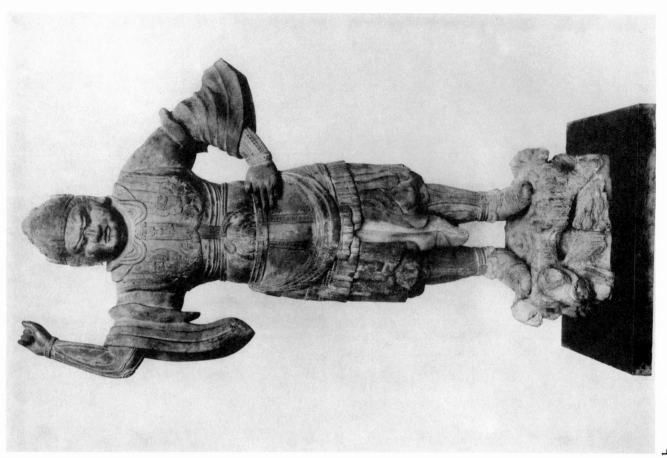

b

201

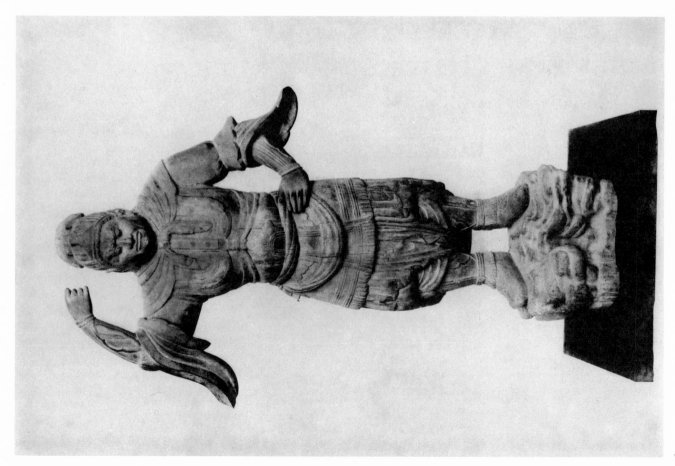

a

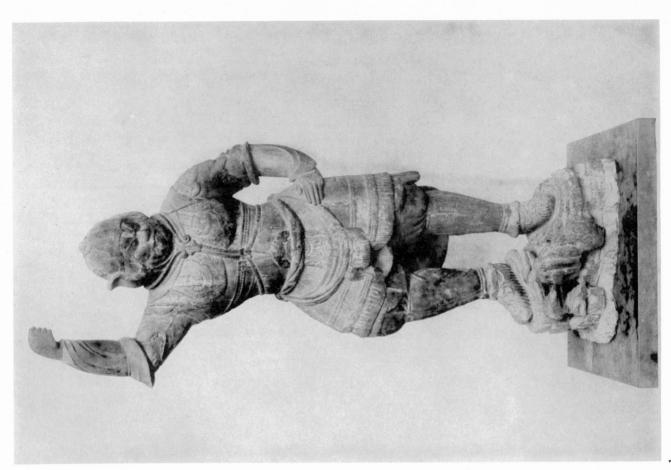

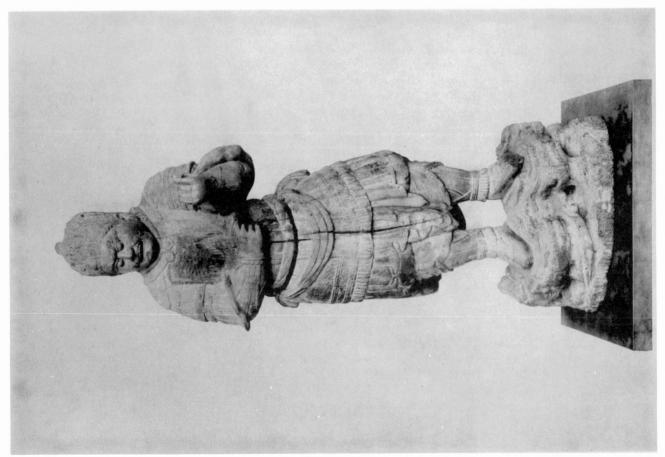

a

b

202

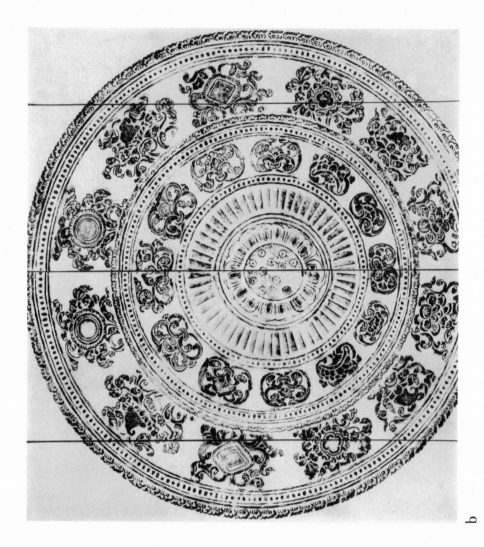

b

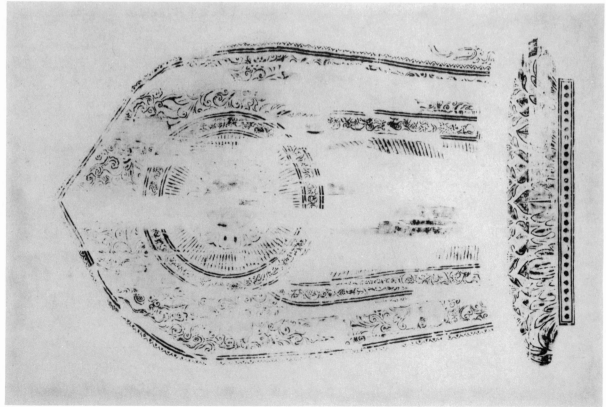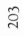

a

203

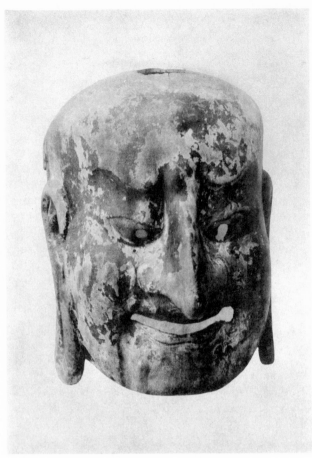

a

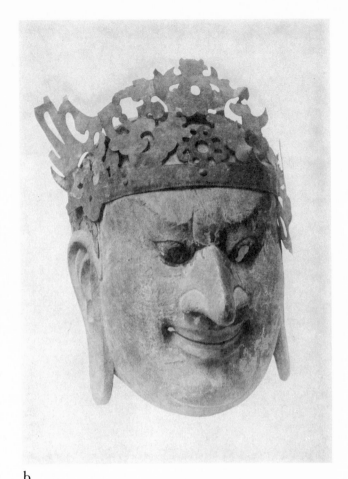

b

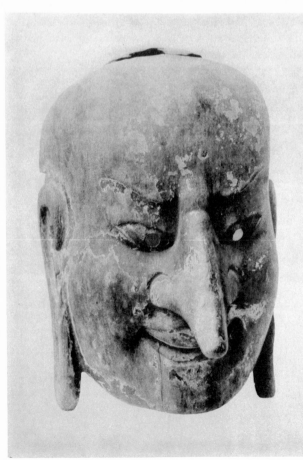

c

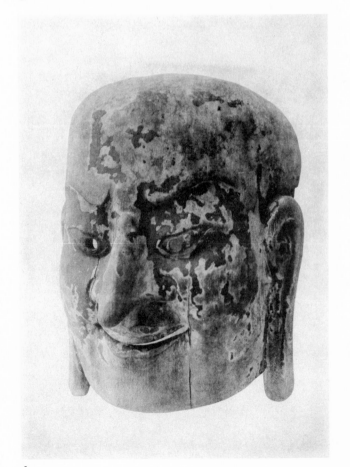

d

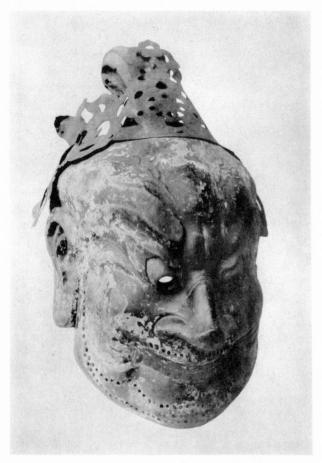

a

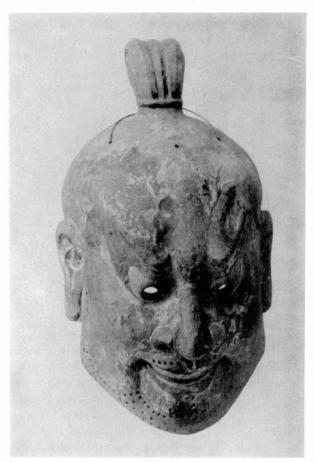

b

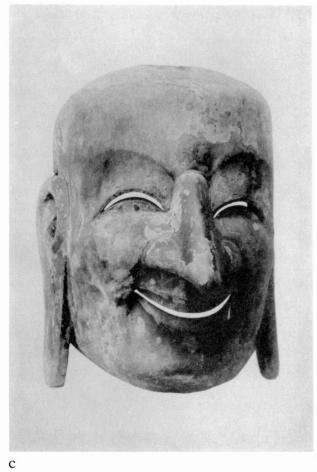

c

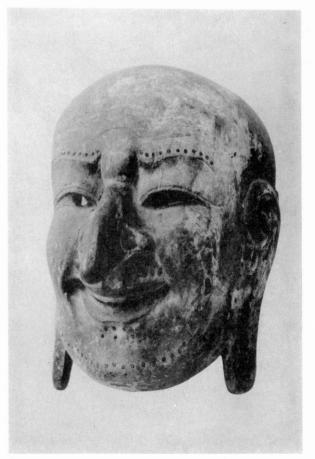

d

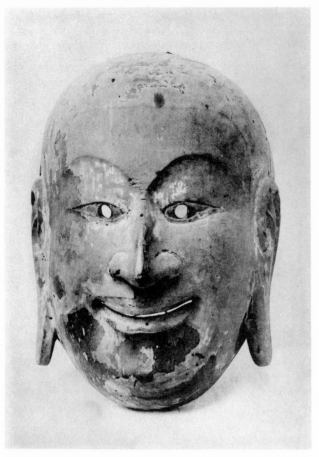
a

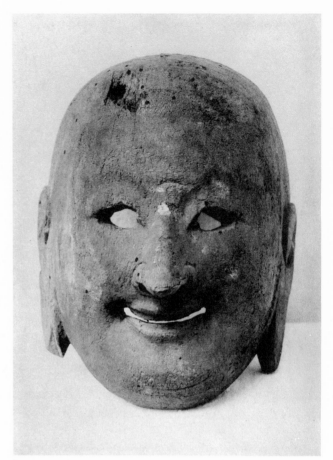
b

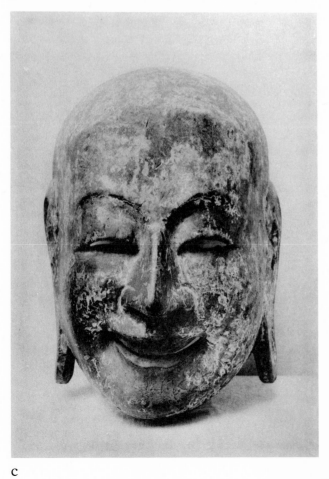
c

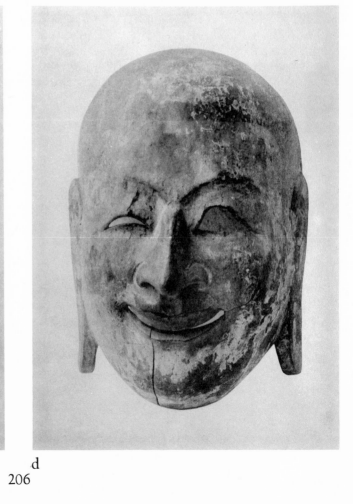
d

206

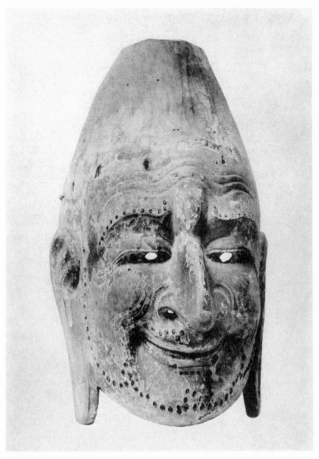

a

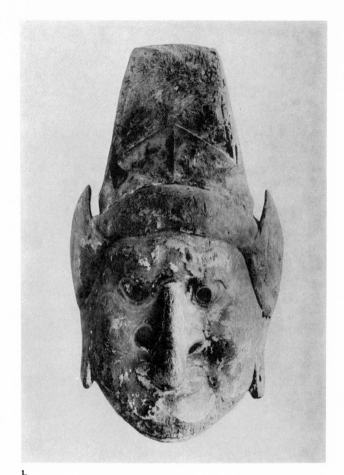

b

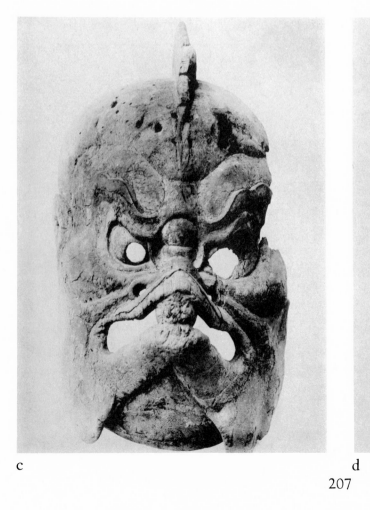

c

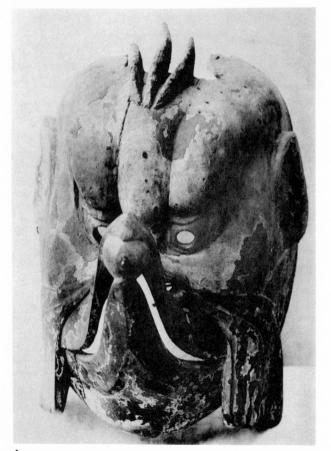

d

207

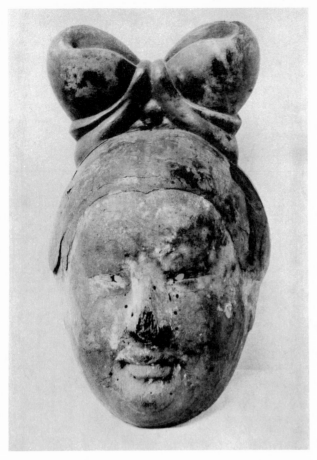

a

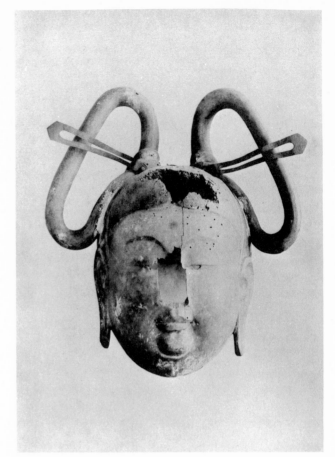

b

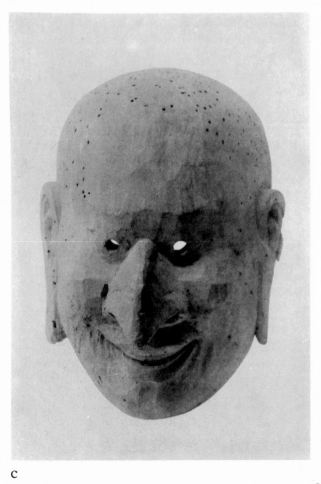

c

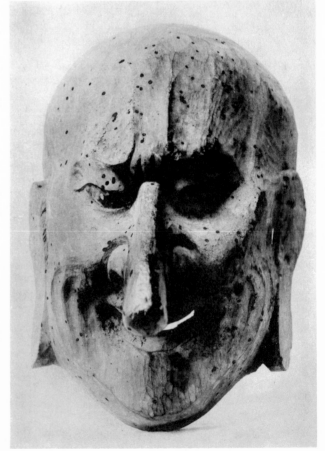

d

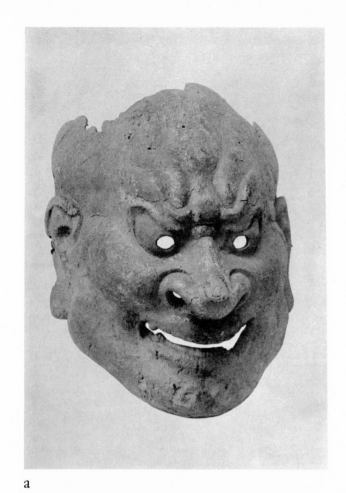

a

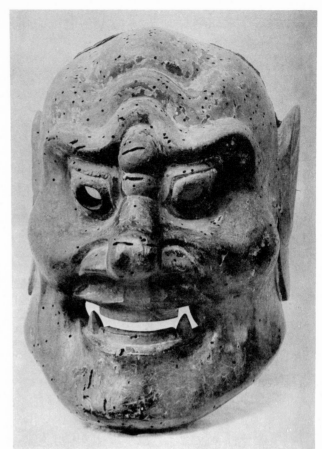

b

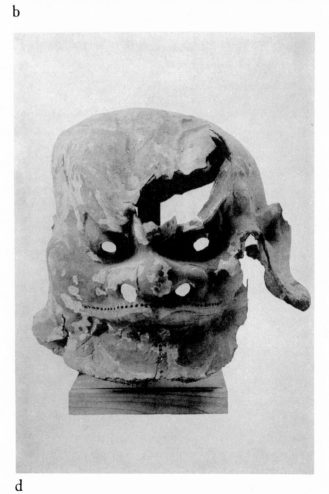

c

d

209

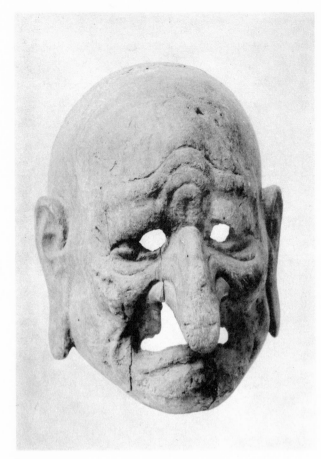

a

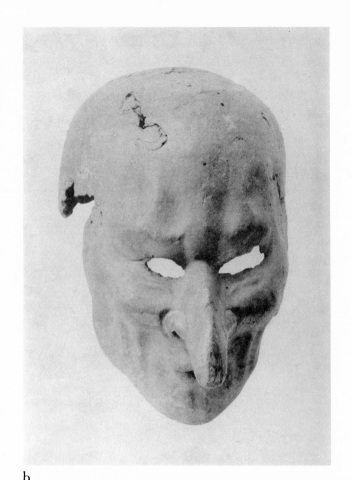

b

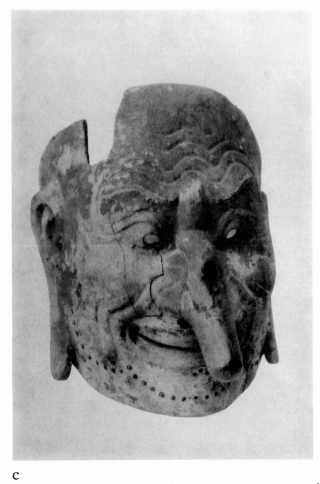

c

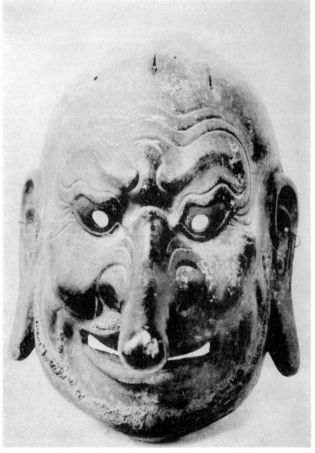

d

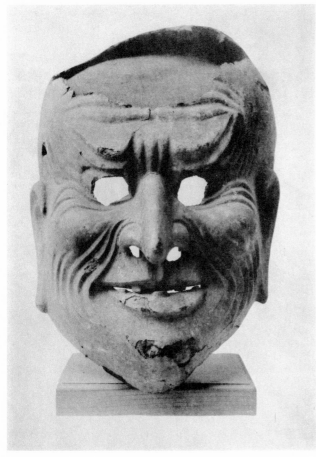

a

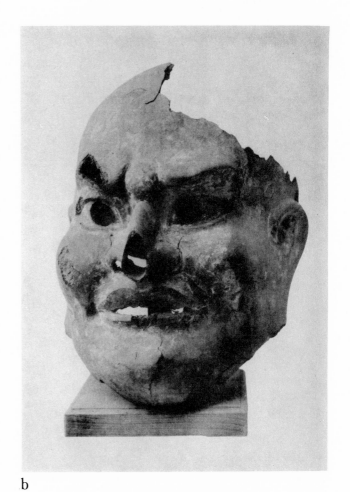

b

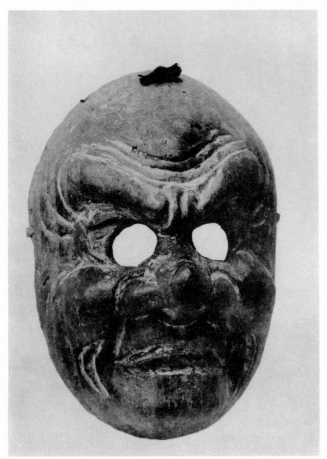

c

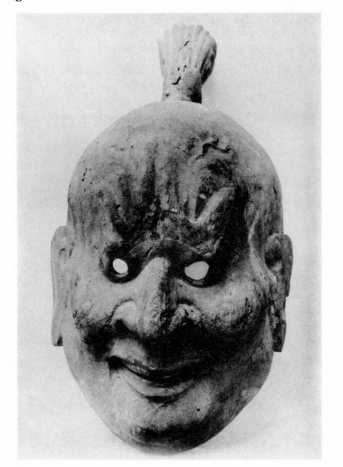

d

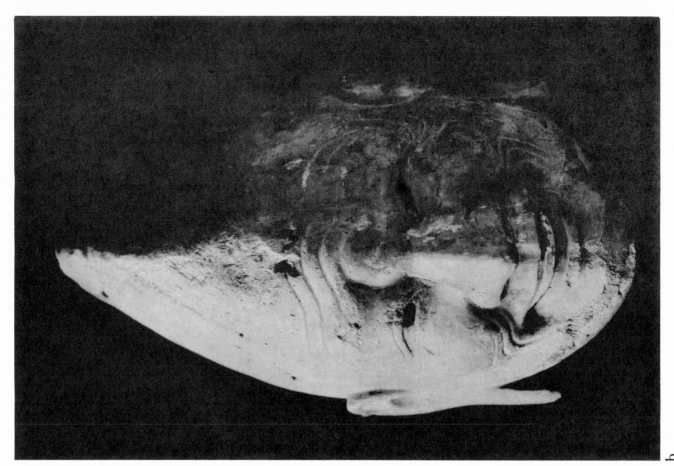

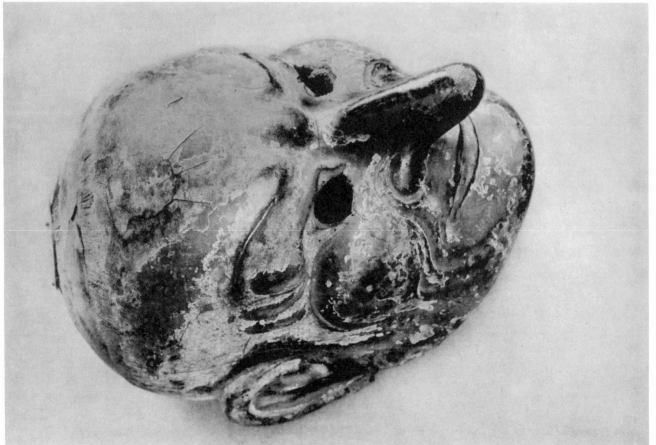

a

b

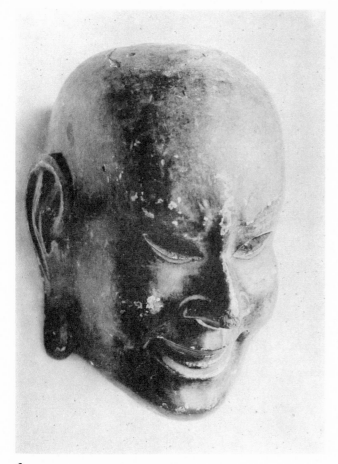

a

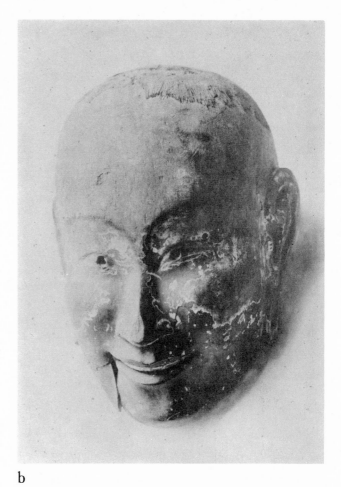

b

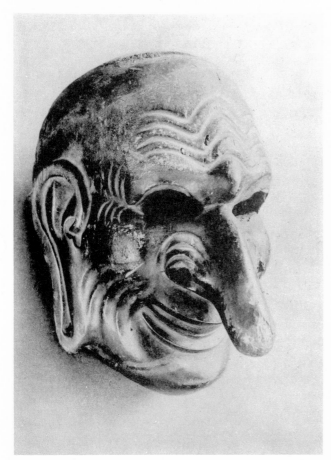

c

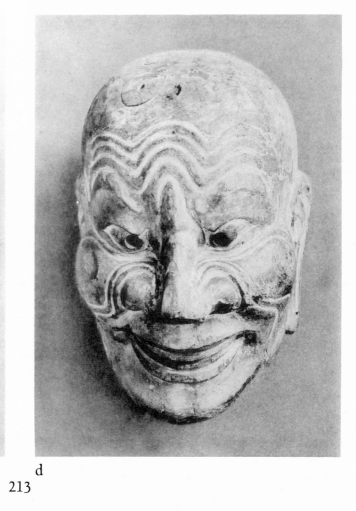

d

213

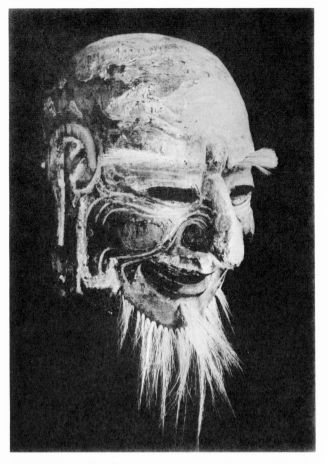

a

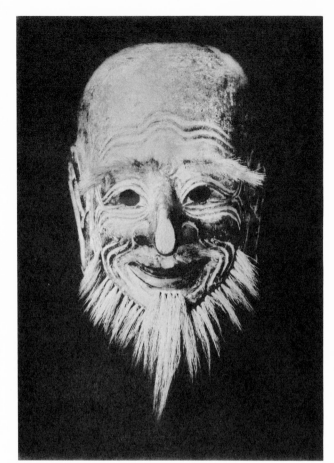

b

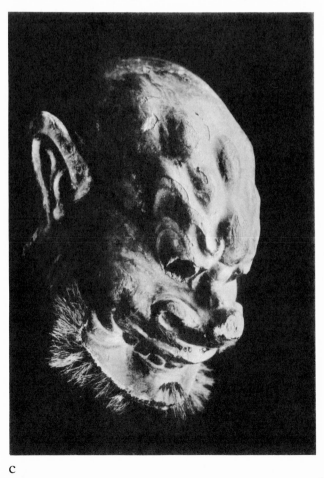

c

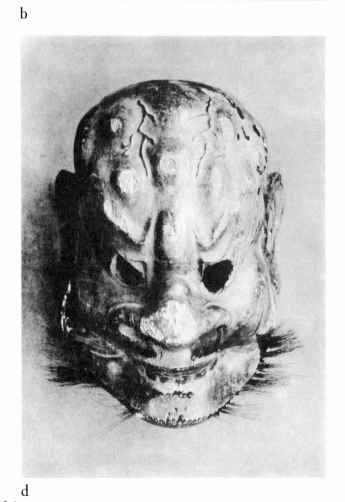

d

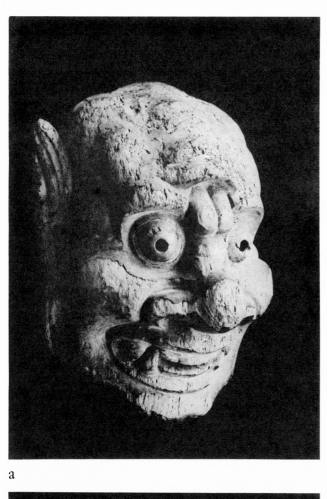

a

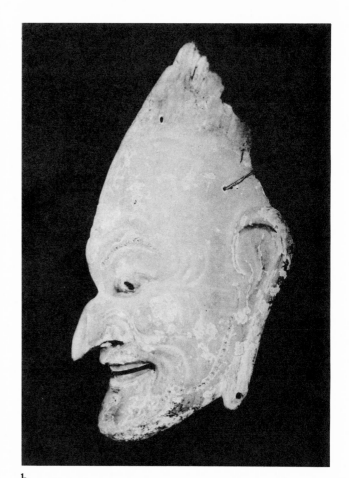

b

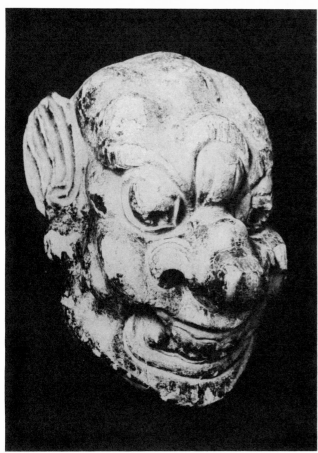

c

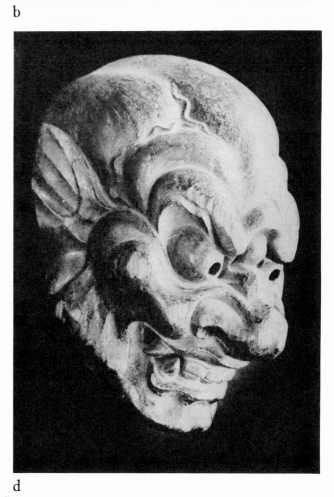

d

215

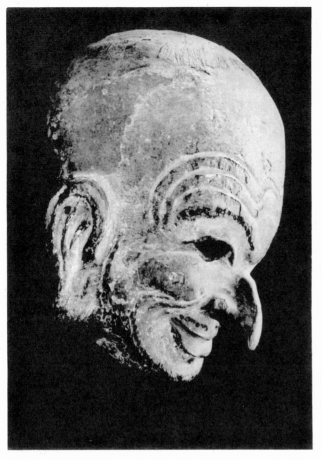

a

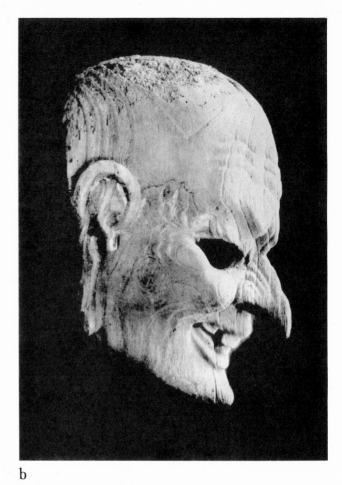

b

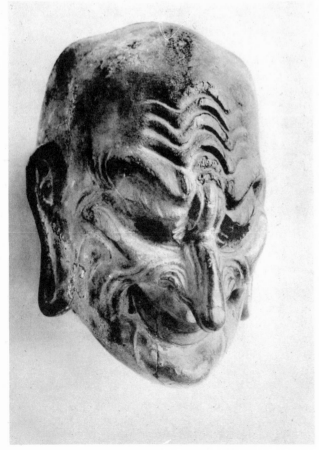

c

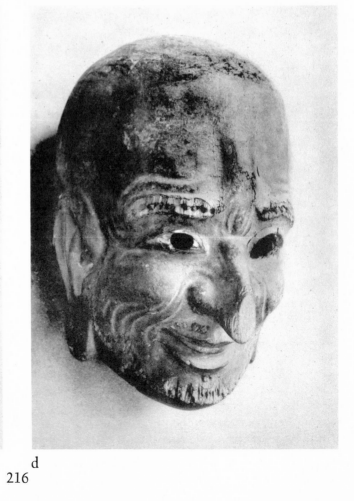

d

216

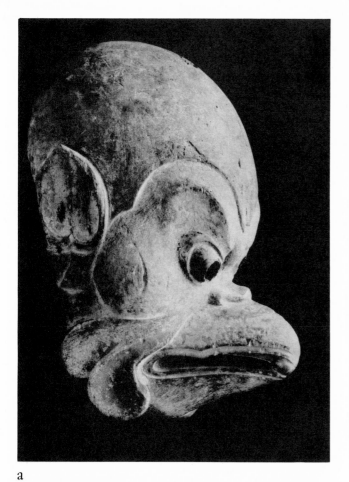

a

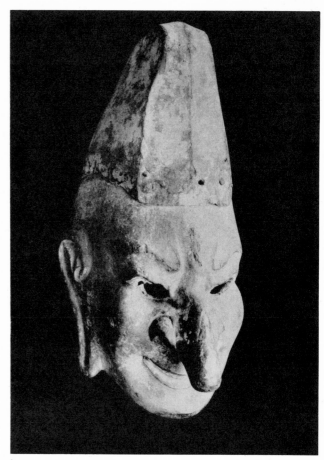

b

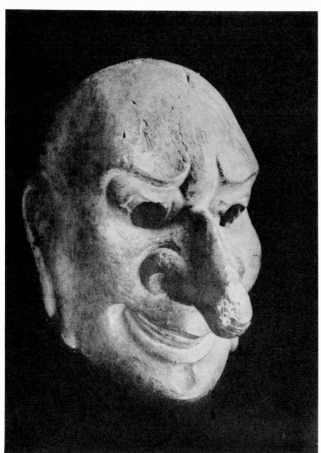

c

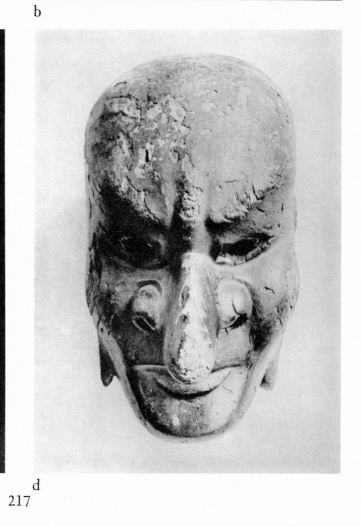

d